AGING MODERNS

AGING MODERNS

Art, Literature, and the Experiment of Later Life

SCOTT HERRING

Columbia University Press
New York

Columbia University Press
Publishers Since 1893
New York Chichester, West Sussex
cup.columbia.edu
Copyright © 2022 Columbia University Press
All rights reserved

Library of Congress Cataloging-in-Publication Data
Names: Herring, Scott, 1976- author.
Title: Aging moderns : art, literature, and the experiment of later life / Scott Herring.
Description: New York : Columbia University Press, [2022] | Includes bibliographical references and index.
Identifiers: LCCN 2022008899 (print) | LCCN 2022008900 (ebook) |
 ISBN 9780231205443 (hardback) | ISBN 9780231205450 (trade paperback) |
 ISBN 9780231556002 (ebook)
Subjects: LCSH: Older people's writings, American—History and criticism. |
 American literature—20th century—History and criticism. | Aging in literature. |
 Modernism (Literature)—United States. | Art, American—20th century—History. |
 Art and older people. | Aging in art. | Modernism (Art)—United States.
Classification: LCC PS153.O43 H47 2022 (print) | LCC PS153.O43 (ebook) |
 DDC 700.84/60973—dc23/eng/20220629
LC record available at https://lccn.loc.gov/2022008899
LC ebook record available at https://lccn.loc.gov/2022008900

Columbia University Press books are printed on permanent and durable acid-free paper.

Printed in the United States of America

Cover design: Milenda Nan Ok Lee
Cover art: Jacob Lawrence, *Supermarket—Periodicals*, 1994. Gouache and pencil on paper, 19¾ x 25½ in. (50.2 x 64.8 cm). Private collection.
© 2021 The Jacob and Gwendolyn Knight Lawrence Foundation, Seattle / Artists Rights Society (ARS), New York.

For Mary Willis, 1917–2010

One of the few good things to say about old age is that you have a new experience. Diminishment is not everybody's most anticipated joy, but there is news in this situation.

—Louise Glück

Contents

Acknowledgments xi

List of Illustrations xv

List of Abbreviations xvii

Introduction: Experimental Aging and American Modernism 1

1. Djuna Barnes and the Geriatric Avant-Garde 22
2. The Special Collections of Samuel Steward 50
3. Ivan Albright's Anti-Antiaging Treatments 78
4. Tillie Olsen and the Old-Old Left 107
5. Queer Senior Living with Charles Henri Ford and Indra Bahadur Tamang 137
6. The Harlem Renaissance as Told by "Lesbian Elder" Mabel Hampton 173

Coda: *After Jacob Lawrence* at Iona Senior Services 202

Notes 209

Index 251

Plates follow page *154*

Acknowledgments

I thank the National Endowment for the Humanities for a 2019–2020 Fellowship. That generous funding provided the psychic space necessary to complete and revise a draft of this book. Though the fellowship overlapped with the start of the COVID-19 pandemic, I count myself lucky that I was able to shelter in place and finish the manuscript from my home. My gratitude as well to my former institution of Indiana University, Bloomington, for strong administrative leadership during this crisis.

I accomplished most of this book's archival research before many libraries and museums closed their doors. For that, too, I am fortunate. Its realization would have been unimaginable—literally, undoable—without support, assistance, and access to materials from the following: Beinecke Rare Book and Manuscript Library at Yale University; Special Collections at the University of Maryland Libraries; New York Public Library; Department of Special Collections and University Archives of Stanford University Libraries; Howard Gotlieb Archival Research Center at Boston University; Lilly Library and Kinsey Institute Library and Special Collections at Indiana University; Leather Archives and Museum (LA&M); Ryerson and Burnham Art and Architecture Archives at the Art Institute of Chicago; Hanna Holborn Gray Special Collections Research Center at University of Chicago; Getty Research Institute Research Library and Special Collections; Lesbian Herstory Archives; GLBT Historical Society; Smith College Special Collections; and the Harry Ransom Center at University of Texas at Austin. I am also grateful to several extra-institutional individuals who are themselves living archives: Cheryl Clarke, Joan Nestle, Deborah Edel, Morgan Gwenwald, Michael Williams, JEB, and Indra Bahadur Tamang.

A number of colleagues in my fields of interdisciplinary study took precious time out of their schedules to read portions of my drafts and answer my queries, including Benjy Kahan, Denise Cruz, Alexander Howard, Bill Maxwell, Rachel Blau DuPlessis, Margaret Morganroth Gullette, Dani Caselli, Justin Spring, Diana Fuss, and George Hutchinson. Christine Oblitas, program specialist at Iona Senior Services' Wellness and Arts Center, meticulously edited my coda. For support and good cheer, I also thank Madoka Kishi, Julia Walker, Jani Scandura, Joe Boone, Brian Glavey, Alberto Varon, Jen Fleissner, Patty Ingham, Linda Charnes, Guy Davidson, Melissa Hardie, Rochelle Rives, Kate Lilley, Lee Wallace, Annamarie Jagose, George Chauncey, John Howard, Elspeth Brown, Mel Micir, Jackie Stacey, Richard Dyer, Ann Cvetkovich, Jess Waggoner, Tim Dean, Patrick Johnson, Cathryn Setz, Mike Moon, Jon Goldberg, Wendy Moffat, Marsha Bryant, Janet Lyon, and Robert Caserio. Rachel Adams's ruminations on aging, care work, and disability inspired the project's later stages. Though I lost one cat, 20/20 vision, and my metabolism during the book's composition, I gained an older writing partner—Shane Vogel—as we both entered the midlife.

I was glad to share rough ideas and rougher drafts with kind audiences in the United States, the United Kingdom, Australia, Japan, and Poland. I likewise learned much from students in several graduate seminars at Indiana, as well as a summer seminar at the University of Nebraska-Lincoln that I virtually led in 2021. Melissa Homestead earns a special citation for organizing that event. Attendees at the First International Djuna Barnes Conference, hosted at Birkbeck, University of London, facilitated my initial thinking in 2012, as well as those who later came out for talks and presentations delivered at UC Santa Cruz, University of Sydney, LA&M, Columbia University, the Queer Thinking symposium held at Sydney Gay and Lesbian Mardi Gras, Sexuality Summer School at the University of Manchester, Washington University in St. Louis, the Center for Material Culture Studies at the University of Delaware, UC Irvine, and conferences organized by the Modernist Studies Association, the Modern Language Association, the American Studies Association, and the Modernist Studies in Asia Network. Finally, I thank Greta LaFleur for inviting me to present some of this research at the New Matters and Queer Life conference at Yale in 2015. I got a good sense back then of a thriving interdisciplinary cohort based around the southern Connecticut shoreline, which now includes Reg Kunzel, Rod Ferguson, Tavia Nyong'o, Dara Strolovitch, Joe Fischel, Lisa Lowe, Jackie

Goldsby, Kalindi Vora, Juno Richards, Daphne Brooks, Matt Jacobson, Katie Lofton, Tim Young, and Joanne Meyerowitz.

The laser-focused insights of Heather Love and Sari Edelstein improved this book's organization and sharpened its claims. How Philip Leventhal secured their reports and, with Monique Briones, saw this book into production during a surge of the pandemic remains both a mystery and a marvel. Minh Vu's fact-checking likewise amazed me. I am humbled by the care that each of these individuals gave my words.

The works of Djuna Barnes reproduced herein are © copyright, Authors League Fund and St. Bride's Church, as joint literary executors of the Estate of Djuna Barnes.

Permission to cite unpublished poetry from the Charles Henri Ford Papers held at the Beinecke Rare Book and Manuscript Library was granted by Indra B. Tamang, literary executor of Ford's estate.

Harold Ober Associates kindly granted me permission to quote from "Old Age," "Old Walt," and "The Negro Speaks of Rivers" by Langston Hughes.

Permission to cite unpublished writings by Tillie Olsen housed at the Department of Special Collections, Stanford University Libraries, was provided by the Frances Goldin Literary Agency.

Permission to cite from correspondence and lecture notes in the Samuel Steward Papers held at the Beinecke Rare Book and Manuscript Library was granted by Michael Williams, literary executor of Steward's estate.

A small portion of the introduction first appeared as "Weak, Frail Modernism," in *Modernism/modernity* Print Plus 3, cycle 4 (2019). A version of chapter 1 was published in *PMLA* 130, no. 1 (2015): 69-91. Segments of chapter 2 were published, respectively, in "The Sexual Objects of 'Parodistic' Camp," in *Modernism/modernity* 23, no. 1 (2016): 5-8, 34, and as "On Late-Life Samuel Steward," in Debra A. Moddelmog and Martin Joseph Ponce's collection *Samuel Steward and the Pursuit of the Erotic: Sexuality, Literature, Archives* (Columbus: Ohio State University Press, 2017), 68-82. Sections of chapter 4 appeared as "Tillie Olsen, Unfinished (Slow Writing from the Seventies)," in *Studies in American Fiction* 37, no. 1 (2010): 81-99.

A brief note on my imperfect terminological decisions: following many others, this book privileges phrasing such as *older persons* when describing those who achieve a significant amount of chronological aging. It also regardfully uses *elder*.

Some of the artists discussed reference themselves as *old, fragile, getting old*, or, in Olsen's unapologetic instance, *truly old*. I was quite curious how they recorded the advance of their later lives. That mattered much more to me than what we think of them today. If ever asked, though, I'll speak on the record: "They deserve their own acknowledgments. I am thankful for what they left us once they left us. I am indebted to those who allowed me to spend as much time with them as I did."

Illustrations

I.1. Affidavit of Mabel Hampton, May 26, 1943 16
I.2. Faith Ringgold, *The Sunflower Quilting Bee at Arles*, 1996 20
1.1. Djuna Barnes, "Dereliction. Pro Vita Sua of (Parasites,Parthengenesis,and Spectre Spring.)," June 1, 1970 30
1.2. Djuna Barnes, "Rite of Spring.," May 25, 1980 32
1.3. Djuna Barnes, "Work in progress: Rite of Spring," undated 33
1.4. Djuna Barnes, "C.O.Bigelow.," December 10, 1980 37
1.5. Djuna Barnes, "Jefferson Market,Barnes.," undated 38
1.6. Djuna Barnes, "Pavan," undated 42
2.1. Robert Giard, *Samuel M. Steward (Phil Andros). Berkeley, CA*, 1988 52
2.2. Samuel Steward to Gertrude Stein and Alice B. Toklas, September 10, 1937 69
2.3. Michael Williams, *Steward Memorial-April 1994*, 1994 76
3.1. Ivan Albright, *Woman*, 1928 79
3.2. Ivan Albright, *Flesh (Smaller Than Tears Are the Little Blue Flowers)*, 1928 84
3.3. Ivan Albright, *Into the World There Came a Soul Called Ida*, 1929–1930 93
3.4. Ivan Albright, *The Vermonter (If Life Were Life There Would Be No Death)*, 1966–1977 98
3.5. Ivan Albright, *Study for "The Vermonter,"* 1965–1966 99
3.6. Unknown artist, photograph of Ivan Albright in his Woodstock, Vermont studio featured in *Yankee* magazine, ca. 1971 103
4.1. Tillie Olsen, draft fragment, undated 132
4.2. Tillie Olsen, inscription to *Yonnondio: From the Thirties*, undated 135
4.3. Tillie Olsen, modification of *Yonnondio: From the Thirties* title page, undated 135

xvi Illustrations

5.1. Charles Henri Ford's daily planner, May 17–18, 1993 141
5.2. Operation Minotaur icon featured in *7 Poems*, 1974 144
5.3. Charles Henri Ford and Indra B. Tamang, Ford's bibliography on Gnamat Design Studio letterhead, 1981? 145
5.4. Arthur Tress, *Charles Henri-Ford, Poet, N.Y., N.Y. 1997*, 1997 154
5.5. Indra B. Tamang, *Indra's Cover for* Blues 10, 1989 157
5.6. Charles Henri Ford, untitled Operation Minotaur collage, 2001 161
5.7. Indra B. Tamang, untitled collage (front), February 10, 1976 163
5.8. Indra B. Tamang, untitled collage (back), February 10, 1976 164
5.9. Indra B. Tamang, untitled collage (front), 1976 165
5.10. Indra B. Tamang, untitled collage (back), 1976 166
5.11. Indra B. Tamang, untitled collage (front), 1977 167
5.12. Indra B. Tamang, untitled collage (back), 1977 167
5.13. Author photograph of Indra B. Tamang, July 10, 2018 169
5.14. Author photograph of apartment 103, The Dakota, July 10, 2018 171
6.1. Cover of *Lesbian Herstory Archives Newsletter* 5, 1979 184
6.2. JEB (Joan E. Biren), photograph of Mabel Hampton featured in *Sinister Wisdom*, November 21, 1978 186
6.3. JEB (Joan E. Biren), photograph of Mabel Hampton featured in *Sinister Wisdom*, November 22, 1978 187
6.4. Artist unknown, photograph of New York City's Pride March, ca. 1980 190
6.5. Photographs of Mabel Hampton, A'Lelia Walker, Wallace Thurman, and Eric Garber, *Advocate*, May 13, 1982 193
6.6. Promotional flyer for Eric Garber's "T'Aint Nobody's Bizness" presentation, 1984 197
C.1. Jacob Lawrence, *Supermarket—Periodicals*, 1994 204
C.2. Sharon O'Connor, *Participants creating collaborative artwork in the Iona/Phillips Creative Aging partnership*, 2019 207

Abbreviations

CHFP	Charles Henri Ford Papers, Yale Collection of American Literature, Beinecke Rare Book and Manuscript Library, Yale University, New Haven, Conn.
CHFP RLSC	Charles Henri Ford Papers, Research Library and Special Collections, Getty Research Institute, Los Angeles
DBP	Djuna Barnes Papers, Special Collections, University of Maryland Libraries, College Park, Md.
IAC	Ivan Albright Collection, Ryerson and Burnham Art and Architecture Archives, Art Institute of Chicago
MHSC	Mabel Hampton Special Collection, Lesbian Herstory Archives, Brooklyn, N.Y.
SSP	Samuel Steward Papers, General Collection, Beinecke Rare Book and Manuscript Library, Yale University, New Haven, Conn.
TOCP	Tillie Olsen Collection of Papers, Henry W. and Albert A. Berg Collection of English and American Literature, New York Public Library, Astor, Lenox, and Tilden Foundations
TOP	Tillie Olsen Papers, Department of Special Collections, Stanford University Libraries, Stanford, Calif.

AGING MODERNS

Introduction

Experimental Aging and American Modernism

Among American modernism's countless novelties was the lived experiment of growing older. That, in a nutshell, is my argument. Concentrating on a handful of authors and artists, I confirm that their modernism was a vital practice inextricable from their aging selves. This experimental art appeared after the Older Americans Act of 1965 and its subsequent amendments, in the midst of mass longevity, and in disagreement with the cultural cliché that late life demands quietude. How, I ask of these understudied cases, did they produce their aesthetics years after the movement's zenith? The long and the short of it: by cultivating what age theorist Margaret Morganroth Gullette terms "old age imaginaries," or what I call modernist elderscapes following sociologist Stephen Katz.[1] Hence *Aging Moderns* explores poems drafted by Left Bank icon Djuna Barnes up to 1982; the mystery novels and souvenir collections of Samuel Steward, a close friend of Alice B. Toklas, that he crafted and culled into the 1990s; Tillie Olsen's writings on the aging female laborer typed before her Alzheimer's disease diagnosis in 2004; Mabel Hampton's performances recorded during the 1970s and 1980s; the paintings and notebooks of magic realist Ivan Albright, who composed portraits of elders until his death in 1983; and surrealism made by Charles Henri Ford and his caregiver Indra Bahadur Tamang at the Dakota apartment building across the 1990s and into the early 2000s.

None fossilized while aging in place. They instead realized an astonishing output well into the later twentieth century, and sometimes beyond. Across multiple genres—poetry, the novel, correspondence, painting, performance, collage, the memoir, the essay, the life review, the personal collection, the public lecture, even the pharmacy order—we find varieties of American modernism generated

by well-worn lives. Whether they worked from a hospital bed in Vermont, an in-law suite in Berkeley, or an apartment in the Bronx, they solved a riddle that puzzled Langston Hughes in his poem "Old Age" two years before his death in 1967: "If there should be nothing new, / Might not the self-same wonders do? / And if there should be nothing old, / Might not new wonders still unfold?"[2] With disparate responses, their archives verify that each replied in the affirmative. That feat alone deserves more acknowledgment than scholars grant them thus far.

My claims for these holdings will sometimes sound straightforward. Yes, University of Maryland documents attest that Barnes wrote in her Greenwich Village apartment for decades after Harcourt, Brace and Company released her novel *Nightwood* in 1937. According to archived materials at Stanford University, so, too, did Olsen for almost thirty more years after she published *Yonnondio: From the Thirties* in 1974. At other times, my subjects led me down unforeseen paths. While Ford wrote scads of haiku in composition books and daily planners into his nineties, he fostered a Nepali modernism now held at the Getty Research Institute as well as the Beinecke Rare Book and Manuscript Library at Yale University. Though she did not associate with the Harlem Renaissance, I was pleased to discover that Hampton extended its projects into the 1980s thanks to her affiliation with the Lesbian Herstory Archives (LHA). Attending to their experimental aging, my own understanding of Afro-modernism, proletarian modernism, queer surrealism, high modernism, Chicago modernism, rural modernism, and U.S. magic realism grew more recognizable and, at the same time, more alien. No matter what modernisms they undertook, they relished what Kathleen Woodward terms "the tradition of the old made new."[3]

They also disproved my own prejudices about what can be accomplished amid what Barnes once lamented as "(such debilities) debilities."[4] As their bodies saw them into many decades of life, their endeavors went hand-in-hand with another underreported triumph: modernism was a passkey unlocking opportunities for creative aging. Even when travel became a bear and the curb a gorge, their artworks give the lie to the ageist chestnut that older adults cannot break ground. Fostering what Robert Reid-Pharr refers to as "ideas of novelty, experimentation, lack of fixity, playfulness, and boisterousness that are *not* often associated with age," they model modernism for a range of ages.[5] They confronted with aplomb the vexations that this time of life—like most times of life—brings to bear on aesthetic capacities. Thanks to their achievements, they left us with much to

learn about modern topoi such as senior living arrangements, antiaging dreamworlds of the rejuvenation industry, intergenerational bonds, transgenerational designs, Black longevities, eldercare, adult day health services, senior centers, and what Susan Sontag describes as the misogynistic double standard of aging.[6] Now my cards are face up, so let me elaborate on how this book contributes to oldish-newish modernisms across an extraordinarily long American century.

I

Modernisms live on. This axiom is the most invigorating claim made by new modernist studies, itself no spring chicken. Reporting for the *Chronicle of Higher Education* more than two decades ago, Scott Heller published a cover story, "New Life for Modernism," whose title cut to the chase. An outsider taking in the scene, Heller was intrigued by the first conference of the Modernist Studies Association held high in the central Pennsylvania mountains between October 7 and 10, 1999. With panel topics ranging from "melancholy, heterochrony, and the long twentieth century" to "postmodern considerations of three poets," some attendees humanely put down what he referred to as "the old modernist studies."[7] Close to a decade later, Douglas Mao and Rebecca L. Walkowitz reiterated this reno in a short essay, "The New Modernist Studies." "Temporal expansion," they wrote, "has certainly been important in the study of literary modernism: the purview of modernist scholarship now encompasses, sometimes tendentiously but often illuminatingly, artifacts from the middle of the nineteenth century and the years after the middle of the twentieth as well as works from the core period of about 1890 to 1945."[8] Another name for this taffy-pulled periodization would be "long modernism," a phrase coined by Amy Hungerford with a lengthy scholastic shelf life of its own.[9]

From the vantage point of older modernist studies, this new iteration is an antiaging serum that, for once, worked. Thirty-nine years before the New Modernisms conference at Penn State University, Harry Levin proclaimed the era's end with a raft of inaccurate age metaphors. Ruminating on "our elders," he found that "all of them grew up in the late Nineteenth Century and matured in the early Twentieth, reaching their prime in the period between the wars."[10] I could go on with his questionable depiction of the early 1960s as "the middle age of the Twentieth Century," but Levin was far from the originating source of a

false ending. Some modernists excelled at reinforcing his temporally limited claim that "we live at least in the afterglow of the Moderns."[11] Playing a mean game of Where Are They Now?, *The Autobiography of William Carlos Williams* (1951) had no problem conjuring a mass die-off: "Stieglitz dead; Hart Crane dead; Juan Gris—at one time my favorite painter—long since dead; Charles Demuth dead; Marsden Hartley dead.... Jane Heap dead; Margaret Anderson, I don't know where."[12] Playing with the hoary trope of last man standing, Malcolm Cowley's *The View from 80* (1980) likewise reminisced that "in my World War I generation of writers, all the famous novelists have vanished."[13]

Subsequent generations didn't always help matters. Neither did mythologizing critics. Grieving H.D.'s passing and the ailments of Williams and Ezra Pound, Denise Levertov's gorgeous dirge "September 1961" keened, "This is the year the old ones, / the old great ones / leave us alone on the road."[14] Far less kind, Weegee's *Naked City* (1945) took much pleasure in finding Alfred Stieglitz huddled alone in An American Place (Room 1710, 509 Madison Avenue). Mistakenly titled "Endings," the final chapter of Hugh Kenner's *The Pound Era* (1971) finds "the dwindling Eliot" who can barely breathe and an incapacitated Williams who "could no longer read and could barely type."[15] Even feminist recovery work undercutting Kenner's misogynistic oversights reconfirmed the wind-up. In the opening of *Women of the Left Bank: Paris, 1900–1940* (1986), Shari Benstock introduces readers to "the malingering appearance of aged expatriates who have outlived their era," spent forces with "a fund of dim memories and stories too often told."[16]

Scholars mining veins of new modernisms have revised these end dates for some time now. Alongside long modernism, we have "the movement's belated modernist project"; "unfinish*able* projects"; "forever modernism"; and a "modernism [that] has not yet come to an end," to name a few.[17] Meant to augment rather than upend this established body of knowledge, my contribution is a friendly reminder: while modernism lived on, so, too, did the modernists. Held in university libraries, in museums, and in extra-institutional collections such as the LHA, their archived lives confirm the movement's perpetuation and complement its legacies.[18] When I revise that last sentence, I honestly have no idea how long modernism will end up lasting. Less engrossed in guesswork, I just know that the artists this book features lasted with their modernisms, and that we have underrecognized these herculean actualizations the further out we get from the mid-twentieth century.

Forthcoming chapters rectify this gap, especially since vulnerable older persons remain a chronic blind spot in the secondary literature.[19] As much as my prior research sought out geographically peripheral queer modernisms (Demuth cripping in Lancaster, Pennsylvania, for one), I am intrigued by those chronologically peripheralized by ageism the closer we get to our twenty-first century. We have underexplored these aesthetic domains, and older modernists should get overdue invitations to participate in our online forums, our Cambridge Companions, our Oxford Handbooks, and our seminars. While they confirm linear chronology with the accident of their births, their longevities further modernism's temporal expansion. Samuel Steward, for example, published his Joycean detective novel *The Caravaggio Shawl* in 1989. Ford, to give another, edited the surrealist magazine *View* starting in 1940 and kept on surrealizing until the early 2000s. These two, like others discussed, made modernism where they could, when they could, while they could.

Framing my project in this manner, I join a wellspring of scholars in mid-twentieth-century U.S. literary and cultural studies considering what Mark McGurl describes as "the obvious continuity of much postwar American fiction with the modernist project of systematic experimentation with narrative form."[20] My chapters speak to these reperiodization efforts as those I feature experiment with new twentieth-century genres such as lesbian-feminist oral history (Hampton) and the life review (Olsen, primarily). They brought their past lives with them as the years after the Second World War kept adding up. Tracking how they navigated what some now call the contemporary, I carry the "sputtering torch of interwar modernism" further than the decade immediately after 1945 and think about artists who are, as McGurl deemed Kay Boyle in her middle age, "a living link back to a more glorious period in American literary history, when giants like Hemingway and Faulkner had been in their prime."[21]

While I do so, I introduce the term *geromodernism* to capture some of the long-term aesthetic effects I chase after. I intend the prefix *gero* to denote a concern with aging that each case study entertains. This marker does not indicate that aging was a sole interest, but it was nonetheless a novel state approached with curiosity even as it occasionally bemused them. Theirs were, to again quote Hughes, "self-same wonders," with the caveat that the self-same is not the same old. One can—they did—continue to innovate with what may no longer seem all that cutting edge.

Undertaking these singular forms of what Woodward terms "an aging Modernism," they also warp received wisdom regarding late modernism's own timing. Writing in 1980, Woodward delineated late modern Anglo-American poetics to be "that span of fifteen years dating from the publication of the *Four Quartets* in 1943 to the appearance of *Paterson V* in 1958."[22] Others in more recent scholarship, such as Michaela Bronstein, confirm this dating. Others see late modernism commencing in the mid-1920s. Still others simpatico with temporal expansion stretch it into the mid-1970s, or thereafter.[23] Fredric Jameson, for one, pushes its periodization into the years following the Great Recession of 2007-2009. Coterminous with his essays on male-directed films collected in *The Ancients and the Postmoderns*, a piece written for *New Left Review* in 2016 gazes past the movement's many fountainheads to analyze films by Russian filmmaker Aleksei Gherman, including *Hard to Be a God* (2013). Astonished by "the last convulsions of a virtually extinct modernism," he identifies "the presence of a few inexplicable meteorites" that may be "omens or warnings, punishments or glimpses of the unknown."[24]

I am less interested in refining when, exactly, late modernism transpired in toto than in attending to modernisms of late. I am also not sold on the bleakness of Jameson's mineral metaphor. Yet part of me runs with this descriptor and approaches the works showcased in *Aging Moderns* like exhibited meteorites in the Janet Annenberg Hooker Hall of Geology, Gems, and Minerals at the National Museum of Natural History in Washington, D.C. Kids on field trips go *wild* for these celestial bodies, and it is good fun to see them ogle at some of the universe's oldest objects crashing into their imaginations. A few of these artists did not leave behind an impact crater, but if they spark an iota of that excitement in scholars today, then we are the better for it. Their experimental aging shows them light-years ahead of our time and its wearisome indifference to older adults.

And, of course, their own. If late-in-life modernisms transpire amid any experimentalist's lifetime—this book's final case study is artwork made at a D.C.-area senior center months before the COVID-19 pandemic began—they also beg the question of occurrence at moments earlier than the ones I entertain. While I do not elaborate at length on these possibilities, my mentions of afterglow and torches and starry, starry nights recall Walt Whitman sharing thoughts on "the early candle-light of old age" in his late sixties.[25] Drawn to "the touch of flame—the illuminating fire—the loftiest look at last," he knew a thing or two about

continuous self-experimentations and their relation to "Old Age's Lambent Peaks." They were, for him, one and the same. In that poem from 1888 reprinted in the 1891–1892 "Deathbed Edition" of *Leaves of Grass*, he imagines a self near seventy scanning "o'er prairie, mountain, wood" and surveying "the lights indeed from them—old age's lambent peaks."[26] His is not the afterglow of the Moderns but a Modern in afterglow. "What am I myself," he has asked of us for more than a century and a half, "but one of your meteors?"[27]

Besides a lighted wick or a falling star, this queer giant on the verge of his own extinction also fancies himself "like some hard-cased dilapidated grim ancient shell-fish or time-bang'd conch (no legs, utterly non-locomotive)." In the same paragraph he tells his audience that "old as I am I feel to-day almost part of some frolicsome wave, or for sporting yet like a kid or kitten."[28] As a partially paralyzed baby goat in Camden, New Jersey, Whitman offers a glimpse into the playful possibilities of modern aging aesthetics in the early 1890s. His is a different vision from Weegee's Stieglitz, Kenner's Eliot, or Benstock's expatriates. With reference to "this late-years palsied old shorn and shell-fish condition," his poetics of disability and aging would have profound influence on writers such as Hughes, who leaned on "Old Walt"—the title of an occasional poem for the *Beloit Poetry Journal* in 1954—as a resource for "finding and seeking."[29]

Each of my case studies renews this embodied tradition of long-life modernism when they dispute gerontophobia across multiple axes of identity. They agree with a passing comment Whitman apocryphally made on April 3, 1888: "we are not going to expect to lose even a losing fight—that would not be like us: we are not easily subdued."[30] Despite their unique hardships, they too delighted in supplement hours. On the lookout for modernisms that keep on going, I shine light on these efforts. I keep my own candle lit.

II

I could not maintain this watch without the foundational insights of critical age studies headed by two feminist theorists I have previously introduced: Kathleen Woodward and Margaret Morganroth Gullette. Many before them labored, in Gullette's words, "to advance the causes of the vulnerable," and many during and after, including Devoney Looser, Leni Marshall, Sari Edelstein, Habiba Ibrahim, and Amelia DeFalco, follow their lead.[31] In terms of forebears, I have in mind

Philadelphia-based revolutionary Maggie Kuhn, who founded the Gray Panthers in 1970, protested federally mandated retirement, backed intergenerational living arrangements, and roasted Johnny Carson's sexism; the gerontologist Robert N. Butler, who coined *age-ism* in 1969 to protest discrimination against working-class older individuals of color and their rights to fair housing; University of Chicago psychologist Bernice L. Neugarten, who theorized "the internalization of age norms" across the second half of the twentieth century; gerontologist and Stephen Smith Geriatric Center affiliate Hobart C. Jackson, a longstanding proponent of Black aging concerns; and sociologist Jacquelyne Johnson Jackson, whose dispatches from "the blacklands of gerontology" blasted the field's normative whiteness.[32] I mean this book to honor these individuals as much as these modernists.

To do so, chapters to come draw on their invaluable concepts such as *double jeopardy*, a phrase promoted by Jackson on behalf of the National Urban League to account for racialized debility. I also rely heavily on terminology refined by Gullette and Woodward over the past four and a half decades while acknowledging that interdisciplinary scholarship in age studies has snowballed. My readings spell out many of their critical terms, but I note in advance that I remain a torchbearer for their age theories unsettling what Gullette refers to as *age ideology* or *decline ideology* and what Woodward deems "the ideology of the aging body in the West."[33] These concepts aim to blunt the explicit and implicit biases that undergird what Butler referred to as "age discrimination or age-ism," which can include "a personal revulsion to and distaste for growing old, disease, disability; and fear of powerlessness, 'uselessness,' and death."[34]

Is it kismet that both Gullette and Woodward deployed modernist literatures to launch their programs back in the day? I have already cited Woodward's *At Last, the Real Distinguished Thing* in reference to "the tradition of the old made new." Subsequent readings included in a second monograph, *Aging and Its Discontents: Freud and Other Fictions* (1991), concentrate on works by Samuel Beckett, Virginia Woolf, and Marcel Proust. Gullette's work likewise draws on Gertrude Stein (*The Geographical History of America or The Relation of Human Nature to the Human Mind*), Willa Cather (*The Professor's House*), and Zora Neale Hurston (*Their Eyes Were Watching God*), among others worrying the line between age norms and age narratives.[35] Together their prolific writings fulfill Woodward's wish for high modernist literary gerontology four decades ago: "that a new way of thinking (and thus being in the world), a new mode of cognition, may emerge in old age."[36]

This book obliges both of their requests that we further develop their insights. Doing so allows me to foreground a few available writings on the aging and the old—not always one and the same—produced within newer modernist studies despite its relative incuriosity about this swath of the lifespan. To curate the standouts, start with Heather Love's contention that "even when modernist authors are making it new, they are inevitably grappling with the old."[37] Extending Love and noting that "modernism is conventionally defined by its allegiance to the new," Michael North nonetheless finds that "the modern breaks itself away from the old by means of an affiliation with the very old."[38] For North, this *fort/da* relationship with antiquity appears in "the pseudo-Greek poetry of the imagists" (think H.D.'s *Sea Garden* [1916]).[39] For Sam See, it courses through works such as Ford and Parker Tyler's *The Young and Evil* (1933) as the two "make literary and sexual modernism new by saying something old" with evocations of a decadent Roman Empire amid their fictive reimagining of the 1930s pansy craze.[40] Still others, such as Elizabeth Gregory, Benjamin Kahan, and Melanie Dawson, attend to the gendering of developing decline ideologies in works by Marianne Moore and Edith Wharton.[41]

I credit these scholars with facilitating my thought. With Whitman in mind, I am equally intrigued about the experimental aging of the temporally expanded modernist self. In a catalogue for the *Georgia O'Keeffe: Living Modern* exhibition held at the Brooklyn Museum in 2017, art historian Wanda M. Corn's overview of O'Keeffe from her birth in 1887 to her "late-life behaviors" finds that "from early on O'Keeffe dedicated herself to a principle she learned from her teacher [Arthur Wesley] Dow at Columbia, to erasing the boundaries between the making of art and the living of life."[42] Corn's observation parallels the findings of historian Christine Stansell's *American Moderns*, which educates us about "a modernism experienced as an artful, carefully crafted everyday life" and to which this book's title and thesis pay deference.[43] My case studies learned the lessons that Dow, O'Keeffe, Corn, and Stansell taught as well, even though only three—Steward at Ohio State University, Barnes at the Pratt Institute and the Art Students League, and Albright at the School of the Art Institute of Chicago—received formal training. Whether the scenario is Barnes revising grocery lists in her Patchin Place apartment; or Hampton taking center stage at a West Village senior center; or Steward clinging to material memories of Stein and Toklas in his Berkeley abode, they expand definitions of modernist production by treating their aging selves as modernism that went on until it couldn't. It isn't

misrepresentation to call them age theorists who confirm present-day age theories, thereby throwing cold water on still-pervasive claims that "old age is averse to innovation."[44]

This experimental aging was never easy street. My frequent citations of "endeavors," "accomplishments," "efforts," and "achievements" highlight how arduous their art often proved to be. Not one reached an idealized state where they found themselves "no longer so distracted by the naturalized body," a vision of disembodiment offered by Gullette to delink older populations from ageist decline narratives.[45] Not all loved the passing of time. Damned if you do keep on and damned if you don't, they remained big believers in creative responses to their lived experiences. However grudgingly old age fell into their laps, they approached it as an aesthetic challenge that compensated for its exasperations. "If you were really going to get old," Steward cheekily advised a correspondent in 1990, "you might as well get as old as you could get."[46]

My readings respect how they merged their corporealizations with these material productions. When one anonymous reader of what became this book's first chapter found my discussion of Barnes's back pain indecorous, I followed the report's lead at the time and largely censored myself. Nervous about making it through the last hurdles of an intensive peer review, I stripped details of how she navigated her words, her typewriter, her workdays, and her writing utensils with osteoarthritis. I do not wish to repeat that mistake. Without question some of my artists stayed in fine health for most of their life. They achieved what too many today normalize as *successful aging*. Others did not and persisted at making art out of their days. Steward "suffered from dental problems, hearing problems, varicose veins, and the dreadful breath-stifling COPD [chronic obstructive pulmonary disease]."[47] His exquisite miniature book *A Pair of Roses* was published in 1993, the year he died. Hampton became interdependent on fellow LHA activists in her eighties. She lectured about her Harlem Renaissance at Rutgers University-New Brunswick in 1987. Albright experienced a stroke. He composed a self-portrait while partially paralyzed. Ford's last year of life saw a stay at an Upper East Side skilled nursing facility. He made surrealist cutouts the summer before 9/11. As much as they grappled with age bias as a devilish chrono-cultural norm, they tussled with their longevity as a psycho-biological fact and an artistic occasion. Living with chronic neurological conditions and low vision, they were honest about their aging bodies when they chartered new modes of

"age-correlated creative decline."[48] The least I can do is return that favor and dignify their embodiments.

On this particular front, their modernist age studies hyperlink them to modernist disability studies, a field that expanded over the past two decades to help us rethink, for starters, ambulation and the urban promenade, "defectives" and anti-immigrant discourses, cognitive disability and literary postimpressionism, and what Paul K. Saint-Amour, theorizing "weak modernism" in relation to weak theory, terms "an ethics and politics of shared debility."[49] I have elsewhere argued that more canonical male modernists were quite intimate with Saint-Amour's characterization of the field when they grew older. One has only to again recall *The Pound Era*'s attention to the disabled and dying Irish, British, American, and Canadian men of 1914.[50] But Eliot's alveoli are not my mark. Though this book is chockablock with illustrations, do a Google image search for its more minor artists to observe how those results feature some of them with prescription eyeglasses or mobility aids. These visuals, like their works, testify to how they experienced and experimented with late-onset disability. When we factor in what Woodward references as "the delicate 'frailty' of the elderly," their aestheticization of these self-embodiments also signals modernist iterations of what she dubs *fragilization*.[51] In undated lyrical lines that chapter 4 closely reads, Olsen referenced this time of her life as "the claw of not being able to's not bend nor lift."[52] Yet these very words recraft her difficulties into modernist prose and transform physical disability into a poetic preview of more life to live.

I don't think it is a distortion to call Olsen a weak modernist who confirms our weak theories. Her poetics of "not being able to's" likewise suggests how age studies, when filtered through the lens of late-onset disability studies, innovates other keywords driving many new modernist studies—motion, migration, and circulation. The same goes for speed, which I later discuss in terms of Olsen's self-proclaimed slow writing. If Woodward is correct that "temporally, aging and disability converge in the case of frailty, a syndrome often associated with advanced old age," then how might such embodiments supplement our understandings of modernism's pacing alongside its revised timelines?[53] Or those negotiating mobility? Ruminating on "modernist mobilities through time and space" in a chapter on "circulating modernisms," Susan Stanford Friedman approvingly cites Michel Foucault, who finds that "we are at a moment, I believe, when our experience of the world is less that of a long life developing through time than

that of a network that connects points and intersects with its own skein."[54] I reintroduce longevities into discussions of modernity's many movements. The Whitmanian worlds these artists built are as wide in scale, scope, and imagination as any planetary network. When we consider the universe of informal caregivers, drop-in visitors, and home health aides who helped them circulate in workrooms and dwelling places, what counts for modernist mobilities further multiplies in keeping with the field's best practices.

I elaborate on this last topic when chapter 5 turns to Tamang's caregiving of Ford, which advanced a global surrealism linking rural Nepal to Kathmandu to uptown Manhattan to senior living. In anticipation of that discussion, let me say that later-life disability allows for unanticipated potentials to emerge from the writer's desk, the painter's studio, and the performer's stage. In his remarks on older biopoliticized bodies, Foucault comments on "individuals who, because of their age, fall out of the field of capacity, of activity."[55] If we approach capacities beyond a social field with clearly defined borders, however, modernist productivities take on as many modes as modernist productions. Once scholars "stop sustaining an outmoded myth of lateness and begin to address the actual conditions of late creativity," we observe older artists who engaged in multiple styles—queer geromodernisms, Afro-geromodernisms, proletarian geromodernisms, and so forth.[56] Hence my interest in the wide range of elderscapes that confirm the complexity of their lives. By gathering them together in one book, I make good on Linda Hutcheon and Michael Hutcheon's rejoinder to late style's strong theorists that "there are as many late styles as there are late artists."[57]

And, unfortunately, as many fields of ageism to foil and to dodge. When older artists' biological aging could sometimes be tedious, the multiple gerontophobias of cultural aging made things so much worse. Undermining age ideologies, their modernisms were a bulwark against this hurt. They sustained themselves by sustaining the vast enterprise of experimentalism. Steward's Steinian prose and Ford's haiku comforted both amid "the frantic-pathetic efforts to stay young and attractive in a culture which admires youth alone."[58] Hampton's erotics threw shade on unfounded fears of old age and desirability in U.S. lesbian-feminist communities. Albright felt liberated by the art world's growing indifference to his passé magic realism. Along with walking canes, portable oxygen tanks, pills for high blood pressure, and countless individuals who looked after them, their prolonged late styles helped them carry on and temper the sting of age norms.

III

Ticking the dates off calendars, these modernisms also double as archives of geromodernity. Consider Ford's papers at the Beinecke, including 21.95 linear feet of materials such as notebooks from the 1990s as well as his medical records acquired in 2004. The finding aid for these documents notes that this acquisition "received a basic level of processing, including rehousing and minimal organization."[59] While they can feel kitchen-sink, these materials are as important as Ford's editorial work for *Blues: A Magazine of New Rhythms* from 1929 to 1930 or *View* in the 1940s. They validate that his post-1945 modernism was also modernism made with Medicare. If you pull seven of these folders from 1990 to 2003, you come across a booklet explaining the ins and outs of this amendment in 1965 to the Social Security Act of 1935; his enrollment in AARP's supplemental Medicare insurance plan; and a snail-mailed notice for Empire Medicare Services marked "for file (archive)" with a fluorescent pink highlighter.[60] These acquisitions are not picayune. Ford's note regarding Empire suggests that communication from this company was correspondence worth keeping—as much a part of his archived life as letters from Pound, Barnes, Joseph Cornell, Wifredo Lam, Man Ray, Dorothea Tanning, and a slew of others.

Like every other archive this book discusses, Ford's Medicare files document the dynamic institutions of U.S. geromodernity, a topic that historians such as Howard P. Chudacoff, Jill Lepore, Carole Haber, Corinne T. Field, and Nicholas L. Syrett have addressed since at least the late 1970s.[61] The final chapter of my previous book detailed the broad strokes of their findings when *The Hoarders* rehearsed how the disciplines of gerontology and geriatrics, emerging in the early twentieth century and institutionalized in the decades thereafter, advanced appropriate and inappropriate modes of aging.[62] Here I repeat that the new science of senescence—the one-word title of psychologist G. Stanley Hall's opus from 1922—worked hand in glove with new consumer cultures, new visual cultures, and new federal programs to naturalize old age norms. "By 1930," Chudacoff surmises, "the medical establishment, private industry, and government bureaucracy had converged in their definitions and treatment of old age. This consensus served to lend to old age a more exclusive distinctiveness, physical, social, and policy-wise, than had previously existed. The climax to this form of age grading occurred with passage of the Social Security Act in 1935."[63] During the second

half of the twentieth century, these developments led to Medicare and Medicaid, the Older Americans Act of 1965 with its support for "multipurpose activity centers," and age-based political mobilizations, including the Gray Panthers.[64]

Threading through these historical innovations is an ignominious advantage of the global North: mass longevity, or what an overly enthusiastic Robert N. Butler terms "the longevity revolution."[65] Even as U.S. citizens witness declines in life expectancy due to deaths of despair and the COVID-19 pandemic, the fact remains that "between 1900 and 2000, thirty years were added to life expectancy at birth and in the middle decades."[66] Race, ethnicity, and socioeconomic disadvantage reduce this average and point to systemic inequalities across the lifespan. Skeptical about idealizing mass longevity, I remain intrigued by how modernists saw their way through its burgeoning institutions—and what documents record these dealings. While Ford relied on Medicare as well as informal caregiving offered by Tamang, LHA documents show that Hampton participated in the home attendant/personal care worker services of the Medicaid-sponsored Center for Independence of the Disabled, New York (CIDNY). A close-knit network of LHA companions also facilitated her experimental independent living. Alongside her Medicaid filing recorded in the finding aid for LHA's Mabel Hampton Special Collection, her archived holdings include a photocopy of their care plan dated August 24–September 4, 1989.

What would it mean to see CIDNY—or Tamang's caregiving of Ford, for that matter—as vital to modernism-making as a bohemian's salon, a cabaret's stage, or a little magazine's editorial office? My inquiry is far from rhetorical, especially when we remember that mass longevities and the lived experience of U.S. modernity historically overlap for much of long modernism. "Starting around 1880," Gullette observes, "... we witness in rapid succession the rewriting of old age as a medical problem, the inventions of retirement, 'pediatrics,' 'gerontology,' 'geriatrics,' 'adolescence,' the middle years, the relocation of a male climacteric from age sixty-three to the midlife, 'flapper,' 'Lost Generation,' 'postgraduate mother,' 'empty nest.'"[67] When I mull over a lost generation of modernist elderhood, my head goes immediately to F. Scott Fitzgerald's "The Curious Case of Benjamin Button," a short story included in *Tales of the Jazz Age* (1922). But consider also W. E. B. Du Bois's compilation *Efforts for Social Betterment Among Negro Americans* (1909) and its catalogue of homes for older African Americans across major U.S. cities as well as smaller towns such as Evansville, Indiana; or narratives of the formerly enslaved recorded between 1936 and 1938 through the New

Deal-era Federal Writers' Project. Or cross-generational violations of regional African American age norms in *Their Eyes Were Watching God* (1937). While her former Eatonville, Florida, neighbors stigmatize "dat ole forty year ole 'oman" for "runnin' after young boys," Hurston's protagonist Janie Mae Crawford erotically embodies her middle years as an affront to this incorporated community's age expectations.[68]

Consider, too, how a queer of color modernist such as Hampton had to negotiate government archives of chronological aging. "Age," historians Corinne T. Field and Nicholas L. Syrett remark, "became increasingly relevant to people's everyday lives as various state and corporate bureaucracies documented birthdates and ages, which in turn encouraged people to believe that age was an important part of their identities."[69] Born in Winston-Salem, North Carolina, Hampton did not possess a document that officialized her birthdate as May 2, 1902, in confirmation of Field and Syrett's observation that "Africans Americans in the South remained less likely to have access to this supposedly universal proof of age."[70] She petitioned what is now the Forsyth County Register of Deeds office and also acquired a May 26, 1943, affidavit of birth signed by two individuals—Gladys Bryce and Charles H. Lewis—"knowing Birth of Child" (figure I.1).[71] Forsyth County's archives may have failed her. This affidavit's repository, the LHA in Brooklyn's Park Slope neighborhood, did not. Taking good care of Hampton's materials, the LHA also houses the print culture of Black queer geromodernity.

Another example from this remarkable archive: amid papers and realia that testify to New York City's lesbian community formations and Hampton's domestic partnership with Lillian B. Foster, you come across an October 1987 article titled "Positive Aging" published in *Prime of Life: A Monthly Newspaper for the Long Living*. Printed by Lutheran Community Services, this piece cites "the latest research in gerontology" and offers advice about "personal issues related to health and longevity." Invoking discourses of "aging optimally" in its references to "PICASSO painting masterfully at 90" and "GRANDMA MOSES at 100," it also nods to "thousands of unsung heroes and heroines, who are busy working, exercising, and working fully regardless of their chronological age."[72] A folder labeled "memorial?" includes this newspaper issue, and it remains unclear to me how much Hampton relied on its claims during her final years. Nevertheless, it offers a window into modernity-at-large as "Positive Aging" popularizes gerontological knowledges, self-care, and Cubism.

16 Introduction

I.1 Affidavit of Mabel Hampton, May 26, 1943. Mabel Hampton Special Collection, Lesbian Herstory Archives, Brooklyn, N.Y. Photograph by Saskia Scheffer.

The personal papers of those such as Hampton, I safely presume, speak to modern aging matters as much as motion pictures such as *Social Security Explained* (1936), housed at the National Archives, or the papers of gero-psychologists such as Hall, held at Clark University in Worcester, Massachusetts. These archives are often where modernist lifecycles meet up with modernist lifespans. As Jean-Christophe Cloutier observes, "Authors increasingly considered the status of their lives essentially as occasions for an archive."[73] Cloutier relies not only on heterosexual writers such as Ralph Ellison to make this claim, but also queer artists and collectors such as Hughes, Richard Bruce Nugent, Carl Van Vechten, and Claude McKay. Their sexual and gender nonconformity is imperative to acknowledge—four of my six chapters are LGBTQ+ friendly—when we also think about the rise of anti-institutional archives such as the LHA (founded in 1974 in an Upper West Side apartment) or the illicit queer feminism latent in

midcentury archives detailed by Melanie Micir, whose *The Passion Projects* offers a compelling model of close reading late modernist collections that taught me much.

Thankfully, the personalized self-collections of my featured artists each captured their later years. Their archives considered the status of their *much later* lives essentially as occasions to defy ageism's trivialization of older personhood. Whether acquired amid a rush for modernist materials after the Second World War that Cloutier details (Ford first submitted materials to the Beinecke between 1946 and 1949) or a decades-later run for explicitly LGBTQ papers (see Steward's multiple collections in chapter 2), the documents they kept during their lengthy lives traverse media to provide snapshots into queer, nonelite, racialized, and nonableist encounters with the *gero* of U.S. modernities. This includes not only print cultures such as *Prime of Life*, but also visual media such as archived photographs of a young Hampton alongside those taken in her seventies. In collections such as Olsen's that feature her high school writings, they also provide us with the opportunity—one neglected in the secondary literature—to track how modernists felt themselves culturally aging over much of the past century even as she, too, did not know her exact chronological age "because I was born at home out in the country. And whether it had to do with their being old-country immigrant parents or not, I discovered only a few years ago when I sought a passport . . . that I had no birth certificate."[74]

I discuss both Hampton's now-iconic imagery and Olsen's sense of younger selfhood in chapter 6 and chapter 4, respectively. Others, I hope, will take up like tasks for complementary artists. Whether I found myself sitting with Ford's homoerotic collages from 2001 in his former Dakota apartment, or at the Art Institute of Chicago's Ryerson and Burnham Library reviewing microforms of Albright's notebooks, what often deflated me was how negligible our own scholarly processing of late-life modernist materials has been. Housing these boxes is a most generous gift to scholars. Working through them is a different issue. Few bothered, and the social invisibilities of older persons unfortunately repeat themselves in the paucity of our archival studies.

Yet hiding in plain sight is a good amount of modernism that clues us into what Woodward terms "the problems of aging and the elderly in our century's industrial culture."[75] This section alone mentioned a 1980s newsletter on optimized aging; an explanation of Medicare benefits; and notes on lesbian communal caregiving. These archived documents amplify essays on the midlife,

experimental life reviews of older women artists, and paintings of the fantastically aging body that my chapters closely read and contextualize. Surely our academic institutions could further tend to these materials, which are anything but "doggerel by a senior citizen."[76] It is not as if we do not have longstanding examples of the newer taking care of the older. "We are food, we are rent and we are medical care for that arrogant and feisty Zora Neale Hurston—who didn't have any of that at the end," Toni Morrison once wrote.[77] Fields of study are not the equivalent of the Lincoln Park Nursing Home, another institution of U.S. geromodernity where Hurston spent her last few months of life. But, in all seriousness, why can't they provide better services?

IV

Morrison's remark leads me, in this introduction's end, to the *why* of a research project that took almost a decade of my life to complete. Besides my desire to patch a hole in the scholarship, I think of these readings as appreciations, a commonplace academic genre that nevertheless remains devalued. Few cite them. Few assign them. Few anthologize them. In an essay in 2001 on new modernist studies and its own swift appreciation in the 1990s, Jennifer Wicke writes that "appreciation (read: valuing) has even less critical cachet and credibility than does intention." Wicke's ruminations on "the rich possibilities for newness" amid "disparate volumes, many of them old, tattered, and shop-worn" has inspired me for years, but I respectfully disagree that "any return to literary appreciation or impressionist criticism . . . would be a critical and theoretical disaster."[78] Heartfelt appreciation can be sharp-witted in its assessment, especially when it attends to the intricacies of its subject-at-hand. I am clear-eyed about Albright's apolitical bent, Ford's Orientalizing stance toward South Asian age cultures, Barnes's disdain for post-Stonewall admirers, and Olsen's less-than-generous public dialogues with later generations of feminists such as Alice Walker. No innocent myself, I dislike these aspects of their temperaments. At the same time, I also appreciate their efforts and embrace the genre as a counterweight against social and institutional devaluations of their artistry.[79]

Making sense of what they did with their respective movements during their lifetimes, I appreciate what they do during our own. These moderns remain what Peggy Phelan called in 1987 "one of the least utilized resources we have of

that fecund period in literary history" in a discussion of Kay Boyle's octogenarian modernism. Like O'Keeffe, who died a year before the *Women's Review of Books* published the line just quoted, Phelan too finds that "the habitual critical separation between art and life is impossible."[80] Maybe some of that same dissolution will occur between their art and your life. To facilitate that fade, this book brings together a variety of undertakings—the hyperindividualized (Barnes), the collaborative (Ford and Tamang), and the collective (Hampton)—that point to sundry modes of exemplary experimentalism.

While you read across these chapters, I ask that you make good use of those case studies that pique your personal interest, inclusive of any applications to artists I did not feature. While I attend to six elderscapes, Phelan's remarks on a disregarded Boyle gesture to complementary modernists as well as those aging into the present as much as Whitman did in the deeper past. Take Faith Ringgold, whose *American People Series #20: Die* (1967) once hung catty-corner in Room 503 across from Picasso's *Les Demoiselles d'Avignon* (1907) as part of the newly renovated Museum of Modern Art's revolving seasonal galleries. In 1996 Ringgold produced a lithographic print, *The Sunflower Quilting Bee at Arles*, at the Brodsky Center for Innovative Editions that she patterned on one of her story quilts started in the early 1980s (figure I.2).[81] Housed at the Philadelphia Museum of Art, the Ulrich Museum of Art in Wichita, Kansas, and elsewhere, limited editions of this print pay homage to older modernists and acknowledge them as resources. Holding up a bordered diamond quilt with panels of sunflowers, Black elders including Madam C. J. Walker train their sights on Vincent van Gogh. In turn, he offers them a vase of fresh-cut sunflowers that looks strikingly like the postimpressionism he painted between 1888 and 1889. In Ringgold's interracial transatlantic imaginary, various moderns offer each other various appreciation gifts, even if leeriness marks this scene (in an incarnation in 1991, Sojourner Truth enquires about Van Gogh's ties to the Dutch colonial slave trade). Reworking needlework, floristry, painting, radical activism, and vanguard printmaking, Ringgold's fantastic art cherishes long modernism by stitching together unlikely genealogies across media, time, geography, race, gender, and aging.

As I revised this introduction, a now ninety-one-year-old Ringgold had continued such endeavors with her smartphone puzzle app *Quiltuduko*, a self-customized riff on Sudoku that expands her recent *Aging-aling-aling* art series. Though no longer available for download, if you were lucky enough to play *Quiltuduko* it would have let you plug rows and columns with panels that may be

I.2 Faith Ringgold, *The Sunflower Quilting Bee at Arles*, 1996. Color lithograph, 22 × 30 in. (55.9 × 76.2 cm). Philadelphia Museum of Art, gift of Anne d'Harnoncourt, 1996, 1996-124-1. © 2021 Faith Ringgold/Artists Rights Society, N.Y. Courtesy of ACA Galleries, N.Y. Photograph by Philadelphia Museum of Art.

abstract (squiggly lines) or figurative (trees). First conceptualizing this app in 2013 according to an interview published on AARP's Disrupt Aging website, Ringgold deemed it an extension of her sustained interests in Afro-modernist quilt panels like those featured in *The Sunflower Quilting Bee at Arles*. Similarly, it expands her resilience in aging. The game, she insists, becomes "a workout that requires memory and focus, and keeps that brain functioning—for young and old alike."[82]

I could go on with others who impress me with contemporary renditions of geromodernism. Rather than sweep that dirt floor, permit me a personal anecdote in closing. With a view from forty-six, I did not anticipate finishing this project started in January 2012. Thanks to an intoxicated driver, a motor-vehicle accident in the fall of that *annus horribilis* necessitated two spinal procedures, no small amount of physical therapy, a profound appreciation for water aerobics, a

world of chronic pain, and a long-term relationship with a foam roller. A senior mentor in American studies once told me that "my back had aged." That comment felt exactly right. At 5:58 p.m. on a crisp October evening, a thirty-six-year-old piece of me oldened in the most surprising way. No psychotherapist needs to explain why I identify with moderns who worked under conditions that age experts refer to as *selective optimization with compensation*.

While I have found these artists quite useful in my midlife, this book is also for a future self who may be fortunate enough to fully inhabit their chronological conditions. To those already there: I trust that you will get something from these disparate experiments with and in longevity. In terms of their numbered days, they did their best with what was within reach. In the end, the results are quite daring. Made with mettle, these visions feel indelible to me even though few remember or ever knew much of this work. Better late than never to share them now with you.

CHAPTER 1

Djuna Barnes and the Geriatric Avant-Garde

For more than four decades we have watched Djuna Barnes age unsuccessfully. In September 1940 Barnes rented a Greenwich Village studio apartment that she occupied until June 18, 1982, when she died at the age of ninety. The opening sentence of a *New York Times* obituary published two days thereafter stated what many still presume: Barnes was "a recluse whose avant-garde literary work won wide acclaim in the 1920's and 30's."[1] Her innovative peak, the obituary posits, was back then—in the heyday of high modernism, when she mingled with James Joyce, Natalie Barney, and other artists in Western Europe—not in the later years when Barnes apparently walled herself up in 5 Patchin Place on a dead-end street known for housing luminaries such as E. E. Cummings. It is as if her creative life stopped once her apartment life began. My chapter casts doubt on this portrait of the artist as an aging recluse.

The *Times* cannot assume sole credit for the caricature, given that numerous posthumous assessments advanced similar representations. Take but two examples. In his biography *Djuna: The Life and Times of Djuna Barnes* (1983), Andrew Field finds that Barnes's artistry extinguished itself: "The silence, then, was not a sudden turn in her life but simply a potentiality that came to the fore when various other things such as sense of self, love, accomplishment, and fame had in one way or the other played themselves out." He then ventriloquizes Barnes's slow death: "Eat sparingly. Wallow in a laundry-basket of manuscripts. Resist letters and knocks on the door."[2] In his memoir *"Life Is Painful, Nasty, and Short . . . In My Case It Has Only Been Painful and Nasty"* (1990), Hank O'Neal likewise recalls Patchin Place's "mysterious and reclusive world" to record "a room full of despair, disarray, and confusion. It appears to be a place shut away from time, but the ravages of time are there."[3] He concludes that "the peculiarity of the second half

of her life, particularly the final years, is without parallel in the history of American literature and tends to overshadow some of her other achievements" (*L* xvi). For O'Neal, later Barnes is better known for enfeeblement than for experimentalism. As one of the oldest old—a clinical term from gerontology referring to "those aged 85 years and over"—she appears in his version as a "shut-in" coasting on the fumes of her modernist classic *Nightwood* (1936; *L* 82).[4]

Other accounts have done more of the same. A personal reminiscence in Mary Lynn Broe's revisionist *Silence and Power* finds Barnes an "eternal, aggravating perfectionist."[5] A Google word search for "djuna barnes recluse" also turns up several additional descriptors, such as "lesbian Modernist recluse," "notorious recluse," and "obsessive recluse." And one three-out-of-five-stars Amazon.com book review of *Nightwood* posted in 2003: "Though bold and intrepid as a beautiful young big city journalist, and later as an expatriate modernist writer living among the Parisian glitterati, Barnes closed the door on the rest of the world in very early middle age, and became a notorious New York City recluse known primarily for bitterness and explosive outbursts of anger."[6] Barnes's literary shrinkage, this last reviewer notes, matched her social shrinkage once she hit her forties.

Admittedly, her later publications are few, especially if we do not count the postobituary *Creatures in an Alphabet*. The last quarter or so of her life saw Barnes publish one play, *The Antiphon*, along with five poems amounting to forty-four lines of verse. In 1958 she published ten lines in "Fall-out over Heaven" for *T. S. Eliot: A Symposium for His Seventieth Birthday*. She wrote twelve lines for "Galerie Religieuse" in *The Wind and the Rain: An Easter Book for 1962*. In 1969 she produced nine lines for "Quarry." Then, in 1971, ten lines made up "The Walking-Mort," both accepted by the *New Yorker*. In 1982, the year after she received a National Endowment for the Arts senior fellowship, her final publication added up to the three lines of "Work-in-Progress: Rite of Spring" for *Grand Street*. Glancing over this bibliography, one would be hard-pressed to call Barnes prolific, but the negative and long-standing conclusions that biographers, reviewers, critics, and contemporary readers infer from these paltry sums underestimate the complexities of her later-life work.[7] Such conclusions overlook myriad aesthetic experimentations that she undertook during her residency at Patchin Place, and they neglect hundreds of vanguard productions that were not published but were archived following her death. How, then, to attenuate the pervasive and gerontophobic image of Barnes as an aging recluse who had laid down her pen?

To answer this question, I shift focus from her minimal literary output to her maximal creative efforts by concentrating not on her published late poems but on the late-life work in full. Special Collections at the University of Maryland's Hornbake Library houses many of these materials, whose extensive reach scholars, save for a select few, have largely passed over.[8] Even the editors of her later poems, Phillip Herring and Osías Stutman, note that their *Collected Poems* (2005) compresses these copious writings into seventy-four discrete units under the heading "Late Unpublished Poems (ca. 1950–82)."[9] This chapter traces what happens when that tally increases to least 2,400 drafts as well as miscellaneous writings that Barnes mixed between them. I thus concentrate on the artist's manifold compositional endeavors—her bountiful poem revisions, her marginalia, her typescript headings, and the links between documents in the Hornbake fonds—to argue that the second half of her lifework was an aesthetic achievement that undermines deep-seated representations of Barnes's creative drought.

I approach the artist's Patchin Place output not as the waning of her earlier modernist efforts but as their intensification. My critical approach does not sidestep Barnes's oftentimes astringent personality or blindly champion her aging, but it does offset bankrupt portrayals of her senility as they inform receptions of her craft. In so doing, I embrace her abundant writings as a variation on what Eve Kosofsky Sedgwick, borrowing a phrase from Barbara Herrnstein Smith, refers to as "a senile sublime": "more or less intelligible performances by old brilliant people, whether artists, scientists, or intellectuals, where the bare outlines of a creative idiom seem finally to emerge from what had been the obscuring puppy fat of personableness, timeliness, or sometimes even of coherent sense."[10] Barnes's "creative idiom," we will discover, showcases this artist rehearsing and revising key components of high modernism—innovation, novelty, and difficulty—across seemingly disparate mediums, such as poetry, grocery store requests, pharmacy orders, private letters, and memoranda. Instead of confirming Barnes as a stifled older artist, my thesis proposes that careful attention to these profuse writings reveals her time spent at 5 Patchin Place as a sublime achievement akin to a geriatric avant-garde. For the record, I don't intend the adjective *geriatric* to dismiss these extraordinary achievements. Barnes loved jesting with her *OED*, and I have full confidence that she took a new twentieth-century word meaning "designed for use by old people" and playfully transformed it into a superb instance of experimental aging on and off her unpublished pages.[11]

I

Let us return briefly to O'Neal, whose recollections nevertheless remain one of the most extensive depictions of the artist during her final years in Ed Koch-era New York City. According to his reminiscence, O'Neal first met Barnes in the fall of 1978. When he entered her Patchin Place apartment, he found her desk "littered with piles of papers, drafts of poems, grocery lists, old bank statements, and thousands of other scraps of paper—all saved for no apparent reason.... Underneath this table are more boxes and papers, filled to overflowing" (*L* 7). In an extended sketch that paints Barnes as an extreme accumulator, he sees nothing but "forty years of accumulated dust" and "serious disorganization" (*L* 8, 6). It is as if she mired herself in squalor by "hoarding every scrap of paper" during a daily grind of getting nothing out the door (*L* 175).

O'Neal's take on Barnes's writing routine is equally contemptuous: "poems written in the middle of grocery lists, and with no organization in the paper clutter everywhere" (*L* 13). Over the years Barnes collated scores of poem drafts in and alongside revised foodstuff orders for the Greenwich Village grocery store Jefferson Market, pharmacy lists for C. O. Bigelow Chemists, and other personalia. This accrual displaces O'Neal, who attempts to standardize these productions into a publication rhythm beyond unorthodox accumulation. Exasperated, he wants her "to get on with the poems" (*L* 78). "Her meager output between the publication of *Nightwood* and her death forty-seven years later may just have been the result of being undisciplined and tending toward idleness," he concludes (*L* 124). Revised lists for fruit juice, fish, wheat flakes, maple syrup, and painkillers are thought to bury her brilliance.

This fairly commonplace account seems shortsighted in its understanding of Barnes's writing regime. It is important to remember that O'Neal's depiction—one that Barnes's later editors enforce when they refer to her unpublished works as "chaos"—is a biographical construction rather than a biographical truth.[12] The two editors, observes Daniela Caselli, "have indeed talked of chaos as a result of these hard to track creative practices; such an interpretation is possible at the price of assuming a degree of incompetence (due, for instance, to old age), but cannot hold from a textual perspective."[13] Taking guidance from Caselli's astute remarks, I am intrigued by the pejorative assumptions that undergird these retellings and her intricate later writings. While her aging and her compositions

are without doubt inextricable, the former is too often thought to undermine the latter.

Barnes, that is to say, found herself trapped within what Margaret Morganroth Gullette calls a *decline narrative*—the inverse of Sedgwick's senile sublime and a formula representing older adults as incompetent, surly, and slouching toward "creative decline."[14] Hence when O'Neal and others depict an elder Barnes as loveless, unproductive, disorganized, and confused, they rely on culturally entrenched stereotypes of the aging body, and they reinforce ageist representations of older individuals as "antisocial, irrational, irritable, petulant, selfish, [and] depressed."[15] Some of this misrecognition, I note in passing, came about when gerontology and geriatrics ingrained themselves into popular and scientific U.S. cultures by the mid-twentieth century, only to flourish in the decades thereafter—the same years that Barnes supposedly cut herself off from the world-at-large. This timing may not be entirely coincidental.

As but one antidote to these cruelties, Gullette offers "critical age auto/biography," a mode of "life storytelling" that grants "some narrative agency, some way of squeezing out from under [ageist] subjections."[16] With phrasing explicitly indebted to life writing theory, Gullette nods to how scholars of modern biography and autobiography—particularly feminist critics on whom she builds—shed light on Barnes's later projects.[17] As much as age theorists query social formulas that dismiss this life course stage, critics in fields such as biography theory note how genres of life writing ripple with representational dangers and possibilities. This is what the Personal Narratives Group, a feminist collective, refers to as "the dynamics of power relations, and in particular the power inequalities between men and women," that saturate memoir, autobiography, and, especially, biography as these literatures navigate the rocky social terrain of publishers, editors, and readers.[18]

Well before O'Neal introduced himself, Barnes was no stranger to vexations of editorial control over her life writing in particular and her creative writing in general. Much of her art drew deep from the well of personal experience (recall her journalist report "How It Feels to Be Forcibly Fed" in 1914; her romance with Thelma Wood, coded into *Nightwood*; her Left Bank lesbian-coterie satire *Ladies Almanack* in 1928; and her inscription of incest trauma into *The Antiphon*). Her artistic life was spent negotiating male publishers and editors in attempts to publish these avant-garde productions—a negotiation best characterized by Melissa Jane Hardie as "the narrative of violence over textual materials."[19] Barnes relied,

for example, on T. S. Eliot to twist Faber and Faber's arm to accept *Nightwood*. Eliot became so engrossed in that novel's revisions that Barnes wrote to her friend Emily Coleman in 1936 that his supervision was "a beast."[20] The feminist critic and life writing theorist Miriam Fuchs reveals that Barnes again found herself beholden to Eliot while drafting *The Antiphon* and attempting to secure a publication venue for the play. Fuchs convincingly finds that the two ensnared themselves in "an unequal power relationship," in which Barnes was forced to perform as "the grateful, compliant author."[21] The elder Barnes "felt she could not trust anyone. Even her great friend T. S. Eliot let her down." When Field asked Barnes for guidance on his biography, "she refused to help him and did not approve of his endeavor."[22] While I will later return to Eliot's influence on Barnes's poetics, for now I stress that throughout much of her creative life, Barnes rarely had sufficient charge over her semiautobiographical works since her life storytelling was perpetually fraught with gendered imbalances. Her "fierce distrust of publishers" is entirely understandable under these historical circumstances.[23]

When we keep these long-standing complications in mind, Barnes's minimal publications following the release of *The Antiphon* make more sense. While a list of verses that O'Neal agreed on with the artist established a baseline for the posthumous *Collected Poems*, Barnes's refusal "to get on" with these writings protested her enduring difficulties of life storytelling across genres.[24] Her supposed incapacity to cease revising seems a strategic recalcitrance given her tiresome experiences with editorial impingement. As Barnes wrote to Coleman in another letter from 1936 documenting her trials with *Nightwood*, she longed "to have my life to myself to do my work in," and she largely shielded herself from the burdens of publication at Patchin Place.[25] Beholden to personal experience and committed to noncirculation, she continued apace her radical aesthetic experimentations in Greenwich Village, but for the most part she bypassed editors and drafted with minimal intrusion.

Building on the work of Gullette, Fuchs, and others, I recast Barnes's supposedly reclusive writings from the late 1950s onward as a personal poetics of "conscious aging," resistant to the gendered pressures of publishing, that carried forth an avant-gardism whose execution "replaces the narrative of decline and degeneration with one of agency through aging."[26] What some interpret as obstinacy, neurosis, or pathological perfectionism was as likely the effect of her immersing herself, with pleasure and relief, in ongoing innovation that did not necessarily terminate in publication, as well as of a commitment to incompletion that undermined the

decline narrative. This recasting challenges misogynistic sketches of the female artist as embittered, a stereotype that Barnes herself sometimes inhabited in public interviews and private correspondence as well as one that was put on her.[27] When we view her through the lens of age studies and studies of biography and autobiography, however, we find a Barnes who was not remiss at socializing or writing. Hence, as much as *Nightwood* draws on Barnes's relationship with Wood or *The Antiphon* on her childhood family relations, so do her voluminous drafts resemble an experimentalist age autobiography, one "refusing to be controlled by an audience" and one whose noncompliance was indebted to modernist tenets.[28] I turn now to the aesthetic intricacies of this decades-in-the-making project.

II

Scant word counts and a lamentable cultural formula of seniority were not the only possible ways of defining a post-1945 Barnes. In *A Festschrift for Djuna Barnes on Her 80th Birthday*, the editor Frances McCullough finds that Barnes's "room, light and airy, is filled with all sorts of incredible things, but most of all with *work*; her paintings, her papers, the poems she is currently writing, whatever."[29] In contrast to a decline narrative, McCullough describes a studio full of activity. Surveying these papers after visiting the University of Maryland's archives years before the release of *Collected Poems*, Nancy J. Levine likewise contends that an "editor would have to make the kind of decisions that could result in an arbitrary version of coherence—pretty, but not what Barnes would have preferred."[30] These are important exceptions to prevailing representations of Barnes as an inhibited elder, and I expand on their insights to hypothesize what Barnes "preferred," given that the artist "wrote so much and burnt so little."[31]

 A visit to the university's holdings reveals the magnitude of what McCullough and Levine encountered. "Actively engaged in trying to build a research center for the study of modern literature," then-assistant director for libraries Robert L. Beare wrote to her in 1972 that Maryland "would be pleased to have your papers as a most valued part of such a center."[32] After some back-and-forth, Special Collections staff acquired a substantial amount of Barnes's writings for $48,000 in 1973. She had originally hoped that her corpus would be purchased by the Beinecke Rare Book and Manuscript Library at Yale, but she rejected a finalized offer of $30,000 made in 1972 by Donald Gallup, former curator of the

Collection of American Literature. In 1977 Maryland proposed to pay $6,000 for more materials and wrote regarding Barnes's "current working projects" that "University counsel suggests that you add a provision in your will that these manuscripts should be offered to the University for $1,800.00."[33] In a portion of one of her will drafts dated May 20, 1980, Barnes asks that her brother Saxon "have charge of all my finished and unfinished manuscripts. If he cannot make them out, destroy them: if he can, to send them to Mr. Robert Beare, of the McKeldin Library, of the University of Maryland."[34]

Her last will and testament altered this earlier version, but the final tally of later manuscripts that the university acquired totaled more than two thousand pages.[35] Most show Barnes using a combination of typewriting and handwriting to compose her works with ballpoint pens and magic markers in an array of colors—black, red, brown, green, blue, orange, pink, and purple—to edit them. Her preferred choice of color for typing drafts also oscillated between black and red typewriter ribbon. These details, we will see, are not incidental to understanding her late-life craft. When submitted to Special Collections, her materials were chronologically jumbled, and Barnes left no extant plan for their consolidation. While she assigned some drafts a date, the timelines of other compositions remain difficult to identify (*circa* and *undated* appear often in these archives). The university carefully categorized these unsystematic manuscripts over almost three and a half decades by explaining that "an attempt was made to bring some order to Barnes's poetry" from 1977 to 2011—with a new series of Barnes's library recently added in 2020—and noting, too, that "the Barnes papers have been processed numerous times in largely piecemeal fashion."[36] As of this writing, the library catalogues these documents under "Series III: Writings, 1911-1980" and divides her "Manuscripts and Proofs—Poetry" into several discrete boxes.

While the Special Collections staff compartmentalized Barnes's writing into units—a remarkable task that facilitates scholarly appreciation and survey—these papers repeatedly blur distinctions between a finished and an unfinished work, a singular poem and a poem cycle, and a completed long poem and its working notes.[37] A prime example is a typescript that the university lists as "Dereliction" and that Barnes dates June 1, 1970 (figure 1.1). Folder archives record that Barnes tinkered on this piece between 1967 and 1974. Assessing its title changes leads to interpretive vertigo: "Delectation," "Parthenogenesis," "Cassation," "Derelict Spring," "Phantom Spring," "Scavenger Spring," "Virgin Spring," "Song of the Fool, or Resurrection Pie," "Dereliction, Parthengenesis, and Phantom Spring,"

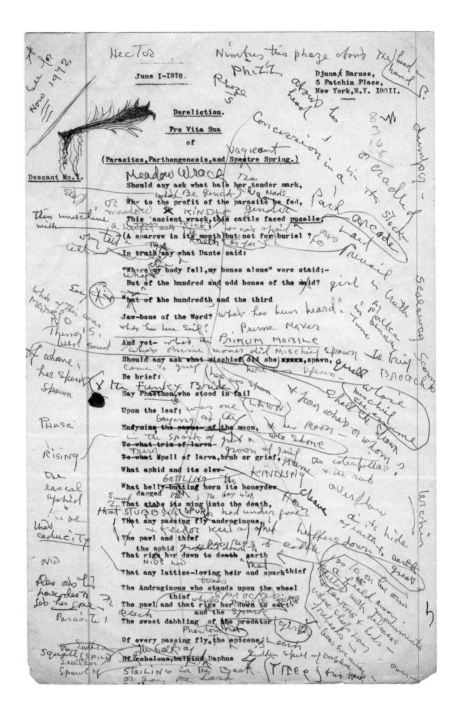

1.1 Djuna Barnes, "Dereliction. Pro Vita Sua of (Parasites, Parthengenesis, and Spectre Spring.)," June 1, 1970. Series 3, box 8, folder 20, Djuna Barnes Papers, Special Collections, University of Maryland Libraries, College Park.

"Discant: Dereliction, Parthengenesis, and Phantom Spring," and so forth. There are more than eleven hundred revisions of this poem, most unpaginated, many out of chronological order in their folders, and a few nearly unreadable because of their extensive markups. On this particular draft, Barnes wrote numbers in the marginalia in the top right corner, doodled in the top left corner, struck out words, crossed out handwritten edits, and revised her name.[38] Undoubtedly well meaning, Herring and Stutman reduce the disorderly richness of this process when they reproduce it as a singular piece of poetry, making a "ruthless selection of a poem from its innumerable variants."[39]

While Barnes never singularized or finalized this poem, she did work to facilitate the release of some compositions. For instance, a folder dated 1970 and titled "Faber and Faber Poems" includes versions of "Discant," "Quarry," and what would become "The Walking-Mort" in an unfulfilled attempt to cull a collection for the publishing house. Yet even the writings included in this collection are greatly revised, as is almost every document in the archives, including, ironically, those in a folder entitled "Miscellaneous Completed Poems."[40] These revisions, I suggest, constitute a metacommentary on her writing processes, one that explicitly theorizes her Patchin Place papers as a decades-long experimental art project that would result in something other than publication. This reveals itself in her practice of grouping poems under headings like "Item taken from <u>Poems in Passing</u>" and "Work in Progress," despite the poems' protean titles. Likewise, under a draft of the last poem published during her lifetime—what would appear as "Work-in-Progress: Rite of Spring"—she types, "Twenty years trying to finish this poem" (figure 1.2).[41] What if we read this sentence fragment not as an end to torment (eleven months per word) but as a mission statement? Finishing the drafts was beside the point, and even this short piece was further revised before the literary magazine *Grand Street* published it in 1982.

The sublimity of this late-life project becomes clearer after examination of an earlier draft, lines of which had initially appeared in revisions of "Dereliction" (figure 1.3). Barnes first types five lines, two of which she strikes out:

 Man cannot purge his body of its its theme
 v As can the silkworm,,on a running thread
 ~~As can the silkworm, on a running thread,~~
 ~~Spin a Shroud to re-consider in~~
 Spin a shroud to re-consider in.

May 25, 1980

Djuna Barnes,
5, Patchin Place,
New York, N.Y. 10011.

Rite of Spring.

Man cannot purge his body of its theme,
As can the silkworm, on a running thread,
Spin a shroud to re-consider in.

Twenty years trying to finish this poem.

1.2 Djuna Barnes, "Rite of Spring," May 25, 1980. Series 3, box 10, folder 9, Djuna Barnes Papers, Special Collections, University of Maryland Libraries, College Park.

> Work in progress
>
> Rite of Spring
>
> Man cannot purge his body of its its theme
>
> v As can the silkworm,, on a running thread
>
> ~~As soon as the silkworm spun a running thread~~,
>
> ~~Which Shroudz was re-considered with~~
>
> Spin a shroud to re-consider in.
>
> ---
>
> Submitted to "The New Yorker";
>
> A totally new idea, as a poem "in progress," as Joyce's
> "Work in progress" ~~slowly~~ *Was* to become "Finnigan's Wake".
>
> Tho Howaed Moss, poetry editor of that magazine,
> was too stupid to see. He wanted it, but only if I would
> change one word. I would not. Thus the booby Moss was
> too/v stupid to see, ~~thus~~ lost the first new move, in poetry—
> a poem waiting, to be continued.

1.3 Djuna Barnes, "Work in progress: Rite of Spring," undated. Series 3, box 10, folder 9, Djuna Barnes Papers, Special Collections, University of Maryland Libraries, College Park.

Underneath these verses, Barnes's typescript then reads verbatim:

> Submitted to"The New Yorker".
> A totally new idea,as a poem "in progress,"as~~z~~ Joyce's
> "Work in progress" ~~merely~~ was to become "Finnigan's Wake".
> Tho Howaed Moss,[poetry editor of that magazine]
> was too stupid to see. He wanted it,but only if I would
> change one word .I would not.Thus the booby Moss was
> too~~v~~ stupid to see,~~thus~~ + lost the first new move,in poetry-
> a poem waiting, to be continued.[42]

I first note the irony of Barnes's emphatic refusal to "change one word" as she crosses out two lines of a five-line poem whose primary "theme" is getting older (if you're looking for the consistency of inconsistency, you have found the Barnesian corpus). I second observe how this document typifies her scorn for editors as it emphasizes "*its* right to tell *its* stories *its* way."[43] I third underscore that in lieu of a despondent muddle of papers, Barnes offers what she considers a well-executed "first new move" in the field of twentieth-century poetics—precisely what Levine discovered when combing through the then unprocessed archive. While I am wary of falling into an intentional fallacy here, I take Barnes's expressed intentions at face value. Instead of getting on with her poems, she grandiosely conceives of their composition as an avant-garde to the avant-garde, a textual performance that advances the international modernism to which she earlier contributed. Or, in her imagining, "A totally new idea" in which published output is purposely scanty, in which papers and drafts of poems accrue more and more, in which writing is a revolutionary state of perpetual revision.[44]

Whether Barnes is correct in her assessments of this avant-garde project's singularity or originality is less intriguing to me than is her act of producing these literary performances. I will draw some unanticipated links to Eliot as well as William Carlos Williams later in this chapter. For now, I note that other modernists, such as Ezra Pound, Louis Zukofsky, and Barnes's acquaintance Marianne Moore, engaged in similar long-term poetic projects, as did later poets, such as Charles Olson. With her explicit citation and her own use of colored pencils, Barnes here casts her aesthetic projects as a poetic furtherance of James Joyce's narratological experimentations in his novel *Finnegans Wake* (1939, originally titled "Work in Progress").[45] Imagining her unfinished papers as "totally

new" achievements always in the making, she relies on a hallmark of high modernism—Pound's directive to "renew thyself daily, utterly, make it new, and again new, make it new"—to conceive of her Patchin Place poems as novelties incomprehensible to an editor such as Moss.[46]

This practice accords well with Hannah Sullivan's observation that modernist writers "used revision . . . not for stylistic tidying-up but to *make it new*."[47] In an argument that historicizes and theorizes "*modernist revisions*," Sullivan suggests that corrective draft overhauls were part and parcel of modernist authorship.[48] Tirelessly working on a day-old draft or, in some instances, a decades-old draft, an aging Barnes continues this tradition when she feels her older writings to be utterly new and energizes them with unending alteration. What reads like confusion to a "booby" editor is instead "a tightrope experimentalism" to be never completed or, stated positively, "to be continued."[49] Barnes's prolonged style thus embodies "a sort of deliberately productive unproductiveness" that Edward Said, following Theodor W. Adorno, paradoxically associates with novel artwork and "the late phase of human life."[50] In so doing her "work in progress" becomes works in progress that function like a late-late modernism forever ahead of its time, one that augments critical readings of her later works as well as scholarship that presses for further blurring of the modernist-postmodernist break.[51]

III

Making it newer as she became older, Barnes expanded this future-oriented poetic revolution of one beyond traditional meter and rhyme: her oldest-old "new move" of continuous revision ripples throughout her archived papers. In the draft of her age-themed "Work in progress: Rite of Spring," she turns her aesthetic theory of chronic modification—in essence, an unpublished memorandum to herself—into an innovative work in progress. She adds a period under the quotation mark that encapsulates "New Yorker" to transform the punctuation mark into a colon. She adds quotation marks around "in progress." She crosses out "merely" and replaces it with "was." She crosses out "thus" and replaces it with a plus sign that signals the word *and*. She adds a dash to her last sentence and a comma after "poem waiting."[52] Anything but frozen in inefficiency, Barnes saw revisionary potential in many of her papers—even in her published works from the 1930s. As she writes in the upper left-hand corner of one undated scrap

of paper, perhaps recalling Mark Van Doren's dismissive review of *Nightwood* in the *Nation* in 1937: "~~Mark van Doren~~ Nightwood. remember to do something about dog in last chapter [as idiots think its "done!"]."[53]

Barnes applied this radical aesthetic theory of works in progress to the other documents that filled her many days—the "whatever" mentioned by McCullough when she marveled at the papers in Patchin Place. These seemingly extraliterary items include her pharmacy lists, several of which are also housed in the University of Maryland's Special Collections. Sometimes these revised lists (many with age-themed contents) are interspersed amid her poem drafts. At other times they are inseparable from them. Between the pages of a draft of "The Hummingbird" later included in *Creatures in an Alphabet*, Barnes jots down a list of medications that she took between November 27 and 29, 1980, on which she crosses out "Nov. 29–'80." Underneath this date, she handwrites "Bow Bells" and "the 7 dials," a reference to the subcultural linguistic tradition of Cockney rhyming slang.[54] In a pharmacy list from 1981 included in the middle of numerous revisions for *Creatures*, she revises her order (no "bitter sweet chocolates"; add "one lavender smelling salts") and crosses out "PBZ expectorant" in the midst of medication lists for Inflamase eye drops, Hycomine cough syrup, and Dyazide tablets for high blood pressure.[55] On the back of this sheet, she types a poem, "The HIPPO," revises the title to read "HIPPOPottomus," and includes another medication regimen. Here she crosses out "disease" and writes "any disease."[56]

Barnes treats her grocery lists as revisionary works in progress as well. In a February 5, 1979, order for Jefferson Market, she decides that she wants two large Kleenex boxes rather than three. She does not want "2 rolls Bounty kitchen towels" or "4 Yellow Dole, no sugar, chunk pineapple—small" or "mild cheddar, quarter of a pound?" or "half pound sweet whipped butter, in tub." She supplements this list with "6 cup cakes."[57] In a shopping list for C. O. Bigelow Chemists apparently dated December 10, 1980, and now in O'Neal's possession, she orders milk of magnesia and adds two revised lines of poetry: "<crenelated roof,holes for shooting through.) / (Kyrie elesison.-Lord have mercy.)" (figure 1.4).[58] In yet another grocery order, she strikes "Half pound of smelts," retypes "Half pound smelts," and writes in "(3 smelts.?)." These foodstuff revisions follow lines of verse at the top of the draft: "that stigeon pond,-lake" (figure 1.5).[59]

These revised documents befuddle those who encounter them. O'Neal reproduces three of the lists in his memoir and finds them challenging. "It may sound ludicrous but the preparation of a grocery list could easily become a four hour

C.O.Bigelow. Gr. 7- 9200 .

Dec1Ø.0980.

1 Natracan.

Large (Mint) Milk of Magnesia.

(crenelated roof, holes for shooting through.)
(Kyrie eleison.-Lord have mercy.)

C.O. Bigelow. Gr 7--Ø 9-200. Dec 10, 1980. Barnes.

Natracan.

Mint Milk of magnesia, large.

tube of Poli-Grip, brown label. not the new, I've got
that, and itd not as good as the old.

1.4 Djuna Barnes, "C.O.Bigelow.," December 10, 1980. Courtesy of Hank O'Neal.

that stigeon pond,-lake.

Jefferson Market,Barnes. Phone ~~655~~-2277 675

Qt.Milk.

~~Half pound of smelts.~~

Half pound Port Salut.

6 oranges.

2 large kleenex.

one Kellogs No I9,wheat flakes?
✓ large BRILLO -- I--

Marmalade/Dundee..English.

~~Garlic (Clove)~~
~~Garlic...head of.~~ *holy*
~~KxxxgxxwheatxflakesxxxxozzI9z~~
~~Kxllagsxwheatxflakesxxxxoxx9.~~

Head of Garlic. (clove)
Pure maple syrup. (camp.)

2 Yogurt. plain.

/ quarter pound Port-Salut cheese.

One Buitoni grated ~~cheese~~...parmison \3 ounces\
liquid soap ?(~~Bald headed man~~) Mr.Clean? Pint.?
3 Haagen-Dazs Coffee ice cream (pints)
2 Cranapple — (quarts)
2 Sun-sweet prune juice—2 quarts)
3 Malted milk ,na~~tural~~ .3 carnation\
Half pound smelts. (3 Smelts.?)

1 Stella Doro bread sticks .

3 macintosh apples

1.5 Djuna Barnes, "Jefferson Market,Barnes.," undated. Courtesy of Hank O'Neal.

Djuna Barnes and the Geriatric Avant-Garde 39

affair: it had to be typed, edited, revised, and finally telephoned to Jefferson Market. It was written just like a poem" (*L* 75). Herring and Stutman likewise describe the lists as "totally unrelated materials" "that have nothing to do with the poem."[60] But it may be that Barnes's everyday doings are not separate from her creative activities and that this overlay of poetry and grocery list is a self-conscious aesthetic practice. As she does to her poems and her commentary to the *New Yorker* and as she wishes to do to the last chapter of *Nightwood*, Barnes turns her grocery and pharmacy lists into aesthetic works in progress, or a private *Living Modern* exhibition circa 1980. The similitude—a grocery list "just like" a piece of poetry—seems deliberate as she transforms her quotidian notes into an unendingly revised poem cycle. Along the way, Barnes reimagines the genre of the shopping list in the last quarter of the twentieth century as an experimental piece of poesy, one full of new things ("Sun-sweet prune juice," a beverage first bottled in 1932 with the aid of the New York–based Duffy-Mott Company) and old ("Kyrie eleƨison," an ancient Greek chant absorbed into the Roman Catholic mass).

I add here—as a brief aside—that Barnes may have taken a cue on these work-in-progress lists not only from Joyce or Pound but also from her one-time correspondent and acquaintance William Carlos Williams. This link may seem strained given that the two artists were never on especially close terms, but Williams also "invented something new" when faced with "the infirmities of age."[61] In *The Autobiography of William Carlos Williams* (1951), a copy of which Barnes held in her personal library, he rehearses the clichéd line on her "evasive ways" and later describes her as "living in poverty somewhere, not, at least, writing," but he also praises her as one of the "newer talents and faces" who were once featured in the modernist magazine *Others: A Magazine of the New Verse*.[62] Interestingly, Williams, too, had conceived of his experimental writing as "a view of what the poet is," as he notes in book 5 of his incomplete *Paterson*. Breaking into a question-and-answer with an unnamed correspondent, he is asked, "Can you tell me, simply, what poetry is?," to which Williams's persona responds that "any poem that has worth expresses the whole life of the poet." A follow-up inquiry several lines later questions an embedded quotation in Williams's poem "Two Pendants: for the Ears" (1949): "But here's part of a poem you yourself have written: . . . '2 partridges / 2 mallard ducks / a Dungeness crab / 24 hours out / of the Pacific / and 2 live-frozen / trout / from Denmark . . .' Now, that sounds just like a fashionable grocery list!" Williams agrees, confirming

that "it is, to my mind, poetry" and that "anything is good material for poetry."[63] A parallel poetic theory applies to Barnes's Jefferson Market requests, though she never explicitly announced her crafting of her own shopping lists as such.[64] She too takes "good material"—material goods—to render strange what may count for a discernible poetic document.

I consequently do not read her lists as slipshod additions to Maryland's Special Collections but as an integral part of Barnes's "totally new" late-life corpus. Though absent from her *Collected Poems*, these verse drafts should not be untangled from the grocery list drafts or her other marginalia. Barnes turns her cupcake orders into a particular form of avant-garde art, and vice versa. "Some of the severely edited pages," writes O'Neal, "took on a visual life of their own, apart from any literary content" (*L* 87). Other typescripts bear out this insight. Some, such as "Dereliction," include nearly indiscernible flower-like doodles. Others feature ink drawings of a red poppy with a green stem alongside the titles of the poems. Still others feature six-pointed red stars hand-drawn or pressed from a rubber stamp. When one also considers Barnes's markup of her writing in variously colored inks, these pages start to look less like incoherent scribbling and more like modernist experimentations that overlay images and words—quasi-surrealist artworks that gesture to her time spent among fellow avant-gardists such as Man Ray and Charles Henri Ford as well as an extension of her own lifelong interest in drawing, painting, and poetics featured in works such as *Ladies Almanack* (1928) and *The Book of Repulsive Women* (1915).[65] Under the rubric of life writing theory, I refer to these drawings as what art historian Jennifer A. González, working in a vein of material culture studies, terms *autotopography*, "a spatial representation of important relations, emotional ties, and past events," which Barnes intermingles with her present life in Greenwich Village—a rather different neighborhood than the one she lived in from 1915 to 1921 while spinning hats as a Provincetown Players playwright, a poet, and a reporter publishing on topics such as Alfred Stieglitz and boat tours of Manhattan Island.[66]

As much as she erased distinctions between a finished and an unfinished work, or a grocery list and a free-verse poem, then, so too did she extinguish differences between the page and her quotidian late life. Barnes transformed her mundane activities at Patchin Place (buying groceries, taking vitamins, ordering medicine) into an aesthetic work in progress under persistent revision. Hence, when Levine's review movingly states that the university's collections are "the record of incredible gallantry and dedication to a goal that receded as

Barnes's growing infirmity made the completion of her last work impossible," I offer a friendly amendment.[67] This impossibility as she aged was a substantial achievement that widened beyond yet enveloped her literary endeavors. Barnes turned her late life into an unfinished poem and her unfinished poems into her late life. As one scholar remarks, "the composition of the poem—and, by extension, Barnes's literary project as a whole—itself becomes the poem's ultimate subject." While the same critic also finds that "nothing she produced after *Nightwood* . . . was successful" and that "Rite of Spring" is "weary and inconclusive," her drafts showcase an alternative sense of aesthetic realization outside publication.[68] By approaching daily life in Patchin Place as its muse, her self-composition was another totally new idea in the midst of modern American decline narratives.

IV

To push the logic of this last claim one step further: blurring the border between writing and grocery shopping, Barnes turned her older self into an unacknowledged avant-garde performance. She put not only everyday writing under correction but also her person, and this self-revision further counters the characterizations of her entropy. As she hyperbolizes in a letter, "I never move from Patchin Place, where I hold my infirmities in one hand, and write poetry with the other."[69] Though she imagines them in separate hands, her "infirmities"—her aging self—and her poetic revolution of one at Patchin Place function in tandem. They go hand in hand in a self-conceptualization where everything becomes work in progress: artwork, daily rhythms, and subjectivity in a studio apartment.

This claim explains an ostensibly unremarkable detail found throughout the University of Maryland's Special Collections: Barnes's name and her street address, which appear at the top of most of her typescripts. Usually she follows her last name with a period or a comma. While this heading regularly appears above provisional poem titles, her name sometimes shares the same line. One poem, for example, could be titled "Pavan" or "Djuna Barnes" (figure 1.6). If you had to pick a working title for the numerous pages housed in College Park, you could do worse than "Djuna Barnes." There is, she noted, little distinction between the productive infirmities of her self-identity and the productive revisions of her Patchin Place "self life writing."[70]

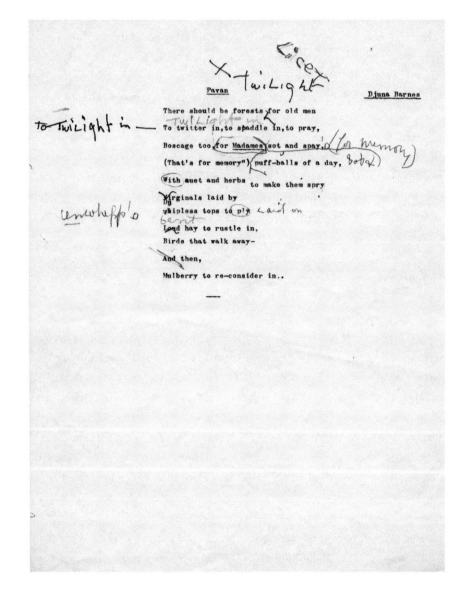

1.6 Djuna Barnes, "Pavan," undated. Series 3, box 11, folder 3, Djuna Barnes Papers, Special Collections, University of Maryland Libraries, College Park.

Cultivation of this cherished space is a recurrent theme, a rejoinder to age ideology, and a pattern that we will see repeated in other elderscapes. "Pavan" is exemplary of this dynamic as the poem rehearses the trope of conscious aging:

Pavan

There should be forests for old men
To twitter in, to spaddle in, to pray,
Boscage too, for Madames sot and spay,
("That's for memory") puff-balls of a day,
With suet and herbs
 to make them spry
Virginals laid by
Whipless tops to ply
Loud hay to rustle in,
Birds that walk away-
And then,
Mulberry to re-consider in,.[71]

Given my strained attempt to reproduce this poem typographically, one may agree with Herring and Stutman's reading of "Pavan" that "the draft never quite emerged from presurrealistic confusion."[72] But if we approach the typescript as avant-gardist age autobiography, the thematic of pleasurable senescence comes into clearer focus. "Pavan" is rife with old-new juxtapositions similar to her poetic grocery lists, which combine mass-produced Häagen-Dazs ice cream alongside citations of ancient Greek. Barnes's lifelong attraction to the etymologies of older languages likewise reveals itself in the poem's references to *boscage* and *sot*. The former term is from an early modern English word for pastoral landscape; the latter can refer to a drunkard and has been in circulation since the late sixteenth century. To these little-used words, she adds a hyphenated *puffballs*, a centuries-old plural expression for "gasteromycete fungi" that also refers to women's skirts, starting in the mid–twentieth century.[73] And the poem may even echo and reconsider—however faintly—an earlier piece on puffballs of pollen-laden trees that Barnes composed in 1917 as a reporter for *New York*

Morning Telegraph Sunday Magazine titled "The Hem of Manhattan." Commenting on the island's architecture as she takes a boat tour aimed at midwestern tourists, Barnes spots "the Old Man's Home" where "gray figures bent like hooks move about the splendid lawns and pause beneath the great trees, spilling their green bloom to the ground. Old men like futile pollen in a breeze whose scattering will bring no profit to the world."[74] "Pavan," by contrast, offers readers a different spot of springtime "green" where the aging frolic around rather than wander with little to no social value.

Indeed, the poem also creatively makes it new with linguistic experimentations interspersed amid older idioms and environments. *Oxford English Dictionary* tells us that *spaddle* is an archaic noun last used around the first third of the nineteenth century to refer to "a small spade."[75] Barnes transforms this gardening implement into a verb: "to spaddle in." Similarly, "whipless tops" makes literal sense if the poem refers to dress shirts worn by disempowered politicians of Parliament, but I believe that Barnes may have had a different intent.[76] "Presur-realistic" phrases such as "to spaddle in" and "whipless tops" showcase the artist crafting new idioms through outmoded words found in her "much-used two-volume Oxford English Dictionary."[77]

As it does so, "Pavan" schematizes and materializes creative agency by approaching aging not as a cultural zone of destitution but as a site of potent and fecund vivacity. From its opening line, the piece conjures an idyll in which "old men" can muck around. Conflating humanity with songbirds, the poem asks for liberty for them to "twitter" or to tweet within. Two lines later, it does the same for women, "Madames" who find sustenance such as "suet and herbs" in this phantasmic bucolic. In the light of my claim that this draft is indistinguishable from Barnes in Patchin Place, can we assume that her hoarder homestead provided literal and figurative room for these revelries? It is not too much of a stretch to read personal autobiography in this poem's arcadia given that Manhattan's denizens "re-consider" the borough's many white and red mulberry trees every spring, that Mulberry Street is a half-hour walk from Patchin Place, and that Barnes spaddled for decades in her abode. "Pavan" marks the pleasures of refreshing old lexicon day in, day out, as it archives Barnes's urban arcadia. While this unpublished poem does not reflect "the joke of old age" or "the indignity of aging" as do some of her other drafts, it unquestionably constitutes "a bold denunciation of the failing of her power" in Greenwich Village.[78]

Moments captured in other documents do the same. A corresponding example of this experimentalist aging appears in one of the sundry drafts of "Virgin Spring," where Barnes includes the following couplet, which she elsewhere repeats: "The slow beat of old ladies wings- / There should be gardens for such things."[79] Akin to "Pavan," "Virgin Spring" pines for a sylvan space that fosters creative freedom. Like other archived poems, its couplet enacts this performative arena through the process of its compositions. In step with the aesthetic patterns of incompletion and innovation that I outlined, on this draft Barnes crosses out "gardens" and handwrites "valleys," "isles," "chasms," "glades," "funnels," "tunnels," "gales," and "corridors." A "slow beat" begun in 1940 (and a complement to Olsen's slow writing discussed in chapter 4), Barnes's Patchin Place avant-gardism offered shelter for her revisionary "wings," and the poem suggests that more cultivated "gardens" or sanctuaries be readied for other women artists.

As much a revolutionary manifesto as her *New Yorker* note to self, these two lines and their unfinished alterations also insist on spaces for revision unencumbered by (male) editorial controls. With their focus on "old men" and "old ladies," we are thrown again back to Barnes's strained relationship with Eliot years after his death from emphysema in 1965. Memories of Eliot remained a psychic irritant long after she broke from him, as archived notes record her rehearsing his passive-aggressive comments about *The Antiphon* and his impatience with her incorporation of his editing. With their antiageism, poems such as "Pavan" and "Virgin Spring" may also speak back and counteract some themes of Eliot both youngish and older. In his poem "Gerontion" (1920, published at age thirty-two), the speaker's persona describes himself as "an old man, / A dull head among windy spaces."[80] In step with gerontophobic depictions of older persons as de-eroticized, the poem's speaker tell us that "I have lost my passion: why should I need to keep it." The final line of the piece is not exactly a modernist promo for AARP: "Thoughts of a dry brain in a dry season."[81] Likewise, in his World War II opus *Four Quartets*, Eliot lays out on a poetic table an ideological autopsy of the older body, particularly in "Little Gidding" (1942): "Let me disclose the gifts reserved for age / To set a crown upon your lifetime's effort." These goodies include "the cold friction of expiring sense," "the conscious impotence of rage / At human folly," and "the rending pain of re-enactment / Of all that you have done, and been; the shame / Of motives late revealed."[82] Himself a near-gerontion

by the time of *Four Quartets*'s publication—Eliot was nearing his midfifties when he published "Little Gidding"—the poems confirm a decline narrative as well as the poet's own gradually "expiring" maturation, especially if we read *Four Quartets* autobiographically, as almost every critic has done.[83] In Kathleen Woodward's assessment, this is an "old before his time" Eliot, a poet who filters "the crisis of middle age as viewed through the distorting lens of a repulsive old age."[84]

In Patchin Place—an Atlantic Ocean removed from Eliot's final years spent in London's Kensington Court Gardens—Barnes may well be responding to a young Eliot on aging as well as an aging Eliot not quite so young. She possessed copies of *Four Quartets* as well as Eliot's *Collected Poems, 1909–1935* in her personal library. As yet another break with his personal and cultural sway—no longer in lived life but after his death—Barnes's poetics are at once generous to the aging male body and also positively attentive to female desires. Her poetics consequently reformat what Eliot refers to in "Little Gidding" as "an easy commerce of the old and the new."[85] Pieces such as "Pavan" and "Virgin Spring" refuse the desiccated elder body and, in yet another departure from Eliot for this artist, function as hymnals to lush and experimental playgrounds across gender. Barnes may have revised not only herself or her poems over the decades, but also parts of *Four Quartets*.

Hence, as she did her unpublished response to Moss's rejection, her pharmacy lists, and her grocery orders, Barnes commits herself and her residence—her "gardens"—to what Caselli terms a "merciless economy of revision, which leaves nothing untouched," including the published works of her modernist peers.[86] I again emphasize the pleasures of this nothing, which is to say her everything. Return to the poem in progress "Dereliction," where she types "Djuna" and then an "x," which she crosses out. In another draft, titled "(Item vrom Poems in Passing.): Phantom Spring," Barnes types over her first and last names and then retypes them with her local, state, and national address.[87] In still another, "The Marian Year," she revises her address as much as herself when she strikes out "N.Y.C." to replace it with "N.Y."[88]

How do we read these edits as something other than a perfectionism that prohibited publication? One way to answer this question might be that Barnes cultivated these so-called identificatory mistakes as yet another instance of interminable revision, that, as a busy older body, she kept in progress rather than finalizing herself later in life. In other moments included in her papers, for instance, we find Barnes typing an apostrophe next to her name where one would typically place a comma and adding the letter l to spell "New Yorl" rather than "New York."[89] In

another she types her address as "5, Patchin Plave" rather than "Place."⁹⁰ Granted, these strokes could simply be the punch of a wrong key and best read as instances of Barnes's debility. The letter l is to the right of the letter k on a typewriter keytop, and the letter v occupies the same relation to the letter c. Yet if we risk overreading and approach them with the same logic that we have applied to her other writings, we can also interpret these errancies as a punch of her sublimely senile hands, as another instance of what Colleen Lamos has diagnosed as her "erratic texts, manifestly unamenable to aesthetic and sexual [and, I would add, gerontological] norms."⁹¹ Barnes's later manuscripts, I believe, left us with gaffes that further necessitate the process of revising herself rather than snuffing it out.

By doing so, these handy infirmities again trouble the commonplace characterization of Barnes as an aging perfectionist who could not get on with the poems. We are instead left with the personal production of what Caselli calls her "always deferred perfection."⁹² Given Barnes's penchant for etymology, I wonder if she was aware that the *Oxford English Dictionary* records a now-obscure definition of "perfect" as "completely formed, finished, or made; completely prepared or made ready," and that "imperfect" meant "not fully formed, made, or done; unfinished, incomplete."⁹³ I'm curious if she was pleased rather than annoyed with herself when she played self-editor and wrote "imperfect" in reference to her short story "The Valet," which *The Little Review* published in 1919.⁹⁴ I wonder if she saw this tendency to imperfection—to allow yourself "to be continued," as she writes in her incomplete letter to Moss—as an ongoing wish that found its perpetual fulfillment in her manuscripts. With her complete works uncompleted, her late life queered the very idea of a work (a masterpiece, a finished piece, a collected work, a finished self). To the list of author's works often cited in the front matter of her published texts—*The Book of Repulsive Women*, *Ladies Almanack*, *Ryder*, *Nightwood*, and *The Antiphon*—Barnes slipped in the errata of Djuna.

To summarize: as these works, "Pavan," her medicine regimen, and the couplet from "Virgin Spring" attest, Barnes's later typescripts further necessitate repeatedly innovating her elder self rather than ceasing to revise it. While previous criticism suggests that the few poems published before her death offer a "detached observation of the painful effects of age," familiarity with the unpublished materials complicates this reception.⁹⁵ Although I agree with Shari Benstock that Barnes's way of life in her last forty-two years "should not be seen (as it usually is) either as an inability to live in the world or as an elaborate eccentricity," I do not see this period of time as a "self-imposed censorship of sexuality

and speech," whereby Barnes "finally refused to acknowledge her body."[96] She acknowledged and, at times, feted the "wings" of women artists like herself as she continued to engage with fellow modernists such as Eliot and Williams. In "Work in progress: Rite of Spring," with its desire for a feminist aesthetic theory "to be continued," Barnes envisions her mortal "shroud" not as an instrument that one "cannot purge" but as something to "re-consider in," a work in progress that pushed her avant-garde aesthetics beyond the line of a finalized poem or a checked-off item on a grocery list and into the enduring drafts of selfhood across four decades.

V

"For years afterward," E. E. Cummings's biographer Christopher Sawyer-Lauçanno tells readers in a much-repeated line, "Cummings would from time to time raise his window and shout across the courtyard, 'Are you still alive, Djuna?'"[97] Did the tired joke land, Estlin? This apocryphal anecdote exemplifies the gerontophobia that I seek to dull, for Barnes would have been too busy to reply to her good neighbor. In a letter to her friend Rudolph "Silas" Glossop, a British engineer, in 1973, she writes, "I've had great wear and smash since 1969. . . . Miss Barnes is in a hurry and can't stop for the amenities."[98] Conceptualizing her aging as a rush job that took decades, Barnes does not see herself as trapped in Patchin Place even though she once described herself as "a form of Trappist."[99] Though Trappist monks rarely engage with the public, their days brim with activities, and Barnes presents herself as feverishly racing against the clock. A letter sent about six years earlier to Glossop confirms this regime: "I get up at five, have my breakfast, and shortly am at the typewriter, at which, except for the off-and-on necessary stop for lying down (the back does not now take very long to crack up), then back again at my books, papers and verse."[100] Turning herself into a late-life work liberated from editorial regulation, she diligently composed this personal medium through daily imaginative revision.

I could cite Michel Foucault and refer to these admirable efforts as a gerontological *ascesis*—the art of existing irrespective of societal misconceptions surrounding one's chronological age.[101] I could mention Robert N. Butler, who ends his classic *Why Survive? Being Old in America* with a line that Barnes would have much appreciated: "But we still have the possibility of making life a work of art."[102] Barnes made good on Foucault's and Butler's observations when she

treated herself as a novel project that postponed completion. In contrast to those who render her withering on the vine, I have argued that she religiously tended to an avant-garde monastery of poems, writing instruments, lavender salts, papers, gourmet ice cream, medications, mulberry trees, personhood, and dwelling. Mixing and matching city life, domestic life, creative life, and material life on page after page, sheet after sheet, she made Patchin Place a construction site rather than a dumping ground for her intricate poetics.[103]

These last remarks recall the Sedgwickian senile sublime. Though her papers look an unmanageable mess to some, this may be the point, given that her late-life project does not fit neatly into aesthetic norms of completed works or editor-approved productions. These "old brilliant" enactments of ongoing self-experimentalism should not be discounted.[104] That said, I do not want this chapter's recasting to forget Barnes's gripes about aging or paper over her conservative urbanoia. New York City, she finds in a letter dated November 9, 1967, is "dirty, dangerous, and in my section, all that <u>and</u> rediculous—hippies—hoppies and 'flower' children."[105] In contrast to the performative aging of Bronx-based Mabel Hampton that chapter 6 details, she was also uninterested in her city's thriving lesbian subcultures.

Yet amid low vision, the curling hands, the collapsing lung, and the hardening heart, Barnes did not stop writing, revising, or challenging her mediums between the Second World War and the Ronald Reagan presidency. Instead of withdrawing into silence, she refused to quiet herself as she maintained contacts with her brother, friends abroad, and newer acquaintances such as Page. Instead of chaotic inefficiency, she sustained and realized a "totally new" model of exceptional production. "Despite her seclusion," a *New York Times* reporter observed in 1971, "she did not stop working."[106] Her life did not become circumscribed through self-isolation but flourished as her modernism reinterpreted a stigmatized social category of debility that inaugurated an unprecedented fusion of literary effort and self-revision. Eliminating distinctions between "infirmities" and composition, Barnes fundamentally reformed the genre of the modern decline narrative—much as she previously did the realist novel, the sensational newspaper report, Freudian dream-work, and the story of sexology. Over many hours she molded her longevity into an avant-garde by rendering the former indistinguishable from the latter. Our scholarship would do well to mark the innovative aim of this personal performance beyond the enduring pathologization of her biography. At the least, let's treat the roughly 366,360 hours of her existence in Patchin Place as something other than an aging modern's wasted life.

CHAPTER 2

The Special Collections of Samuel Steward

You would never guess that Samuel Morris Steward is a crucial figure for queer American modernism. Unfortunate, since he spent much of his long life in close contact with established modernists and published experimental writings of his own starting in his later years. In 1937 a youngish Steward trekked to Bilignin, France. There he spent a "magic summer" with Gertrude Stein and Alice B. Toklas and returned to their leased chateau in 1939.[1] He kept in frequent contact with Stein until 1946, composing an affectionate obituary for "the grandmother of modern literature" several months after her death.[2] He visited Toklas seventeen times in Paris starting in 1950.[3] His correspondence with these two was released in 1977 as *Dear Sammy*. The 1980s then saw two novels based on this threesome's friendship: *Murder Is Murder Is Murder* in 1985 and *The Caravaggio Shawl* in 1989. Each subtitled *A Gertrude Stein–Alice B. Toklas Mystery*, both are modernist in content and, especially in the latter's case, in form as well. Yet Steward's biographer, Justin Spring, begins his *Secret Historian: The Life and Times of Samuel Steward, Professor, Tattoo Artist, and Sexual Renegade* (2010) with a disheartening opener: Steward "is practically unknown and nearly all his writing is out of print" (ix).

Despite a few reprints of his work in the past decade, this comment rings true. Spring sought to revivify Steward's relevance in *Secret Historian* by reviewing untapped holdings at Indiana University's Kinsey Institute; Boston University's Howard Gotlieb Archival Research Center; Bancroft Library at the University of California, Berkeley; Leather Archives and Museum in Chicago's Rogers Park; and what he calls a "vast, soiled, jumbled, and deeply disturbing collection of papers, photographs, drawings, and objects" saved (thank God) by Steward's estate executor Michael Williams (410).[4] In the book we discover much.

Reared in rural Ohio by beloved aunts, Steward left teaching in Chicago to become an admired tattoo artist and an acolyte of sexologist Alfred C. Kinsey. Under the pseudonym Phil Andros, he published ten pornographic novels between 1953 and 1984, during which time he moved to Berkeley in 1964 and opened a tattoo parlor in Oakland. As Spring also details, Steward documented his sex life starting in the early twentieth century, including encounters with Lord Alfred Douglas (a lousy lay), playwright and novelist Thornton Wilder (same), hundreds of anonymous men (better), Rock Hudson, and silent-film star Rudolph Valentino.

Several critics have written on these trysts and his impressive pornography collections, but I am equally interested in Steward's friendships with women and his lifelong wish "to immerse himself in the avant-garde milieu" (42). While contemporary audiences may venerate Steward's sexual proclivities, few feted the modernist artwork that he produced between the 1970s and the early 1990s. When mentioned, the focus rests on what Spring terms Steward's "final, isolated years" full of "literary failure" for an artist who "simply ran out of steam" (412). There is some justification for this take. His relocation was by no means easy after he moved from Chicago to the West Coast. "Justifiably terrified" yet financially beholden to inking members of the Hells Angels Motorcycle Club for a stable income (334), he also grew wary of "the ramshackle hippie commune next door" to his home—so much so that he found himself "placing live-ammunition booby traps" inside his residence (382).

Alongside these scaring encounters and his apparent creative falling-off, Steward's interior life appears just as tormented after he retired from his Anchor Tattoo Shop. In *Secret Historian*'s closing chapters, we find him "withdrawn from the San Francisco gay scene, where he felt himself an entirely unwelcome older man" even as he found friendship in the city's leather/BDSM community (370). We also discover that he excelled at hoarding. Spring states that the residence "became almost horrifyingly dirty in his last years—partly because in his eccentric old age Steward became a compulsive hoarder, and partly because Cranford and Blackstone, the two dachshunds he acquired after [his previous pet dog] Fritz's death, had never properly been housebroken" (399). A black-and-white photograph of an elder Steward reprinted in *Secret Historian* confirms and denies this situation by sweeping it under the rug (figure 2.1). Taken by Robert Giard, the portrait shows a stern-faced Steward sitting in a leather recliner. He faces the photographer with one of his canines

2.1 Robert Giard, *Samuel M. Steward (Phil Andros). Berkeley, CA*, 1988. Gelatin silver print, 20 x 16 in. (50.8 × 40.6 cm). Manuscripts and Archives Division, New York Public Library. Copyright © Estate of Robert Giard. Photograph by Permissions and Reproduction Services of The New York Public Library.

asleep in his lap. Behind him are numerous clocks as well as hourglasses of various sizes. Foregrounded in the photograph is a statue of naked males that dominates a third of the picture's frame, perhaps for good reason. "The squalor of Steward's home," remarks Spring, "was skillfully concealed by the photographer" (n.p.).

While *Secret Historian*'s valuation of these late-life events remains blessedly mild, others' have not. *Windy City Times* finds that "it's difficult to see Samuel Steward outside so many modern labels—as a recovered alcoholic, sex addict, starfucker,

pill popper, hoarder, obsessive/compulsive, depressive, [and] masochist.... Steward probably was all of those things." The reviewer concludes that it all amounts to "a dismal end to an incredible life."[5] And from author Andrew Holleran, writing for the *Washington Post*: "A rather sad wannabe: a man who wanted to move to Paris but never did, a writer whose dream of a great novel devolved into porn, a college professor who ended up a tattoo artist in the Oakland slums."[6] Judging from these incriminatory assessments, it seems that Steward should have cashed in his chips and called it a life, even though he published well into his final year of living.

This all-but-forgotten final work, to begin to better measure his enduring productivity, was *A Pair of Roses*. Reproducing a sliver of *Dear Sammy* and Steward's obituary for Stein, this miniature book also included a short essay by poet Marvin R. Hiemstra praising Steward's "delight-filled Path" through "personal history."[7] Published before he died on December 31, 1993, at the age of eighty-four, *Roses* typifies Steward's abiding interest in modernist writing—whether as a twenty-something or as an octogenarian near death. Given his persistent involvement with the movement, how might we better approach him as something other than a wannabe who flamed out in a hoarder's den? Such portrayals fall squarely within a decline narrative that casts him as a sad old queen with one foot in the grave. While I do not underestimate the burdens that his final home address at 2016-X Ninth Street placed on his daily interactions, I paint over depictions of Steward self-medicating with the glory days of Bilignin or buried alive by too much stuff.

Rather than cast Steward as a footnote to modernism, I place him belatedly front-and-center. To do so I reassess the hoarding and fame-seeking that paradoxically allowed him to ensconce himself into the modernist canon as late as the 1980s. He did so, this chapter argues, by crafting his residence into a gay modernist lifeworld—what Spring calls his *Gesamtkunstwerk*—on the page and off (102). Forthcoming sections explore Steward collecting and archiving modernist objects, mentoring modernist fans, revising modernist credos into a queer theory of aging, and authoring modernist prose that memorialized cross-generational alliances between lesbians and gay men. Attending to these preoccupations clarifies how his California decades facilitated his shift from a fledgling groupie in his late twenties to a bona fide modernist author by his midseventies. In his much-maligned abode, Steward emerged near the end of his biological existence as a master modernist *après la lettre*.

I

Before I address these writings, I lay to rest dismissals of Steward's hoard, items of which are better approached as collectibles that kept him in close contact with the avant-garde he emulated as a young-enough adult. I state this with full awareness that Steward's accumulations remain beyond refute, but this activity does not indicate dotage. On the contrary, his final address epitomizes a lifetime of queer collecting that was, in no small part, modernist in spirit. Spring tells us that "the bungalow had become so severely congested with books, papers, ephemera, and household garbage that there was little room for anyone apart from Steward to sit" (399). Steward's estate executor, Michael Williams, likewise reports that "a mass of things piled up on indiscernible pieces of furniture." Amid these piles one could find "tins of coins, boxes of can openers, bottle openers, and salt dispensers, piles of papers and lots of rinsed, empty dog-food cans which hadn't made it to the garbage pail. . . . Clutter everywhere." In Steward's bedroom, a home stager's nightmare: "a single bed [and] all around it was a heap maybe a foot high of discarded magazines, paperbacks, used Kleenex, support hose, and other items of clothing."[8] Though neither Spring nor Williams rebukes these material relations, others' moralizing disdain reinforces a decline narrative that squelches deeper appreciation of Steward's domestic material culture.

There are other ways to assess these piles besides what a hoarding specialist would term senile squalor syndrome. During an interview I conducted with Williams, I learned that Steward treated his hoarded rooms not as a hovel but what he called "a sacred place."[9] In our conversation, supplemental details emerged about Steward's late-life material culture that affirm his steadfast interest in the international avant-garde. According to Williams, the bungalow hoarding signaled a rich object world rather than its often-presumed impoverishment.[10] In his compact house we find "a sea of escape fiction" as well as "two collections other than the books and paper" including "tattooing [and] tracing papers" (W). A visitor would have encountered "old implements—apple corers, peelers" that reminded Steward of "growing up in rural Ohio where his aunts did a lot of preserving" (W). Sam, Williams fondly ruminated, "loved anything that was an implement—built his TV set as a kit" (W). He also hoarded "books on cryptology [and] police band codes. [An] endless variety of clocks—cuckoo clocks—clocks where you could see all the moving parts, thirty to forty clocks—flat-faced ones with circles rather than numbers."[11]

This penchant for gathering memorable things around his person was a hobby begun years before his move to California. As Spring recounts in *An Obscene Diary: The Visual World of Sam Steward*, Steward decorated Chicago apartments that he rented from the late 1930s to the mid-1960s with "created murals, small clay erotic sculptures, incised metal and glass objects, bent-wire sculptures, caricatures, and Dada-inspired and Surrealist-inspired decorative objects."[12] These playthings were anything but passively admired by the multitude of men who made their way through Steward's abodes. Far from debilitating the artist in his middle years, such possessions were emotionally and erotically sustaining objects suggestive of a vivid psychic interiority.

This being the case, I speculate that Steward found pleasure in his hoarded goods in Berkeley. Love, fascination, fantasy, investment, self-archiving, attachment, memorialization, and genealogy are keywords that come to my mind when I dwell on Williams's personal reminiscence. In my impossible recollection of a residence I will never enter, the plethora of peelers function like mechanical madeleines to transport Steward back to a pastoralized childhood in Ohio; the tattooing instruments, a pleasant reminder of his days spent in contact with the flesh and blood of men; the piles of books, a respite from wearying fears of neighbors next door. It seems that Steward enjoyed his gadgetry even as he became mired in it. His Berkeley bungalow became as perversely pleasurable a space as his Chicago bachelor pads, a residence dedicated to the "queer domesticity" of material contacts rather than a horror fest of abominable housekeeping.[13]

How do these nourishing goods correlate with Steward's devotion to modernism? Spring's passing mention of Steward's Dada and surrealist furnishings offers one clue (he met André Breton in 1937 and also visited the Café Odeon). Another Steward himself provides in his "On Keepsakes, Gew-Gaws, and Baubles" (1948), an *Illinois Dental Journal* essay published under the pseudonym Philip Sparrow that alludes to his personal interest in collecting modernist items. In this two-page piece, Steward distinguishes between "magpie and pack-rat people" and "genuine keepsakers."[14] Tut-tutting the former, he commends the latter and places himself amid their company:

> There is . . . some thorns from a well-loved rosebush in a garden set among an unforgettable circle of blue hills. There are the treasured letters from old loves long-forgotten, and friends who died, and names from youth and the

past, dim and misty as dreams half-remembered at noon. All of these things touch the little chords of memory; they are visible and tangible talismen that call occasions back to us, acquaintances and friends.[15]

This citation of that "well-loved rosebush" is an implicit reference to Stein and Toklas's flower gardens. Published nineteen months earlier in the same journal, his eulogy "On Gertrude Stein" closes with a wistful memory about tangible things he experienced in Bilignin that he carried back to the American Midwest: "Much used—but still serviceable—is a serrated tomato knife that [Stein] and Alice bought me one day in Chambéry. And on a layer of cotton in a small tin box are some thorns, sentimentally plucked from the rose-bushes at the house in Bilignin."[16] While one may uncharitably read these sentences as fame mongering, his collections nevertheless concretize a bond he initiated with modernist giants thanks to animate and inanimate gewgaws.

Note, too, the reference to the tomato knife alongside Stein's roses. Steward's hoard of old kitchen implements in Berkeley recalls individuals other than his dear aunts, including one of the world's more famous modernist cooks after Harper and Brothers published *The Alice B. Toklas Cook Book* in 1954. This inexpensive blade thus functions as an enchanted bauble that transports Steward back to a high point of the international avant-garde, a time when Stein had achieved renown after the release of her best-selling *The Autobiography of Alice B. Toklas* (1933) and after she and her partner had returned from a triumphant literary tour of the United States between 1934 and 1935. So important was this object to Steward that it reappears throughout his writings, including his penultimate novel where he again makes mention of "a small paring knife with a serrated edge to cut tomatoes and things."[17]

When considered within the arc of his lengthy life, these collectibles resonate historically and aesthetically. Steward "saw himself as a collector," stressed Williams. He "thought of himself... as a curator" as he hoarded modernist memories for at least half a century. While I am unsure if his executor auctioned off that serrated knife or if all of the rose-scented potpourri was tossed out with the tissues (the former is not listed in the Beinecke's finding aid for its Samuel Steward Papers, though one can request his Accu-Jac electronic masturbation device, his leather bull whips, and, following an acquisition in 2019, his soft-porn nightlight), the Berkeley bungalow was time well spent as Steward merged modernist

memorabilia and late modern life: "Add to these a *canivet*," he says, "a pinprick portrait of Voltaire done by the nuns of Cirey in 1750 and given to me by Alice Toklas... and you would have enough to live on the rest of your life" (C 142).

Given this extensive interaction with modernist things, several accumulated items in Berkeley evidence Steward's collecting as an aging modernist practice. In *Collecting as Modernist Practice*, Jeremy Braddock outlines the key roles that institutions such as Philadelphia's Barnes Foundation (begun in 1922) and Washington, D.C.'s Phillips Collection (begun in 1921 as the Phillips Memorial Art Gallery) played in documenting, organizing, and preserving modernist artwork in the United States, and he notes that Duncan Phillips arranged his acquisitions as a parallel mode of "modernist domesticity" that Stein and her brother Leo cultivated in their shared residence of 27 rue de Fleurus from 1903 to 1914.[18] Suggestively, Braddock theorizes that a modernist "material collection is itself an aesthetic object, even, more pointedly, an *authored work*."[19] By no means an elite collection, Steward's bungalow parallels this tradition since he thought himself a "keepsaker" of a modernist past. His hoarder-home functioned as both shrine and archive to modernist locales and personages as he compiled old modernist things—a devotee who acquired ephemera, letters, dried flowers, and utensils from experimentalists he adored. Far from a crypt, his Berkeley bungalow was a cultivated salon of unspeaking objects that kept correspondences with Stein and Toklas alive and well.

II

Alongside the queer domesticity of this modernist collecting, there is a complementary way to interpret these piles that undercuts the pathos of late-life hoarding. When Steward informs readers that his selected items provide "enough to live on for the rest of your life," his decades-long practice of accumulating stuff doubles as queer age theory that complements recent writings by the likes of Sari Edelstein, Cynthia Port, José Esteban Muñoz, and Kathryn Bond Stockton.[20] His emotional and material relations enabled him to compose and, over the course of a lifetime, revise a singular theory of maturation that responds to gerontophobia-at-large as well as age bias saturating modern American gay male subcultures. Steward's thoughts on collectibles provided psychic resources for a gay man who, in the choice phrasing of Spring, "passed

through" sexual modernity from the advent of the hetero-/homosexual binary in the early twentieth century to the apex of the HIV/AIDS crisis in the 1980s (413). This section teases out this trail of thought and its fidelity to a few modernist credos.

Steward initially published his most explicit statement on aging as "Detachment: A Way of Life" at the age of forty-nine—a numerical milestone for this artist as he further entered middle life. In 1958 he released this essay in the multilingual Swiss homophile magazine *Der Kreis / Le Cercle / The Circle*, a venue that signals how closely Steward associated his thoughts on modern things with his sexual identification. In this piece he unflinchingly states that "there is nothing that can be done to prevent our growing old," but he does suggest how to dodge ageist thinking.[21] "Time," Steward hyperbolizes, is "the greatest of all sadists," and he calls for "a kind of masochistic resignation" whereby "we may as well accept it with fatalism" (D 35). Acknowledging the insurmountable aging of his body with an embedded allusion to his BDSM practices, he consoles himself against temporal punishment with a unique riff on his essay's title. By *detachment*, Steward implies a social retreat from seeking out youth-in-essence and, in his gendered instance, cruising "the young god of all our dreams" (D 34). "What is necessary for this detachment?" he asks. "There must be inner resources, built up carefully over the years: a love of books, or music, or of something in which real interest is possible." Even better, he offers two sentences later, "a store of inner resources," or, by the end of his life, a hoard (D 35).

Steward informs us that inspiration for this late-life philosophy of modernist collecting came from an unnamed acquaintance who liked lots of things:

> We need, further, a built-up stock of memories to sustain us. Since our emotional lives are so frequently cut into small pieces, our hearts broken until there is nothing to see in them but the mendings, it is not unusual for us to place great love in things, in material objects, to which we develop sentimental attachment. There was a friend who once said that when he was seventeen he knew that he was going to be seventy, and began to keep records and a journal so that they would remember his past loves for him, and help him to induce his pleasure. He collected photos, and clippings of hair; and his piano and dresser-top became a forest of gilt and mahogany frames, each holding some young god's likeness. (D 35)

Personal collections become personal memories become personal "mendings" that repair the psychic damage done by gerontophobia. Aging, Steward suggests, can be hard on bodies but even rougher on old souls. The irony that he learns this praxis of curation from a forward-thinking male friend (age unknown) who began to detach as a teenager does not go unnoticed, nor should the paradox that social disengagement prompts deeper connection to others and "material objects" as it glues one's aging present with one's aging past—and "past loves."

Years later Steward returned to "Detachment," when he published a revised version of this creed as a coda to his memoir *Chapters from an Autobiography* (1981). The alterations to the piece from 1958 are minor but of interest. He itemizes his abstract ideal of detached rumination: "We need all the inner resources, or at the very least a treasury of memories to sustain us. Since our emotional lives are fragmented, we should have a vast stock of tangible things to invest our love in: mementos, memorabilia, photographs . . . anything which can stimulate us, can make us remember" (*C* 141). He places greater emphasis on the emotional pay-off of such disengagement: "Then you can truly say that you are alive, and that you are living" (*C* 142). He lists other objects in his commemorative coffers alongside Toklas's tomato knife and Stein's potpourri, including "a purplish magenta ceramic rose stolen from the ledge of Oscar Wilde's tomb in Père-Lachaise cemetery" and "a construction hardhat"—the latter a testament to his enduring desire for working-class cisgender men (*C* 141, 142). Prior to this coda he also intersperses revised lines from the original *Der Kreis* essay that reattribute his theoretical discovery to himself rather than his anonymous friend: "for when I was seventeen I knew I was going to be seventy. And there were going to have to be tangibles to which the imagination and memory could be tied, devices to stimulate nostalgia and the remembrance of things past" (*C* 129).

This last quotation attests that Steward based his revised age theories not solely on his collector-friend's personal example but on modernist authors that he admired, taught, and, in some cases, visited. The reference to Proust is obvious enough, particularly given that *Chapters* functions as life writing stimulating nostalgia thanks to "a flood of happy recollections rushing to the screen of memory in recalling those days at Bilignin" (*C* 58). There is also a debt to Thomas Mann's *The Magic Mountain* (1924) when he compares his Berkeley collecting to the leisure activities of that German novel's sanatorium residents. But the

sharpest avant-garde influence on "Detachment" was Stein by way of Thornton Wilder. Though he buries this lead in *Chapters*, Steward says so himself in the essay "On Getting to Be Forty" (1949), which begins: "Some years ago Thornton Wilder called my attention to a passage that Gertrude Stein had once written in *A Long Gay Book* about getting old. 'Do you know,' he said intensely, for he had just passed forty, 'I have read this passage aloud to many people, and have seen them actually grow pale as Gertrude approached the description that fitted them.'"[22] A familiar essay like others composed for *Illinois Dental Journal*, "On Getting to Be Forty" thus exemplifies what Margaret Morganroth Gullette terms "entry-into-decline stories," or personal reckonings with midlife steeped in "nostalgia about the useful past and fear of bodily decay."[23]

Yet while Steward bows to the social pressures of midcentury U.S. age ideology, "On Getting to Be Forty" also works as a midlife manifesto that underpins his later-life detachment philosophy. He approaches this chronological marker as both a biological fact ("eventually everyone still above ground has to be 40") and a culturally induced concern.[24] While Stein's prose may shock at first, it also enables Steward to extend her modernist theories of growing older and generate an antiageist discourse with his two versions of "Detachment." After pessimistically comparing himself to the title character of Wilde's novel *The Picture of Dorian Gray* (1890), Steward returns to Wilder's comments in his "Forty" essay: "Said Gertrude Stein in that passage: 'When they are a little older they are commencing mentioning aging to prepare any one for some such thing being something that will be showing in them.' That's me, bub."[25] Quoting from Stein's narrative of 1933, Steward's selected passage sounds uncannily similar to his friend's recognition that "when he was seventeen he knew that he was going to be seventy." Like Stein, this little-older teenager too sees that aging "will be showing" and emotionally firewalls himself with memorabilia. Further, as much as Stein finds that aging individuals must "prepare any one for some such thing," Steward refers to detaching as an act "built up carefully over the years." The passage from *A Long Gay Book* so impressed the artist that he paraphrases it again in his novel *Murder Is Murder Is Murder*:

"When people are a little older they are knowing then that they have been younger," said Gertrude.

"That part you wrote in *A Long Gay Book*," said Alice, "which you are quoting just now—do you remember what Thornton said about it? How when he

read it to people they would actually grow pale as he approached the sentence that described them as they were 'when they were a little older?'"

"Yes," said Gertrude. "That's a damned good page of writing, ain't it."

"It is indeed," said Alice. "Page twenty-five in the first edition, as I remember."

"We are growing older," said Gertrude.

"So is everybody else," said practical Alice. (M 151–52)

What starts off as a short piece about "the soliloquy of age anxiety" in "On Getting to Be Forty" consequently becomes a theoretical foundation for "Detachment" that helped Steward get to be seventy-five to see *Murder Is Murder Is Murder* released—all the while "commencing mentioning aging."[26]

I myself could soliloquize about Stein's literary experiments with aging—how *A Long Gay Book* presciently diagnoses the standardized march of geromodernity by logging "a young one and an older one and a middle aged one and an older one and an almost old one and an old one"—but I keep the spotlight on Steward's citations of modernist thought.[27] Drawing on Stein, Proust, Mann, and Toklas, Steward amassed a theoretical stockpile of stimulating ideas that prepared him well for his experimental aging. We may even add Wilder to this illustrious mix, given that his avant-garde play *Our Town* (1938) has Emily Webb, the play's main character, detach from earthly relations after she dies in childbirth but continues to exist in an unspecified afterlife during the drama's third act.

Steward, like Webb, kept on going despite an acute—and not always self-inflicted—disconnect from his own social worlds. The modernism buoying "Detachment" allows him to respond to a subcultural climate that had itself internalized ageism and viewed sexual desirability as a trait granted primarily to those who had yet to hit forty. Poignantly, Steward writes that "as we grow older, we suffer from the dwindling number of admirers, and may make pathetic efforts to keep young and attractive, to keep from becoming an 'auntie'—darkening the hair along the temples, rubbing eye-cream or some tan enamel make-up over the pockets below our eyes, wearing a male girdle of some sort to hold the dreadful slackening of the belly. Lord, we fool no one!" (D 34–35). This figure of the auntie—or the feminized older gay male—can and does haunt modern gay male imaginaries as a misogynistic sign of shame in pre- and post-Stonewall America. In his gay slang dictionary from 1972, for example, lexicographer Bruce Rodgers finds that the term refers to a "middle aged homosexual. . . .

To the younger homosexual, an auntie often translates as anything over thirty having lived too long with nothing to show for his age. Youth is the premium in the real world, but it is the criterion in the gay world."[28] While Steward witnessed firsthand the subcultural grievances of youth's "criterion," he embraces himself as this auntie by disengaging from gay male gerontophobia: "But with detachment, it may be granted that we will grow old as easily as possible, as good men should, knowing the virtue of giving up at the psychological moment, the right time, *le moment juste*" (D 35).

Like earlier cited passages from "Detachment," Steward revised these lines for *Chapters*. Writing in his early seventies and fairly apathetic to new Gay Liberation scenes in the post-Stonewall Bay Area (he felt himself an "outcast," *Secret Historian* tells us [320]), his antiageist criticisms became more pointed at himself and at gay men when he denounces "the frantic-pathetic efforts to stay young and attractive in a culture which admires youth alone" (C 140). With Steward cognizant that some might view him and his kind as pitiful old queer men, a brushed-up "Detachment" serves as one way to hold on to dignity in yet another era that diminished him. Thanks to Alice, Gertrude, Thornton, Thomas, and Marcel, he navigated his aging and his multiplying objects as something more than desperate living. The tomato knife cut into good memories as the blade fended off sexual modernity's bad chronological timing.

Thematically reliant on modernist masterpieces, his age theories thus drew deep from the well of the avant-garde to think through ageism. Feeling himself shunned by the body fascism of the Bay Area, he taught himself how to delight in a sentimental array of things that he could fondle, caress, and care for as he curated the modernist past and his material late life. In so doing he scripted a self-instruction guide for finding one's way through decline ideology within and without America's queer communities that was indebted to experimental resources such as *A Long Gay Book*. Referring to what it calls "the problem that looms large for every aging homosexual," his autobiography asks a gendered question: "In what year does a good man stop it all?" (C 138). With hard lessons learned from cherished modernist exemplars, Steward's response became clarified: you don't, bub.

III

He didn't. Thus far I have addressed how Steward reformatted some of his writings into "a way of life" modeled within his packed Berkeley home. The

remainder of this chapter examines how Steward further merged his investments in tangibles with his queer theories on aging to fashion himself a novelist of modernist prose in the final decade of his life. Shifting the gears of my analysis, I look at how Steward realized his long gay age theories not only in his dwelling but on the page thanks to two companion novels from the 1980s, *Murder Is Murder Is Murder* and *The Caravaggio Shawl*. As noted earlier, both are tellingly subtitled *A Gertrude Stein–Alice B. Toklas Mystery*. The first and second of an incomplete tetralogy, both commemorate an avant-garde that permitted Steward to disengage from ageist social climates and likewise prove him a modernist innovator thanks to their experimental narrative strategies—some of which he out-and-out imitated from artists he knew and esteemed. This section focuses on *Murder*; the next turns to *Shawl* as these overlooked texts continue on the fictional page what "Detachment" theorized, what his home materialized, and what Steward, to again cite Spring, desired in the 1920s and then achieved six decades later: "to immerse himself in the avant-garde milieu."

While scholars and lay readers alike have begun to reassess his pornographic novels, a novel such as *Murder* remains by and large ignored, receiving scant notice as a mediocre example of the gay male detective fiction subgenre.[29] In 2011 one Goodreads reviewer accurately summarized this uncritical reception while at the same time casting the "light" novel as an insignificant achievement: "These little books tend to get dissed by the mystery crowd for not being serious mysteries, by the Stein crowd for not being serious books about her and by the Sam Steward/Phil Andros crowd for not being intelligent erotica."[30] To this day, Steward's later writing cannot win for losing even as it braids distinct genres into an unprecedented mash-up of modernism, mystery, and softcore pornographic prose.

Though it contributes to the critical problem, the reviewer's assessment is not inaccurate even as it underserves the novel's thematic and formal advances. While generically true that *Murder* is a mystery novel in step with Steward's interest in criminology and sleuthing, from its first chapter onward it announces its debt to modernism with a subtle-as-sledgehammer nod to Stein's *Blood on the Dining-Room Floor* (written in 1933, published posthumously in 1948), a first edition of which Steward owned, according to archived materials at the Bancroft Library. "Currently," he writes, "she was *en bloc*—as the French say—a writer's block had descended on her.... Even the mysterious death of Madame Pernollet, the hotel-keeper's wife over in Belley, had not been able to get her started on a murder mystery which she dearly wanted to write, especially since she thought

she had a wonderful title for it, *Blood on the Dining Room Floor*" (M 9). As much as "Detachment" takes its cue from *A Long Gay Book*, so too does *Murder* mimic Stein's mystery, which is neither hard-boiled nor true crime. Rather, Stein's text falls within a specialized genre of what literary critic Matthew Levay terms "modernist crime fiction." "Echoing Ezra Pound's infamous challenge to 'make it new,'" he finds, "Stein advocates a kind of detective fiction that . . . can breathe new life into old forms, as 'it is much better to make an old thing alive than to invent a new one.'" Levay quotes from Stein's essay "Why I Like Detective Stories" (1937) in support of a claim for *Blood*'s formal experimentalism and concludes that the book's "effort is perhaps more important than the outcome" given its current status as one of her slighter avant-garde pieces.[31]

The same can be said for Steward. Acknowledging *Blood* as a template for *Murder*, his fiction also finds that "it is much better to make an old thing alive" as an aging gay writer in his seventies crafts a queer age novel about aging lesbian modernists in their sixties. Three pages into *Murder*'s first chapter, the narrator highlights the novel's investment in aging avant-gardism:

> A small part of the world knew Gertrude Stein as the grandmother [she was sixty-three in that year of 1937] of avant-garde American literature, the influencer of the styles of Hemingway, Anderson and many others, the practitioner of arcane and hermetic [and some said automatic] writing, and the light of the world to her lover-companion Alice B. Toklas. A few of the world knew she adored reading murder mysteries, but not many knew that she and Alice had solved several murders themselves: the forgery and murder at the Louvre, the mystery of the verger who died defending the weeping Madonna, the weeping willow crime, and the disastrous Hollywood scandal of the starlet's death. (M 9)

While this full paragraph crescendos to a deep insider-knowledge by rhetorically downsizing from "a small part" to "a few of the world" to "not many knew," it is unclear if the passage's main concern lies with its revelation of Stein and Toklas's solved crimes. While the description establishes a fictional Stein's credibility as a successful sleuth, the opening sentence inscribes her an avant-gardist "grandmother" aging quite well, thank you, as the last finds her and Toklas to be gumshoes. The remainder of *Murder*'s plot makes good on this formula: while the narrative concludes with Stein and her partner cracking a homicide case in Bilignin,

the narrator spends pages describing everyday life between two aging moderns as they cook, eat dinner, sleep, walk their dog, garden, motor through the French countryside, banter and bicker, flirt, anticipate sex, dust their residence, and reminisce. Without question, Stein and Toklas are also ideal detached agers who each identifies as "a magpie" who "never throw anything away" since "it's all going to Yale to the archives, that's the way Donald Gallup wants it" (*M* 160).

Interestingly, *Murder* does something similar with Steward's fictionalized self, a gunsel ostensibly meant to help Stein and Toklas crack the case of who killed one of their community's villagers. Toklas first makes mention of him in the novel's second chapter under a writing pseudonym—John McAndrews—that Steward often used in the 1960s in journals such as *Der Kreis*. In *Murder*'s seventh chapter, "Johnny-Jump-Up," Alice describes McAndrews as "young, well fairly so, won't he be twenty-seven this year, and he's inclined to whoring" (*M* 43). The eighth chapter's opening erases any doubts that Steward looks back on this younger self with detachment:

> He was, alas, a somewhat respected professor at some Chicago university named after a saint [although Gertrude often confused the name of it with a dog's paw], but he was more or less a whore at night, or a hunter of stags, or some kind of predator.... It was he who kept Alice supplied with kitchen gadgets, and sent bundles of paperback detective stories to Gertrude. They loved him for various reasons, none of them the least sexual. (*M* 47–48)

In a chapter that begins with a single-line paragraph—"What a reunion!"– Steward in Berkeley treats the arrival of Johnny-jump-up in Bilignin as a charm that unifies his younger pseudonymous self with the older author who conjures him (*M* 47). Stated differently, Steward stockpiles words on a page that imagine Johnny-jump-up in order to detach back to a time full of "euphoria and brilliant storms of talk, talk, talk!" (*M* 47).

At the same time, this narrative also marks Steward as an older artificer of things past. Readers discover Johnny to be a teacher, a paramour, and a useful sleuth, and Steward also casts this fictive version of his younger self as a modernist writer-in-the-making. One brief exchange near the novel's midpoint bears out this claim. When McAndrews complains to Toklas about the "dull" students in his DePaul University classes that he has introduced to Stein's writing (as Steward himself recalls in his unpublished memoirs), she replies:

"Gertrude told you once that you should have been a butcher," said Alice. "You will never get any writing done, using that word-finding part of your brain all the time. It's worn out by evening, and then when you try to write, nothing will come out."

"But if one has nothing to say, then one can say nothing, can one?" he said.

"You are beginning to sound a little like her," Alice said. (*M* 112)

I'm pleased to second her observation. With their exchange, the novel not only incorporates Steward's younger self, Toklas's older self, or memories of his visits with the two. *Murder* also reprints dialogue supposedly spoken by Stein to Steward—a process comparable if not equivalent to his citation of modernist titles and prose in earlier works such as "Detachment" and *Chapters*. At such moments *Murder* presents Johnny's attachment to Stein and Toklas as a mentee-mentor relationship that coaches him into proper modern prose writing as much as "the grandmother of modern literature" did for Ernest Hemingway and Sherwood Anderson. He too becomes part of her modernist lineage.[32]

Johnny McAndrews, however, is not the only one who sounds like Stein "the influencer." *Murder* as a whole begins to sound more and more modernist as the plot recites quotations that Steward overheard or read from Stein, Toklas, and their friends. Besides recalled conversations and reproduced correspondence that he printed in *Dear Sammy*, the novel repeatedly direct quotes, paraphrases, and alludes to *The Alice B. Toklas Cook Book* as well as *Everybody's Autobiography* (1937). Four examples among many:

Murder: "After a pot of tea at home and some of Alice's special cookies, of which Gertrude was very fond—those made with rice flour and eggs and rolled into little sausage shapes, and when cold painted with a water icing flavored with rose water." (142)

The Alice B. Toklas Cook Book, from the "Recipes from Friends" chapter: "'Cookies': Roll them into little sausages and place on a buttered baking sheet in a moderate oven. When cold paint with a water icing flavored with rose water." (254)

Murder: "I am I because my little dog knows me and can tell the difference between cheese and me." (120)

Everybody's Autobiography: "You are you because your little dog knows you" (46); "I am I because my little dog knows me." (66)

Murder: "I'm just going to sit and breathe and be a genius." (153)

Everybody's Autobiography: "It takes a lot of time to be a genius, you have to sit around so much doing nothing, really doing nothing." (72)

Murder: "I hate all this," Gertrude said. "I hate meeting trains and saying goodbye to them and waiting to meet people and then seeing them go away." (133)

A conversation between Steward and Stein in *Dear Sammy*: "I hate meeting trains and saying goodbye to them and meeting people and seeing them go away." (6)

To this list we add the novel's title, which signifies on Stein's claim that "rose is a rose is a rose is a rose" from her poem "Sacred Emily" (1913) and repeated in her poem "Lifting Belly" (1915–1917).[33] Likewise, it may signify further on other lines from "Sacred Emily," which claims, five lines after "rose is a rose is a rose," that "page ages page ages page ages."[34]

As Steward mixes their words with his own, the novel moves from reliance on vanguard genre (*Blood*'s experimental detective fiction) to reliance on vanguard prose. In *Murder*'s case, modernist prose here becomes modernist *pastiche*. I do not mean *pastiche* in the conventionally postmodernist sense—what Fredric Jameson refers to as "specific reactions against the established forms of high modernism."[35] I instead mean *pastiche* as a tried-and-true genre of writing whereby an author sincerely seeks "to copy the style of" a more established forebear.[36] Precedent for this style began soon after Steward's first visit to Bilignin. In a September 10, 1937, letter to Stein and Toklas ("Dearest Two"), he writes at the bottom of one page, "Can you see how much of *Everybody's Autobiography* I have taken with me, I have been thinking in its style," and on the top of the following page, "so if I am a disciple at all in any way I must imitate." In this same letter Steward also included an experimental piece he titled "A Detective Story" that imitated Stein's modernist prose style. At the end of this short story he again affirms his "great love in things... to which we develop sentimental

attachment" when it turns out that the answer to this mystery is that "'I love G & A,' written on wall paper of guest room at Bilignin" (figure 2.2).[37]

Why do this? Rather than uninspired pilfering, chunks of *Murder* read like a modernist collection of words that parallels Steward's modernist hoarding of things. Words function like gewgaws. To his collection of some old modernist tangibles Steward added old modernist text. While this project seems derivative, it is not as if he "ran out of steam," as often presumed. Quite the contrary: Steward the *pasticheur* takes old modernist material and makes it newish in 1985—much as he did with "Detachment" in 1958 and "On Getting to Be Forty" in 1949. Hence while Spring argues that when Toklas died in 1967 "she was his last living connection to that higher, better, literary life to which he had once aspired—a life once so close that now seemed entirely lost to him" (261), I suggest this bond deepened over his long-term relationship to the international avant-garde. Marking their intimacy, Steward titled this association in an *Advocate* article, "France & Gertie & Sam & Alice," in May 1981.

In the novel *Murder*, Johnny is not simply an enthusiast of modernism but a modernist practitioner-to-be. In writing *Murder*, Steward became an imitative innovator but an innovator nonetheless. His lack of inventiveness was the engine for his experimentalism, an irony that should not be held against him. It has not for others. Observes Michael North in reference to modernist authorship at its height, "Many admitted—or even insisted—that what seems new is really only the old come back again."[38] With regard to Steward, I invert North's claim: what seems really old is only the return of the new. Among the many creative hats that Steward wore—devotee, collector, avant-garde-inspired age theorist—he became an experimental author by recalling *Blood* in Berkeley and making a fictive batch of "Alice's special cookies" in the mid-1980s.

IV

"1989 was oddly enough a pretty good year for me, which made it somewhat extraordinary, because I turned eighty in July—a thing that astonished me no end, since it was the first time *that* had ever happened to me."[39] For sure. Published four years after *Murder* during this "extraordinary" year, *The Caravaggio Shawl* further secures Steward's reputation as a late-to-the-game modernist writer by expanding the formalist repertoire of his vanguard narrative schemes.

> This is very important. 47
> Paragraph.
> Then turn to face the big dipper or the pole star which has nothing to do with a polecat or a poleaxe or a pole as we know it.
> And why is a board base why should it be called that is it low.
> From the western corner no the eastern count six vacant things, no five. The sixth is full.
> Of which row
> As many as you have eyes or ears
> And there it is and really and truly it is true because I put it there I did not scrape off paper because that was done but this was not done but now it is.
> And so is this.
> Goodbye
>
> "I love G & A," written on wall paper of guest room at Bilignin

2.2 Photocopy of Samuel Steward's "A Detective Story" with brief note included in a letter to Gertrude Stein and Alice B. Toklas, September 10, 1937. Box 2, folder 19, Samuel M. Steward Collection, Howard Gotlieb Archival Research Center, Boston University. Reproduced by permission from The Estate of Samuel M. Steward.

While Steward again appears as John McAndrews, he is no longer one houseguest among the many visiting Stein and Toklas from abroad: "She [Stein] was fond of Johnny. She had admitted him into the innermost circle and had said things to him and had told him things that she had never discussed with anyone else but sweet Alice, dear Pussy."[40] Like *Murder*, the detective work in *Shawl* too seems a footnote. The most significant plot difference between the two is a shift in setting from Bilignin to Paris, where Stein and Toklas solve the mystery of who killed their maid's husband.

Also akin to *Murder*, the narrative emphasizes aging modernist bodies while introducing a senile sublime. *Shawl*'s Stein negotiates osteoarthritis, but this inflammation does not stifle her creativity as a self-avowed grandmother of avant-garde literature. Four pages into the novel's first chapter, Stein has the following exchange with her lover:

> "Since you are really and truly a real genius with your own charmed circle, I believe that doesn't matter at all."
>
> "Who was it, who was the critic who called me the mother of modern literature," Gertrude asked.
>
> "The grandmother, Lovey, the grandmother."
>
> "Hell," said Gertrude with obvious irritation, "I guess we really are getting old."
>
> "No," said Alice. "We *are* old. It is 1937, and two months ago, exactly to this day, April 3, you were sixty-three, and the end of this month I will be sixty."
>
> "Are we done for then," asked Gertrude with a sigh.
>
> "At this point," said Alice, "I will not again recite for you the catalogue of artists, writers, musicians, sculptors, composers, and creators in all fields from mathematicians to physics and beyond who did their best and most wonderful work in their years after sixty." (S 10–11)

Lampooning stereotypes of older individuals as scatterbrained, this remarkable passage echoes and alludes to Steward's praise for Stein in his 1947 *Illinois Dental Journal* obituary, Toklas's comments on aging in *Murder*, and the title of James R. Mellow's biography *Charmed Circle: Gertrude Stein and Company* (1974). In keeping with themes introduced across decades of Steward's writing, it confirms Stein as an older modern and Toklas as a critical age theorist. Both become aunties or, to

cite subcultural lingo for aging lesbians, crones. None of these lives are past their imaginative prime or, as Steward's Stein warily puts it, "done for."

Yet another shared similarity between these two novels is *Shawl*'s even denser citation of modernist prose. There are several more-or-less reproduced letters from *Dear Sammy*, and *Shawl* misquotes from Hemingway's memoir *A Moveable Feast* (1964). One also finds reference to one of Stein's better-known experimental writings besides *The Autobiography of Alice B. Toklas* and its follow-up quoted in *Murder*: "I am liking lifting bellies and caesars and seize hers and loads of cow coming out instead of little squalling bundles" (S 146). This last quotation is a potpourri of lines from "Lifting Belly," published in *Bee Time Vine and Other Pieces* in 1953. The book is, overall, a dizzying mix of high modernist quotations and paraphrasing.

I would be remiss if I did not also mention *Shawl*'s references to Stein's *Q.E.D.* and "Idem the Same: A Valentine to Sherwood Anderson," but this last citation from "Lifting Belly" is of primary interest in terms of further understanding Steward's behindhand modernism. Unlike *Murder*'s fairly accurate citations, this quote occurs in a chapter entitled "Kayaking up the Medulla Oblongata," which Steward patterns off of the eighteenth and final "Penelope" episode of *Ulysses* (1922). Joyce's novel was one that Steward esteemed as much as *The Magic Mountain* or *À la recherche du temps perdu*. His shorthand lecture notes from a course on The Modern Novel that he taught at DePaul in the mid-1950s, for example, reveal his keen appreciation for Joyce's "free exprmntatn in tech" and the "psy richnesses of mod mind."[41] In this Joycean "Kayaking" chapter—a development that builds on *Murder*'s word hoarding—*Shawl* introduces a modernist formalism that matches its modernist content by way of homage to *Ulysses*. Mirroring the free indirect discourse and lack of punctuation that structures "Penelope" until the episode's ultimate period, "Kayaking" offers access to Stein's subjectivity via the much-used but still serviceable method of stream-of-consciousness. "I am a lot smarter than Molly Bloom," the chapter commences, "and anyway walking with poor Basket limping along here in the gardens of the Luxembourg is always conducive to my thinking clear and limpid thoughts" (S 145). Stein's stream-of-consciousness continues for the chapter's entirety as she mulls over her childhood in Oakland, eighteenth-century wig-wearing, and her Parisian flat's exterior decorations. At times she also repetitively conjures the famous last word of *Ulysses*: "yes I know"; "I think back home yes" (S 145, 147).

As earlier noted in my discussion of *Murder*, these depictions of Stein's headspace via *style indirect libre* do not necessarily signal a practice of metafiction, nor pastiche, nor metamodernism. *Shawl* thinks itself modern literature from its opening chapter to its last, where we find Stein and Toklas discussing the French translation of her writings by Éditions Gallimard. In so doing the novel functions as the culmination of a lifetime of Steward's engagements and excursions into the avant-garde, and it is a logical bridge to his final publication, *A Pair of Roses*, mentioned in this chapter's introduction. In that miniature book, Steward takes his place next to Stein and Toklas in the final year of his life as a fellow traveler in modernist authorship, and he inches closer with this mystery from 1989 that whimsically reimagines several episodes from *Ulysses*. To again quote his Toklas, he sees himself as one of the "creators" doing "their best and most wonderful work" well after the age of fifty-nine.

We might, then, retract a claim made after *Secret Historian*'s publication that laments Steward "wanted to move to Paris but never did." Adding to his two visits to Bilignin and the seventeen to Paris were a few others in the 1980s, just not in person. I am not being glib when I frame his aesthetic excursions as such since it is telling that Steward composed works like *Murder* and *Shawl* in Berkeley during this decade. These narratological experiments, like his modernist collection of rose petal potpourri featured in *Chapters*, allowed him to imaginatively return to France to get a better handle on the Bay Area's psycho-subcultural climate. With versions of what my students would refer to as *shipping* (a genre of fan fiction in which one scripts a new relationship for fictional characters), they permitted Steward to think up even more novel proximities to his own past to bring 1937 into 1989 via modernist prose. Stated otherwise, Steward's writing was a form of elder self-care.

Can you blame him? Even as I aim for greater appreciation of his last few works, I do not idealize his final decade by glossing over the obstacles of his later life. To his hardships amid Bay Area ageism, we can add "my chronic difficulty with my ole worn-out bronchial tree which keeps actin' up now & then, + all the other complications of my anecdotage, but as Katie Hepburn says, 'I'm fine—if you don't ask for details.'"[42] Inhabiting Stein's point of view or Johnny's head in *Shawl* may have been one way to get out of his own. A detached Steward recognizes that his days of youth are gone, but these mysteries featuring McAndrews also function as avant-garde memories that offered psychic release from corporeal debility, a unique example of what Gullette refers to as "creative alternatives

to aging practices."[43] You can call this a "retreat to a cottage in Berkeley" if you like, but it is just as much a successful revision—a revisit—of long-ago queer modernist lifeworlds that palliated his present condition.[44]

V

Samuel Steward took a lifetime to become a modernist, yet his was a lifetime of modernism. This paradox structures his creativity from the late 1920s to the early 1990s, and he appears to have documented this self-contradiction. "I have lived on the fringe of the literati. I've picked up a few crumbs from their table," he once boasted.[45] A complementary moment in *Chapters* asserts that "the loosely bound group at Ohio State University which embraced Marie Anderson, Robert von Riegel, Virginia Cooley, myself and others considered itself in the forefront—very sophisticated and au courant. Possibly we were by those days' standards—maybe even intellectual and avant-garde" (*C* 44). Regardless of these conflicting self-accounts, my survey records his complex relationship to the avant-garde: from a student of modernism starting in the 1920s to a collector of modernism starting in the 1930s to a eulogizer of modernism starting in the 1940s to an author of modernist literature starting in the 1980s.

In this last period of his artistic life, he also became a "senior mentor" to younger generations.[46] While true that Steward felt isolated from many of San Francisco's gay men, some did trek to his bungalow in an uncanny echo of his own visits to Stein and Toklas's chateau. Despite Bay Area gerontophobia, the beloved "Old SOB" served as a model for these individuals.[47] States one friend in 1982: "Now, decades later, a handsome young man bicycles across the Bay Bridge from San Francisco in order to attain his own symbolic link to Gertrude Stein by sleeping with Sam every so often."[48] As an instance of what *Shawl*'s Stein refers to as "arrivistes" or "real climbers," this young man sought out a Steward known for accumulating, lauding, revising, drafting, and experimenting with modernist forms in print and in his bungalow (*S* 91). His small, hoarded home had become a destination point whereby an auntie of the international avant-garde held court and cross-generational cross-identifications flourished.

This "handsome young man" who visited a grandfather of modernist literature was most likely Scott Andersen, whom Spring describes as "a strikingly handsome twenty-five-year-old porn actor" (391). At the end of *Chapters*, Steward

describes Andersen as another one of the "tangible things" that enters his life. He tells readers of his delight at meeting Scott at party, and his surprise at the actor's desire for the elder accumulator's proximity to the modernist avant-garde:

> A few days later Scott came to see me, to get the copy of *Dear Sammy* signed.... He gave me also a large color photograph of himself, naked, with one arm uplifted to a branch, his lithe tanned swimmer's body amidst a total background of greenery—cedars and firs—his genitals barely showing before merging with the green out of which his body sprang. On the back of it he wrote: "I enjoy your company, and look forward to more visits in the future. I hope to be as charming and witty as you are when I am past thirty!" (C 137)

Scott would send other photographs to Steward as well as missives of admiration and adoration. Contrast his adoration of Sam to critical reception of Steward's California decades. Did the porn actor identify as a gerontophile? Or as an *auntie-queen*, a "young man who seeks the companionship of older men?"[49] Did he find the supposedly squalor-ridden spaces as "charming and witty" as the man himself? Did he want to be hoarded by giving Steward his portrait? Rather than doleful, Scott treats Sam like a novelty—an aging Steward is a fresh revelation as well as a living-breathing participant in the avant-garde. Steward, in turn, transfigures Scott into another form of detached collecting as he records this relationship for readers of *Autobiography*. The sixty-something thus treats the twenty-something as yet another pleasurable addition to his lifelong hoard of things and people, older and newish.

Perhaps Stein educated Steward on this matter as much as she coached him into her experimental senile sublime, since Steward functioned as a sexy grandfather to Andersen as much as Stein appeared as a playful grandmother to McAndrews, Andros, Sparrow, Johnny-jump-up, and Steward. Maybe it was Thornton Wilder. Or maybe Oscar Wilde, almost a decade deceased when Steward was born in 1909. In an oral interview with the Gay and Lesbian Historical Society of Northern California (now the GLBT Historical Society) in 1983 that doubles as what geriatricians term a life review, Steward recalls that

> I have always been fascinated with historical connection going back and when I was able to make that one connection with Wilde through Lord Alvin

> [sic] Douglas, well I thought I had really achieved something, you know? Ah, no, it gave me individually a sense of continuity, of importance, if you will, because I was connected with the early homosexuals of nineteenth century, at least one or two of them, and ah, that led a lot of us in the '30s and '40s to become what I suppose today you would call groupies, except, well no. We weren't groupies, we had too many idols or heroes we suspected were homosexual. That's one of the reasons I was reading Thomas Mann.[50]

Refusing the title of "groupie" that still sticks to his reputation, Steward outlines his deep "historical connection" to queer modern experimentalists. He again works "to make an old thing alive," and the interview functions as a complement to the intergenerational friendship he maintained with Stein and Toklas. These links to international modernism serve, in turn, as a template for his friendship with gay youth such as Scott, who would also make his own transatlantic journey to pay respects to Stein, Toklas, and Wilde in 1981.[51] Almost thirty years before Spring's biography was released in 2010 and thirty-two boxes of literary papers, correspondences, and realia were acquired by the Beinecke in 2012, Steward's Berkeley sensorium had already become a finding aid for queer modernism. As much as Stein taught him how to age well with her model of *A Long Gay Book*, so too did he do the same for others. He was, by my account, a living-breathing queer archive, and he repays the debt of strong mentorship by connecting youth such as Andersen to that heady moment of sexual modernity in person at his home and on the page with his books. A memorial organized in April 1994 by Michael Williams at Le Bateau Ivre after Steward's death noted this with a decorated poster board featuring Steward, Stein via Picasso's 1905–1906 portrait of her, Toklas, Steward's dog, his deeply ironic Moral Majority card, and a note to Andersen (figure 2.3). He was obviously a special collection for some.

From his graduate days at Ohio State University onward, the modernist avant-garde was something that Steward learned how to do and do quite well. It was a movement in which he was educated in the Midwest, which he taught students in Chicago, and to which he contributed on the West Coast. Steward writes in his memoirs that "as the years went on," he "passed into the land where Everyman must eventually go, that of the older human being" (C 119). While doing so, this former teacher tutored others into his elder experimentalism. In some respects, scholars have yet to fully appreciate his contributions to literary and material cultures. Ironic, since at the time of their publication his writings

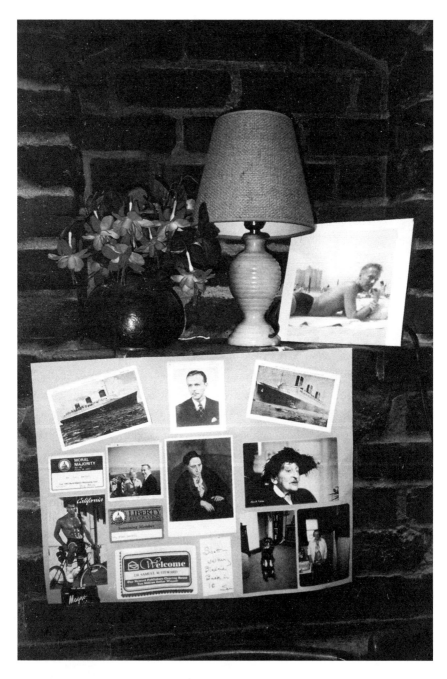

2.3 Michael Williams, *Steward Memorial-April 1994*, 1994. Box 1, Samuel Steward Papers, General Collection, Beinecke Rare Book and Manuscript Library, Yale University, New Haven, Conn. Reproduced by permission from The Estate of Samuel M. Steward.

were not wasted on the young, nor the old, nor, perhaps, the departed. "Steward," we are told, "sometimes says that he thought he was writing for lonely old men living in hotel rooms."[52] Except, well, yes and no. He was also writing for queer kids like Scott in the 1980s and 1990s, eager students of LGBTQ U.S. literature who may not have been fortunate enough to experience an entry-into-decline story during the height of the global HIV/AIDS epidemic.

At the same time, he was also writing for deceased modernists like Stein, who would have been 115 years old had she lived to see *The Caravaggio Shawl*'s publication. Thinking about her beloved Johnny-jump-up in *Shawl*, Stein wishes that "one day Johnny would become a writer if he could ever stop drinking, and then maybe he would write about her, far into the future when she was dead and gone. And help bring people back to her writing once again. I would like, she thought, to be rediscovered every twenty or twenty-five years" (S 62–63). As much as he borrowed from modernists, Steward uses his literature and his crafts in his Bay Area cottage to reintroduce her experimental writings to other appreciators.

My wish is akin to Stein's as I have brought us back to Steward's prose and personal dwelling years after he too has been dead and gone. We should commend his bottomless fame-seeking and his scorned accumulations, as well as the fact that he turned his homestead into an elderscape for experimental aging. His days were never uncreative. He lunched with friends, gave readings at bookstores, went to the movies, paid taxes, ordered medical supplies, celebrated birthdays, remembered his first Alcoholics Anonymous meeting, chatted "on the telequeen network," ceaselessly wrote letters, responded to fan mail, dealt with respiratory disability, checked in on old tricks, negotiated "an increase in my cognitive slippage" thanks to "my horribly advanced age," rewrote portions of *Ulysses*, recast the two lives of Stein and Toklas into three, and cemented his standing within the literary history of the Euro-American avant-garde.[53] So "bless little Sammy ... with our love," as Stein consecrated Steward on his thirtieth birthday in an occasional poem she dated "Bilignin 1939."[54]

Done, with an addendum. Bless poor old Sammy on all the anniversaries that followed while lifting girdled belly in Berkeley, turning brief visits to France into the trip of a lifetime.

For Justin Spring and Michael Williams

CHAPTER 3

Ivan Albright's Anti-Antiaging Treatments

I don't expect most of my readers to recognize an Ivan Le Lorraine Albright painting if they are lucky enough to see one. To begin to grasp how this painter remains the least familiar of my case studies thus far, start with two exhibitions that put his work before the ogling eyes of many museum-goers. Each was staged in the early twenty-first century, and both failed to confirm Albright as a leading American modernist. The first exhibition, *American Modern: Hopper to O'Keeffe*, appeared at the Museum of Modern Art from 2013 to 2014. Among mainstays by Georgia O'Keeffe, Charles Demuth, Stuart Davis, Jacob Lawrence, Alfred Stieglitz, and others, the exhibition included *Woman* (1928), its lone Albright painting (figure 3.1). The portrait features a mature white female shrouded in a black fur coat. Excess wrinkles, blemishes, and yellowish discoloration mark her chest, and the same goes for her furrowed brow and enlarged hands. Despite the inclusion of this painting, however, Albright went unremarked in the exhibition's accompanying catalogue essays.

Fast forward half a decade to another exhibition, *Flesh: Ivan Albright at the Art Institute of Chicago*, which opened in the spring of 2018. Promoting Albright as an experimentalist whose career spanned Great War watercolors of shrapnel-shredded limbs to end-of-life self-portraits composed a few months before his death on November 18, 1983, the Art Institute of Chicago's exhibit emphasized "the theme that obsessed the artist throughout his career: the decaying human body."[1] Museum-goers did come to gawk at these pieces, but the exhibition itself acknowledged—confirmed—Albright's depreciation. "Ivan Albright has been tucked, it seems, into a corner of art history, gaining respect for his craftsmanship and singularity of vision but maybe not quite a full place among the 20th-century American giants," observed one *Chicago Tribune* reporter.[2]

3.1 Ivan Albright, *Woman*, 1928. Oil on canvas, 33 x 22 in. (83.8 × 55.9 cm). Museum of Modern Art, New York. Digital Image © The Museum of Modern Art/Licensed by SCALA/Art Resource, New York. Photograph by Museum of Modern Art.

These two exhibits point to a difficult-to-shake understanding of Albright. Though major art institutions inside and outside of the United States have acquired and display his paintings, these works often appear worthy of rubbernecking rather than engagement. Reviewing his standard reception, you get the sense that he was more of a mad geriatric dermatologist and less of a formally trained innovator (one *New York Times* review of *American Modern* cites *Woman* as "grotesque").[3] With critics typically analyzing his portraits as lurid spectacles of aging's effects on women and men, they confirm Albright's off-kilter place within American modernism. At the same time, they underestimate his accomplishments within interwar modernism proper as well as the decades thereafter. Indeed, MoMA framed its selections between the years 1915 and 1950—yet another instance of how U.S. modernisms happened back then that disregards its ongoing achievements. Is there any surprise, David M. Lubin stated in 2016, that Albright is "a painter who is little known today"?[4]

I hope to rectify this commonplace, so I open with these exhibits to suggest that museum staff and modernist critics have not gone far enough in understanding Albright's lifelong commitments to modernist experimentation beyond registering their own—and the general public's—agreement that this painter specialized in suspect portrayals of older persons. That said, a handful of scholars have labored to better contextualize his artwork. We owe them much. In one informative reassessment, Susan S. Weininger situates Albright's paintings beyond the grotesque and within "work categorized variously by historians as surrealist, magic realist, visionary, or untutored."[5] In an earlier piece, Weininger cites Albright as "a surrealist, a mystic realist, a magic realist, a romantic realist, a subjective realist, and a realist-expressionist."[6] "Age and decrepitude," notes another art historian when describing the 1920s, "were largely excluded from a popular consciousness conditioned by liberated mores and seemingly endless advertising propaganda touting the means and benefits of bodily perfection. Ivan Albright (1897–1983) was one artist who opened his mind and eyes to the inevitable fact of physical decline."[7] From the start of his work in the Jazz Age to its end in the early 1980s, Albright interrogated these cultural matters of modernist flesh and the ideological aging of twentieth-century skin. By the crash of 1929 "he had begun to develop his signature aesthetic that conveyed an almost hyperreal sense of aging, flaccid, or carbuncular flesh," and he spent the remainder of his career refining and repeating this aesthetic.[8] Having "achieved a mature style" in his early thirties, his art nevertheless traverses several strains of

U.S. modernism—a regionalism based first around Chicago and later in Vermont, as well as what was once referred to as *magic realism*—that provided conceptual platforms for his unsubtle protests against modern age discrimination.[9] More than merely grotesque, his durational modernism prodded fears over growing older.

As such, Albright is a sound choice for considering how modernist visual cultures, in tandem with the literary, responded to waves of gerontophobia across the long twentieth century. His case study complements writings we have encountered so far from Barnes and Steward (both visual artists in their own right). In what follows I spend some energy on Albright's poetics and prose—his sketchbooks and his not-so-good free verse—as they aid our appreciation, but my main focus is his painting. Visuals such as Albright's are a complementary medium for countering gerontophobia as it announces itself through the desperate eradication of aging skin that you can see. Citing this "relentless cult of youth" in her account of how "decline . . . distorts visual culture," Margaret Morganroth Gullette finds that "over our whole life course, visual culture has tremendous power, setting the ways we can regard our own bodies and those of others (call this the historical side of 'age specularity')."[10] Hers is a theoretical insight about seeing ageism that this chapter historically refines. Its overarching thesis is that Albright's portraits visually experiment with modern decline narratives in order to break with modern decline narratives.

Certainly, there are others we could turn to in service of this claim. I have in mind O'Keeffe, who worked into her nineties with the aid of assistants such as Juan Hamilton; Paul Cadmus, the subject of a Public Broadcasting Service documentary, *Enfant Terrible at 80* (1984), who sketched homoerotic pieces until his death in 1999; Cadmus's friend and former lover George Tooker, who painted care facilities such as *Ward* (1970–71); Harlem Renaissance bohemian Richard Bruce Nugent, whose watercolors from the 1970s and 1980s were reproduced in 2002; George Morrison (Wah Wah Teh Go Nay Ga Bo), who painted surrealist landscapes into the 1990s; the spidery crafts of Louise Bourgeois; and Jacob Lawrence, who finished his *Supermarket* series in 1994 and a focus of my coda. This incomplete list suggests that an *American Modern* exhibition spanning beyond the Second World War awaits curation. In the meantime, I detail how Albright works against twentieth-century gerontophobic cultures via his years-long aesthetic experiments with modernist skin, or what art historian and Minneapolis Institute of Art curator Robert Cozzolino refers to as his "lifelong

preoccupation with aging and mortality" that "addressed head-on the process of aging, for which he had enormous fascination and respect."[11]

More than any critic to date, Cozzolino has labored to recover Albright's contributions to experimental American art. His exhaustive research advances that of others, including my own. He is on record for compiling "the underlying archival research" for an Art Institute retrospective in 1997 foreshadowing its exhibition of 2018, where his "written contribution to the catalogue included seventy-four short essays on the ninety-three objects included in the colorplate section." Beginning with a lament that we have misjudged Albright's experimentalism, he cites this labor in his dissertation in 2006 with its focus on "corporeal modernism."[12] This chapter takes Cozzolino's findings as definitive, and it extends his observations as well as those made by Weininger and a few others. To do so I show how Albright's portraits of elder people tackle an important facet of decline culture's visual component—its overreliance on the overpromising falsehoods of antiaging. As we will see, Albright works with and against modern American culture's decades-long preoccupation with age-cessation via promises of skin rejuvenation that spiked in the early twentieth century. The painter employed this modernism to query such gerontophobia, and his was a lifetime project of visualizing older flesh that refuted what Gullette terms "the sci-fi fantasy of rejuvenation."[13]

To confirm these claims, I closely read several paintings, including *Flesh (Smaller Than Tears Are the Little Blue Flowers)* (1928), *Into the World There Came a Soul Called Ida* (1929–1930), *Self-Portrait* (1935), and *The Vermonter (If Life Were Life There Would Be No Death)* (1966–1977), that trouble this decline ideology. I end with a brief reading of Albright's self-portraits from the 1980s that do more of the same. Given the swift emergence of his "mature style" in the 1920s that persisted well into the 1980s, I intend the wide chronological stretch of these sites to show how Albright's experimental visual culture tracks long-range effects of cultural aging and responds to an ever-burgeoning rejuvenescent modernity, a phrase the following section further details.[14]

Spilling ink on Albright will, I also sense, benefit modernist body studies when placed in closer conversation with critical U.S. age studies. While we have stellar accounts of the former (studies of the proto-trans third sex, dandies, birth control activists, traumatized soldiers, and newly identified "adolescents"), discussions of skin are harder to come by save for a few exceptions. In her book-length study of Josephine Baker, Anne Anlin Cheng writes how "we might understand raced skin as itself a *modern material fascination*," and the same goes,

Albright shows us, for aging epidermis.[15] Likewise, Maud Ellmann has detailed "skinscapes" in *Ulysses*, and I am interested in how we might apply this neologism not only to the printed page but to the stretched canvas.[16] Tracing older age groups with charcoal, oil, and utmost care, Albright's portraits of crepey skin are more than up for this task.

I

Examine *Flesh (Smaller Than Tears Are the Little Blue Flowers)* (figure 3.2). Finished the same year as *Woman*, this painting also highlights age-themed degeneration. A sitting portrait whose subject has been identified as Arline Stanford, the painting's title and composition put emphasis on Stanford's aging flesh.[17] Framed against a darkened background, her skin's whiteness contrasts with the chair she sits in, her strapless dress, and the bowl of flowers in her left hand. Albright overstresses Stanford's wrinkled skin with creases along her neck, clavicle, rotator cuff, antecubital fossa (elbow pit), forehead, and hands. Like *Woman*, this painting is one of many in a long line of aging subjects that constitute his almost century-spanning oeuvre: a fisherman in California, a bartender in Chicago, a white-haired midwestern farmer, a rustic Vermonter, his dying self at age eighty-six.

Though completed in 1928, the flesh that Albright features—spectacularizes—is not that of a modern girl around the world, but of a much older one. *Flesh* is nevertheless of its historical moment as the first third of the twentieth century saw personages such as the flapper (average age: ~18–30 according to *Oxford English Dictionary*) go historically hand-in-hand with counterparts known as *flapperdames*, or "aging women, old enough to be grandmothers, dancing with young male partners at afternoon dances."[18] These comparative forms of womanhood were not social equals. Seeing that "age grading... intensified in the first three decades of the twentieth century," youthful women often found themselves sexually desirable at the expense of those no longer thought to possess this fleeting trait.[19] Au courant flappers were worthy of art deco *Vogue* covers. Forebears to the contemporary insult *cougar*, flapperdames were the talk of no one's town.

Albright's anti-*Vogue* painting of Stanford, however, sidelines Jazz Age youth for an intensive focus on cultural aging's corporeal impact.[20] As I have proposed, the painter shared a keen interest in aging's effects on the body's largest organ with many in the 1920s. A bit more historical background for this growing

3.2 Ivan Albright, *Flesh (Smaller Than Tears Are the Little Blue Flowers)*, 1928. Oil on canvas, 36 × 24 in. (91.4 × 61 cm). Art Institute of Chicago, gift of Ivan Albright. Photograph by The Art Institute of Chicago/Art Resource, New York.

concern with skin reveals how Albright not only took up aging as his theme (a standard observation) but also took on antiaging imperatives. Delving into the cultural forces that produced disparaged flapperdames, this section canvasses the historical climate that contributed to a work such as *Flesh*'s critical stance on youthful rejuvenation. In her reference to "the sci-fi fantasy of rejuvenation," Gullette dates these pipedreams to the early twentieth century when she references "the desire in a population that before World War One could not have imagined the prime of life taking such perverse forms."[21] Other scholars in age studies, such as Chris Gilleard and Paul Higgs, have commented extensively on linkages between "rejuvenation and modernity," "the art of rejuvenation," and "rejuvenative appearance management."[22] Extending their insights, I give an overview of the cultural anxieties behind modern skin that undergird Albright's objection to these emergent aging norms.

While interest in antiaging phenomena existed before this decade, by the later 1920s significant swaths of the U.S. population had become youth-centric, or what Lubin refers to as "the can-do, anything-is-possible, make-yourself-new youth fetish of the booming twenties."[23] Cultural historians, in particular, have remarked on this facet of U.S. modernization, itself something of a cliché when we conjure this decade. Nonetheless, there is truth to this "fetish." T. J. Jackson Lears, for one, identifies "a veneration for youth" within modern advertising campaigns pitched to both men and women and finds that such marketing idealized "smoother, cleaner, more athletic, and more obviously youthful models of beauty"—precisely the features that one would see in the visual cultures of major magazines such as *Vogue* (founded in 1892).[24] Lears's adjective "smoother" is especially suggestive and recalls Steward's passing mention of antiaging cosmetics in chapter 2. It hints at how manufactured concerns over aging skin were part and parcel of modern cultural regimes that stoked desires for young-looking appearances and gerontophobic fears over the passing of time. "At the turn of the twentieth century," Sander L. Gilman likewise observes, "the number of individuals who desired to 'pass' as youthful began to increase. Medicine began to strive to fulfill patients' desire and make them more youthful. What had been the stuff of myth became the material of the clinic and the laboratory."[25] Part of American modernity, we might unfortunately say, was not only the rise of youth culture but the wishful eradication of growing older.

Feminist science studies scholar Susan Squier has referred to these wishes as "age-extension strategies," one successful ploy being "rejuvenation therapies."[26]

This imperative for a natural glow, a firm chin, and a creaseless smile took on several forms, including elite medical procedures, semi-elite beauty regimes, and more popularized cosmetics promotions that pledged to repair the supposedly harmful effects of aging. "'Rejuvenation' research," Gilman notes, "became a subfield of endocrinology and led to the craze for 'organotherapy' in the 1920s."[27] Proselytized by many, the craze's most prominent advocate was Austrian endocrinologist Eugen Steinach. Take, for example, *Rejuvenation: How Steinach Makes People Young* by poet, novelist, and Nazi sympathizer George Sylvester Viereck. Writing under the penname George F. Corners in 1923, Viereck insists that "rejuvenation is a reality, not a dream" while championing Steinach's surgical procedure of a partial vasectomy to rejuvenate aging men (W. B. Yeats and Sigmund Freud both went under the knife to awake, respectively, with placebo effects such as new poems from the Nobel Prize–winning Irish poet and a new theory of female homosexuality from the founder of psychoanalysis). Even more interestingly, Corners links rejuvenation therapy to a new historical period: "If the 19th Century was the Century of Mechanics, ours, no doubt, will be known as the Biological Age. The last century taught us how to fly. The present century teaches us how to restore youth by tapping the secret reserves of the Endocrine System."[28] Promoted throughout the United States, these ideals of rejuvenescence were thought to offset senescence as "typical manifestations of old age (dizziness, difficulties of breathing when engaged in muscular exertions, pain in the limbs) disappear. Typical manifestations of youthful vigor are noted. His face blooms, his wrinkles vanish."[29]

By no means whatsoever were cisnormative or queer men the primary recipients of antiaging's questionable assurances. "Women," Corners observes, "have been successfully Steinached" with X-ray machines aimed at their ovaries.[30] For those women with lesser means, other alternatives were there for the taking. The historical observations of Gilleard and Higgs are worth quoting at length:

> It was not until the early decades of the twentieth century that rejuvenative methods emerged as phenomena with mass appeal, as practiced by the new breed of "beauty doctors." Amongst the various techniques on offer, the beauty doctors promised to reveal new skin by peeling off the "old," using acetic, carbolic (phenol) or salicylic acids or, more daringly, to "plump out" ageing, thinning faces by injecting Vaseline or paraffin under the skin. A few began to pioneer radical skin lifting procedures to remove crow's feet, bags below the eyes and facial lines.[31]

Scores of estheticians, store clerks, and advertisers for individual regimens likewise advanced dermatological procedures whereby "skin-care systems required cosmeticians to apply an array of cleansing and 'nourishing' creams and to massage the face with wrinkle rollers, muscle beaters, or other devices."[32] Women such as Arline Stanford were goaded to remove their supposed epidermal impurities, to replenish their skin, and to erase any evidence of rhytides. Think over the cultural anxieties that began to house themselves across gender, race, and class in the folds and flaps of a hand, a neck, or a face injected with petroleum jelly as "businesses encouraged a high degree of self-consciousness."[33] Review, too, this list of products available by the fourth decade of the twentieth century to attenuate these sensationalized concerns: "contour cream, crow's-foot cream, deep pore cleanser, eyelash grower, eye wrinkle cream, scalp food, hair color restorer, rejuvenating cream, muscle oil, skin food, wrinkle eradication, skin tonic."[34]

This litany of antiaging products comes from a *New York Times* exposé in 1940. Other primary documents confirm the findings of those who have traced the swift advent of the cultural antiaging industry in the United States. Here are a select few that paved the way: an advertisement from 1919 for Eleanor Adair Ganesh Strapping Muscle Treatments, which proclaimed that "this original method of invigorating the muscular structure of the skin by gentle, rapid tapping and strapping, is Mrs. Adair's own and holds first place as a proven method of scientific skin rejuvenation"; an *American Medicine* article in 1927 that trumpeted "the rejuvenation of the skin by subcutaneous injection of a serum obtained by immunizing rabbits with a preparation of the epithelial juice of guinea pigs"; a tome in 1940 entitled *Modern Cosmeticology* from the Brooklyn-based Chemical Publishing Company, which promised that its creams "do therefore *delay the onset of wrinkles*"; and issue after issue of *Motion Picture Magazine* rife with advertisements for Gervaise Graham Hair Color, Pompeian Day Cream, and Láradium, which would "restore weakened tissues and see wrinkles no more! with Láradium Facial... new achievement for skin rejuvenation."[35] These four snapshots attest to the "modern material fascination" with aging skin that this chapter's introduction foreshadowed, and it had great pull on women and men alike, with vows of tightening, toning, polishing, and hiding the supposedly unwelcome effects of age.

This quick rundown of modern skin cultures alludes to what Albright witnessed and reworked in a painting such as *Flesh*, given "his willingness to resist the blandishments of a youth-obsessed culture."[36] His was, without doubt, a

shared cultural interest. At the same time, however, it was also a shared questioning of antiaging regimens. While Freud, Yeats, and others such as American novelist Gertrude Atherton praised rejuvenescent techniques, detractors of this antiaging culture did raise their voices. Not everyone agreed, as the best-selling author of *Black Oxen* (1923) told one newspaper, that "I saw one woman, a veritable hag, who looked about 30 a year after treatment."[37] The *New York Times* exposé cited earlier relied on Food and Drug Administration watchdogs to monitor the truthiness of cosmeticology; a theatrical production such as Eugene O'Neill's *The Fountain* (1923) queried the mythic search for the Fountain of Youth; and a novel such as Zora Neale Hurston's *Their Eyes Were Watching God* (1937) celebrated protagonist Janie Mae Crawford's erotically charged midlife with no cosmetic adjustment in sight.

Though he was never really a team player, Albright joined these modernist rebukes of aging. As much as art historian Elizabeth Lee, following Lubin, argues that his paintings "respond to consumerism and the rise of beauty culture in the 1920s," so too do they speak against its profitable pillar of antiaging treatments. Lee's incisive observation that "Albright's paintings question the assumptions underlying period efforts to make a face" could thus be further extended in terms of U.S. age culture's wish to unmake its flesh.[38] Unlike cosmetologists, his work does not hide or erase aging. He instead uses his canvas to showcase a Láradium skin cream ad gone funhouse. In an aesthetic practice of *anti*-invigoration, Albright does not do away with the supposed ravages of visualizing aging but makes this phenomenon more transparent. If, as Gullette has suggested, "the commerce in aging" should "more aptly [be] called the 'uglification industry,'" then one way to decipher *Flesh* is to see Albright's painted oils and pigments as antirejuvenation creams and serums carefully applied to faces and bodies.[39] Arline Stanford is not a failed modern beauty we should pity. She rebuts imperatives to be forever young promoted by movie magazines, beauty parlors, and pseudo-scientific journals.

Likewise, Stanford's exposed flesh helps us think differently about ahistorical *vanitas* interpretations often characterizing Albright's work. As Weininger notes, "Albright's entire oeuvre can be viewed as a twentieth-century exploration of the *vanitas* theme in which he pondered the connection between the physical and the spiritual and the relationship of growth and decay, time and space, the finite and infinite."[40] How might we recast this commonplace about "growth and decay" within the antiaging norms that this section traced? *Flesh*'s parenthetical

title—*Smaller Than Tears Are the Little Blue Flowers*—is a guidepost. It is important that Cozzolino identifies these tiny petals as forget-me-nots.[41] Given the rejuvenant geromodernity that Albright engages—and that Stanford the model may have historically experienced—we can treat them as a literal plea for viewers to remember her, as a request for us not to forget about her in a moment when women such as herself were cast as past their prime. That moment, feminists such as Barbara Macdonald and Cynthia Rich insist, is far from over, yet a symbol of decline takes on new resonance for an older woman amid the rejuvenation-infatuated 1920s.[42] *Flesh* creatively ages one female's body and finds grotesque the modern cultural aging industry.

II

Many of his other works do so as well. The previous section argued that Albright's paintings undermine an emergent "uglification industry" in their spectacular representations of creases and wrinkles that naturally begin to appear on any human body. At the same time, he also experimented with aesthetic techniques of premature aging through a unique brand of modernism known as magic realism. This is a complementary way to understand how his works undercut modern age norms across gender, not only in terms of content but also in form. It would be an overreach to call Albright a feminist—he never identified as such—but his paintings allow for a critically gendered analysis that considers how antiaging discourses affected sexes correspondingly, if not equally. This section focuses on two paintings, *Into the World There Came a Soul Called Ida* (1929-1930) and *Self-Portrait* (1935), to confirm these claims. Like *Woman*, like *Flesh*, neither piece effaces aging. They instead visualize embodiments freed from the decline narrative of lost youth.

Albright had cultivated interest in such modernist techniques when he lived in Warrenville, about thirty miles west of Chicago—"the youngest of world metropolises," noted J. Z. Jacobson in *Art of Today, Chicago 1933*, who saw Albright "as a vanguard."[43] Before I confirm this claim, I ask that we bear in mind Cozzolino's remarks about artists based in this midwestern metropolis: "Chicago modernist art has always incorporated 'abstraction' and 'figuration' as simultaneous rather than dialectic conditions of art making."[44] While many of these artists are now "seen as hermetic, anti-modernist and irrelevant to twentieth-century art history"—one flip take on Albright—Cozzolino finds "pluralism as a

distinctive feature of the Chicago art scene which encouraged and sustained many simultaneous styles without the pressure to form a 'school.'"[45] Often working alongside global movements, artists such as Albright thus achieved "highly personal visions in accordance with the aims of modernism."[46]

Instances of this "accordance" appear in modernist poetry that Albright drafted in the mid-1930s. Personally filed under "VERY IMPORTANT POETRY" and now archived at the Art Institute, these poems function as thematic companion pieces to his paintings and testify to his interest in standard modernist tropes, such as the futility of the Great War:

> Red fields of Flanders
> See the blood waving
> In each poppy that grows
> In the white slack lime fields
> Covering the disassembled white bones
> The field of death
> Where men were blown to death
> For a two percent increase in silver
> And those who were maimed
> Now have steel arms and tin fingers
> And still little flags of the nations
> Waving in each land
> But when the wind blows in Flanders
> The poppies like blood stand
> And move back and forth in the fields
> And now dictators sit on each throne chair
> In the new governments.[47]

An homage to Canadian poet John McCrae's "In Flanders Fields" (1915), this untitled poem participates in an ingrained tradition—from Claude McKay's sonnet "If We Must Die" (1919) to T. S. Eliot's *The Waste Land* (1922) to Willa Cather's *One of Ours* (1922)—of critiquing the First World War and its legacies. But it also treats battlefields such as Flanders (most likely the Ypres Salient) as a wounded body. "Disassembled white bones" fill the soil of "slack lime fields"; poppies gush blood in "the field of death"; and injured soldiers wear metal prosthetics to replace limbs and digits. These were events that Albright vicariously experienced

when he was a soldier in Nantes, France, from 1918 to 1919. Here he painted watercolors of war "wounds...inflicted by bullets and shrapnel, swords and spears, or plastics and chemicals."[48] As much as he, like other modernists, had the truncated lives of young men and women on his mind in the years between the two world wars, Albright also considered their flesh.

I return to this observation at this chapter's end. For now, I note that Albright would critically age this wartime theme of lost youth. In a folder organized in 1959, he included an untitled free verse sonnet dated approximately 1935 by Art Institute archivists that queries the plight of an older person:

> Years are leaving me old and worn
> Like driftwood washed on the beach
> I have been wrecked on the reefs of life
> And the years are laying me cold
> On the sands of the shore
> Driftwood on the yellow beach
> The young talk not to me
> They do not see the wetness of my eye
> To full pain have I grown
> Driftwood on the sanded beach
> My heart aches for someone to love me
> For flowers cover those I knew
> My hair is as white as the driven foam
> I am just driftwood high up the beach.[49]

Here decline ideology haunts the speaker's culturally shipwrecked self. Cast away from a youthful generation ("the young talk not to me") and rendered "cold," "worn," and socially bereft, the white-haired and unnamed persona transforms into cultural "driftwood." This mournful spectacle of an older adult is a recurring trope across Albright's unpublished literary writings, and I note that his *vers libre* poem—sentimental in its recognition of temporal loss yet ironic in its recognition of isolation—is also an antirejuvenative revolt at seeing oneself "wrecked" by decline narrative. "My heart," the speaker laments, "aches for someone to love me."

This brief close reading seems fairly transparent as I read the poem's primary symbols and its epic simile. I would like to offer a chancier interpretation that gets

us closer to the modernism supporting Albright's Chicago-based portraits. If the poem dates from the mid-1930s, then Albright would have been approximately thirty-eight when he drafted it. If we assume this poem's persona to be a first-person "I" rather than an anonymous speaker—a biggish *if* given its lack of gender pronouns—then Albright *prematurely* ages himself from early middle age into a white-haired older white man who has disregarded rejuvenation imperatives. Note that the speaker's persona has no identifiable age, and it is unclear exactly how many "years" have been "leaving me old and worn." Written in his late thirties, these lines toy with the fear of *aging too fast*—itself an ideological underpinning of the rejuvenation industry. If so, Albright poetically realizes in the mid-1930s what Gullette in 2004 calls an "unconscious belief" now ingrained in twenty-first-century ageism: "that decline is as inevitable as disease and has an early onset."[50]

One of Albright's paintings, *Into the World There Came a Soul Called Ida* (1929-1930) also performs such "early onset" aging (figure 3.3). Featured in *Art of Today, Chicago 1933* and formally akin to *Woman* and *Flesh*, *Ida* showcases its subject Ida Rogers sitting in what may be a darkened boudoir as she holds a mirror in her right hand and a powder puff in her left. The Art Institute's descriptive label for this painting is typical of Albright's contemporary reception and symptomatic of late modern decline narratives: "the model—a pretty young woman named Ida Rogers—studies her ravaged appearance in a hand mirror, holding a powder puff to her chest as if to conceal her aging body.... This work is a powerful reminder that the passage of time can be relentless and unforgiving."[51]

I am not as sure. I wonder if it is "the passage of time" that is especially vicious or the cosmetic industry's "unforgiving" quest to profit mightily from claims to decelerate chrono-biological aging. Like his short modernist poem, Albright does not hide the effects of aging. Nor does the painting's rouged subject appear to use face powder to cover over her wrinkles. Albright, in fact, expedited the aging of this "pretty young woman" when he composed her portrait and anticipated a negative reception:

> I call that painting *Into the World There Came a Soul Called Ida*. I thought people might say: she's ugly and is a prostitute and all that stuff. She is twenty years old, married, and a very decent, nice girl. Human nature—especially when looking at art work—is such that the layman who doesn't know much about art will look and if the face isn't painted like a beautiful, polished smooth piece of pottery, they won't like it; they'll think it's bad.[52]

Ivan Albright's Anti-Antiaging Treatments 93

3.3 Ivan Albright, *Into the World There Came a Soul Called Ida*, 1929-1930. Oil on canvas, 56¼ × 47 in. (142.9 × 119.2 cm). Art Institute of Chicago, gift of Ivan Albright. Photograph by The Art Institute of Chicago/Art Resource, New York.

As much as his poetry might envision Albright in his later thirties to be an "old man," so too does his modernism take a rather young adult and prematurely age her skin well beyond representations of womanhood featured in modern U.S. cultures of youthfulness. Anti-Athertonian, the painting ironizes stereotypical evidence of having aged badly—notice Rogers's cellulite and varicose veins on her

lower right leg as well as their bruised coloration—as it muddles distinctions between flapper and flapperdame. Rather than realistically depicting a female who has lived for two decades, *Ida* speeds up her aging. Flouting standard conventions of femininity as Ida Rogers sees this incredible self in her handheld mirror, what may appear to be figurative realism is instead an outlandish visualization of a later-in-life twenty-year-old.

Given these twists in age identification that Albright paints on Rogers's flesh, we should approach *Ida* not only as Chicago-based modernism, but as a keystroke of another "alternate modernist trajectory" known as *magic realism*.[53] A term often attributed to MoMA's first director, Alfred H. Barr Jr., from *Painting and Sculpture in the Museum of Modern Art* (1942), the phrase refers to another vanguard largely overlooked by new modernist studies. Popularizing the genre in the United States with a MoMA exhibition, *Americans 1943: Realists and Magic Realists*, Barr originally defined *magic realism* as "a term sometimes applied to the work of painters who by means of an exact realistic technique try to make plausible and convincing their improbable, dreamlike or fantastic visions."[54] As with Chicago's modernists, the exhibition's catalogue, *American Realists and Magic Realists*, noted that "this trend has appeared not as a concerted movement" and included works by Cadmus, Z. Vanessa Helder, Audrey Buller, Edward Hopper, and Albright, whose *Woman* and *Ida* were displayed as exemplars of magic realist technique.[55] Identified as one of the many "young contemporary American artists" by a press release for this exhibition, Albright was also spotlighted for his "super-realism" that "shocks as many as it fascinates."[56] The accompanying catalogue then again singled out Albright for his tendency "to convince us that extraordinary things are possible simply by painting them as if they existed" given his "deliberate mortification of the flesh."[57] Later critics would expand magic realism's definition, finding that the genre's practitioners created "representational images that are rendered mysterious, disturbing, or out of the ordinary through unusual juxtapositions of common, naturalistically represented objects."[58] Originally one of its more identifiable adherents, Albright never ceased working within this modernist style.

With this elaborated definition in hand, we can refine our reading of *Ida* to see that Albright used magic realist technique to prematurely age Rogers, to turn a realistic portrayal of a twenty-year-old woman into a fanciful paean to the perpetually aging body. Working against the grain of antiaging cultures, *Ida*

offers a "deliberately aged" woman made unusually senescent thanks to the fantastic possibilities inherent in vanguard formulas.[59] With this painting Albright purposefully confuses how viewers might properly identify Rogers on the chronological spectrum, and perhaps this is why some dismiss his portraits as grotesque. Not because he uglifies a young woman, mind you, but because he turns aging into nothing but an unidentifiable number. *Ida*, at core, blurs a cultural divide between looking younger and looking older. Incorporating the shock of the new with his shock of the I-can't-tell-how-old, Albright's artwork melds the youthful with the senescent to the aversion of many museum-goers. One mode of magic realism—the belief that aging can be undone with deep pore cleanser—is matched by another as *Ida*'s experimental skin treatments counter other experimental skin treatments.

All this said, a few questions nag at me after I zoomed in and out of the countless smartphone photographs that I took of this painting while archiving at the Art Institute in the winter of 2016. Was Ida Rogers ever denigrated as a *face stretcher*, 1920s slang for "an old woman who attempts to look young?"[60] Was her body put in the visual service of an ageist misogyny? Or did she and others find this portrait of herself inspiring? Or beautiful? I do, as gray hairs take over my own head and wrinkles wrap me loose. To me, her youthful body-in-decline is not wan, lifeless, or adrift. Exaggerating a twenty-year-old's aging by speeding up epidermal changes rather than advancing norms that would slow them down, Albright showcases maturation's attractiveness amid modern "age apprehensiveness."[61] He features Rogers as an eroticized being holding up a mirror not only to herself but to a culture that ridicules sexualized older women—an innovative affront to the modern culture of rejuvenation. My hope is that Rogers saw herself as stunning as I did.

Intriguingly, Albright would apply these experimental magic realist techniques to his own person in a painting from 1935 titled *Self-Portrait*. Also featured in the *Americans 1943* exhibition and completed the same year that he wrote his poem about aging-as-cultural driftwood, the painting shows Albright, like Rogers, to be impossibly older than one might be visually trained to think. Thick wrinkles cover this Father Time's forehead and the crease between his eyebrows. Hyperbolic pleats underneath his eyes are as large as his lower eyelids. Most of this undulation is implausible, and *Self-Portrait* fits neatly into magic realism's conventions. Employing techniques of aesthetic wrinkling featured in *Ida* to his own body—and mirroring, in turn, his poems on advancing age—Albright takes

a straightforward self-portrait and realizes a new imaginary of anti-antiaging. He himself undertakes an anti-Steinach treatment.

By now I hope we better comprehend the overarching aims of Albright's "deliberate mortification of the flesh" when contextualized within the heterogeneous aesthetics of modernist American visual cultures. Or that we better grasp a toss-off line such as one featured in a *New York Times* obituary of Albright: "His 1928 'Woman,' in the Museum of Modern Art, is a garishly lit portrait of a woman who could be 40 or 70 years old."[62] I also hope we see his art as a highpoint in American modernism rather than the pictorial equivalent of an old folks Halloween mask. Working with themes of antiaging and fears over premature aging, Albright's works invoke cosmetics and lost youth only to reimagine them with inconceivably aged models, himself included. This is the core of his impressive experimentations with geromodernity's fixation over youthfulness. He was by no means the only modernist painter to exalt aging bodies (Florine Stettheimer's magisterial *Portrait of My Mother* [1925]—Rosetta Stettheimer, age eighty-four—stands as a parallel modernist treatment of aging white womanhood, as does *Family Portrait, II* [1933]). But Albright was one of the first twentieth-century painters to use magic realism to thwart the unfeasible rejuvenation of senescence. As early as the 1920s, and, the next section argues, as late as 1977, he utilized modernist techniques to turn himself and others into something utterly fantastic amid ever-intensifying gerontophobia.

III

The previous two sections established the historical context as well as the modernist idioms enabling what art critic Barbara Rose termed Albright's "bizarre style" in 1969.[63] Though I disagree with her assessment, I have argued that his early-onset mature style was as much a maturing style misunderstood by critics and spectators to this day. The next two sections extend this insight as Albright continued his experimental techniques with magically unreal flesh during and after World War II. Across these decades the painter did not waver from his modernist skinscapes as abstract expressionism, pop art, minimalism, and photorealism emerged as vital movements. Albright knew of these developments, but they appear to have had little, if any, sway on him.[64] Long after the spotlight on American magic realism faded, however, his core aesthetic and major themes

continued apace as the artist completed anti-antiaging pieces in the 1970s and 1980s. Having achieved brief national notice in *Life* magazine with his *Picture of Dorian Gray* (1943–1944), commissioned for the Hollywood studio film of 1945, Albright diligently worked on other age-themed paintings, such as *Portrait of Mary Block* (1955–1957), *The Vermonter (If Life Were Life There Would Be No Death)* (1966–1977), and numerous self-portraits completed up to his death in 1983. He finished many of these works in Vermont, where he moved with his wife Josephine Medill Patterson Reeve to Woodstock in 1965. Here his magic realism met up with a rural modernism that countered not solely the decline narrative of individual flesh but that of an aging regional population as well.

Take, for instance, *The Vermonter (If Life Were Life There Would Be No Death)* (figure 3.4). Finished two years after the end of the Vietnam War, the painting was completed by Albright at age eighty after laboring over it for more than a decade. Now housed at the Hood Museum of Art, Dartmouth College, *The Vermonter* resumes his earlier anti-antiaging stylistics. A sitting portrait of Kenneth Harper Atwood, this subject has been identified as "a seventy-six-year-old member of the Vermont House of Representatives and retired maple farmer."[65] Like others that preceded it, this painting, too, magically realizes Atwood's flesh beyond verisimilitude and thrusts its model into a hard-to-date old age imaginary. Much as his earlier portraits placed youthful models into chronological indiscernibility, *The Vermonter* continues this aesthetic by disorienting the cultural markers of advanced old age.

A comparison between Atwood's flesh in *The Vermonter*'s initial study (1965–1966) (figure 3.5) with that in the finalized painting supports this last claim. The chalk study features Atwood's hands reasonably wrinkled over a lifetime. *The Vermonter* is, by contrast, calculatingly unrealistic: outsized dorsal surface aged well beyond any conventional standard. Albright paints deep ridges that appear almost like fleshy gullies, valleys of skinscape so pronounced that an attentive viewer could count them one by one along each finger. While a mundane feature of any older body, wrinkled hands become fantastically experimental via *The Vermonter*'s modernist form. Similar observations could be made for Atwood's face, neck, and the glimpse of his upper chest offered by an unbuttoned shirt.

Recorded in his sketchbook, Albright's thoughts on this portrait provide more insight into the painting's extended execution. In one faintly stream-of-consciousness entry titled "Notes on Vermonter" and dated January 28, 1968, he writes:

3.4 Ivan Albright, *The Vermonter (If Life Were Life There Would Be No Death)*, 1966–77. Oil on masonite, 34¼ × 26½ in. (87 × 67.3 cm). Hood Museum of Art, Dartmouth College, Hanover, N.H., gift of Josephine Patterson Albright, Class of 1978HW.

3.5 Ivan Albright, *Study for "The Vermonter,"* 1965–1966. Charcoal, pastel, and oil on canvas, 35 x 26⅞ in. (88.9 x 68.3 cm). Art Institute of Chicago, gift of Ivan Albright. Photograph by The Art Institute of Chicago/Art Resource, New York.

> Get translucence of flesh—the rhythm of skin creeping up and down back of hand—flesh—make flesh more like flesh than ever has been made before—make flesh—flesh—yellowish glow translucent and white sparkle on skin—as ~~weather~~ temperature changes the flesh skin tightens or loosens and becomes flabby. [indecipherable] stomach looks fleshy—terribly close accuracy—makes flesh—color takes care of self—make flesh close—close and closer—until you feel it.[66]

Albright's claims for "accuracy" alongside "white sparkle" seem contradictory, but they are in line with the aesthetic logic of his magic realism. On the one hand, his commitment to "terribly close accuracy" regarding human skin recalls precisionism, a vanguard movement known for clearly delineated drawings and advocated by painters such as Demuth. On the other hand, Albright's account of flesh reads like Stein-speak: "make flesh—flesh." Repeated nine times, the word *flesh* here becomes a loose but not completely empty signifier with regard to identifying chronological age. *The Vermonter*'s aging flesh is, in fact, simultaneously tight, "flabby," and "fleshy"—a not inaccurate description of the model's unrealistically modernist skin. While the painting grants "close and closer" precision with its meticulous detailing of fleshy flesh, Albright's experimental technique nevertheless distorts, skews, and disorients aging even as he aims, like many magic realists, for "ultrasharp focus."[67] Decades after *Woman*, *Flesh*, and *Ida*, he continues to refine his aesthetic innovations by making and remaking "flesh more like flesh than ever has been made before."

In keeping with his investments in magic realism, Albright's overarching technique in *The Vermonter* might be said to invoke a terribly close imprecisionism. His portrait of Atwood is fleshy, but exact chronological dating of his subject is fuzzy. Is the painted model in his sixties, his seventies, or his one hundred seventies? *The Vermonter* mystifies late modern attempts to distinguish advanced aging and defamiliarizes lifespan categories that geriatricians and gerontologists standardized in the 1970s with descriptors such as "young-old" and "old-old." In 1974 psychologist Bernice Neugarten coined the first two terms whereby "the young-old come from the group composed of those who are approximately 55 to 75—as distinguished from the old-old, who are 75 and over."[68] I have no evidence that Albright was aware of this jargon, but *The Vermonter* introduces chronological ambiguity via its magical "fleshy" flesh as well as its "yellowish glow." Its skinscape thus confirms another observation Albright made about his late-late magic realism on August 12, 1980: "Make more and more mystical picture / What is reality—isn't the unreal more real."[69]

While *The Vermonter*, like *Woman*, *Flesh*, and *Ida*, is a portrait in step with aesthetics that Albright first developed in the 1920s, this painting also begs a question: What if it focuses not only on a fantastic aging of a person but also on the fantastic aging of a population? Its title points us to New England, and I wonder if it ironically invokes what Maria Farland terms "rural decline"—and not just Atwood at age seventy-six but Albright at age eighty.[70] By *rural decline*, Farland and other scholars attentive to cultural and aesthetic representations of nonmetropolitan environments reference a common social fantasy that rural locales are less socioeconomically or artistically vibrant than their urban counterparts. At its core, the term is also an economic decline narrative for sparingly populated geographies, but it can confirm an ageism for those who inhabit these spaces. This trope was a long-standing one, having emerged in the nineteenth century and sustained itself thereafter. "The twentieth century," notes one social historian, "has seen an intensification of such efforts to preserve (and market to tourists) the 'oldness' of New England" even as the region dealt with the long-term aftermath of its "depopulation problem."[71] Given its wealth, Woodstock, Vermont, does not perfectly fit this bill, but its residential mean does skew older.

Within and beyond New England, regional modernist painters in the 1920s and 1930s confirmed and tweaked these ruralized decline narratives. Identifying O'Keeffe, Hopper, Grant Wood, Thomas Hart Benton, Marsden Hartley, and Demuth as rural modernists, Amanda C. Burdan finds that "a number of [their] peopled works specifically denote the passing of the 'old' way of life in the modern world."[72] She then spotlights John Steuart Curry's *The Old Folks (Mother and Father)* (1929) for "contributing to the idea of the slowly fading rural type."[73] Though a discussion of modern cultural aging does not come into sharp focus here, it is clear that regional and rural modernists introduced, confirmed, and sometimes experimented with the concept of an aging population in decline. Albright goes unmentioned in this recent account of rural modernism, but he was no stranger to these regional idioms when he worked in the U.S. Midwest.

It makes sense, then, that he would apply his ongoing attempts to query cultures of youthfulness to a region where he resided for a chunk of his life. Undercutting norms of age identification, *The Vermonter* also enables Albright as a small-town Vermonter to short-circuit gerontophobic decline narratives about a supposedly fading population that he inhabited (rural New England) and a supposedly fading population with which he was associated (those advancing in

age). "When asked in 1966... whether it is true that artists also paint themselves when they paint their sitters," Cozzolino recalls, "Albright admitted that, for this project, he had indeed selected a model 'who has lived and who feels as tired as I do.'"[74] Albright worked on the painting for the entirety of his seventies, and *The Vermonter* refers to Albright-the-transplanted-New Englander as much as it as does to Atwood.

A *Yankee* article in 1971 by modernist art collector John Davies Stamm confirms intimate associations between these two men. Focusing on *The Vermonter*'s composition and reproducing photographs of Albright in his Woodstock studio with his incomplete portrait, Stamm presents Albright as an ensconced modern regionalist who disorients aesthetic categorizations: "Call him a magic Surrealist, an all-American realist, or what you will, but no label really fits. He is an incomparable contemporary artist, painting in his inimitable way in New England."[75] The essay also visually captures a tripartite arrangement that underscores affinities between Atwood and Albright. One featured photograph shows Albright sitting in the middle of the picture with a dummy model of Atwood behind him and an unfinished *Vermonter* to his left (figure 3.6). Given similarities between the color of their clothing (both light blue), posture, and size, the dummy looks to me as much like Albright as it does Atwood.

Perhaps his self-professed cross-identification with this New Englander was not simply a fatigue born out of growing older, but a weariness with having to spend his later life within regeneration cultures depreciating those who survived long enough. It is hard for me to make a case that Albright grew tired of his experimentalism. His drawn-out acts of composing, sketching, theorizing, and completing *The Vermonter* undermine themes of rural-based decline narratives that encompass not only aging New Englanders such as Atwood but also a Green Mountain State modernist such as himself. "Though Ivan Albright is 73 today," Stamm assessed, "he still has the bouncy step of a 16-year-old and the ageless magic of the master painter."[76] In a callback to his *Self-Portrait* of 1935, the extended act of painting *The Vermonter* magically realizes Albright in his seventies and eighties. Like Ida Rogers aging beyond her years and like Atwood, he too is potentially several ages at once or no age at all: in Stamm's account, a teenager, a septuagenarian, even "ageless" as his craft. With both this painting and the eleven-year-long act of its execution, Albright merges rural modernism with fantastic self-embodiment to become a living exemplar of magic regionalism.

The artist in his studio in Woodstock, Vermont. On the right is his painting of Kenneth Atwood entitled simply, "The Vermonter." The dummy behind Mr. Albright serves as a stand-in for Mr. Atwood and as a full-time reference for details of folds and color. The unconventional single source of light is from a small trap door in the ceiling, located directly above his easel. Everything beneath this sharp column of light becomes etched in Albrightesque detail.

3.6 Unknown artist, photograph of Ivan Albright in his Woodstock, Vermont, studio, ca. 1971. Reproduced in *Yankee* magazine article, "The Shadows of Ivan Albright," 105.

Having outlived the historical apogee of American modernism, Albright's later artistic life thus broadened his Chicagoland magic realism to incorporate a vanguard version of what one art historian refers to as "Yankee modernism."[77] Working not in the vicinity of "the youngest of global metropolises" but amid the supposedly fading populations of rural Vermont, he did not turn to rejuvenation therapies or antiaging nostrums to achieve that "bouncy step." He instead embraced his creative life as an older artist and confidently worked in his out-of-date medium. For close to two decades in New England, Albright did not reinvent himself, but he did not stop his modernism. No one-trick pony, he sustained his criticism of the cultural aging industry by making older individuals, groups, regions, and even his person into experimental novelties of anti-antiaging art. "To make new things— / Time in this life is running short," he reminded himself several years before his death in 1983.[78] The art of growing older and older, he realized again and again, could sometimes be fantastic.

IV

Hospitalized at Mt. Ascutney Hospital and Health Center in 1983 after a major stroke, Albright composed several self-portraits fifty-five years after *Woman* and forty-eight years following his *Self-Portrait* of 1935. Like his earlier works, these pieces collectively counter rejuvenescence by insisting on the epidermal effects of a lengthy life rather than hiding aging's effects. They also record his dying. "The late self-portraits," observes one critic, "provided an occasion for the aged artist to give shape to his own flesh."[79] "The series of self-portraits done during the last three years of his life," finds another, "uncompromisingly portray his own disintegration."[80] Both are correct. A self-portrait he signed and dated "Ivan Albright 1983 Ascutney Hospital," for example, displays his stroke's aftereffects with left facial drooping. Without question, this piece again confirms Albright's as an "accurate and pitiless observer of his own human flesh."[81]

One also has to wonder if these sketches of late-life disability made in a hospital full of wounded patients recalled another time when he made sketches in a hospital full of wounded patients—an infirmary in Nantes, France, where he produced close to four hundred watercolor drawings of lacerated soldier flesh in several sketchbooks. The Hanna Holborn Gray Special Collections Research Center at University of Chicago archives two of these sketchbooks, with another

held at the Art Institute. The latter provided a digitized version for museumgoers to scroll through at its *Flesh* exhibition in 2018, mentioned in this chapter's introduction. With close accuracy, this artwork depicts war wounds to human legs, feet, ankles, thighs, livers, backs, stomachs, hips, throats, gluteal muscles, chests, ears, noses, and skulls.

There are several ways to read these drawings: as juvenilia; as visual record of total war; as illustration of the impossibility of regaining lost youth. I mean no irony by my last interpretation. Technically, tragically, several of Albright's sketched corpora belonged to young men who did not rejuvenate. Their deceased flesh made them members of an age-group who would not participate in 1920s youth culture, or what Hemingway, allegedly via Stein, termed the Lost Generation. Albright's watercolors literalize Stein's comment about the dislocations brought on by modern warfare, and every critic notes their impact on his aesthetic. "As an impressionable twenty-year-old, Albright had served as a medical illustrator in an army hospital in France, where his job was to record in meticulous and unemotional detail the travails of the body in pain. He never managed to shake this experience, and it seems to have informed his outlook."[82] Likewise: "the war dead haunted Ivan Albright into the 1930s."[83] These watercolors are thus magic realist in their appalling demonstration that "extraordinary things are possible," as Lincoln Kirstein stated in his introduction to the *Americans 1943* exhibition—here, the obscene deaths of teenagers in the trenches.

Given his sustained engagement with thinking athwart youthfulness from war-torn Western Europe to big-city Chicago to small-town Vermont, I believe that the modernism he undertook at that infirmary haunted him in 1983, too. Affiliation exists between his self-portraits facing life's end and his war portraits at the start of his adulthood. The former is the apex of an aesthetic impulse expedited by the Great War: "Here we find more than a germ of his later preoccupation with the merciless analysis of human flesh."[84] Chronologically speaking, his self-portraits from the 1980s are also a tribute to another lost generation: culturally discarded elders like his vulnerable self. Albright's dying self-portraits, I mean to say, invoke countless other moderns who were in their twenties and thirties during the First World War. Unlike the millions of youth who would never grow young-old, old-old, or oldest-old in gerontology-speak, these individuals were not casualties of a pointless war. They acquired "lifetime that turns golden hair to a white," as one of Albright's archived poems lyrically phrases it.[85] Nevertheless, they were often casualties of a pointless age ideology. Many found

themselves culturally abandoned by the not-so-hidden injuries of ageism and would die forgotten in a much later era, one where "there seems to be no place today where a wrinkled and mottled appearance enhances social appreciation and acceptance."[86]

These individuals perished not in No Man's Land but were, Albright himself experienced, "wrecked on the reefs of life." To this day his experimental paintings across the long twentieth century plead with us to reckon with ageist depreciation across gender. "A culture needs to see people of all ages on the stage of the world," writes Gullette, "rather than the increasing *disappearance of older default bodies* that results from the cult of youth."[87] With skin-imperfecting brushstrokes from 1918 to 1983, Albright obliged.

CHAPTER 4

Tillie Olsen and the Old-Old Left

Unlike Ivan Albright, Tillie Lerner Olsen was showered with memorials after her death on January 1, 2007. In their February 2007 newsletter, the Gray Panthers of San Francisco, for one, honored the proletarian-feminist with a resounding "Hail and Farewell." This Bay Area group was but one arm of a national movement launched in 1970 to later protest the carceral state and climate change, among other causes. As their name signifies, Gray Panthers took initial inspiration from radical political organizations such as the Black Panther Party, founded in 1966, in their fight against ageism.[1] One of several branches located across the United States, the West Coast contingent felt Olsen one of their own. Reproducing three photographs of Olsen "in the 1940s, the 1970s, and in August 2005," an *SF Gray Panthers Newsletter* praised her as an "author, activist, and role model par excellence for working women." It then reproduced a lengthy interview that she granted the *Progressive* in 1999, in which Olsen confessed that "I haven't published a lot of anything. But it does go on, it's taught, anthologized." After mentioning her "writing about a revolutionary generation," she remarked that "there aren't many of my generation left who did make history. I'm going to be eighty-eight."[2]

Of course the organization venerated her. On July 8, 2001, she had given a public performance at a LaborFest poetry reading sponsored by the Gray Panthers and held at City Lights Bookstore in San Francisco's North Beach neighborhood.[3] The historical convergences at work on that day likely felt uncanny to the activist-author. LaborFest, its website informs visitors, "was established in 1994 to institutionalize the history and culture of working people in an annual labor cultural, film and arts festival." The idea for the festival, the site goes on to note, "begins every July 5th, which is the anniversary of the 1934 'Bloody

Thursday' event" when two San Francisco workers were murdered for "supporting the longshoremen and maritime workers strike," which "brought about the San Francisco General Strike" that same summer.[4] One of many protestors jailed during the strike that sparked LaborFest—and also one of the writers who composed an experimental account of the 1934 protests for the modernist-inflected journal *Partisan Review*—was Olsen. The through line that made possible her participation at a Gray Panthers LaborFest event in 2001 reaches back not only to new social movements of the 1960s and 1970s, but to events of the 1930s that she witnessed and transformed into modernist prose. Olsen, we could say, participated in a LaborFest from the middle of the Great Depression to the start of the third millennium, from around age twenty-one to around age eighty-nine.

This being the case, her creative affinities with the Gray Panthers point to a confluence of labor, poetics, aging, and modernism that infuse her mid- to late-life writings. We have yet to fully canvass these links, though we now have extensive scholarship on her proletarian-feminist modernism as well as her literary gerontology. In terms of the latter, there is the Olsen "best known for her book *Tell Me a Riddle*," a collection of four short stories from 1961 made famous for its titular tale about Eva, a Russian American revolutionary dying from cancer in Southern California.[5] Ostensibly focused on the fraught marriage of two working-class émigrés, "Tell Me a Riddle" derides the age ideologies common in post–World War II biomedical institutions. "What did the *doctor* say?," asks one of the protagonist's concerned daughters. Ventriloquizing the male medical expert, her sibling dryly responds: "Old age is sickness only if one makes it so. Geriatrics, Inc."[6] As suggested in her *Progressive* interview, collections such as *Night Light: Stories of Aging* (1986), *The Norton Anthology of Literature by Women* (1985), and *Literature and Aging: An Anthology* (1992) had reprinted this story as a model of antidecline narrative.

In terms of her proletarian-feminist modernism, we likewise have the Olsen who "lent a heartfelt voice to the struggles of women and working-class people" with *Yonnondio: From the Thirties* (1974).[7] For those unfamiliar with this experimental novel's tortuous path to publication, the standard story goes like this: Tillie Lerner first published portions of what she later titled *Yonnondio* as a short story, "The Iron Throat" (1934), in *Partisan Review*. *Proletarian Literature in the United States: An Anthology* republished it a year later. She then paused this work-in-progress following the birth of the first of her three children with her husband Jack Olsen. More than three and a half decades later, the couple discovered

partial draft fragments of its incomplete narrative centering on the working-class lives of the Holbrook family in the American West. In the fall of 1972 and the early winter of 1973, Olsen pieced together these fragments, stating at this time that she changed nothing in the original manuscripts. Published to wide acclaim, the seemingly unfinished novel had no proper ending. The New York Public Library (NYPL)'s Henry W. and Albert A. Berg Collection of English and American Literature as well as the Department of Special Collections at Stanford University Libraries now house *Yonnondio*'s draft fragments, replete with extensive handwritten marginalia.

With little exaggeration, we can say that *Yonnondio* secured Olsen's place in American modernism as much as "Tell Me a Riddle" secured her a place in modern literary gerontology. She was, in fact, deeply "influenced by T. S. Eliot's *The Waste Land*," and she had "put a photo of Virginia Woolf on her desk, imitated Woolf's stream-of-consciousness writing, copied passages from Katherine Mansfield's journal into her own, and parodied Gertrude Stein" in the years before she started that novel's drafts.[8] Scholars such as Seth Moglen, Joseph Entin, Alan Wald, and Jessica Berman have embraced these associations to cast *Yonnondio* as a highpoint of proletarian modernism.[9] Such praise matches that of feminist scholars of revolutionary working-class literature Paula Rabinowitz, Deborah Rosenfelt, and Constance Coiner, who mined the novel for its keen observations regarding reproduction and class.[10] Regardless of their interpretive emphases, each would agree with Susan Edmunds that *Yonnondio* holds an "honored place in contemporary canons of radical modernism."[11]

While these influential tracks assessing Olsen's major published works have assured her high standing within various twentieth-century literary traditions, Olsen's subsequent carryovers of feminist, antiageist, and working-class concerns via modernist technique have gone largely unremarked. This inattention begs correction, especially since tried-and-true modernist elements such as temporal disjunction, stream-of-consciousness, and fragmentation inform "Tell Me a Riddle" much as they do *Yonnondio*, and since many of *Yonnondio*'s typescript fragments reveal Olsen ruminating on an aging self much like the narrator of "Tell Me a Riddle." Indeed, her writings during and after *Yonnondio*'s compilation in the early 1970s deepened her earlier investments in what "Tell Me a Riddle" pointedly terms "Geriatrics, Inc." To better fill in this gap in Olsen scholarship and think further about the value of unfinished work across the lifespan, this chapter explores how she applied experimental aesthetic techniques first developed

in her 1930s writings to ruminations on the plight of one aging female laborer in the 1970s and the decades thereafter: herself.

In so doing, I take my cue from Michael Denning, who reminds us that "the figures of the Old Left continued to work through the 1960s and 1970s, and many of the most interesting works of the cultural front are products of the second half of the century." Cataloguing fictions such as E. L. Doctorow's *Ragtime* (1975), Denning's exemplary case studies also include Olsen's works, which he sees as "embodiments of a Popular Front structure of feeling."[12] Extending his insight, this chapter focuses on Olsen's writings from the 1970s to the 2000s, or what she variously termed her "UNDONES UNFINISHEDS" and her "unfinisheds of the unfinished."[13] While she sometimes confirmed her writer's block when asked about her relatively slim bibliography ("I haven't published a lot of anything"), she nevertheless wrote well into the twenty-first century. Special Collections of Stanford Libraries houses scores of her unpublished poems, numerous lectures, experimental life reviews, and multiple revisions to the 1974 edition of *Yonnondio*. Olsen named some of these pieces her "re-livings, rememoryings, [and] reevaluatings," and these writings attest to the emotional and physiological intricacies of her aging into a new epoch.[14]

Closely reading these documents that range from the early 1970s to 2003, I contend that during these years Olsen fostered a body of modernist working-class literature whose structures of feeling supplemented class consciousness with feminist age consciousness, or what we might call a LaborFest of experimental aging. When cited by age studies scholars, *age consciousness*, like the phrase *feminist consciousness*, often refers to "a dawning sense of oppression and a politics of action to alter that political, social, economic, or cultural position."[15] Approaching her unfinished writings as another iteration of her revolutionary modernism, I sense that Olsen's age consciousness—while not unrelated to the "conscious aging" cited in chapter 1—radiates a politicized awareness largely absent in the artists previously addressed. Once recalling her "closeness to my eighty-sixth year," Olsen defined the felt experience of this age cognizance in Woolf-like terms, describing "the ever heightening consciousness of the significance, the meaning, of what (is) happening around her, and remembered from the past." For Olsen, we find, aging was nothing more and nothing less than a series of these modernist epiphanies bound to ongoing "relationships, activisms, [and] (besides too many recommendations) writing."[16] My chapter tracks such

revelations—her new consciousness as an old-old leftist—as this tireless laborer augurs an unfinished revolution of poetic aging tied to a prolonged modernism that we have only begun to excavate.

Before I do so, a few words about the year 2003: in her biography's final chapter, Panthea Reid notes that Olsen "was diagnosed with mid-stage Alzheimer's" in 2004.[17] Family members such as Jesse Olsen Bay as well as friendly acquaintances confirm this date.[18] Stanford's archives also hold restricted medical records on this matter inaccessible to researchers. I refrain from retroactively reading this diagnosis into Olsen's writings prior to this date, even though I would not want to foreclose this possibility given superb criticism by Rachel Adams, Marlene Goldman, Anne Basting, Amelia DeFalco, and others on dementia, Alzheimer's disease, and creative aging.[19] Adams, in particular, has done much to help us think better about links between aesthetics, Alzheimer's, female bodyminds, and what she terms "slow emergency"—a phrase that reverberates with Olsen's own observations on her slow writing that I soon discuss.[20] When I do reproduce Olsen's unpublished typescripts from 2003 and others close to it according to an agreement signed with the Frances Goldin Literary Agency, I replicate her drafts and their revisions with minimal to no standardization. Spelling errors stand, as do erratic spacings of words, phrases, and lines, as do wayward strikes of her typewriter. Best, I sense, to approach this typographic terrain as a testament to Olsen's remarkable efforts amid her late-life debility, or what Leni Marshall refers to as "conscious ageility."[21] Even better: as another instance of the Sedgwickian senile sublime we also saw at work and at play in the Barnes papers.

I

Before I outline this later unpublished modernism, I want to suggest that Olsen conceived *Yonnondio* as a product of the 1970s as much as the 1930s, as a project championing an unfinished working-class revolution that laid the groundwork for her subsequent writing dedicated to radical age consciousness. While reviewers and critics usually treat this novel as a relic of the Great Depression that its author retroactively pieced together, I find that *Yonnondio* is and is not "unmistakably the work of a young author" at the same time that it is and is not "a

classic example of the 'proletarian literature' of Tillie Olsen's youth."[22] To approach it as a salvaged literary object that speaks solely to the Great Depression overlooks that Olsen produced proletarian modernism well into the last third of the twentieth century. More generally, this understanding of Olsen's craft denies that the literary movement she facilitated and embodied was, to quote Susan Stanford Friedman, a "recurrent" modernism well documented by official archives.[23]

One reviewer, for example, characterized *Yonnondio* as "Tillie Olsen's Late, Late Novel" and wrote in 1974 that "she left it as it was written—the older writer being friendly to the young writer she once was, preserving the best of the young writer. The result is an astonishing piece of work by one not long out of her teens."[24] I again invoke Denning to worry this observation. Given his extended timeline for Popular Front aesthetics, I think that the second half of *Yonnondio*'s title is as important as the first. While critics trace the title's allusion to Walt Whitman's "*lament for the aborigines*" in his poem "Yonnondio" (1887) and approach Olsen's novel as a "tragic" work, we can press on what follows the colon—*From the Thirties*—to gain more insight into its prolonged production.[25] Given feminist claims that the novel "spoke then, and speaks now, to core issues in women's history," *Yonnondio* qualifies not as a failed but as an unfinished—as in unconcluded—revolutionary work that stems from and beyond the 1930s.[26] As such, we might ask what the novel has to say about the decades that follow the Great Depression rather than preserve it in that period's historical amber.

Remarks by Olsen included at the end of the novel's 1974 edition invite us to approach her work across the modern/postmodern divide. Dated "San Francisco, February 1973," her "A Note About This Book" tells us:

> There were usually two to fourteen versions to work from: 38 to 41 year old penciled-over scrawls and fragments to decipher and piece together. Judgment had to be exercised as to which version, revision or draft to choose or combine; decisions made whether to include or omit certain first drafts and notes; and guessing had to be done as to where several scenes belonged. In this sense—the choices and omissions, the combinings and reconstruction—the book ceased to be solely the work of that long ago writer and, in arduous partnership, became this older one's as well.[27]

Through "judgment," "decisions," "guessing," "choices," "omissions," and "combinings," *Yonnondio* became a decades-in-the-making "reconstruction" that a middle-aged

Olsen produced "in arduous partnership" with her twenty-something self. Contrary to the main vein of its reception history but with no sleight of interpretive hand, we could say that she composed its modernism in 1972 and 1973 as much as 1935 or 1932.

One Olsen scholar, Christopher P. Wilson, agrees with this last insight. In his meticulous review of *Yonnondio*'s fragments held at NYPL, Wilson finds that these documents show "how great a role editorial choice and memory, rather than sheer transcription of a 1930s artifact, actually had in Olsen's own recovery of *Yonnondio*." He writes that "Olsen may well have restored words from drafts from *earlier* in the thirties"; that "I have found no evidence that *Yonnondio* was the title Olsen chose in the thirties"; and that "Lerner/Olsen seems not to want to leave the reader with that sense of completion, satisfaction, *release* associated with the cathartic moment or, indeed, with the completed rather than fragmentary form."[28] To his archival findings I add that *Yonnondio*'s 1974 edition also revises the short story "The Iron Throat," reproduced in *Proletarian Literature in the United States*. This edition does not reprint the short story verbatim but alters word choice and punctuation.

Complementary fragments of *Yonnondio* housed at Stanford likewise support Wilson. Amid four folders that staff have organized as "*Yonnondio*, makings," Olsen claims and then strikes out "no re-writing, new writing" and that "the rest is fragments, shards, unfinisheds.—that lay for nearly forty years with the pages you have just read."[29] Yet this same university archive records scrupulous revisions to what would become the 1974 version of *Yonnondio*: extensive reminders to Olsen's publishers that "corrections essential to be made, are prefaced with an asterisk*"; stream-of-consciousness notes to self that document that she "reversed placed back a deletion used a crossed out line phrase or alternate scenes or drafts" that amounts to "putting back what that 23 year old crossed out."[30] Remarkably, one unpublished fragment also finds Olsen pivoting on her public claim that there is "no re-writing" when she writes that "I have changed nothing, [indecipherable] but in a sense I have cheated. I have had to use my writers judgment and skill of these last years to select which words, which sentences, which version; to do the weaving and cutting in the last chapters."[31]

Amplified by archival holdings at Stanford, Wilson's observation that "the province of the Olsen of the 1970s is equally potent" as that of the 1930s proves useful for my argument regarding the text's persistent revolutionary politics.[32] The novel's working-class modernism ("the nameless FrankLloydWrights of the

proletariat have wrought their wondrous futuristic structures of flat battered tin cans") may tell us as much about dreary socioeconomic conditions of the early 1970s as it does dismal socioeconomic conditions of the 1930s or, for that matter, of the 1920s.[33] This historical period was, after all, a half-decade of embryonic neoliberalism that saw the global crisis of the OPEC oil embargo in 1973 and resultant swings in stagflation that stymied the U.S. economy. Trade presses released dire title after dire title, including *The End of Prosperity*, *No Growth Economy*, *The Disappointing Economy*, and *U.S. Capitalism in Crisis*. For its part, the Congressional Quarterly produced a thick pamphlet on *Inflation and Unemployment* that noted "by the end of [1974], the recession had hit hard. Unemployment jumped to 6.5 percent in November. Disposable income for the year actually fell."[34]

More often than not, these texts invited comparisons between the early 1970s and the Great Depression. "By the end of the 1960s," wrote Marxist economists Harry Magdoff and Paul M. Sweezy, "with the United States being forced by Vietnamese resistance and rising anti-war feeling at home to reduce its military commitment in Southeast Asia, the underlying expansionary forces were clearly weakening, and the long upswing was showing signs of coming to its natural end in a period of stagnation similar to that of the 1930s."[35] While this recession was not the kind of classically defined depression earlier witnessed by American publics, conservative and progressive analysts alike drew parallels between the two, and the early 1970s economic downturn joined its predecessor in having wide-ranging effects on working-class Americans. Stated in *Yonnondio*'s terms: the hardships that families such as the Holbrooks faced in the 1920s weren't ever finished, as Olsen wrote in the 1930s and then again in the 1970s. Their suffering and pain were instead unconcluded, a socioeconomic product of the contemporary era as much as an artifact of the Great Depression.

Olsen's novel registers this cross-generational class consciousness, and we should revise the critical commonplace that her "politics and anger are a part of a particular decade."[36] To historically cordon off the novel diminishes the scope and the scale of her aesthetic interventions, whether in *Yonnondio* or in adjacent writings that I later address. We are instead better off positing that her "unfinished project"—a spectacular work of working-class modernity forging a political bridge across the twentieth century—was neither silenced nor lost.[37] In his essay "*History and Class Consciousness* as an 'Unfinished Project'" (1988), Fredric Jameson theorizes this concept of the unfinished project at

length. He begins his piece with a generous evaluation of Georg Lukács's *History and Class Consciousness* (1923), yet near the end of his essay the focus shifts. Moving from an extended overview of Lukács in the 1920s to second-wave feminist activism, he writes: "What emerges from the feminist project, and from the speculations it inspires, is an 'unfinished project': namely the differentiation of all those situations which I have neutrally tried to characterize as 'constraint,' which are often monolithically subsumed under single-shot political concepts such as 'domination' or 'power'; economic concepts such as 'exploitation'; social concepts such as 'oppression'; or philosophical concepts such as 'alienation.'"[38]

Linking Lukács in 1923 to feminist theories of exploitation, domination, and power under later twentieth-century capitalism, Jameson then concludes with a paradox: some finalized projects—which for him also means some books—have yet to be completed. *History and Class Consciousness*, he writes, "is alive in the past and a perpetually fascinating object of historical meditation." Following this claim, he revises himself: "I think that it would be better, however, to consider that, like the *Manifesto*, it has yet to be written, it lies ahead of us in historical time."[39] Rather than seeing Marxist or feminist political projects from the 1920s, the 1930s, or the 1970s as finished events with definitive conclusions, Jameson champions—rather than mourns—the status of the unfinished cultural text as a productive space that reaches for an end not yet present.

Considering the decades-long self-collaboration she announces in "A Note About This Book," Olsen makes a Jamesonian move. Her novel waits out late capitalism in a unique form of what she elsewhere theorized as slow writing. In a transcript of a talk she delivered at Emerson College the same year she published *Yonnondio*, Olsen offered the following self-assessment, some of which she included under the subheading "On Writing Slowly":

> I'm a slow writer. I was much faster when I was writing *Yonnondio* and was young and in my early twenties, but I lost whatever ardor, sureness, that confidence of knowing, having to say that maybe has to do with being young.... But now the slowness has to do with too much being in my head, with all those years in which I wasn't writing, but was living, and living not only a very fully as a human being, but also living a life. And it was a working life.... I've written thousands of pages, yet when I've finished, certain things

from those pages are not going to be in it, except they *are* going to be in it, even if not on the printed page.[40]

In this noteworthy admission—one that counters her biographer's claim that she was "an easily distracted procrastinator"—Olsen links her lateness to her maturity and implicitly confirms a commonplace association of youth with swiftness.[41] Yet given that her labored slowness stems as much from "too much being in my head" while living "very fully," these deliberative writing practices do not incapacitate her creativity even though the feeling of losing "ardor, sureness" may frustrate it. Acknowledging her prolificacy amid sparse published output, Olsen's compositions deepen her self-consciousness, and vice versa: across her temporally expanded modernism she produces "thousands of pages" even though her primary publications amount to *Tell Me a Riddle*, *Yonnondio*, and *Silences* (1978), a 306-page pastiche of personal memoir, feminist theory, and literary analysis. Her preface to this patchwork text confirms her claims for slow writing: "The substance herein was long in accumulation, garnered over fifty years, near a lifetime; the thought came slow, hard-won; the talks and essay, the book itself, elicited."[42]

Affirming her "hard-won" modernism in this lecture, Olsen also offers an unexpected counterpoint to ingrained associations between modernist writings of all sorts and speed—or what Enda Duffy, quoting Aldous Huxley, refers to "as the only new pleasure of modernity." Overviewing "the horrors of slowness" in modernist literatures and movements such as "the speed-obsessed work of Italian Futurism," Duffy finds that speed as "a new sensory experience was fostered, celebrated, and thrilled to" by many during the movement's historical apex.[43] Duffy's claim is accurate, yet Olsen provides a less pejorative perspective on slowness: her gradualness was a boon to her self-styled "late development" as she composed and revised versions of *Yonnondio* in the 1930s and subsequent decades thereafter.[44] Though the two found themselves at opposite ends of the political spectrum, she nonetheless shares a compositional affinity with Barnes, who likewise preoccupied herself with incomplete literary experiments over many long years.

Interestingly, *Yonnondio* introduces a complementary version of this slowness. After the Holbrook family moves from a South Dakota farm to an unnamed flyover city, Jim Holbrook finds work in a meat-processing plant during a scorching summer. One morning he heads into the assembly-line "kill room," where the temperature reaches 110 degrees (114). As he works in near-fatal conditions, the

factory's bosses press the workers to speed up the line while a fellow employee turns to Jim and the other proletarians and urges them to slow it down. "'Slow it,' Kryckszi sends the message to Misho, to Huff, to Ella. 'We got to slow it'" (124). A page later the novel repeats this mantra—*Slow it, we got to slow it*—but it is not clear whether Kryckszi or Jim utters this unattributed line, which could also be voiced by Olsen in 1974 (125). It is as if the unfinished, slow-going project that constitutes *Yonnondio*'s pieced-together fragments echoes and amplifies her Emerson College remarks as well as on-the-job working-class wisdom. Years in the making and still incomplete, her modernist novel amounts to an aging textual revolution written "only on scraps of paper, on tattered pages, in lines of yellowed notebooks, [indecipherable] and in the perished being of she who I was 37 years ago."[45]

II

Along with Olsen's other observations about *Yonnondio*, this last quote makes clear that her slow-going proletarian modernism produced not only an aging manuscript but also ruminations on her own temporally extended life. Across these many reflections, she continued apace with *Yonnondio*. After the novel saw print in 1974, Olsen tinkered with its prose to such an extent that a 1989 reissue changed its final line. Five years later came another reissue that provided several alternative endings, each outlining the respective fates of the Holbrook family members. An "Editor's Note" dated March 1994 that Olsen proofread with the aid of her daughter Julie Olsen Edwards introduced these potential conclusions:

> What follows are three of the original fragments, released now by Tillie Olsen into the light of publication. In addition, using those old "outlines, drafts, scraps" she has woven together a chronology to fill in, as best possible, what transpired in the times between the fragments—and after. Furthermore, the words in nearly all of the chronology are the exact phrases, lines, notes, incidents, as written in the drafts by that long-ago young writer who was she, in the 1932–1937 years.[46]

It remains unclear who originally drafted these words, but a phrase such as "long-ago young writer" appeared twenty years earlier in Olsen's 1974 note minus

118 *Tillie Olsen and the Old-Old Left*

the hyphen. Thanks to an extensive accession that Stanford Libraries undertook in 2009, we can nonetheless assume that Olsen played a role in its making. A supplement to its initial processing indicates she informed her editor, Trish Todd, that "I am very unhappy with the editor's note and have deleted the last sentence" as she also offered "last minute suggestions and changes" faxed to Todd.[47] Poignantly, Olsen signed off on these edits with "A wretched 'best I can manage [nothing wretched about the love].'"[48] As the 1974 note, the editor's note in 1994, and her archived correspondence with Todd all make clear, these remakings of *Yonnondio* from the 1970s to the 1990s mull over the psycho-physiological differences between her younger self as aspiring modernist-laborer and her older self who drafted her modernism "in my ever-lessening time."[49]

Other unpublished fragments archived at Stanford interspersed amid those that became *Yonnondio* testify to these "re-livings, rememoryings, [and] reevaluatings." The latter prompted the former. Take four examples in the same folder:

Reader, life overbore that young woman, that young mother who 41 years ago began this book, 38 put it aside

for near 40 years clogged my brain,
 never settled
the dust blows conceals shrouds
 became the corpses of them, unwritten

I have to say like Tolstoy I, I Live If I live and If I [am able to] finish my book you will see that this girls writing was prelude, was presage too, but maturity.....

Mazie Sistie Will they take momma over the hill when she gets old

why did you rise, dead girl,
young girl (long ago girl)
writing girl

Back—in that state in the 40 year ago
journal tears wedged behind my eyes always[50]

Hovering between prose and poetry, some of these typewritten fragments constitute revisions to revisions of her "Note About This Book" from 1974. Others emphasize Olsen's anguished thoughts about characters in *Yonnondio*, especially the quoted line that entertains what it might mean for the Holbrook siblings to witness their mother go "over the hill." Still others find Olsen quoting Leo Tolstoy's later writings as the Russian author pondered his final days. Despite these disparate topics, Olsen rehearses a common thread: the distinction between their author as a "young girl" who was also a "writing girl" and an older Olsen who looks "back—in that state." It bears repeating that she renders these lyrical self-assessments in "hard-won" experimentalist formulas: juxtaposition, collage, typographic innovation. As an aspiring modernist-laborer influenced by Eliotic and Steinian style in her teens and twenties, she applied avant-garde techniques not solely to her fragmented novel but to representations of her own laboring "maturity" in her sixties. "Never settled" even as they gathered dust for decades, these fragments about her aging self could be categorized as another instance of her proletarian modernism, a point that my next two sections explore in further detail.

Given their blurred distinction between modernist life writing and an older "writing girl," these archived slips of paper read to me like the fragmented age autobiography of an experimental revolutionary. As such, Olsen revolutionizes another twentieth-century genre—the life review—that enriches her developing age consciousness. Chapter 2 mentioned this genre in passing. In Olsen's case, it saturates her unpublished artwork from the 1970s onward. First identified by gerontologist and psychiatrist Robert N. Butler in an influential essay for the journal *Psychiatry* in 1963, the life review was initially unfamiliar to many post–World War II medical professionals who would popularize it beyond their subfield of psychogerontology.[51] Butler's premise was simple: "This paper postulates the universal occurrence in older people of an inner experience or mental process of reviewing one's life."[52] Mindful of a break with past selves that one could remember if not fully recover, an elder's life review was meant to integrate the individual's consciousness across the lifespan. Essentially, this self-assessment was a prolonged mental exercise

akin to psychically scrapbooking a lifetime of events as these individuals collect their fragmented thoughts. In so doing the genre relies on an orderly stream-of-consciousness whereby older persons recall, evoke, and come to terms with the past. With Olsen in her early sixties at the time of their composition, her modernist self-notes enact this psychologized self-narration as she perceives a widening temporal gulf between her present self and the "long ago girl."

My mention of stream-of-consciousness also suggests that an unacknowledged modernism permeates the life review inaugurated by Butler and embraced by Olsen. Few humanist-minded gerontologists or literary critics have commented at length on this generic aspect save Amelia DeFalco and Kathleen Woodward. The latter casts the life review as part and parcel of literary age studies. "Robert Butler's 'interpretation' (the word is his) of reminiscence in the elderly," she writes, "has, as we shall see, some affinities with a literary mode of thought."[53] Specifically, Butler's twelve-page account of the genre cites works by W. Somerset Maugham, Samuel Beckett (*Krapp's Last Tape*), and Henry James (*The Ambassadors, The Sense of the Past, The Ivory Tower*) as exemplary instances of such reminiscence. Subsequent age critics, such as former AARP administrator Harry R. Moody, would widen Butler's source materials to claim that "in due course [the genre] achieved supreme expression in Proust's great novel *Remembrance of Things Past*."[54]

These citations each suggest that the life review's debt to modernism is unmistakable. James, in particular, stood out as a paragon to Butler. The latter's *Psychiatry* article quotes eight extensive passages from "The Beast in the Jungle" (1903), a famously modernist narrative detailing the losses that overwhelm an aging John Marcher after the death of his close friend May Bartram. Turning the tables of modernist literary history on Butler, we could say that James originated what Butler initiated for later twentieth-century gerontology. The latter formalized a mode of consciousness—what Walter Benjamin termed "the weight of long experience" in 1940—already in wide literary circulation.[55] A novelistic genre for the second half of the twentieth century, the life review was paradoxically modernist-inspired and modernist-devised. Regrettably, this lineage has been overlooked.

The fragmented working-class life reviews of Olsen nonetheless tap this geromodernism. Recording piecemeal "rememoryings" as she composed *Yonnondio*,

she borrowed her neologized self-narrations not so much from Butlerian psychiatric gerontology as from the authors he cited to confirm his universalizing narrative. *Silences* alone cites James, Baudelaire, and Proust. Instances of life review likewise transform the realist prose of "Tell Me a Riddle" into Eva's italicized stream-of-revolutionary reminiscence: *"An unexamined life not worth / Strong with the not yet in the now / Dogma dead war dead one country."*[56] In her self-commentaries throughout *Yonnondio* fragments, Olsen would further politicize such modernist literary gerontology and infuse the life review with a deeper sense of her own working-class age consciousness—the activist-laborer who stopped writing *Yonnondio* for a few decades even as its modernism "for near 40 years clogged my brain."

With James's depiction of a pained John Marcher in mind, this section concludes by noting that Olsen's innovative reminiscences were never easy psychic tasks for an artist who spent "too much being in my head." Far from nostalgic acts, these "rememoryings" dredged up losses suffered by her younger self. At the same time, they allowed her proletarian modernism to expand into age consciousness in the 1970s as she encountered the novelty of her maturing body and mind—her *"psychic body"* as Woodward would have it.[57] Take, for instance, an extraordinary document housed at Stanford consisting of two fragments taped together. This compilation could be read as a longish prose-poem that ruminates on overlaps between *Yonnondio*'s extended production and Olsen's extended life. Two select passages run as follows:

> reader there is no end there is no ending
> far better that Id put my time into smedley
> the power diminishes
> the feverish pregnant girl writes less and less In Stockton after
> Minnesota
> there is hunger The baby becomes an upright animal self propelled
> theproblems seem intolerable she who wrote these draftsisno more
> piecing them
> together it sounds ponderous embroidered wrong
> if you wish to read what I couldnot again bury away
> perorations crude rhetoric earier had literary quality
> I am absolutely at a loss how to surmount mydifficulties

maybe it is all no good everything in the world is
 produced by labor (andif its machines labor went
 into the makingof them, as labor operates them)
not like the problems of my own writing
guessing guessing nothing seeming quite right
in this time I could have written it new[58]

Here, commentary about *Yonnondio*'s compositions becomes indistinguishable from an experimental life review that senses "she who wrote these draftsisno more." In this ruminating ebb-and-flow, Olsen fears that she should not be making her slow modernism even as she keeps on making this slow modernism. She feels she should instead make literary history and help to recover the feminist working-class writer Agnes Smedley, whose novel *Daughter of Earth* (1929) saw republication by The Feminist Press in 1973 thanks partially to Olsen's efforts. We can thus date this painful reflection sometime in the early 1970s when Olsen was in her late fifties or early sixties, during a time when she felt her youthfulness fade.

In this document, at least, Olsen's fretful perception about her former self also overlaps with worry about her place in U.S. literary history. Her experimental projects, it seems, initially felt temporally inappropriate to her even though she considered *Yonnondio* a continuation of her 1930s modernism. This passing observation adds a psychological component to the post–World War II "Popular Front structure of feeling" that Olsen exemplifies. Though I earlier argued that she saw her modernism as ceaseless, this particular life review also reveals her fear that many thought the movement had gone off the boil by the 1970s. Hence the pressure to make her writings even more "new"—to make it newer by making it contemporary—and her sense that she should undertake to rescue work for "long ago" working-class literatures rather than extend her own projects into the 1970s. This distressed fragment is best interpreted in part as a response to developing norms of twentieth-century literary periodization. For Olsen, refuting these norms demands a draining psychic labor that complements the exhausting work that produces "everything in the world." Yet again, her age consciousness supplements her class consciousness.

Adding insult to Olsen's perceived injury of bad timing is also her fear of bad writing: in particular, that her temporally impudent work will be dismissed

("maybe it is all no good"). While she negotiates conventions of periodization, then, Olsen also navigates twentieth-century norms of creative aging. She finds that her labors as a working mother produce an imagination where "the power diminishes." She questions her "literary quality" and finds her "perorations crude." She embodies what Linda Hutcheon and Michael Hutcheon refer to as "the crisis of confidence that aging artists might experience . . . related to the internalization of this stigmatizing 'script of decline,' inactivity, and helplessness."[59] This is what Olsen, in *Silences*'s catalogue of creative obstructions, herself theorized as "Fear of aging. Subject to. Fear of expressing capacities."[60]

Despite these anxieties, Olsen found compensations as she took on the mantle of the aging female proletarian-activist. Though she claims she is "at a loss at how to surmount mydifficulties," she nevertheless recrafts these reservations into a stream-of-consciousness document. Much like her psychically fraught *Yonnondio* "combinings," the project of piecing these fragments together via the modernist life review—no matter how dubious it felt to her at the time—results in a unique form of experimental aging. Through often anguished "rememoryings" with "no ending" in sight, Olsen writes more and more about how "the feverish pregnant girl writes less and less." Once a "long ago girl" drafting "The Iron Throat" in the 1930s, she would become an older leftist who left behind an earlier "working life" but again started her labor anew in the 1970s. After living through numerous twentieth-century recessions and one Great Depression, Olsen fully embraced this art of aging her class consciousness.

III

From the 1970s onward, Olsen matured into this public role as an older proletarian modernist and drew attention to herself as an elder activist-writer. Despite initial worries, she built a substantive public and private writing career via readings and protests across the United States, China, and elsewhere. In an event held on behalf of the Women's Party for Survival in 1982, for example, she told her San Francisco–based audience that "I am, in the other way, in the way that those of us who were lucky get to be seventy are old, truly old. Ever dearer to me are the things in life and the new life, and that there should be memory, and that there should be a heritage, and light, and eyes to see it."[61] At a Radcliffe College forum three years earlier, she stated that aging had paradoxically

invigorated her as much as it did a well-known postimpressionist: "I also said to myself, what Van Gogh said in his work: nothing has been wasted, and the power to work is another youth."[62] She then quoted from Ralph Waldo Emerson's "Song of Nature" (1859) and compared her experience to Henry James and Emily Dickinson:

> And I said to myself and discarded it: and out of spent and aged things I framed the world anew. Because I still have what Henry James was so stricken by when he got around the Woolf children: what he called the hungry futurity of youth, because I still have that hungry futurity.... I do feel in the words of Emily Dickinson—and I'll change it to personal, change one word in it if she'll forgive me—"the harm of time is on her, the infamy of years." I do feel that tonight, and that's been a long personal preface.[63]

Even as she embedded her mature self within two centuries of American literature, Olsen inflected this novel public persona with working-class consciousness: "I stand before you as one of a generation of whom perhaps three percent of us got into college, eight percent at the most."[64]

At the same time that she presented herself as an elder spokesperson of the Old Left speaking to New Left feminists and new generations of working-class citizens, Olsen also chipped away at her experimental poetics of aging.[65] While I do not underestimate the influence that friendships with lesbian-feminist writers such as Adrienne Rich or a Confessional poet such as Anne Sexton had on her writing during this period of her life, the rest of this chapter elaborates how Olsen's late-life poetics intensified her age consciousness by analyzing modernist fragments produced largely after *Yonnondio*'s first publication in 1974. To do so, both this section and the next focus on documents processed during the Department of Special Collections' accession of Olsen's papers at Stanford in 2009: over fifty boxes of literary writings and correspondence authored prior to her diagnosis of Alzheimer's disease in 2004, which led to her care at an assisted living community in Oakland, California. Across this archive, Olsen realizes her "hungry futurity" and, mindful of "the infamy of years," records the apprehensions and gratifications of her aging laborer's body. As with her life reviews, these writing tasks were psychically arduous and compounded by what Woodward terms *fragilization*, or her body's increasing frailty.[66] With Olsen "conscious of our diminishments," this section surveys what one critic dubs her "unorthodox writing produced in unfavorable

circumstances."[67] The next closely reads a single folder that amplifies the gerontological thematic, the modernist techniques, and the bodily travails that Olsen's literatures traced in her lifetime's daunting final quarter.

Collectively, these papers document Olsen's creative aging through an affirmative poetics of creative decline: her aging body in chronic pain; her aging body in labor; her aging body in productive constriction; her aging body closer to death. This last claim seems paradoxical given that decline narratives collude with ageism. Yet decline is not, Olsen insists, inherently oppositional to creative aging: the former advances the latter, while her late-onset debility undercuts "Geriatrics, Inc." Like Albright's magic realism, then, these poetics renovate the decline narrative and enhance her counterintuitive insight that "the power to work is another youth" even as she grew frailer. Rendered in the standard modernist formulas that Randall Jarrell once classified as "external formlessness" and "a jerky half-prose *collage* or *montage*," this poetic prose does not shy away from the difficulties that her body presents.[68] New psycho-physiological experiences of advanced old age instead offered Olsen an unexpected gerontological twist on the long-standing idea of working-class struggle, and she again draws on her modernist influences to lyricize "this pullin me to put together, publish from my girl self to now.... from letters (of others too) clippings beguns and dones and nascents and utterances a life."[69]

To get a better sense of these "nascents and utterances" written while Olsen chronologically aged into her later life, examine this untitled poem filed under "Miscellaneous fragments, undated":

> Days
> the mouth smiles
> the eyes are eager
> the face, too, eager
> strong steps the body
>
> it is at night
> ~~times~~ the harm happens
>
> pressed to the sheets in anguish
> contorted distorted
> the wrinkles iron in
> the sags the pouches happen

> the earthquake grooves
> its fissures
>
> aging
> aging
> takes place[70]

This poem is an ode to the novelty of aging consciousness. Written in free verse with its third stanza alluding to Olsen's short story "I Stand Here Ironing" (1956), the poem pivots on the pleasures and pains of a body transformed by "the earthquake" of senescence. Refusing "to be either flatly optimistic or pessimistic" about the body-in-decline, the poem successfully ages its speaker even as the speaker may not age as optimally as desired.[71] Irregular poetic lines mirror the "contorted" body with the double repetition of the one-word line "aging" reinforcing the drip-drip of accumulated "days." In a similar dynamic that insists on aging's complexity across quotidian late life, Olsen elsewhere refers to "the rush to go on WRITING even with a new with all the UNDONES UNFINISHEDS" even though "I feel the loss of capacity with every day night hour."[72]

A complementary fragment dated "ca. 1990s" also draws on two influential experimentalists—Baudelaire and Edna St. Vincent Millay—to make analogous observations:

> all visible in my face for the first time
> writ the years, the years
> death as deadline
> make haste why do ye tarry
> the claw of not being able to's not bend nor lift
>
> ***
> yes BAudelaire that black wing in its shadow this day[73]

Facing "death as deadline," Olsen expedites her creative output ("make haste") as her slow prose rushes to meet life's cutoff date. Material writing conditions become a formidable task under these corporeal conditions, a "claw" that frustrates with its "not being able to's" and her body's difficulty with bending or lifting objects. At the same time, her slow writing also becomes a metaphorical life

review "all visible" on Olsen's wrinkled face, itself a modernist poem that records many years of living. This imagery thus visually presents Olsen as both a chronologically tattered page and a living record of longevity—one fragment of modernism among her many pieces of prose.

Invoking *ubi sunt* and *tempus fugit* motifs, Olsen's multiple inversions (death's enlivenment, the writer's body as text, artistic capacities enabled by corporeal incapacities) culminate in a passing allusion to Millay's translation of Baudelaire's "Mists and Rains," a rendition that was part of a cotranslated edition of Baudelaire's *Flowers of Evil / Les Fleurs du mal* (1857) Millay undertook with George Dillon in 1936. The line beginning "yes BAudelaire" echoes the line "My mounting soul spreads wide its black wings of a crow," featured in Millay's version of "Brumes et pluies," a poem by Baudelaire that praises "dismal seasons."[74] This dense allusion is an apt callback, and not just because *Flowers of Evil* contains infamous paeans to elder individuals. As Millay's preface to her coauthored translation remarks, Baudelaire's poems show keen interest in "the corruption of the ardent and well-cared-for flesh."[75] Olsen's citation of "the years, the years" inscribed on the persona's face thus extends Millay's observation and one of Baudelaire's central themes to her own working-class body. While a Baudelaire-inspired Olsen may not be the first go-to image when we invoke this feminist-proletarian writer, pause to recall that her early writings were "influenced by the romantic traditions of nineteenth-century poetry and its twentieth-century practitioners like Millay."[76]

As she composed these works, Olsen also continued her experimentation with the life review by producing stream-of-consciousness writings such as the following four extracts that she typed on a single sheet of paper:

> Undone why? puill yourself togethger (changed in our time to
> get your shit together) its not shit what "undone" you
> O 75 and 3/4s years
>
> ***
>
> Haunting, tearing, doing me in too o that 60 year old self. . . . But I <u>did</u>
> produce: REbecca: bciblios; the 30s stuff; unevens utterances
>
> ***
>
> start again: d but , you, stocked your memory well worked at it that too,
> no longer

so early too "only" 60 the concern with aging, death[77]

A sticky note still attached to this archived document dates these comments as "1997/8," or around the same time that Olsen moved from San Francisco to an in-law suite in Berkeley. Together these lines reminisce on Olsen's literary career in her sixties and seventies as she looks back from her mideighties. She refers to her edition of the nineteenth-century American author Rebecca Harding Davis's "Life in the Iron Mills" (1972); bibliographies and reading lists that she published between 1972 and 1974 for *Women's Studies Newsletter*; and "the 30s stuff" that would become *Yonnondio*. As she does so, Olsen collapses the distinction between her "UNDONES"—her unfinished life writings—and becoming "undone" by aging. A perpetually late bloomer who got an "early" start, she composes by gaining composure, by making disjointed modernist "unevens" out of older "stuff," including her aging self.

Such lines grant us deeper insight into the aesthetic logic behind Olsen's diverse fragments from the early 1970s to the closing of the twentieth century, or what this section earlier quoted as her "pullin me to put together." Olsen's unfinished works from this period of her life may have remained "undone" in the archives, but they did not undo her. Like *Yonnondio*'s fragments, they are "not shit," nor should they ever be treated as such. Stream-of-consciousness writings such as these instead underline the "hungry futurity" made possible by creative decline as she transforms herself into a gerontological *complaint* in that word's double meaning: a poetic lament for her frail body and an implicit protest against gerontophobia that mirrors her public activism. "I _did_ produce," this honorary Gray Panther insists in a rebuke to what Elizabeth Gregory calls "a prejudice against taking seriously the work of an older woman."[78] Collaging the fragments of her "undone" life into haunting lines of poetic prose, Olsen recalls herself at "75 and 3/4s years" as an unfinished project who will perpetually "start again" no matter the psychic cost. Harboring a growing "concern with aging" yet fully "stocked" with stores of "rememoryings," her primary aesthetic success remains her eventually dying self draped across a lifetime of ceaseless toil:

beauty of life

it cannot be that it is almost over for me that

the years ahead for work will not be

[my one life
my only life]⁷⁹

IV

I cannot emphasize *toil* enough across these later writings, for Olsen's class consciousness—the sense of herself as a matured laborer—was never far removed from these experimental takes on advanced age consciousness. We have seen that she records the difficulties of laboring to write as she struggles with her aging body, or what she calls her "not being able to's." These later-life writings likewise address linkages between "living not only a very fully as a human being" and "working life" as a body with late-onset disability that can no longer easily engage in manual wage labor. Unlike her younger self who often cast the workplace as an impediment to writing, a fragilized Olsen offers a more capacious definition of *work* without losing sight of how economic necessity impedes creativity at any stage of life. While she never entered conventional retirement, Olsen did sense herself a member of an older intellectual work force.⁸⁰ As she felt herself to be "this strange writer underclass lowerclass," Olsen's age consciousness further expanded her sense of class consciousness across her unpublished writings.⁸¹ Invoking the title of a short *New Yorker* piece from 2014, "What Kind of Worker Is a Writer?," that featured a 1930s Olsen as its centerpiece, these understudied documents reply: "What kind of writing isn't work?"

This commitment to imagining herself as an older laborer becomes a constant refrain in writings composed from her midseventies to her later eighties:

> inching it along
> and at this rate it'll be 2020 and I dont mean perfect vision
> either
>
> ***
>
> shaky the physical 6 ½ hrs. in bed

must not do that again my resourceless
body

that is age they say to work within known
limitations[82]

anguish of age of slendering means

will stay in this little room and work commit what is left [indecipher-
able] to me; of me contract my universe who wants universe[83]

I quote her thoughts on work (her writing environment, her routine, her commitment to revisions, her meager financial "means" aided by Social Security income) because we have not sufficiently witnessed an oldest-old Olsen as a modernist-laborer. To the best of my knowledge, scholars of long modernism have not interpreted these materials at length. Save for close family members who cultivate her reputation with their websites, few have considered the labors involved in this unfinished modernism over the many years after *Yonnondio*'s first edition.[84] Yet in these untapped archives we find an Olsen whose writings produce what she refers to as "the old in a new form."[85] Resourceful amid her lost resources, she nurtures her writing "within known / limitations" not just of twentieth-century capitalism (a standard reception of her work), but of twentieth-century mass longevity.[86] Harkening back to her earliest leftist literatures with their observations on daily toil, this experimental prose conceptualizes her self as a laborer facing head-on the "anguish of age" while plugging away "in this little room."

Titled "Tillie's verse [photocopies, chronological]," a folder from Stanford's accession elaborates on this decades-long project. Though it is unclear if Olsen ever meant to gather these writings for publication, and though I have not yet been able to confirm its collator, the folder's careful and unattributed compilations is intriguing, especially when we compare it to the other archival arrangements that I have previously mentioned. While Stanford's finding aid for this accession clearly identifies her correspondence with friends, family, and fellow writers and approximately dates her notebooks, it rightly cites many of Olsen's

incomplete compositions as "miscellaneous fragments, undated." By contrast, this folder consists of photocopied and untitled verse and prose, with most drafts organized and enumerated 1–38 in handwriting that does not appear to be Olsen's. Save an initial outlier draft located and dated "MacDowell 82–85," the folder's numbered typescripts move in chronological order from her remembrances of "early life" to 2003, while six of these typescripts remain undated. Some of these pieces are life reviews and are marked as such: "remembering 40s + 50s." This same unidentified handwriting marks others with a date and sometimes a location: 1962, "1968 Amherst," "early 1970s historically," "1972-thinking for Stanford class," "end of 1970s," "early 1980s," "80s–90s Banff," 1991, 1996, and 2003. A few of these pieces Olsen herself dates in typescript, such as "MacDowell/November, 1968" or "Dec. 1982," or in personal handwriting such as "1974?" Some original drafts of these photocopied documents appear elsewhere in archived folders titled "Miscellaneous fragments, 1968–2003," which Olsen typed on white or baby blue sheets of typing paper that she termed her "blueys."[87]

I single out this folder's documents because they chronologically age Olsen's poetics while collating her "unfinisheds," her reminiscences, and her modernist age consciousness across more than seven decades. Together they provide an intimate sense of her lifelong revolutionary undertakings. At the same time, the chronological numbering also suggests that her personal poetics of aging can be approached as a revolutionary project that reaches back to the 1930s—or much earlier. In an undated draft numbered 1 and marked "early life," Olsen defines herself as "a political animal" whose working-class roots connect her to "the sacking burning raping of the ancient world."[88]

The apex of such poetics appears in a photocopy of an untitled, edited poem numbered 34 whose original typescript is held in the "Miscellaneous fragments, 1968–2003" folder (figure 4.1):

 face that aged in the mirror
 pouches sags
 gouges
 life formed proud I flaunt you

 hair that flaunts winter

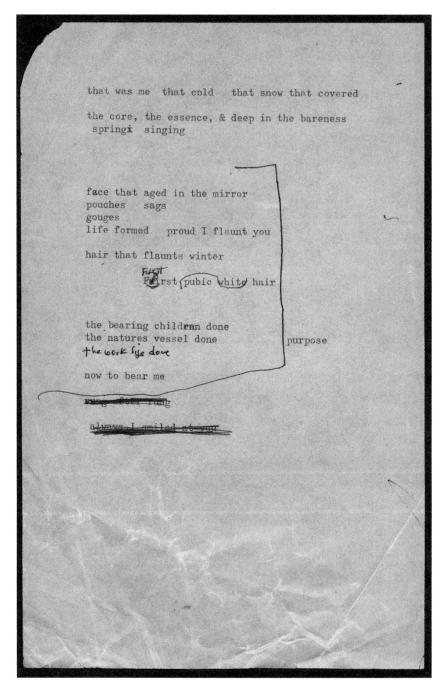

4.1 Tillie Olsen, miscellaneous draft fragment, date unknown. Series 14, box 18, folder 7, Tillie Olsen Papers, Department of Special Collections, Stanford University Libraries, Stanford, Calif. (M0667). Courtesy of the Department of Special Collections, Stanford University Libraries. Reproduced by permission from Frances Goldin Literary Agency.

First white pubic hair

the bearing children done
the natures vessel done purpose
[the work life done]

now to bear me[89]

Like others in the "Tillie's verse" folder, this poem features commonplace modernist poetic techniques: free verse, lack of capitalization and punctuation, uneven spacing, and irregular repetition. The poem's arc finds the persona vertically assessing her corporeal frame, first scanning her face and finally examining her lower body. The age specularity chapter 3 cited here meets age self-consciousness as the mirror projects back an older self. Rather than disgust or shame at a "vessel" that "sags," however, the speaker is "proud I flaunt you." Coupled with debility written in and onto the poem, this pride applies not only to flesh but to a lack of reproductive capability. The antirejuvenative speaker dignifies herself as a postmenopausal older woman.

Her age consciousness also begets a new form of feminist class consciousness. The work of reproductive labor is "done." So, too, Olsen handwrites, is "the work life done." With the possibilities of both child-bearing and intensive manual labor over and done with, the poem moves toward a different "purpose" and meaning of labor: namely, the speaker's effort "now to bear me." Intent on birthing herself with reproduction no longer feasible, the poem's speaker employs creative decline to conjure an image of innovative self-reproduction in the later stages of a woman's lifespan. I hear echoes of "[my one life / my only life]" in these lines that introduce a new form of labor at the end of a female worker's reproductive life cycle, one that Olsen fully realized as an aging writer of working-class modernism. Replete with what she elsewhere termed "those body metaphors" and mindful of "my bodys, capacities farewells," the poem is an acceptance and refusal of *memento mori* from a former member of the U.S. workforce still working for the Popular Front.[90] Or as a page dated 2003 from the "Tillie's verse" folder phrases it as its speaker negotiates some "bargaining" power with her life expectancy:

> my work what not done cannot now now be done o myu undones
> my unfinished
> if I bvelieved in bargaining 5,6, [indecipherable] writing years 92
>
> let us sleep now[91]

V

Olsen wrote this last piece four years before she died at age ninety-four on New Year's Day in 2007. These lifelong labors posthumously continue. When I taught *Yonnondio* to thirty undergraduates at Indiana University five years after her death, we came across yet another one of her revisions to this text. One of my students, Miranda Hoelberg, had ordered a used 1994 reissue from Amazon Books. Unknowingly, she had purchased a signed copy with several of Olsen's handwritten inscriptions and emendations (figures 4.2–3).

After we confirmed Olsen's handwriting by comparing Hoelberg's book with documents held at Stanford, our class sat silent in collective wonder. Sometime after Olsen released the latest version of *Yonnondio* thirteen years before the Great Recession, she again labored over her incomplete project with this copy by revising its front matter. On the initial title page, which includes the lone word *Yonnondio*, Olsen adds two lines: "'Unlimn'd they disappear' / Visibility creates reality." On the second title page, which includes the novel's subtitle, she handwrites "(yet still such live)." On an italicized preamble to the first chapter, she amends the narrative's timeframe from the 1920s to the 1930s. Most important, her autograph includes a salutation that doubles as a note of gratitude to unnamed future readers:

> Thank you, dear reader,
> my co-creator therefore,
> for it is your reading
> which raises life from
> these pages.
>
> —Best,
> Tillie Olsen
>
> ———
>
> (Anna on reading - p. 96)

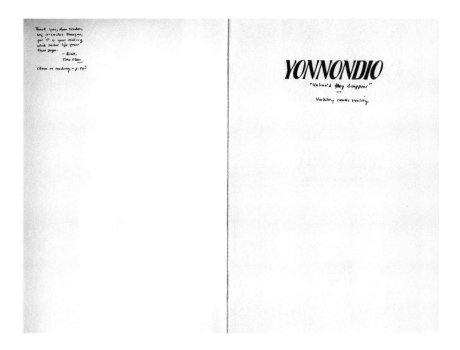

4.2 Tillie Olsen, inscription to 1994 reissue of *Yonnondio: From the Thirties*, date unknown.

4.3 Tillie Olsen, modification of 1994 reissue of *Yonnondio: From the Thirties*'s title page, date unknown.

I don't know when Olsen wrote these remarks. What is clear is that these brief, pointed, and gracious inscriptions do not guarantee her biographer's claim that, in later years, Olsen "had lost her ability to synthesize" or "that she could no longer write."[92] As this chapter has shown and as Hoelberg's copy attests, such claims can be made only with a restrictive sense of aesthetics, production, and effort—all of which Olsen cultivated for almost all her remaining life after she published *Yonnondio* in 1974.

And, it turns out, well beyond her final decade of living. Along with scores of experimental fragments housed at NYPL and Stanford, we should praise Hoelberg's copy of *Yonnondio* as part of Olsen's extended modernist archives. This signed edition is one of the many "unfinisheds of the unfinished" Olsen began in the 1930s that carried into the twenty-first century. Writing to a reader she never met, Olsen engages in another tried-and-true Whitmanian mode of address to those that the Good Gray Poet once referred to as the "dim unknown—or young or old—countless, unspecified, readers belov'd."[93] Olsen's address imagines this individual to be a fellow traveler in her modernist-feminist prose, an intergenerational "co-creator" who "raises life" through the act of reading. She asks this interlocutor to revise *Yonnondio* after we last thought that she had last revised *Yonnondio*.

This unfinished production returns us to Olsen's remarks in the *SF Gray Panthers Newsletter* that her work "does go on" because "it's taught, anthologized." It returns us to Jameson's remarks that the unfinished project "has yet to be written, it lies ahead of us in historical time." It returns us to Olsen's remarks that her readers—her collaborators in contemporary proletarian modernism—continue her aesthetic labors: "for it is your reading / which raises life." Finally, it returns us to one of Olsen's primary aesthetic tasks in her later life: recovery work that revives the dead. Hoelberg's revised copy, I have come to believe, is but another instance of Tillie Olsen's revolution that stretches from her participation in a 1934 labor strike to her writings on the elder worker.

So, again, *we got to slow it*. Does Hoelberg's edition of *Yonnondio*—or Olsen's entire corpus, for that matter—not fulfill this tempo? Olsen's writings suggest a radical, centuries-spanning project that waits for us, wherever we might be. An unending modernism took its time to become more and more unfinished across *Yonnondio*'s many revisions, her many poems, and the many students who engage her work in their continuing studies of Old Left revolt. Thanks to you, dear readers, her UNDONES remain undone.

CHAPTER 5

Queer Senior Living with Charles Henri Ford and Indra Bahadur Tamang

It was 113 years ago today that Charles was born, in 1908. When I first met him in Kathmandu he was already past sixty years old, which to me, being eighteen or nineteen at the time, seemed very old. Now I'm past the age that he was then, so I can imagine that he still felt quite energetic then, because I still do.

—Indra B. Tamang, February 10, 2021

Besides film critic Rex Reed and Rosemary's half-demon baby, one of the many unexpectedly queer things to emerge from the Dakota apartment building on Manhattan's Upper West Side was Nepali modernism. I did not yet realize this innovation when I found myself sitting next to a box of surrealist Charles Henri Ford's cremains while chatting in apartment 103 with his former caregiver and collaborator Indra Bahadur Tamang. My finding is a world away from clickbait posted by the *Wall Street Journal*, which exclaimed "The Butler Did It—at the Dakota" after Tamang inherited a multimillion-dollar estate from actress Ruth Ford following her death on August 12, 2009. To be precise, Ford bequeathed Tamang two Dakota apartments—her own as well as her late brother's studio along with "a valuable collection of Russian surrealist art."[1] Born around 1953 in Phakhel, Nepal, Tamang first encountered Ruth's older sibling in 1972 while waiting tables at the Panorama Hotel in Kathmandu's Khichapokhari district. After he left this job to become Ford's steward, he moved to the Dakota with Ford in November 1974, assisted him until his death on September 27, 2002, at age ninety-four, and aided Ruth until her passing. Tamang was on and off at the Dakota in the 2000s, and at present he lives in Woodside, Queens, and upstate New York with his wife

Radhika. These last five sentences include basic facts that outlets such as *Village Voice*, *Boston Globe*, *Times of India*, BBC News Online, and WNBC retold ad infinitum for those fascinated by life at the Dakota—"a Mecca for tourists" after John Lennon's assassination at its West 72nd Street entryway in 1980.[2]

While intriguing to reporters, the queer domesticity that Tamang and Ford fostered for almost twenty-eight years in their studio garnished little interest. The same could be said for much of Ford's late-life work. At age twenty-one, Ford launched his little magazine *Blues: A Magazine of New Rhythms* from the family-owned Gilmer Hotel in Columbus, Mississippi, in 1929. He subsequently coauthored his audacious experimental novel *The Young and Evil* (1933) with film critic and poet Parker Tyler, earning Gertrude Stein's praise despite her distaste for his lover, Russian-born neo-Romanticist Pavel Tchelitchew. Having achieved prominence as editor of the New York–based surrealist journal *View* and publishing works by André Breton, Leonora Carrington, Man Ray, and Marianne Moore, a modernist once puffed as "America's No. 1 Surrealist" did not foresee a stumble into "the dustbin of history" nearly a half-century later.[3] When most pause over the final quarter of his life, they may recall that he was one of sixty-seven oral histories that historian George Chauncey conducted for his groundbreaking study *Gay New York* (1994) with aid from SAGE (Senior Action in a Gay Environment, now Services and Advocacy for GLBT Elders), a post-Stonewall advocacy group based in Greenwich Village for older sexual and gender nonconformists.[4] Or obituaries memorialize him for being "a gadfly in the upper echelons of the U.S. / European avant-garde from the late 1920s through the present."[5]

Yet archived artwork crafted by this gay Mississippian and a previous president of the Tamang Society of North America nevertheless reveals much about how senior living enables experiments with frailty. Conventionally, the term *senior living* references later twentieth- and early twenty-first-century housing arrangements for those reaching what poet Louise Glück calls "that time of life / people prefer to allude to in others / but not in themselves."[6] Heirs to the Old Man's Home mentioned in chapter 1, this modern invention of old-age institutions (OAIs) comprises Sun Belt retirement communities launched in the 1960s and assisted living facilities (counting memory care) backed by "early adopters of the hospitality-congregate model [that] included Hyatt, Marriott, and Emeritus."[7] *Senior living* can also entail familial or paraprofessional care. At its broadest, senior living functions as a synonym for the everyday domestic activities of a later life as exemplified by works such as *Take Charge! The Complete Guide to Senior Living in New York City* (1999) and the artists I have thus far featured.

Having discussed spaces such as Barnes's Patchin Place abode and Steward's cottage, I now bring the built environment to the forefront of my larger argument. While individuals who inhabit senior living spaces do find their days filled with arts and crafts as much as, say, care work, it almost goes without saying that such elderscapes do not usually appear as avant-garde hothouses. When scholars in American modernist studies train their critical lenses on domestic settings—these accounts are blessedly many—the tendency is to valorize salons at 27 rue de Fleurus, art colonies in Taos, bohemian flats in the Village, or rent parties thrown by Harlem's infants of the spring. Having first moved to the Village in 1930 and then on to Paris in 1931, Ford was no stranger to some of these innovative subcultural settings. He incubated and recorded many with *The Young and Evil*, a crucial resource for scholars tracking down the historical emergence of urban gay U.S. communities.

Before Ford died, however, he had something important to say about growing older—in his instance, creatively frailer—within the modernist built environment, and a turn to his later life at the Dakota further expands what counts for experimental aging alongside the case studies previously traced. As I will show, archives held at the Getty Research Institute's Research Library and Special Collections, at Yale's Beinecke Library, and in Tamang's personal possession document that Ford and Tamang labored on genres of surrealist haiku and collage as they shared significant swaths of their creative lives. While their bond was at times infused with a queer orientalism, theirs was nevertheless a long-term relationship that resulted in a coproduced avant-garde encompassing collaboration, stewardship, and, in due time, senior care. In one of New York City's more famous apartment buildings, I argue, the two transformed their life at the Dakota into a surrealist senior apartment.

Framing Ford and Tamang in this manner continues this book's through line on four interconnected fronts. First, Ford's oldest-old materials complement his more youthful ones. Best known for a novel written at age twenty-five, his compositions in his late eighties and early nineties present us with yet another example of creative aging as it here overlaps with aging in place.[8] Second, alongside Barnes's high modernism, Ivan Albright's magic realism, and Tillie Olsen's proletarian modernism, we witness a queer modernism akin to Steward's yet beholden to an Americanized surrealism that Ford first nurtured in the 1930s. Third, given that Tamang's attentive watch facilitated these materials, underexplored collaborations between these two teach us much about modernists and their caregivers, however imbalanced this relationship. At this late date we have detailed

scholarship on auxiliary roles undertaken by editors such as Alfred Kreymborg and Alain Locke; wealthy patrons such as Charlotte Osgood Mason; museum curators such as Alfred H. Barr Jr.; publishers like Alfred and Blanche Knopf; art collectors such as Peggy Guggenheim; and others. Add caregivers to this incomplete list of those who promoted American modernism. Some, of course, took care of themselves as they entered old age (José Garcia Villa lived alone in a West Village apartment until his death in 1997). Others, like Moore, cared for an older parent. Still others received caregiving. Think Williams with his wife Florence (Floss) Herman Williams, "who continued to take care of her husband, though there were days when the time seemed to drag interminably" after Bill's strokes; Zora Neale Hurston at the Lincoln Park Nursing Home; or Olsen at an assisted living community.[9] We should add Ford and Tamang to this list, especially as the latter facilitated Ford's experimental aging with his own creative caregiving.

That last observation leads me to the fourth, and most consequential, contribution rendered by this archive: given that their sustained comradeship was as much a vexed companionship, assessing Ford and Tamang's arts and crafts fulfills Kathleen Woodward's request that we commit to "*telling stories of caregivers and elders together.*"[10] Hence this chapter progresses from an initial focus on Ford's later life writings to his collaborations with Tamang. Doing so not only provides a more nuanced picture of Ford at the Dakota, whom we often associate with a young and evil avant-garde. Attending to Ford's geromodernism leads me, serendipitously, to Tamang's own.

I

Until his death in 2002, Ford tinkered on a poetics of surrealist frailty that tracked his increasingly fragile body and his increasingly fragile standing within U.S. artworlds as well as urban queer male subcultures. About a half-decade after Chauncey's interview in 1986, he started to draft a staggering number of surrealist haiku centered on these interlocking themes. Prior to these years, Ford shuttled between four residences: in the 15th arrondissement of Paris; at Zampeliou 73 in Chania Town, Crete; in Kathmandu; and at the Dakota. Once fragilization made global journeys more cumbersome, he found himself spending most of his days on the Upper West Side with occasional summers in Montauk and Westhampton: "I feel like I'm on / A boat that won't be going / Anywhere

it's moored."[11] With his former mobility altered, he admitted to himself in 1994 that "Haiku and cutouts / That's about as far as I / Can go this winter."[12] In another of his many daily planners filled with line after line of decent-enough poetry, he told himself that "First Young and Evil / Then oldie but goodie it / All balances out."[13] Citing his pansy craze-era novel via Clinton-era haiku, Ford here folds the title of his once-banned book into a blithe assessment of his newfound membership within the oldest-old (figure 5.1).

With some more and others less sanguine about this chronological threshold ("I'm sitting here like / an idiot thinking / I'm invulnerable," he wrote around 1999), these untitled haiku numbered at least five thousand.[14] A scalar overview of these largely unpublished writings—all now held at the Beinecke—is jaw-dropping. Ford's At-A-Glance day planner from 1993 alone included hundreds of handwritten haiku that he marked up with pink, orange, and blue ink pens. Then a composition book titled "Bathtub Haiku" from 1993–1994 filled from front to back, then another notebook, and then yet another he titled "Haiku

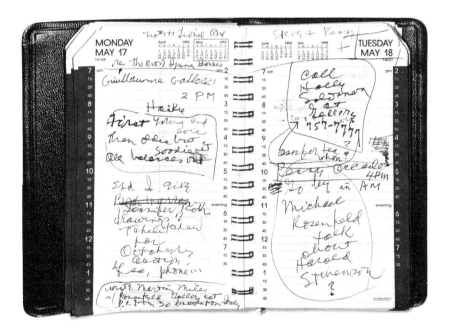

5.1 Charles Henri Ford's daily planner, May 17–18, 1993. Series 2, box 13, Charles Henri Ford Papers, Yale Collection of American Literature, Beinecke Rare Book and Manuscript Library, Yale University, New Haven, Conn. Reproduced by permission of Indra B. Tamang.

Autobiography," dated 1994. Around age ninety, Ford produced still another artist sketchbook he called "Haiku Group Title." While archivists identified working titles for some of these compositions after the Beinecke's acquisition in 2004, these notebooks also feature Ford testing out myriad titles: "The Minotaur Sutra and Other Haiku," "The Charles Henri Ford Experience," "Haikubiographica," "Less Than Total Recall: Memoirs in Haiku," "Magic Scissors: Cutouts and Collages," "Readymades Recycled," and "Personæ / Not to be confused / with Personæ by Ezra Pound." In addition to these unpublished writings, he also wrote for literary art journals such as *BOMB* (1991), *World Letter* (1998), and *Milk* magazine (2001), as well as the edited collection *50: A Celebration of Sun and Moon Classics* (1995). It is no exaggeration to say that his pace at the Dakota in the last decade or so of his life outstripped his productivity at the start of his career.

Ford nonetheless considered this Dakota space and the poetics produced there a recycling of earlier commitments to surrealism. If the Dakota's security guards were to have allowed you access to this ninth-floor, eight-hundred-square-foot apartment while he was alive, you would knock on its doorway that featured a golden "Charles Henri Ford / Operation Minotaur" sticker and then enter a light-filled room with a kitchenette. A small bathroom would be to your right, an alcove bedroom to your left. A heavy wooden desk anchored against a wall facing West 72nd Street would have been covered with composition notebooks or collages-in-progress. A collage composed by Tamang would have hung prominently between two windows.

That "Operation Minotaur" label is key to grasping the modernist magnitude of this domestic space. It served to remind guests that these living quarters were an ongoing surrealist endeavor in the 1990s, as well as an extension of entrenched surrealist themes launched in the 1930s. Operation Minotaur (sometimes abbreviated as OM) alludes not just to ancient Minoan mythology of the half-man, half-beast that terrorized Cretans, but to a surrealist periodical of the same name coedited by Breton and Pierre Mabille from 1933 until the outbreak of the Second World War. The first edition of this Paris-based *Minotaure* showcased a Minotaur-themed collage by Picasso as well as four of the artist's frontispiece sketches, including one titled *Minotaure assis avec un poignard* that featured the monster brandishing a dagger.[15] Ford had previously forwarded along this tradition of *Minotaure* with *View*, a magazine meant "to replace, in America, the European vanguard publications that folded as World War II approached: *transition* and *Minotaure* of Paris, and the *London Bulletin*, the British surrealist journal for which Ford had been the American editor."[16] His Dakota days sustained this decades-long connection after

a risqué film, *Johnny Minotaur* (1971). "The Minotaur left / Knossos for Breton Picasso," one haiku boasted, "then was made mine."[17]

Such surrealist linkages were actually earlier "made mine" after Ford's visit to Kathmandu in 1972. With *View*'s run ending in 1947, Ford appears to have first conceptualized his restoration of the surrealist Minotaur in the middle of the 'Me' decade while living in Nepal seventeen years after the nation-state granted its first tourist visas. Included in the thirty-four boxes that constitute the Beinecke's Charles Henri Ford Papers is a notebook titled "Operation Minotaur, Volume 1" dated 1976 and signed "C. H. Ford / GPO Box 829 / Kathmandu / Nepal." According to one of his stamped passports archived at the Getty Research Institute Library, Nepal's Central Immigration Office granted Ford a tourist visa upon his October 10, 1972, arrival. Almost four months later he signed a lease in the city's Gyaneshwor neighborhood under the name "Charles Henri Ford / Ford Minotaur Films" and dubbed this residence the Hermitage. Motivated by Nepali street art and especially by Newar traditions of *putali* puppetry, Ford then decided to brand this Operation Minotaur with "a skeleton template" that revised Picasso's Minotaur frontispiece and included the figure in his collection *7 Poems* independently published in Kathmandu (1974) (figure 5.2).[18]

Soon thereafter, he folded his artistic endeavors, including those with Tamang, into what he called Operation Minotaur's "Global Workshop" during his later seventies, eighties, and nineties. An *Operation Minotaur Manifestation* exhibition at October Gallery in Kathmandu in 1984, for example, listed Tamang as collaborator. Ford likewise imagined his various international residences to be Operation Minotaur bases, and he once cited his sister Ruth as a New York Representative.[19] Gnamat Design Studio letterhead likely dated 1981 notes her participation, lists both his name and Tamang's, and identifies their Kathmandu studio as A Division of Operation Minotaur (Gnamat is Tamang spelled backward) (figure 5.3). Further linking himself to the Minotaur mythology, he titled his collection of poems from 1991 *Out of the Labyrinth*, and haiku notebooks as well as artwork often featured mailing labels that give his address or Tamang's as "Charles Henri Ford / Operation Minotaur / 1 West 72 Street / New York, NY 10023" or "Indra / Operation Minotaur / One West 72nd Street / New York, NY 10023." With the title of this project also signifying on the Buddhist mantra *om* (Ford published his trilogy *Om Krishna I*, *Om Krishna II*, and *Om Krishna III* between 1979 and 1982), *View*'s former editor simultaneously drew inspiration from local Nepali culture—what his friend and fellow expatriate Ira Cohen calls "a cross-cultural synthesis of surreal intent."[20]

144 *Queer Senior Living*

5.2 Operation Minotaur icon from *7 Poems*, published by Bardo Matrix in Kathmandu, Nepal, 1974. Photograph by Rémi Brandon/Soccochico.

As he did so, Operation Minotaur extended experimental modernist poetics that predated but nevertheless informed the surrealist movement. As his reference to Pound's collection *Personæ* (1926) in one haiku-filled notebook cited earlier suggests, Ford considered many of his OM haiku written in the 1990s to be modernist in form, while he once cited Edo period Japanese poetry as a main influence.[21] Inquired one interviewer in 1986 at the Dakota: "In the later issues of *View*, you always ran Rimbaud's famous injunction 'il faut être moderne.' What did it mean to you to be 'moderne'? Is it still important for you?" Ford tellingly responded: "It means exploring a domain of poetry that has been untapped. In my haiku I do that too. There's still something enigmatic, still avant-garde. It never really changes."[22]

GNAMAT DESIGN STUDIO
A Division of Operation Minotaur

Charles Henri Ford P. O. Box 829
Indra Bahadur Tamang Kathmandu, Nepal

New York Representative: Ruth Ford

Charles Henri Ford BIBLIOGRAPHY
Prose
The Young and Evil: Paris, Obelisk Press, 1933. Novel--written with Parker Tyler.
 Paris, Olympia Press, 1960. The Tr_veler" Companion Series, No. 80.
 Cover photo by Herbert List.
 New York, Arno Press, 1975. A New York Times Company publication.
Poetry
A Pamphlet of Sonnets. Majorca: Caravel Press, 1936. Frontispiece drawing, Tchelitchew.
The Garden of Disorder. London: Europa Press, 1938. Frontispiece portrait drawing,
 Tchelitchew. Introduction by William Carlos Williams.
 1939
 Norfolk, Conn./New Directions.
ABC's. Prairie City, Ill.:The Press of J_mes A. Becker, 1940. Cover collage,
The Overturned Lake. Cincinnati, Ohio: Little Man Press, 1941. Frontispiece and
Poems for Painters. New York: View Editions, 1945. title-page by Matta.
The Half=thoughts, the Distances of Pain. New York: A Prospero Pamphlet, distributed
 by Gotham Book Mart, 1947/ Cover drawings by Dimitri Petrov.
Sleep in a Nest of Flames. New York: New Directions, 1949. Introduction by
 Edith Sitwell.
Spare Parts. A New View Edition, distributed by Horizon Press, New York, 1966.
 'Artist's book' in photolitho, printed in Athens, Greece.
Silver Flower Coo. New York: Kulchur Prrss, 1968. CollAge poems. Cover: people=collage
 by CHF from photographs by Peter Fink.
Flag of Ecstasy. Selected Poems. Edited by Edward G. Germain. Los Angeles:
 Black Sparrow Press, 1972. Cover-portr_it, photograph by
 Henri Cartier-Br sson.
7 Poems. Kathmandu, Nepal: BArdo Matrix, 1974. Cover-portrait, photogra]h by
 Ira Cohen.
Om Krishna I: Special Effects. Cherry Valley, N.Y.: Cherry Valley Editions. Volume one
 of a tetralogy. 100 copies with prints by CHF
~~in production.~~ with Collage=prints by Indra.
Om Krishna II: From the Sickroom of the Walking Eagles. Cherry Valley Editions. /
Sedret Haiku. The Red Ozier Press. With ~~photographs by Indra.~~
 drawings by Isamu Noguchi

Books and Magazines, Editor of:
Blues. A Magazine of New Rhythms. Columbus, Miss., 1929-30.
View. A magazine of literature and the arts. New York, N.Y., 1940-47.
The Mirror of Baudelaire. Norfolk, Conn.: New Directions, 1942.
A Night with Jupiter & Other Fantastic Stories. New York, N.Y. A View Edition,
 distributed by XX The Vanguard Pr ss.
Young Cherry Trees Secured Against Hares,. The selected poems of Andre Breton,
 translated by Edouard Roditi. XXXXXXXXXXXXXXXX New York, N.Y.
 194 : View Editions. With drawings by Arshile Gorky. Cover by Duchamp
Green Song by Edith Sitwell. Poems. With cover & frontis]eieud by Tchelitche . New York,
 XXX N.Y.: A View Edition, 1947. Distributed by the Vanguatd Press.

5.3 Charles Henri Ford and Indra Bahadur Tamang, Charles Henri Ford's bibliography typed and edited on Gnamat Design Studio letterhead, 1981? Series 6, box 53, folder 5, Charles Henri Ford Papers, Getty Research Institute, Los Angeles (900194). Reproduced by permission of Indra B. Tamang. Photograph by Getty Research Institute.

With scores of these unchanging haiku, Ford thought himself preserving a mode of "moderne" poetics stretching back to the final third of the nineteenth century. His citation in *View* was to Arthur Rimbaud's *A Season in Hell* (1873), but we should recall that works such as Amy Lowell's "Twenty-Four Hokku on a Modern Theme" (1921) and Pound's "In a Station of the Metro" (1913) Westernized the genre of haiku given that "avantgardism played a fundamental role in the spread of haiku poetics" beyond its popularization in the United States by artists such as Yone Noguchi.[23] Situating himself in this lineage, Ford began drafting his own haiku compositions in Kathmandu in the 1970s and variously titled this project "Secret Haikai," "Haikus from a Diary," and "Haikai for Indra." Such preoccupation with haiku would last well into the final decade of his life when making art became more taxing. Alongside collages that the next two sections detail, these modernist/surrealist poetics were at the heart of his Operation Minotaur undertaken at the Dakota.[24]

I have spent several paragraphs spelling out their associative links to Breton, Picasso, and Rimbaud, but how, exactly, were Ford's haiku surrealist in execution other than his performative pronunciation of them as such? When an interviewer asked him in 1986, "What do you think has been . . . the consistent thread that has run through all of your activities?," he pithily replied: "Surrealism," but the compositional intricacies of his poetics need elaboration.[25] When you comb through the archived notebooks, they initially suggest that Ford scribbled down every single line of haiku that popped into his head. Some he would revise or discard with an X crossed over them. Most he left as is. While a clear link between these hastily written poems and surrealist technē may not be self-evident, Ford once likened his 5-7-5 syllable combinations to observations written in what he called his "street diary": "I kept a notebook with me at all times and wrote wherever I was. . . . I even developed the technique of writing while walking as though it were a camera instead of a diary."[26] He likewise once wanted to title his haiku "Automatic Memories" given that "I sometimes feel like / A Haiku Automat this / Is one that came out."[27] "If they come to me," he told another interviewer, "I have to write them down quick, otherwise they fly out of my head."[28]

As a self-styled "Haiku Automat," Ford used a technique for drafting his haiku that was fairly mechanical, and he frequently punned on a surname he shared with a certain American automobile: "I had a T-shirt / That read Old Fords Never Die / They Just Run Faster."[29] What may look like a motorized toss-off from one perspective is, however, time-tested surrealism from another. As he confirmed "the surrealist's mission" in 1986 to be "tapping the unconscious, the irrational, the

incongruous and the nonsensical," Ford-as-Haiku Automat advanced surrealist traditions of automatic writing.[30] One haiku made this connection most explicit: "Thought collages means / Leaving yourself open to / free Association."[31]

Further confirming this link to surrealist practice, his stream-of-consciousness haiku likewise call back to what Ford, in a poetic theorization of even earlier semiautomatic writings, referred to in 1950 as "a more 'free' somnambulism" that informed his collection *Sleep in a Nest of Flames* (1949).[32] Hence even when an interviewer identified the compositional contradictions inherent in his haiku production by noting that the genre is "strictly form," Ford insisted that "a haiku can be surrealist. . . . [I]t ends up being surrealist because of the superimposition—two unrelated things that make a whole which seems to be a collage."[33] With his voluminous haiku, he yet again made *Minotaure* his own by reimagining surrealist engagements with automatism as part of "The Charles Henri Ford Experience."

Such being the case, Ford's "Haiku Autobiography" drafted in the final decade of the twentieth century refuses easy distinctions between his frail embodiment, his surrealized experiences of aging, and his long-standing modernist techniques. Given that one mid-1990s haiku theorized that "All writing is sur- / Real some of it is more sur- / Real than most of it," his Dakota poetics maintained that "when you reach my age / Everything seems unreal like / A motion picture."[34] With Ford's OM haiku functioning as everyday life writing, becoming oldest-old would turn into another surrealist act for this artist, one that he earlier deems "an experiment of / endurance in an / abnormal situation" and that he refers to in a questionnaire in 1996 as an "hallucinatory everydayness."[35] With thousands of his poems recording this "surrealism latent in the real" that he experienced while growing older, Ford's composition books carried forth an Americanized strain of surrealism that tracked "nonsensical" states of waking life alongside those repressed in timeless psyche.[36] Transcribing his activities and observations at the Dakota via semiautomatic writings and labeling this Upper West Side residence a "still avant-garde" workshop, he would dedicate himself to the haikubiographica of this surrealism for the remainder of his days.

II

Unlike Ford's former lover Barnes and her experimental revisions, Operation Minotaur's immersive undertaking was not a privatized enterprise aimed at short-circuiting the whims of male editors or publishers. Notebooks record that

Ford meant to publish some haiku as *The Minotaur Sutra*. As the golden doorway decal announced and as Gnamat Design Studio letterhead semiofficialized, OM was also visible to all who made their way to his apartment. But how many wanted to do so? "The Charles Henri Ford Experience" often reveals that Ford felt himself becoming more and more incongruous upon entering deep old age. *Oxford English Dictionary* tells us that the phrase "oldie-but-goodie" mentioned in one haiku I cited at the start of the previous section was coined in the 1930s to describe past-prime popular cultures, and that it also means a "hackneyed idea or joke; a cliché."[37] Ford's haiku confirm this definition and frequently fret that "America's No. 1 Surrealist" had fallen off the charts, steady-as-it-goes innovation notwithstanding. His surrealist notebooks record a sense of lost insiderdom as well as an intuition that he was aging into irrelevance. One haiku from around 1993 laments that "You'll be more famous / than Eliot that prophecy / Ain't come true yet."[38] Though he kept writing in an avant-garde idiom, Ford feared he was becoming a relic despite a reprint of *The Young and Evil* in 1988. While the later 1990s saw criticism of this novel—most notably by Joseph Allen Boone—he died before Brent Hayes Edwards, Juan A. Suárez, Tirza True Latimer, and, especially, Alexander Howard published subsequent scholarship on Ford's oeuvre.[39] In almost real-time, his haiku chart how his corporeal fragilization gradually overlapped with this precipitous drop in reputation.

Patti Smith, for one, agreed. Years after she visited Ford at the Dakota with Robert Mapplethorpe, her memoir *Just Kids* (2010) praised him for having "introduced Surrealism to America" but thought him "secretly wishing he were back in the salons of his youth, lorded over by Gertrude Stein and attended by the likes of Breton, Man Ray, and Djuna Barnes."[40] Smith's *sic transit gloria mundi* assessment is not incorrect, but something else is going on with Ford's investments in experimentalists encountered back in the day. Erroneously thinking himself the last of his modernist cohort, in his cutting-edge haiku he paradoxically chronicles what art historian Joanna Pawlik refers to as "the outmoding of the outmoded."[41] They show him coming to terms with outliving most of American modernism's queer practitioners including Barnes and his interlocutor Joseph Cornell. Take one representative haiku: "Older than I am / Paul Cadmus Philip Johnson / Anybody else."[42] That "anybody else" would eventually include surrealist Dorothea Tanning (1910–2012), who published *Coming to That: Poems* at age 101 in 2011, and who did not forget Ford when she recounted their friendship for *Café Review* in 1996. But in this haiku Ford cites fellow gay male experimentalists

Cadmus (1904–99) and Johnson (1906–2005). The former was a magic realist best known for queer-themed paintings made with egg tempera; the latter, a Nazi sympathizer also known for International Style–inspired designs such as the Glass House. Ford, it seems, felt these connections condensing down to a pittance, and this shrinkage became a rather surreal experience for an artist once accustomed to situating himself at various epicenters of avant-garde ferment.

Other poems invoke complementary motifs of compounding loss: "The day he hit ninety / He felt as though he'd been / thrown against a wall" and "Here are evoked the / Ghosts of memory see how / they drag the mind back."[43] In this second haiku Ford crafts a three-line life review, a genre detailed in chapter 4. Robert N. Butler theorized that the mnemonic life review was meant to help older individuals gain "wisdom and serenity."[44] Surrounded by "ghosts of memory," Ford wisely senses with candidness that tranquility was not to be had after his earlier social worlds evaporated. "Life," he wrote in 1994, "used to be just / A bowl of cherries now it's / More a garbage dump."[45] Whether this observation relates to his aging self, his increasing irrelevance to U.S. art scenes, or both is indiscernible to me. Ford clearly became increasingly known as that "gadfly" mentioned in this chapter's introduction with an accurate fear that his "Charles Henri Ford Experience" had gone off-brand. "The fashion for him," one critic assessed in 2003, "now seems partly tied to his longevity—Ford as a relic of New York gay life in the 1930's."[46]

Perhaps this reading helps explain Howard's astute insight that Ford "need[ed] to pepper his late poetry with so many references to friends and former artistic acquaintances."[47] His "Automatic Memories" add up to a tangled mesh of bygone modernist relations, but "Memoirs in Haiku" also functions as a retrospective that only his lonesome bothered to write. Across notebook page after notebook page march all the old familiar faces: Barnes, Dorothy Parker, W. H. Auden, Pound, Stein, Natalie Barney, Federico García Lorca, Moore, and E. E. Cummings; surrealist proponents and proto-surrealists such as Breton and Giorgio de Chirico; and postmodernist artists such as Andy Warhol and William S. Burroughs. We find Ford musing over Barnes in Patchin Place: "Djuna loved laughing / I made her laugh you've set me / Back ten years she said."[48] We find him teasing about the sexual exploits of avant-garde circles via the gay subcultural vernacular of *dishing the dirt*, or mischievous gossip: "Who was it went to / Bed with Djuna Barnes Kay Boyle / Peggy Guggenheim."[49] In another poem he turns the first and last names of several modernist acquaintances and

mentors into haiku: "Ezra Pound Gertrude / Stein William Carlos Williams / And Wallace Stevens."[50] Pound advised Ford on editing *Blues*; Stein mentored Ford, as did Williams; and Ford published Stevens's "Materia Poetica" in *View*. Yet the irony is that by the time he died he was known mostly for knowing much more famous modernists. A rather disheartening encapsulation of this downfall was the title of a three-page *Gay and Lesbian Review* essay from 2001, "Charles Henri Ford Was There," which concluded with no elaboration that the artist "now 93, spends his time making collages and writing haikus."[51]

Cry him a river. While you do, remember that Ford's longevity exiled him not only from passé environs but also from contemporary gay life. While his haiku recount former sexual exploits in New York City, Paris, Kathmandu, and elsewhere, this "ghost of the avant-garde" felt chronologically unmoored amid later twentieth-century American gay male subcultures.[52] I mean no disrespect to gerontophiles who pound his city's mean streets, but scores of poems report that few desired him. Like Steward with his essay "Detachment," Ford faced this rejection head-on with compositions insisting that "[d]irty Old / Men Need Love Too."[53] There's a much-needed M.A. thesis to be written on how versions of this cringey phrase, based on moral panics of male perversion and predation, appeared in late-nineteenth-century U.S. medical textbooks on demented senility, then Cold War tomes such as *Geriatric Medicine*, then in a song from 1969 by the very heterosexual jazz guitarist Joe Negri, and then in the filthy mouth of an older homophile activist cited in the classic study *Out of the Closets: The Sociology of Homosexual Liberation* by Laud Humphreys (1972).[54] Whether dirty old men ever need the love remains an open-ended question, but Ford's plaintive citation resounds. His surrealist haiku record where ageism meets up with what one Gay Liberation Front activist termed "the youthism of gay life . . . [whereby] millions of gays over 30 are lonely, isolated, rejected, unloved, and unwanted."[55] Was anyone shocked, then, that he did not think himself one of Manhattan's "foxy grandpas"?[56]

Still, Ford did not shirk from the gerontophobia that all my modernists also had to negotiate in one form or another. He too called out ageism while his poems record that "This ninety-year-old / Body is getting me down."[57] Though he was temporally exiled from modernist days of yore, his chronological endurance art recognized that "Tolerating a / Tottering body" was key to his particular "art of aging."[58] Faced with the fact that "Days no longer trip / the light

fantastic now they / go by with a thump," he often expressed a befuddled curiosity at just how nonsensical his nonagenarian life had become—a prime instance of the surreal manifest in the reality of his ever-aging body.[59] "Where is the mirror?," he wrote in 1998 or 1999, "I want to see if I look / Fragile as I feel."[60] While I cannot in good faith tell you that these poetics facilitated what Mary Ann Caws calls "the unleashing of the marvelous"—a key tenant of surrealism—they do document a queer geroresilience that never tipped over into what Swedish gerontologist Lars Tornstam terms *gerotranscendence*, or an idealized belief in optimal, spiritualized aging.[61] Though he did live to see their entrenchment within U.S. age ideologies, Ford was uninterested in ideals of successful aging that promoted functional mastery, and I do not want to reduce his complex affect down to what a geriatrician would write up as low life satisfaction. His haiku instead ask us to think about what can be managed when you approach late life as a mixed bag. As a one-line poem observes: "sweet and sour like old age."[62]

Despite his frustrations with growing older as a gay male modernist, then, Ford's haiku concluded that something's lost, but something's gained in living over thirty thousand days. "There's no where to go," he observed. "Here's to not moving / Drink it up and live it out."[63] Though he could not have known that he would live for almost seven more decades after he published *The Young and Evil* nor that he would chronologically surpass most of his age-graded peers, other poems similarly emphasize possibilities inherent within corporeal constrictions: "Keep your pencils / Sharpened the creative instinct / Is the last to go."[64] Perpetually finding himself flaming "out out out out out / Out out out out out out / Out out almost out" even though his days added up and up and up and up, this modernist embraced the unreal situation of making surrealism a decade after *American Quarterly* published its retrospective on Modernist Culture in America in 1987.[65] In astounding numbers, his haiku-in-place turned a New York apartment building into a phantasmagoria of experimenting with the trials and tribulations of maturity. Beginning his career in one hotel by editing *Blues* in the American South, he would end it in another former hotel on the East Coast by working on poems that tracked this self-periodization: "His life span was for / Most of the twentieth / Century whose was mine."[66] Unlike that little magazine he sold for $3 a subscription, however, by the end of the second millennium no one really wanted any volume of a modernist who had seen much, much better days.

III

Except Tamang, who is literary executor of Ford's estate. While these surrealist haiku document Ford's fragilized capacities, they also archive hours and hours of Tamang's labor as their shared life at the Dakota gradually blurred distinctions between caregiving and modernist collaboration to become a two-person collage. Take but three exemplary poems confirming Tamang's centrality to Ford's late life:

> Putting up with my whims and
> Curses (who? Indra)[67]

> Someone To Watch Over
> Me who do you mean Indra
> Bahadur Tamang[68]

> Indra Bahadur
> through thick and thin
> stayed with me[69]

Earlier, Ford had composed odes to Tamang in *Om Krishna III* and dedicated *Om Krishna I* "to Indra Bahadur Tamang / With love and gratitude."[70] Even earlier devotionals include his unpublished drafts of haiku, which he began in Kathmandu. Though poor compensation for Tamang's often unpaid stewardship, these paeans and acknowledgments mark his caregiver's primacy during the years that Ford formalized and instantiated Operation Minotaur. Over almost three decades at the Hermitage and at the Dakota, Tamang facilitated this modernism not only by preparing meals for him, picking up parcels for him, and helping him organize his days, but also by becoming his part-time muse. That said, I am much more interested in Tamang and Ford's joint collaborations than in Tamang as a spur for Ford's late-life surrealism. This section and the next detail how their cross-generational connection collaged their lives into a major component of turn-of-the-twentieth-century OM while they mainly spent time together in New York.

Before I survey productions supporting this last claim, let me acknowledge outright Ford's exoticization of this artist-caregiver, one inseparable from his

exoticization of Asian males in general. In unpublished life writings such as "Erotika Asiatica: A Haiku Testament" (ca. 1972), now held at the Getty Research Institute's Research Library and Special Collections and which Ford revised into "Poet in Kathmandu: An Oriental Idyll," now held at the Beinecke, his ethnopornographic texts characterize a thinly veiled Tamang as a colonial cliché: "the beloved and quintessential, the adorable and attentive page-boy."[71] In an interview in 1974 for *Gay Sunshine*, Ford asserted that "[Tamang's] different, but he's kind of the ideal that I was looking for in all these Italians and Greeks and never found."[72] In a subsequent conversation he stated that "Indra is the prototype of The Legendary Companion."[73] I respect the thorny ways that any intimate relationship negotiates imbalances over any period of time, yet these early depictions of Tamang are akin to what Eng-Beng Lim refers to, in the context of "colonial legacy," as "queer couplings at once dirty and tender, patronizing and enabling, real and fantastic," and what Boone neologizes as homo-orientalism.[74] While Nepal, unlike its geographic neighbor India, was never formally colonized, Ford nonetheless situates his middle-aged self and his fantasies of a younger Tamang within this queer tradition that Lim links to other international male literary modernists.[75]

Such comments also betray Ford's thin knowledge of Tamang's upbringing in particular or a modernizing Nepal in general: little reflection on Tamang's rural-to-urban migration to the nation's cosmopolitan capital; little insight into Tamang's impoverished ethnicity or connection to one of Nepal's indigenous Buddhist populations resistant to Hinduization; little understanding of his elite status as a sixty-four-year-old American participating in what anthropologist Mark Liechty describes as Kathmandu's "expat hippie arts scene" that stemmed from Western tourism first begun in 1955.[76] It seems that Ford did not learn to speak Nepali fluently, though he drew on Kathmandu Valley cultures as a creative resource. His knowledge of Nepal was mostly akin to promotional travelogues published in the early 1970s, such as *Know Nepal and Nepali* or *Hill Resorts of India and Nepal: A Traveller's Guide*. I also cannot detect much consideration on his behalf for what Mukta S. Tamang deems the "Tamang diaspora"—now estimated to be in the thousands—thriving in New York City neighborhoods such as Woodside following migrations enabled by the Immigration and Nationality Act of 1965.[77] Flattening the cultural density of regional and globalized Tamang, Nepali, and Nepali American cultures ("I find a completely new inspiration here, probably because it is the East"), Ford's exoticized inattention places him squarely

154 *Queer Senior Living*

within another all-too-"moderne" tradition that parallels his queer orientalism: surrealism's fetishism of indigenous populations.[78]

While Ford's unknowing mars his archives, his relationship with Tamang nevertheless shifted over the decades to become a sustaining partnership beholden to experimental aging in place (figure 5.4). Across a quarter-century, what began as an imbalanced stranger intimacy developed into a long-term familiarity and a shared collaboration. In *Operation Minotaur: Haikus and Collages by Charles Henri*

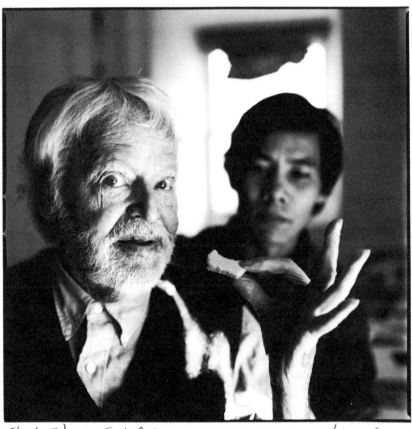

5.4 Arthur Tress, *Charles Henri-Ford, Poet, N.Y., N.Y. 1997*, 1997. Gelatin silver photograph, 11 x 14 in. (27.9 x 35.6 cm). Brooklyn Museum, N.Y., gift of William and Marilyn Braunstein, 2009.86.16. © 2021 Arthur Tress Archive. Photograph by Brooklyn Museum Image Services.

Ford and Photographs by Indra Tamang, published four years after Ford's death, Tamang's author bio states that "he befriended Charles in 1972 & became his collaborator & caregiver until his death."[79] They were not lovers, but they did become deeply loving. When an acquaintance asked Tamang about the nature of their relationship, he replied that "my intention was to have work and a better life than what I had in the village, and that was all. I never in a thousand years had other intentions."[80] Ford, for his part, fantasized that their close relationship was almost marital, recording "Indra's and my 20th anniversary" on the second day of August in a day planner in 1993.[81]

Such cross-generational, cross-racial, translocal intimacies were never divorced from intimate labor, or what promotions for assisted living today refer to as companion services. While Ford gradually found himself in one twentieth-century master narrative—mass longevity—Tamang gradually found himself in another: eldercare provided by the global South, as detailed by sociologists and anthropologists such as Evelyn Nakano Glenn, Linta Varghese, Cati Coe, and Martin F. Manalansan IV.[82] Tamang's remuneration remains fuzzy. Ford was at times reliant on selling his former lover Tchelitchew's art for income, and payment to his steward-turned-collaborative-caregiver was under the table, or "part of the so-called 'gray market.'"[83] Two years after Ford's death, Tamang reminisced that Ford "was a thousand percent dependent on me in the later part of his life."[84] But he himself also "never thought about working so many years. I was not 100% certain what my future would look like."[85] His tense and tender ties to Ford were quite precarious, and I have thought often about the nights that Tamang spent at the Dakota before he wed Radhika Lama the day after Christmas in 1997. How restless were they? How comfortable was he? Ford's haiku reflect worry about his status in late life as former interlocutors became modernist all-stars. Tamang worried about his livelihood before and after he became a permanent resident of the United States in 1997.

Within the "messy micropolitics"—Manalansan's apt phrasing—of this sweet and sour relationship, the two made their modernism.[86] More often than not, collage was the linchpin. Begun in the mid-1930s, Ford's investment in collage makes sense given that juxtaposition was an established surrealist technique that gallery owner Julien Levy identified as one of the movement's core traits in his survey *Surrealism* (1936).[87] In an interview in 1986, Ford confirmed that "surrealist collage" was one of "the sources and goals of [his] visual aesthetics" and that "I've just come down to saying life itself's a collage."[88] Fine and good and in

keeping with his theories of automatic haiku-as-life writing, but I add that Tamang, too, operated in this experimental language of queer modernist collage. He affirmed that "the best collage Charles created was the life that Charles lived." His blog *Hermitage* posted that "Charles taught me that form of art as well, and for a time I too made collages and saved photos and magazine cuttings to use later."[89]

Tamang undersells himself. One of the many marvelous collages that he made after he undertook his own modernism starting in the 1970s was with the life that Ford had thus far lived. The year 1989 saw the release of a collaborative tenth and final edition of *Blues*, which they worked on at the Dakota. Overtaking the literary magazine *Unmuzzled OX*, which ran from 1971 to 2001, this last issue of Ford's first magazine included contributions from Allen Ginsberg, Afro-surrealist Ted Joans, and novelist Lynne Tillman. While Ford's brainchild, *Blues 10* also featured Tamang's geromodernism, printed when he was around thirty-six. Its table of contents page displayed Tamang experimenting with Ford's aging by collaging the latter's modernist enterprise. Using tried-and-true surrealist techniques of cutting, pasting, and rearranging, this 4 × 2½-inch collage juxtaposed three paintings and two photographs to spell out the magazine's title (figure 5.5).

Reading sequentially, this artwork incorporates the following:

B features Pavel Tchelitchew's *Portrait of Charles Henri Ford with Book* (1937).
L features Tchelitchew's *Blue Boy with a Pitcher (Charles Henri Ford)* (1933).
U features a black-and-white passport-size photo of Ford for a Nepal trekking permit—probably 1981.
E features Tchelitchew's *Portrait of Charles Henri Ford* (1933).
S features Carl Van Vechten's November 14, 1934, photograph.

Underneath this collage is a cutout of a black-and-white photo of King Oliver's Creole Jazz Band circa 1923 featuring Louis Armstrong. Titled *Indra's Cover for Blues 10*, Tamang's collage repurposes an artist whose works he would later inherit and, he once stated, sell off to pay for his daughter's tuition at Boston College and remit to family members in Phakhel.[90] He mixes and matches a twentysomething Ford with a midlife Ford thanks to the youthful portraits by Tchelitchew and Harlem Renaissance fixture Van Vechten. Released right around Ford's eighty-first birthday, Tamang's artwork thus collages Ford's lifespan

I.2 Faith Ringgold, *The Sunflower Quilting Bee at Arles*, 1996. Color lithograph, 22 x 30 in. (55.9 x 76.2 cm). Philadelphia Museum of Art, gift of Anne d'Harnoncourt, 1996, 1996-124-1. © 2021 Faith Ringgold/Artists Rights Society, N.Y. Courtesy of ACA Galleries, N.Y. Photograph by Philadelphia Museum of Art.

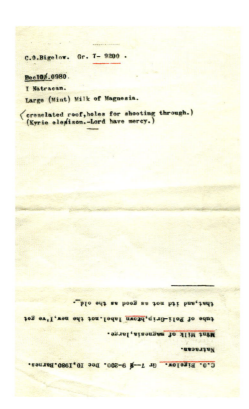

(top, left) 1.4 Djuna Barnes, "C.O.Bigelow.," December 10, 1980. Courtesy of Hank O'Neal.

(bottom, left) 3.1 Ivan Albright, *Woman*, 1928. Oil on canvas, 33 × 22 in. (83.8 × 55.9 cm). Museum of Modern Art, New York. Digital Image © The Museum of Modern Art/Licensed by SCALA / Art Resource, New York. Photograph by Museum of Modern Art.

(bottom, right) 3.2 Ivan Albright, *Flesh (Smaller Than Tears Are the Little Blue Flowers)*, 1928. Oil on canvas, 36 × 24 in. (91.4 × 61 cm). Art Institute of Chicago, gift of Ivan Albright. Photograph by The Art Institute of Chicago / Art Resource, New York.

3.3 Ivan Albright, *Into the World There Came a Soul Called Ida*, 1929–1930. Oil on canvas, 56¼ × 47 in. (142.9 × 119.2 cm). Art Institute of Chicago, gift of Ivan Albright. Photograph by The Art Institute of Chicago / Art Resource, New York.

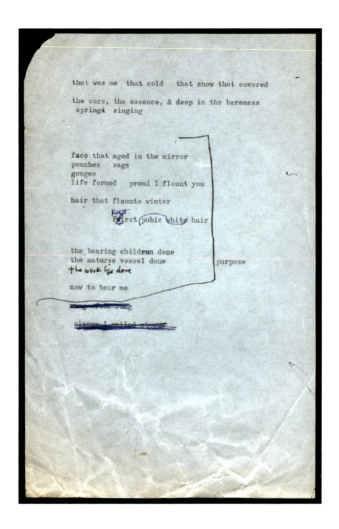

(top) 4.1 Tillie Olsen, miscellaneous draft fragment, date unknown. Series 14, box 18, folder 7, Tillie Olsen Papers, Department of Special Collections, Stanford University Libraries, Stanford, Calif. (M0667). Courtesy of the Department of Special Collections, Stanford University Libraries. Reproduced by permission from Frances Goldin Literary Agency.

(top, opposite page) 5.7 Indra B. Tamang, untitled collage (front), February 10, 1976. Series 6C, box 53, folder 5, Charles Henri Ford Papers, Getty Research Institute, Los Angeles (900194). Reproduced by permission of Indra B. Tamang. Photograph by Getty Research Institute.

(bottom, opposite page) 5.8 Indra B. Tamang, untitled collage (back), February 10, 1976. Series 6C, box 53, folder 5, Charles Henri Ford Papers, Getty Research Institute, Los Angeles (900194). Reproduced by permission of Indra B. Tamang. Photograph by Getty Research Institute.

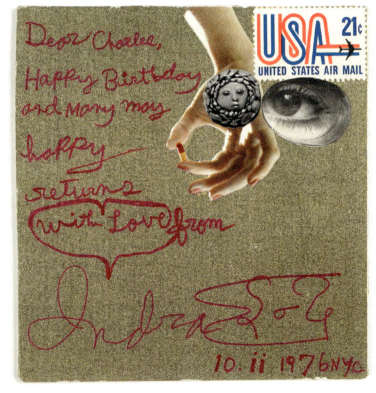

Dear Charles,
Happy Birthday
and many many
happy
returns
with love from

10. ii 1976 NYC

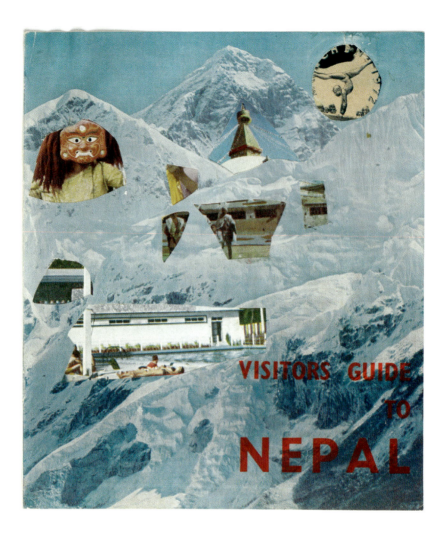

(above) 5.9 Indra B. Tamang, untitled collage (front), 1976. Series 6C, box 53, folder 1, Charles Henri Ford Papers, Getty Research Institute, Los Angeles (900194). Reproduced by permission of Indra B. Tamang. Photograph by Getty Research Institute.

(top, opposite page) 5.11 Indra B. Tamang, untitled collage (front), 1977. Series 6C, box 53, folder 2, Charles Henri Ford Papers, Getty Research Institute, Los Angeles (900194). Reproduced by permission of Indra B. Tamang. Photograph by Getty Research Institute.

(bottom, opposite page) 5.12 Indra B. Tamang, untitled collage (back), 1977. Series 6C, box 53, folder 2, Charles Henri Ford Papers, Getty Research Institute, Los Angeles (900194). Reproduced by permission of Indra B. Tamang. Photograph by Getty Research Institute.

WITH BEST COMPLIMENTS OF:
ROYAL NEPAL AIRLINES

HIMALAYAN SIGHT SEEING FLIGHT
TWIN OTTER.

'77

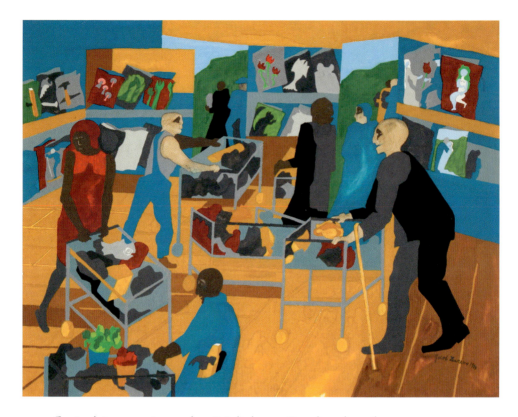

C.1 Jacob Lawrence, *Supermarket—Periodicals*, 1994. Gouache and pencil on paper, 19¼ × 25½ in. (50.2 × 64.8 cm). Private collection. © 2021 The Jacob and Gwendolyn Knight Lawrence Foundation, Seattle / Artists Rights Society (ARS), New York.

5.5 Indra B. Tamang, *Indra's Cover for* Blues 10, 1989. Reproduced by permission from the artist.

from young adulthood to older adulthood by recycling Van Vechten's queer Anglo-American modernism and Tchelitchew's queer Russian American modernism as well as Ford's tourist documents from his travels to Nepal. Concentrating on Ford's facial features, his is an aesthetic experiment with Ford's physiological age.

Though this collage concentrates on Ford, I underscore that Tamang utilizes Ford's portrait to undertake his own modernism within the Dakota in the late 1980s. We could designate this experimentalism in a few ways. Mindful of his cutout of Joe Oliver's jazz band, we might regard him as a participant in the deep tradition of Afro-surrealism advanced by *Blues 10* contributor Ted Joans, who was Ford's close friend and dedicated his poetry collection *Our Thang* to the artist in 2001. Considering that he scissors-and-pastes a photo stamped by immigration officials at Nepal's Ministry of Home Affairs alongside Tchelitchew's surreal images, we could also categorize this project with a neologism: *gerogeomodernism*. I add to Laura Doyle and Laura Winkiel's coinage when I mull over how Tamang plays with Ford's aging passport here as well as his own status as a South Asian artist. My thinking about this matter has also been influenced by Jessica Berman's claim, regarding pre-independence modernist Indian literatures, that "we will not see it as simply mirroring or mimicking the metropolitan canon."[91] I do not believe that Tamang's experimentalism is derivative in any pejorative sense. His transnational modernism taps the vein of Ford's tried-and-true surrealist lineages—he refers elsewhere to his admiration for Man Ray and Rimbaud—but I do not want us to lose sight of the fact that a member of the indigenous Tamang community crafted this piece. While he did not identify with cosmopolitan Nepali surrealists such as Shashi Shah or a vanguard Nepali collective such as SKIB (Shah, Krishna Manandhar, Indra Pradhan, Batsa Gopal Vaidya) who started, like him, in the early 1970s, his is nevertheless a worlded surrealism that is part and parcel of OM's Global Workshop, which "reworks yet revalues modernist bricolage."[92]

The takeaway, I sense, stays the same no matter what we decide to call this rich and strange work: collaging Ford's aging selves with his own transnational self, Tamang contributes to the modernist magazine *Blues* as much as Pound or Williams or Kay Boyle. Ford may take the form of the possessive here, but Tamang's cover art places him in the long line of the movement's incomplete global genealogies. As much as Ford drew from Kathmandu street cultures to brand OM starting in the 1970s, so did Tamang draw from Ford's lifespan to

make this cross-cultural collage. To call back to that Gnamat letterhead: Ford's Operation Minotaur was Tamang's Design Studio, too. To spin out one of Ford's haiku: "From Gautier to / Baudelaire to Jean Cocteau / To Charles Henri Ford" to Indra Bahadur Tamang, who watched over Ford making modernism and at the same time forged his own.[93]

IV

Recalling Ford's theory of life-as-collage, we also find that shared life at the Dakota allowed for "radical juxtaposition that produces new insight" into Tamang's extensive caregiving informing Ford's ultimate modernist productions in 2001.[94] Before this section describes these intricate mashups of collaboration and collage, imagine what their Dakota apartment had become once Ford's health took occasional turns for the worse. Archival documents detail that the proponents of Operation Minotaur found themselves in a labyrinth of geriatric care management. Included in the same Beinecke collection that houses Ford's haiku is a box of largely unprocessed medical documents from the 1990s to 2003 testifying to an intensifying surreality: a Medicare Part B application starting at age eighty-eight in 1996, an AARP Medicare Supplement Plan in 1998, Explanation of Benefits (EOB) form after EOB form after EOB form, bills for "therapeutic exercises," "neuromuscular reeducation," and "gait training therapy" from the Dewitt Rehab and Health Care Center in the summer of 2002, bills from the East River Medical Imaging Association, bills for emergency care, posthumous claims for renting a wheelchair with leg rests.[95] Ford had marked up earlier medical documents from the late 1990s with perplexed queries in blue, black, and yellow markers: "Indra, do you understand this? (I don't!)"; "Indra, what to do?"; "Indra, do we understand this?"; "Indra, what shd be done—if anything—about this?"[96]

File after file, invoice after invoice, these documents piled up over Ford's later life and continued to be mailed to his Dakota apartment address (now The Estate of Charles Henri Ford) a year after his death on September 27, 2002. None has the fantastic aura of a fur-covered teacup by Meret Oppenheim or Man Ray's photograph from 1933 of a black-and-white female nude titled *Minotaur*, which were both featured in newly renovated MoMA gallery space dedicated to "Surrealist Objects." Nor, for that matter, did apartment 103 fit conventionally "fantastic architecture," such as Antoni Gaudí's *Sagrada Família* or Kurt Schwitters's

160 Queer Senior Living

Merzbau, both cited in MoMA's exhibition catalogue in 1936 on Dada and surrealism.[97] But we should treat a Medicare summary notice addressed to the New York City base of Operation Minotaur as yet another instance of "the innate surrealism of America" that made Ford's later life even more realistically unreal.[98]

Amid these irrationalities of growing oldest-old within this Americana Not-So-Fantastica, Ford kept at surrealist collage as much as he did surrealist haiku. Tamang's caregiving provided stability for Ford as he produced his pieces during this increasingly difficult time, one that saw Ford admitted for a spell to what is now the Upper East Side Rehabilitation and Nursing Center. While we looked over a pile of Strathmore drawing pads that Ford had filled with pretty good collages, Tamang recalled to me that "Ford almost until end of his life would lie in bed, then get up, and then start cutting."[99] Many of these were cutouts of the skeletal icon that Ford originally used as a trademark for Operation Minotaur. A frailish Ford would take a sheet of paper, cut out the design, and usually paste them into an octagon. A good example of cross-generational intimacy with one's own person, this is the same technique that U.S. kindergarteners use for making paper snowflakes to post on schoolhouse windows during the winter season. One haiku by Ford poignantly reflected this process as well: "Second childhood's here / Not only because I'm cutting / Out paper dolls."[100]

Not all these collages, however, are kid-friendly. Some were from softcore U.S. gay male magazines like *Blueboy* and *Men*. Witness one collage incorporating material probably from an *International Male* catalogue alongside a knock-off Warhol of Che Guevara (figure 5.6). With Ford finishing this piece in the summer of 2001 and signing it with his surname, it fits with another working title of his late-life corpus, "Magic Scissors: Cutouts and Collages," which paid homage to Matisse's paper cutouts made while bedbound, such as *The Parakeet and the Mermaid* (1952) and *The Swimming Pool* (1952). "I'm doing collages now," Ford told one curious interviewer. "I picked up on the way Matisse worked in his last phase—cutouts."[101] Though he yet again recycles a modernist tradition by "laying claim to a position behind the curve, introducing outmoded Surrealist [and an ailing Fauvist's] practices into a different context that was itself on the wane," this untitled cutout also reuses contemporary American gay male print cultures based in New Jersey and Los Angeles.[102] Featuring a shirtless and toned male body, it should be placed in genealogies of queer collage fostered by Warhol, Cornell, and Mapplethorpe—and critiques of older adults as sexless. While he, unlike Olsen, was never an affiliate of the Gray Panthers, the collage recalls a

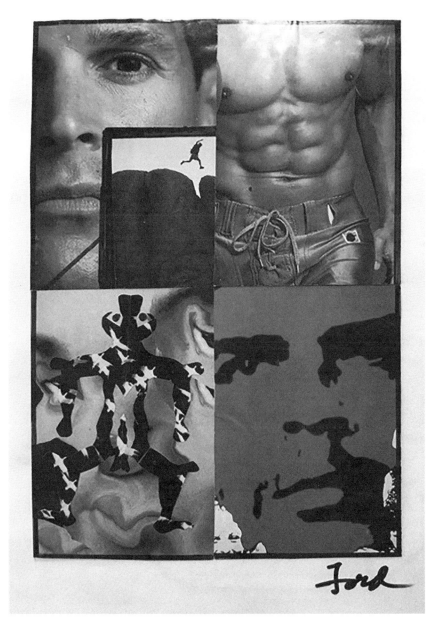

5.6 Charles Henri Ford, untitled Operation Minotaur collage, 2001. Reproduced by permission from Indra B. Tamang. Photograph by author.

quote in founder Maggie Kuhn's memoir *No Stone Unturned* (1991) when the activist reflected on her romance in her seventies with a twenty-one-year-old comrade from the University of Washington: "Make sex an art."[103]

I don't know if Ford used OXO Good Grips scissors originally "developed for older consumers" to make this collage, but I do know that Tamang aided him when he took care of Ford.[104] Collages signed by Ford such as this one were sometimes made with Tamang's help if the scissors proved too cumbersome to manipulate or too heavy for cutting.[105] Shared collaging with shared clippers thus became a *magique* activity of daily living closer to the end of Ford's life. In their normative usage, activities of daily living (ADLs) refer to essential actions such as cooking, bathing, and grooming that home care workers will often facilitate for frail individuals. But queer collage-making was a vitalizing ADL for Ford as well. On days when I feel most generous, I like to think that surrealist collage-as-ADL helped him avoid institutionalization for as long as possible—thanks in no small part to Tamang's experimental home care.

Tamang, it turns out, had also been making an aging modernism years before his collaborator became unable to cut out paper dolls—and well prior to his *Blues* cover in 1989. Holdings at the Getty Research Institute Library document his interest in queer modernist collage starting in his early twenties, when he swiftly mastered the form. Ironically, the finding aid for its Charles Henri Ford Papers makes no mention of this activity in its Biographical and Historical Note detailing seventy-nine boxes of Ford's effects following an acquisition in 1990. Though he remains unlisted among its indexed contributors, the collection nevertheless includes a raft of Tamang's work included in a series filed under "Miscellaneous Art Material."

Having "successfully completed the requirements of the English Language Conversation Course, Level One" at the American Culture Center on December 16, 1976, in Kathmandu, Tamang had earlier learned this language of queer modernist collage after his chance encounter with Ford at the Panorama led to his employment around August 1973.[106] He would continue this artwork after the two moved, on and off, into the Dakota a year later. Nested within the Getty Research Institute Library's extensive records, for example, you find a modernist birthday card-collage for Ford signed and dated February 10, 1976, alongside another modernist birthday card-collage wishing America a happy birthday in 1985 (figures 5.7–8). Made when he was around twenty-three for Ford turning sixty-eight, the former collage wishes Ford "a happy birthday and many, many

5.7 Indra B. Tamang, untitled collage (front), February 10, 1976. Series 6C, box 53, folder 5, Charles Henri Ford Papers, Getty Research Institute, Los Angeles (900194). Reproduced by permission of Indra B. Tamang. Photograph by Getty Research Institute.

happy returns." At the same time, it pokes fun at heteronormative coupling as it records their own coupledom in New York City "with love."

As of this writing, there is no Hallmark card that celebrates or historically documents the queer surrealism of their intergenerational relation. Tamang nevertheless gives us one as he experiments with this genre. In his history of the twentieth-century U.S. "birthday industry," Howard Chudacoff reminds us that the birthday card is a modern invention meant to foster what he calls "institutionalized age consciousness" across the lifespan. "Late in the 1940s," he observes,

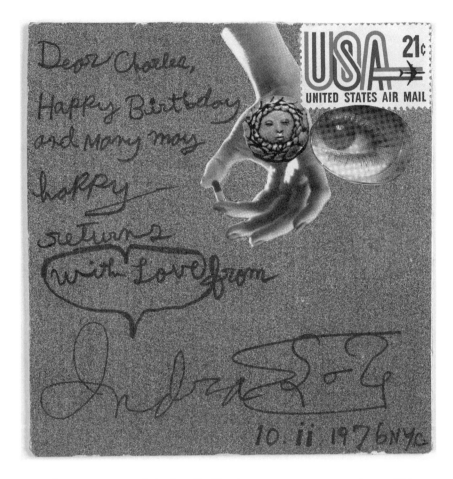

5.8 Indra B. Tamang, untitled collage (back), February 10, 1976. Series 6C, box 53, folder 5, Charles Henri Ford Papers, Getty Research Institute, Los Angeles (900194). Reproduced by permission of Indra B. Tamang. Photograph by Getty Research Institute.

"Hallmark brought out a card series for elderly birthday celebrants, which included special messages directed at people in their sixties, seventies, eighties, and even nineties."[107] While Tamang's birthday card participates in this now-ingrained cultural tradition, he formally surrealizes the genre with his modernist collage. In so doing he also conceptually surrealizes the genre with his affectionate address to Ford.

Other preliminary Operation Minotaur productions now held at the Getty Research Institute Library showcase Tamang making his own lifespan as

Queer Senior Living 165

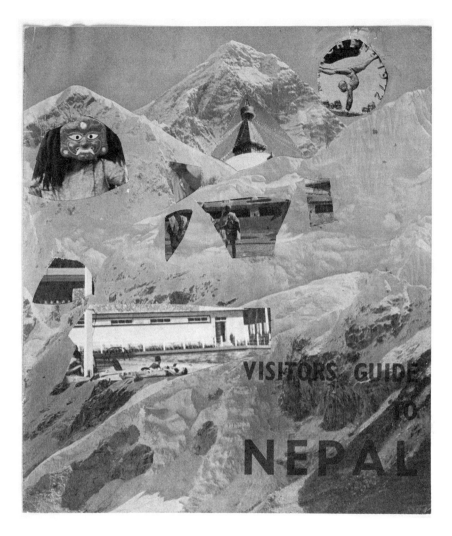

5.9 Indra B. Tamang, untitled collage (front), 1976. Series 6C, box 53, folder 1, Charles Henri Ford Papers, Getty Research Institute, Los Angeles (900194). Reproduced by permission of Indra B. Tamang. Photograph by Getty Research Institute.

modernist as he did Ford's in *Blues 10*. One piece collages images such as Pashupatinath Temple and the Boudhanath Stupa from a *Visitor's Guide to Nepal* from 1973, an English-language promotional travelogue published by Nepal's Department of Tourism that listed "government-recognized hotels with all modern facilities," including the Panorama, where he and Ford first met (figures 5.9–10).[108] Another collages a popular memento of post-Rana-era international travel to

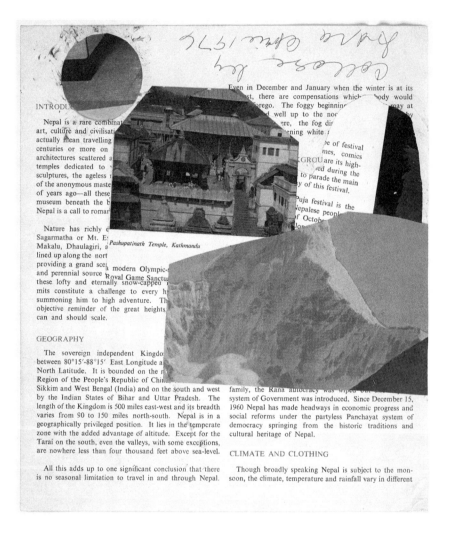

5.10 Indra B. Tamang, untitled collage (back), 1976. Series 6C, box 53, folder 1, Charles Henri Ford Papers, Getty Research Institute, Los Angeles (900194). Reproduced by permission of Indra B. Tamang. Photograph by Getty Research Institute.

Nepal (figures 5.11–12). Dated 1977, this particular collage superimposes the Statue of Liberty behind a snapshot of the Himalayan Mountain Range featured on a Royal Nepal Airlines postcard, and it calls back to Marcel Duchamp's collage of Breton's face onto the Statue of Liberty for the cover to *Young Cherry Trees Secured Against Hares* (1946).[109] Mashing up an iconic pastoralized image of U.S. immigration with iconic Nepali geography with an iconic carrier launched in

5.11 Indra B. Tamang, untitled collage (front), 1977. Series 6C, box 53, folder 2, Charles Henri Ford Papers, Getty Research Institute, Los Angeles (900194). Reproduced by permission of Indra B. Tamang. Photograph by Getty Research Institute.

5.12 Indra B. Tamang, untitled collage (back), 1977. Series 6C, box 53, folder 2, Charles Henri Ford Papers, Getty Research Institute, Los Angeles (900194). Reproduced by permission of Indra B. Tamang. Photograph by Getty Research Institute.

1958, the piece likewise surrealizes his migration that contributed to the Tamang diaspora in New York City. I have to wonder if he also had his status as an immigrant laboring eight miles away from Liberty Island on his mind.

To summarize: both Tamang and Ford were superb, sustained practitioners of this surrealist art form from their earlier days together to the turn of the twentieth century. Often made in-house at the Dakota, their collaging records what I can only think to call *assisted modernist living*. Tamang's was not solely the intimate eldercare of a disregarded modernist but also modernist eldercare. His caregiving, like Ford's aging in *this* place, went completely surreal as it became hard to tease out what is in-home care and what is collage. Ford's sustained queer modernist collage, I mean to say, is as much Tamang's sustained queer modernist collage, which is as much Nepali home-care modernism. Caregiving itself became a "collaborative experiment" at such moments—a mix of aesthetic and intimate labor that complemented Ford's poetic labor and extends surrealism's established interest in the joint endeavor.[110] Now archived "near [Tamang's] house in Queens" after he sold his Dakota apartment in 2019, their Magic Scissors production exemplifies "the fusion of the dissimilar" that was queer senior living when America's no. 1 surrealist was fourteen months away from dying.[111]

V

The preceding is some of what I came to after my visit to the Dakota for a few hours on July 10, 2018. Tamang had kindly driven in from Queens to share materials that have yet to find an institution willing to purchase them: photographs of Ford taken by Van Vechten and Henri Cartier-Bresson; those 2001 cutouts; his own collages. These days his life itself remains a robust experiment in aging as he continues in his later sixties with his family in Woodside and upstate New York, his fellow Tamangs, and his online street diary, *Hermitage*, where he occasionally blogs about growing older, his travels, and his memories of the Fords in the Dakota (figure 5.13). Before he would sell this apartment, Tamang had used the space as "an office, and a place to house the many boxes and file cabinets full of art, papers, photos, and memorabilia from Charles and Ruth, and my own artwork as well."[112] My visit confirmed this description when I stepped into a space overstuffed with large cardboard boxes, old files, and two bookcases stacked with titles such as Mina Loy's *The Lost Lunar Baedeker* (1996), copies of *View*, and

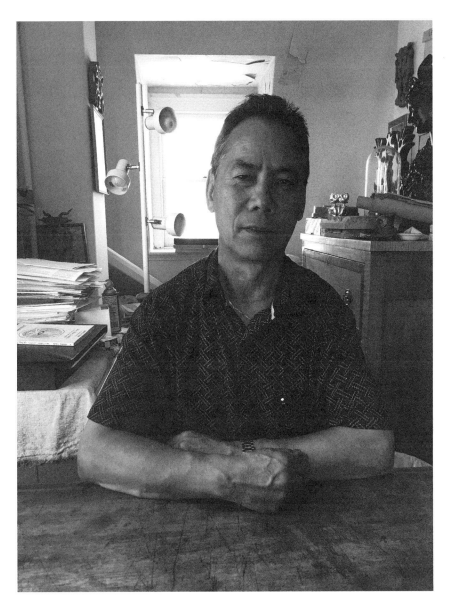

5.13 Indra B. Tamang in his former Dakota apartment, July 10, 2018. Photograph by author.

reprints of *The Young and Evil*. In its common area were Ruth Ford's wheelchair and Ford's exquisitely cremated corpse, some of which Tamang had already interned at Ford's burial plot in Mississippi. The Operation Minotaur decal then still marked the entryway into this space almost sixteen years after its originator's death, and another of Tamang's many collages still hung above a bric-a-brac table that held a brushed nickel OM figurine (figure 5.14).

With Tamang spending most of his time outside Manhattan after Ruth Ford's death, this apartment felt to me like a storage facility, a gallery, a queer South Asian archive, and a retrospective of Operation Minotaur's own "ghosts of memory" that collaged the still-living with the recently deceased. A self-professed custodian of Ford's memory, Tamang had partaken in an alternate form of caregiving as his poorly compensated servitude in the 1970s became continuous archival care by the 2010s. "I feel privileged and honored to have the stewardship of his work and his archives full of historical treasures," he tells his readers on *Hermitage*. "Wherever you are, Charles, you are missed, and forever appreciated."[113] But this empty yet overflowing apartment, I also sensed, stood as another record to the surrealization of Tamang's own global modernism, given that this artist used it to house "my own artwork as well" during and after his appointment as president of the Tamang Society of North America in 2008 and his participation as one of its Executive Board advisors starting in 2018. No wonder, then, that he held on to the place for almost a decade after Ruth Ford's bequest. Or that he hated giving it up. What one poet observed of Ford in 1996 is as true for Tamang in the third decade of the twenty-first century: "In new york he completely turns over / his life / style in the form of an archive."[114]

Yes, "Charles Henri Ford Was There," to again quote that title of a *Gay and Lesbian Review* retrospective in 2001, which is a direct quote from Stein's *Everybody's Autobiography* (1937). "Charles Henri Ford," her memoir recalls, "was there already but that was not interesting. One does like to know young men even though as soon as that they are not any longer young."[115] Stein accurately predicted Ford's chronological predicament. Many lost interest in him as he grew older, but I want this chapter to reignite curiosity about his longevity, his companion's experimentalism, and their avant-garde residence. In ways Ford did not anticipate, his tireless modernism fostered a supreme instance of Nepali modernism in the United States. Over the decades their interdependent exchanges were far from unproblematic, but his queer innovations at the Dakota facilitated Tamang's

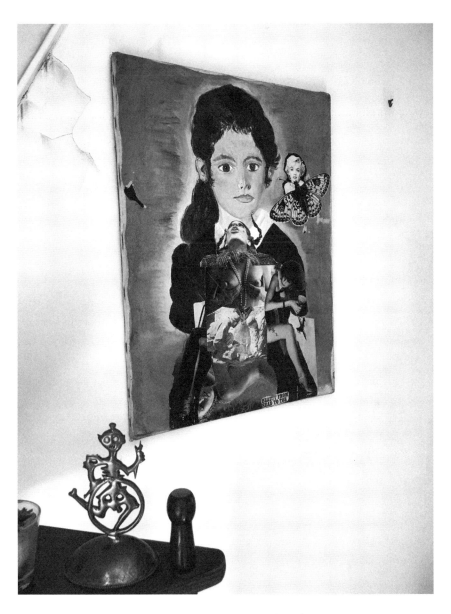

5.14 Indra B. Tamang's collage hanging near pewter replica of Operation Minotaur icon in apartment 103, The Dakota, July 10, 2018. Photograph by author.

own—together and separately. A found object recycled by Ford in older age, surrealism too became a readymade aesthetic for Tamang years before he naturalized in 2009.

The best collage that Charles and Indra created was, in sum, the life that Indra and Charles lived, one in which "The Charles Henri Ford Experience" melded into a modernist version of what Anne Basting terms *creative care*.[116] My conclusion is not hyperbolic when we recall that one working definition of collage is "a couple living together without benefit of marriage, in an arrangement that had been 'pasted' together."[117] Ford and Tamang were, of course, never married to each other. Yet by the end of Ford's long life, OM's global studio space had become an exceptional jumble of seemingly unrelated things—an older Anglo-American male, his South Asian partner, short-term skilled nursing facility visits, frantic collage making, wageless life, haiku drafting, a frustrating body, Nepali modernism, grueling care work, and Medicare B. Given discrepancies between Ford's privilege and Tamang's poverty, the two would never equalize over the many years they worked on this project. What a huge loss. However unreal this sentence sounds to me when I read it back to myself, they nonetheless turned Ford's aging in place into one of American surrealism's most remarkable productions.

I truly hope that this chapter has complicated glib newspaper accounts such as "The Butler Did It—at the Dakota." The headline underreports as much as it oversimplifies, for Ford and Tamang did so, so much at 1 West 72nd Street, apartment 103. For almost three decades they built a Palace of Knossos capturing the surrealization of aging in America. In an Upper West Side apartment worth a pretty penny, they proved themselves as groundbreaking, if not more so, as Ford and Tyler, Ford and Barnes, Ford and Tchelitchew. This duo should join the ranks of other collaborators, such as Stein and Toklas, Hughes and Hurston, and Pound and Eliot, as two who kept doing it—modernism, I mean—while they grew older, crafted, and slept in a ninth-floor nest of flames.

CHAPTER 6

The Harlem Renaissance as Told by "Lesbian Elder" Mabel Hampton

"Youth speaks," Alain Locke trumpeted in December 1925 at the tender age of forty, "and the voice of the New Negro is heard." Vocalizing a "generation now in the artistic vanguard," this resounding chorus of cutting-edge voices included "a vivid galaxy of young Negro poets" such as Claude "McKay [then thirty-six], Jean Toomer [thirty or thirty-one], Langston Hughes [twenty-four] and Countée Cullen [twenty-two]."[1] Each figured prominently in Locke's landmark volume *The New Negro*, a revised version of a March 1925 *Survey Graphic* issue that further formalized the Harlem Renaissance. In this expanded anthology, Locke's rising generation would be joined by Zora Neale Hurston (thirty-four), Richard Bruce Nugent (nineteen), and Gwendolyn Bennett (twenty-three). "Thoroughly modern, some of them ultra-modern," these artists differed, Locke assessed, from "veterans of a hard struggle" such as W. E. B. Du Bois (fifty-seven) and James Weldon Johnson (fifty-four), given that the former "constitute a new generation not because of years only, but because of a new aesthetic and a new philosophy of life" (Y 50, 49). Including other poets, playwrights, novelists, and musicians he mentioned in passing, Locke's generation collectively averaged somewhere in their thirties.

Part of the success of these younger New Negroes, Locke observed, was that "they have shaken themselves free from the minstrel tradition and the fowling-nets of dialect" entrapping "several unhappy generations" prior (Y 48). Their "modernity of style" thus offset racist and ageist depictions of post-Reconstruction Old Negroes—representational deformations of African Americans as simultaneously too young ("infantile, easily led, insensate") and too old ("ubiquitous black geriatric stereotypes") (Y 51).[2] In Henry Louis Gates Jr.'s memorable phrasing, Locke's was an attempt to inaugurate "a new generation of middle-class

African-Americans [who] would construct a still 'Newer Negro,' once again at the expense of the Old, in a desperate process of collective self-fashioning as a form of racial survival."[3]

Interestingly, when New Negroes of the 1920s disavowed such supremacist fantasies of "an Old Negro best forgotten," aging aided their "new aesthetic" recorded within Locke's anthology and without.[4] When youthful moderns speak in *The New Negro*, old age flows through this immense project. The persona of Langston Hughes's "The Negro Speaks of Rivers" (1921), written while he was a teenager, tells us that "I've known rivers ancient as the world and older than the flow of human blood in human veins," and Hughes compiled age-themed poems such as "Mother to Son," "Aunt Sue's Stories," "As I Grew Older," and "Death of an Old Seaman" for his first book of poetry, *The Weary Blues* (1926).[5] Best known for his stream-of-consciousness short story "Smoke, Lilies and Jade" (1926) focusing on a fey nineteen-year-old bohemian, Richard Bruce Nugent contributed a diasporic fantasia, "Sahdji," featuring a fifty-nine-year-old Konombju in East Africa. Included in the anthology's complementary unit on "The Negro Digs Up His Past," Arthur Huff Fauset transcribed a folk tale, "T'appin (Terrapin)," told by a formerly enslaved Oluale Kossola (Cudjo Kazoola Lewis), whose life narrative Hurston would record as *Barracoon: The Story of the Last "Black Cargo"* (1931; published in 2018). Often unremarked by scholars, modernist youth of the Harlem Renaissance repeatedly engaged with novel retellings of the old.

Then, too, we have the intergenerationalism of the New Negro endeavor itself. Intergenerational conflict no doubt structured the Renaissance during its height in the later 1920s. Think Hughes's manifesto "The Negro Artist and the Racial Mountain" (1926), its championing of "we younger Negro artists," and its rebuke of a bourgeois Talented Tenth supported by Locke and Du Bois.[6] Or *enfant terrible* Wallace Thurman's first issue of *Fire!!*, a poke-in-the-eye to Renaissance elders with its subtitle's explicit devotion to youth. But ample evidence of collaborations across the younger/older spectrum also exists, including an interracial relationship between Hughes and Carl Van Vechten, "a discoverer and sponsor of promising young Negro writers," as McKay recalled in *A Long Way from Home* (1937).[7] Locke's biographer Jeffrey C. Stewart also notes that "youth forced White and Black ideologues to add a new concept—generation—to the prevailing lenses of race and class used so extensively by Du Bois."[8] Even Locke's subsequent reassessment of the Renaissance relied on generational metaphors,

prophesizing in 1939 "that the 'New Negro' movement is just coming into its own after a frothy adolescence and a first-generation course."[9] Lest we forget, given that the *New Negro*'s editor was "an aging gay man," this new, newer, newest project was as queerly oriented as it was generationally minded.[10]

Enter Mabel Hampton, who saw this New Negro intergenerationalism to full fruition in the extraordinary final decades of her life. An unbilled chorine who worked at Harlem's Lafayette Theatre and the Garden of Joy in the 1920s after migrating from North Carolina to New York City in 1909, Hampton would be memorialized by the *New York Times* as well as regional and national LGBTQ newspapers as a "lesbian elder" following her death at age eighty-seven.[11] Honored for her extensive affiliations with the Lesbian Herstory Archives (LHA) since the 1970s and close relationships with LHA founders such as Joan Nestle, Hampton would become a crucial resource before and after her death for U.S. LGBTQ historians and cultural critics such as Barbara Smith, Eric Garber, and Lillian Faderman—especially her oral histories recorded and archived at the LHA, which contextualized the queer Harlem Renaissance that Locke, Thurman, Hughes, Cullen, and Nugent all spoke through.[12]

While she has gathered modest attention from new modernist studies, Hampton was part of a wider New Negro project during the 1920s. Though she did not formally associate with figures mentioned in *The New Negro*, she was intimate with renowned performers Gladys Bentley and Ethel Waters as well as their extensive social circles. In her reimagining of a queer and trans 1920s Harlem, Saidiya Hartman has fabulated this milieu to cast Hampton as but one of many African American ultramoderns. Arguing that "few, then or now, recognized young black women as sexual modernists," Hartman approaches Hampton's stage performances and her self-performances as part of "*the revolution before Gatsby*" and casts her as one of the underacknowledged "social visionaries and innovators" whose young lives double as avant-garde productions.[13]

Part of Hampton's vanguardism, for Hartman, includes her interracial, intergenerational erotics as a young butch exploring the big city.[14] Reworking archived oral histories that the LHA digitally uploaded onto its website, Hartman rehearses Hampton's participation in a sex party hosted at A'Lelia Walker's Harlem apartment at 80 Edgecombe Avenue. An older white lover, Ruth, initiates Hampton into this underworld. Others such as Gladys, "this beautiful woman, tall and brown skinned with gray hair," help to facilitate a "sensual

education" that concludes, in Hartman's telling, with Hampton working as a domestic during the Great Depression. Such is Hampton's "*beautiful experiment* in how-to-live" as a modern queer of color youth across the generational divides.[15]

Did the party end? Might Hampton's later-life endeavors at the LHA and elsewhere be as modernist as these scenes? Unlike this book's other featured artists, Hampton did not publish a novel. She did not write poetry. She did not paint. She did not collage. Yet her revolutionary performances persisted decades after her interactions in 1920s Harlem. Extending Hartman, I argue that Hampton's late life was as much a social innovation as her young adulthood, and that as a modern continuing her modernism, she maintained allegiance to intergenerational experimentation well into her seventies and eighties. Via these self-performances in the 1970s and 1980s, Hampton extended the New Negro project of queer intergenerationality in the later twentieth century. Her cross-generational relationality, we find, involved fellow African American butches in their forties, white femmes in their thirties, and a cis white gay man in his twenties curious to learn more about the vivid galaxy that Hampton once explored. These admirers, in turn, venerated Hampton as a Renaissance forebear up to and long after her death on October 26, 1989. Through her archived words and images, she enabled the queer Harlem Renaissance to further flourish into the 1980s and beyond. When Hampton speaks as an old-timer in the pages to come, we will again hear the voice of New Negro youth.

By giving center stage to her later life, I contend that Hampton never ceased the vanguard performances she undertook at the Lafayette or, in Hartman's account, Walker's apartment.[16] She just worked different venues when she performed older versions of herself in her later seventies and eighties as a wise if world-weary elder eager to tell tales of her former life as a Harlem neophyte. Like several notables in Locke's anthology, this one-time dancer thus contributed to the queer New Negro project of short-circuiting ageist depictions of African Americans while affirming older—and younger—generations, including her own.

Tracing these achievements across her published and unpublished oral histories, several photographs, and a traveling slide show (among other sites), my focus on Hampton as a concluding case study deepens this book's overarching argument on two interlocking fronts. First, by further elaborating on the theme of cross-generational encounters discussed in earlier chapters, emphasis on

Hampton's final decade reconfirms that sustained generational engagements (positive or negative) were vital to moderns in their pursuit of the new.[17] In a century increasingly structured by age segregation—what Howard Chudacoff describes as "the continuing habit of peer association carried throughout the lives of people born after 1900"—Hampton's relational intimacies dismissed this norm as she interacted with cohorts across the age spectrum.[18] Second, by performing the figure of the modernist elder with *and* for subsequent generations, Hampton actualized LGBTQ "age and youth in action," a catchphrase used by Gray Panthers committed to "preserving the precious compact between the generations."[19] Like the revues in which she danced or the wild parties she attended, Hampton's modernism was also an electric collective undertaking, one bolstered by younger friends, transcribers, photographers, documentarians, librarians, caregivers, poets, and lay historians. Together this motley crew captured the singularity of a life that bridged queer Afro-modernist projects of the 1920s with rediscoveries of said projects in the 1970s and 1980s. Though Hampton was not featured in Locke's anthology, her many shared years of experimentation nonetheless enriched the Renaissance's "matured expression."[20]

I

With the Lesbian Herstory Archives as one of her bases, Hampton advocated an intergenerationalism that situated her, in Hartman's words, as "a queer resource of black survival."[21] Combing through the eight boxes that constitute the Brooklyn-based LHA's Mabel Hampton Special Collection, you find as many documents and realia about her older age as you do about her youth. Alongside her correspondence from the 1920s, there is a living will, a power of attorney notice, plans and payments for a headstone she would share with her partner Lillian B. Foster at St. Raymond's Cemetery in the Bronx, notices from the Center for Independence of the Disabled, New York, home health care forms, Joan Nestle's guide for Hampton's caregiving, an issue of *Prime of Life: A Monthly Newsletter for the Long Living* from 1987, a photocopy of a speech she delivered to audiences at a Pride march in 1984, and hundreds of pages of painstakingly typed transcriptions of her oral history. As these collective materials make clear, the seventies and eighties were as formative for Hampton as the twenties and the thirties.

Many of these items also testify to an intimate life that she shared with Nestle, her close friend and fellow activist. Thirty-eight years her junior, her future caregiver first met Hampton in the early 1950s when the latter was employed as a domestic worker by Nestle's mother. "Our two lives, Ms. Hampton's and mine," Nestle recalls, "first intersected at a sadly traditional and suspect crossroads in the history of relationships between black and white women in this country."[22] This interracial relationship became long term, with Hampton and Nestle appearing together at LGBTQ functions throughout the 1980s and with Nestle tending to a frail Hampton in their multigenerational household. As a note included with Hampton's oral history attests: "After Lillian Foster's death in 1978, Ms. Hampton frequently stayed at the archives, having her own key and using it as a base for her work in the community and her many trips to Atlantic City. In 1987, Ms. Hampton moved in with Lee Hudson and Joan Nestle and the archives, having grown too ill to keep her apartment in the Bronx."[23]

Their intergenerationalism encapsulated the LHA's mission. From its earliest iteration to its current incarnation at a Park Slope brownstone, lesbian archivists dedicated themselves to cross-generational encounters in order to neutralize "those who exiled us from generational continuity."[24] In the LHA's first June 1975 newsletter, which also mentions a request for tapings, Nestle and her compeers issued a statement of purpose: "The Lesbian Herstory Archives exists to gather and preserve records of Lesbian lives and activities so that future generations of Lesbians will have ready access to materials relevant to their lives."[25] Reinscribing heteronormative modes of kinship and succession, a third newsletter reminded its mailing list that "the Archives is both a library and a 'family album': an attempt to preserve our living experiences beyond our generation and reconnect with our family of the past" via oral histories.[26] Nestle's essay "Radical Archiving" (1979), published in the Philadelphia-based *Gay Insurgent: A Gay Left Journal*, likewise referred to these efforts as "an act of mothering, of passing along to our daughters the energies, the actions, the words we lived by."[27] From its get-go, the LHA was a collective experiment with aging across lifespans that undercut homophobia and sought out alternative family trees.

For some, these long-lost family members featured in the LHA's book collections and recorded life narratives included British, American, and French sapphists ("Past Communities, the Bloomsbury Group, the Charmed Circle, Renee Vivien, Colette, Romaine Brooks") as well as butches like Hampton.[28] Given

their desire to "to end our generational loss of memory," this recovery work—a modernist-inflected genealogy, really—was meant "to offer heroines to a community in short supply of accessible elders."[29] In one of her transcribed oral histories, Hampton realizes this mission by recollecting the queer Harlem of her twenties for a younger cohort reading *Orlando* on the 1 train up to the LHA. In a May 1981 interview that marvels at a sex party hosted by Walker, Nestle reminds Hampton that "this was the time known as the 'Harlem Renaissance' when there was a lot of new Black Consciousness. People like... Tell me if these names are familiar to you. Jean Toomer, who had written a book called *Cane*, was writing. And Langston Hughes." Hampton subsequently responds, "I maybe heard all the names. I had to during that time, I had to hear it, see? Yeah, I had to hear the names because I was in the Life along with them." Bloomsbury, apparently, had met the buffet flat.

When Hampton recalls being "in the Life" with Hughes in her early twenties in order to fill in gaps of generational amnesia, an aging self that would quickly become iconic in the lesbian community is just as prominent. While she reminisces that "we were going to parties, the girls all had the parties" in Harlem, "and they uh, they had drinking and carrying on," these social experiments just kept on going with Hampton at the LHA.[30] *To carry on* means more in LGBTQ slang than sexual carousing. In subcultural parlance it also denotes "to last" or "to endure" as much as "unrestrained hilarity or commotion."[31] Hampton mixes and mingles these definitions with her retold life narrative. Hence when she remembers that "when I was thirty I was runnin' like gangbusters! Oh, boy, I was runnin' after girls, I was carryin' on.... All the girls, in the show—I was in the show—was dancin' in the nightclubs, I just had a ball!," I'm not so sure that she stopped these modernist performances when she verbally danced with other butches and femmes who dropped by the LHA.[32] "She shared in welcoming the visitors," Nestle elsewhere tells us, "some of whom had come just to meet her."[33] At 215 West 92nd Street, apartment 13A, this older family member of the Black queer community carried on with her carrying on.

The quoted line that cites Hampton "runnin' after girls," in fact, comes from a transcribed oral history reprinted in *Sinister Wisdom*, a lesbian-feminist journal based at the time in Lincoln, Nebraska, that invited social and aesthetic experimentations with cross-generational aging.[34] Published in 1979 in a special issue on the theme of "being old and age" and edited by a twenty-five-year-old Susan Leigh Star, the piece was titled "Surviving and More: An Interview with Mabel

Hampton" and conducted by Nestle. Featuring contributions from Audre Lorde and Adrienne Rich with photographs by JEB (Joan E. Biren) and Tee Corinne, the issue provided readers with "visions of new kinds of oldness," and novel forms of intergenerationalism characterized its contents from Star's introduction to Hampton's interview.[35] Star writes in this introduction that "the process of editing this issue has been an extraordinary one for me: I feel oldened, enriched by it" (I 7). Part of this editing, however, was not just the issue in its entirety, but also the transcription of Hampton's oral history in her late seventies. Parenthetical remarks posted at the end of Hampton's interview with Nestle alert readers that the piece was "(transcribed and edited by Leigh Star)" (S 24). Editing Hampton's words thus aided the oldening of a midtwenties white lesbian that reorients her life course perspective. Inspired by her story of survival, Star goes on to call for a cultural revolution in how lesbians approach their collective aging: "moving from intergenerational to transgenerational to freely agenerational anarchy, where *we* designate what is relevant, where we leap times together, explode the continuity of history by refusing to see ourselves in terms of a 'life cycle,' and moving instead into a life layering" (I 7).

In line with Star, the shared conversation between Hampton and Nestle muddies normative life cycles and facilitates "the process of 'intergenerational' sparking between Lesbians" (I 7). Nestle introduces her friend as *"a wise strong loving woman who never lost her integrity either as a Black woman or as a Lesbian"* (S 21). When asked, *"What do you have to tell younger Lesbian women? What would you want to tell them about what they have to look forward to, about feelings about aging? All these women are frightened of getting older,"* Hampton issues a curt reply: "Oh, that's *stupid!*" (S 23). Refuting gerontophobia, she tells Nestle that she renews herself daily with indifference to the cultural baggage that comes along with her long life. *"Were you ever afraid of getting old?,"* Nestle inquires, to which Hampton responds, "No, I never thought about getting old. I just lived from this day to the next day, to the next day, see, because it ain't necessarily gettin' old because you're going to stay here until your time is up, whether you're two years old or a hundred and two!" (S 23). Acknowledging her mortality, Hampton states that "in years to come I might be gone, but thank God at least I'll go down in history" because of the LHA's collections (S 24). In the meantime, she looks forward to its generational meet-ups ("we need to work together and stick together"), and she's enthusiastic about those in attendance (S 24). *"How*

do you feel about women yourself at this point? Do you still find women attractive? Oh, yes. [emphatically] Yes, I do, I find them very attractive, and a little desirable, um hm. I still smile at them, and they smile at me, and that makes it better" (S 21). Sharing her story with Nestle and other women, Hampton allows them to spark a connection to the queer past, but she's also wooing them with her self-performance.

The charged erotics of these performative words for younger lesbians add a measure of sinisterity to the Black wisdom Hampton offers. *Sinister Wisdom* took its title from a phrase in Joanna Russ's novel *The Female Man* (1975) involving a sexualized encounter between an older protagonist and a seventeen-year-old girl: "*Everyone knows* that if you start them young they'll be perverted forever and *everyone knows* that nothing in the world is worse than making love to someone a generation younger than yourself.... Don't exploit. That little girl's sinister wisdom."[36] Hampton's wise advice to younger lesbians is equally heterodox. As Kathleen Woodward reminds us in an important essay on feminist anger and aging, wisdom's "connotation of dignified behavior" in old age should be discarded, and it is as if Hampton uses wise words to further continue her carrying on.[37] Hers is a queer art of saging, another subcultural term for "growing wiser while growing older" that also denotes "creating connections between the young and old members of the gay community."[38] This wisdom that Hampton grants other lesbians is how to be a sinister queer—an unapologetic deviant—in the midst of homophobia: "I advise everyone: you have to live right, and you're living right if you're a Lesbian!" (S 22).

That Hampton presents herself as a desiring lesbian almost three years before she turned eighty is exquisite. As if we need reminding, such self-portraits are exceedingly rare in any modernist archive. Equally important is how this self-presentation undercuts damaging forms of ageist racism that mark Black populations across the long twentieth century—a confirmation of Sari Edelstein's observation, following Ruth Wilson Gilmore, that "long lives themselves [appear] as acts of resistance to the objectives of entrenched racism."[39] Pathbreaking Black gerontologists such as Jacquelyne Johnson Jackson and Hobart C. Jackson spent much of their careers in the 1960s and 1970s calling for more attention to such *double jeopardy*, or the compounding vulnerabilities of minority aging that Hampton undoubtedly experienced.[40] Compiled, in part, during Jackson's tenure as chair of the National Urban League's Health and Welfare Subcommittee

on Aging, *Double Jeopardy: The Older Negro in America Today* (1964) opens with a furious lament that "until recently, the Negro who managed to age 65 and beyond was 'invisible.'"[41] Hampton complements such gerontological knowledge production when she insists on her prominence and proclaims freedom from long-standing constraints-in-age:

> *Mabel, do you ever get angry at how you get treated in this society, as an older Black woman?*
>
> [M]e, being my age, I believe I can do anything I want to do. And if I don't like you, I don't bother with you. Therefore, you cannot hurt me, because I don't give you a chance. I read you before you read me, and that's your worry. (S 23)

In this remarkable reply, Hampton sages against ageist depictions of African Americans with a sinister wisdom confirming Edelstein's claim that "longevity itself might be read as a mode of defiance."[42] Offering herself as living proof, these comments get to the heart of the "and more" of her interview's title. Refusing to be a throwaway body, she presents herself as an unsentimental survivor who lived to tell butch tales of Harlem at the LHA and in the pages of a lesbian-feminist journal.

You can only imagine that these self-performances set audiences ablaze. An unpublished free verse poem archived in the Mabel Hampton Special Collection captures the sparking of intergenerationalism that turned into a conflagration. Titled "On the Occasion of Her 78th Birthday—To Mabel Hampton" and composed by Sonny Wainwright, the poem's first two stanzas record how Hampton's oral histories erotically oldened those gathered at the LHA:

> Just magnificent your image
> Sitting talking listening
> At the archives
> Cheerful live wire Currents of excitement
> Testing a crowded room for attractive women
>
> Telling of the old days
> "We had our good times
> And I knew many women"

Commenting on a 1919 photograph of Hampton (then seventeen) that the LHA featured on the cover of its fifth issue in 1979, Wainwright then went on to commemorate Hampton as a sexual renegade who turned Nestle's apartment—and the LHA's newsletter—into a combustible cruising ground:

> That photograph revealing roving rakish eyes of
> Burning sexuality Cruising the country from
> The cover pages of an archives letter.
> Fifty years later this brimmed hat over brazen smile
> Sets fire to nostalgia and buxom lust.

Linking a teenage Hampton in early-twentieth-century Harlem with a septuagenarian Hampton on the late-twentieth-century Upper West Side, Wainwright captures a leap across time that continued the queer intergenerationalism of the New Negro project. "Counting your birthdays," goes the poem's closing line, "We count ourselves."[43] Chronological aging here is a playful numbers game whereby Hampton's individual life widens the Afro-modernist network—or, to repeat Star's phrasing, "a life layering" of the older with the younger with the middle-aged. Full of "burning sexuality," aflame with deviant modernism, and igniting antiracist age criticism, it is as if the sparks of Hampton's sinister oral history continued the work started by Thurman, Hurston, Hughes, and Nugent in *Fire!!*—only by this later date the devotion was to an older artist whose flame never went out. "Mabel Hampton, friend and activist, speaking to me in her 80th year, in 1981: 'Joan, there are some women I can't touch because the desire burns my hand like a blue flame, those women, those women!'" (figure 6.1).[44]

II

As Wainwright's poetic homage to Hampton's photograph attests, "just magnificent" images of her aging and attendant intergenerationalism often accompanied her words of wisdom. New Negro advocates well understood this tactic.[45] *The New Negro* often put images and words beside each other, with an illustration by Aaron Douglas complementing Nugent's "Sahdji," for example. "Negro Youth Speaks" likewise reprints and retitles Walter von Ruckteschell's sketch of a youthful Black male, *Young Africa*, from the *Survey Graphic*'s Harlem issue as

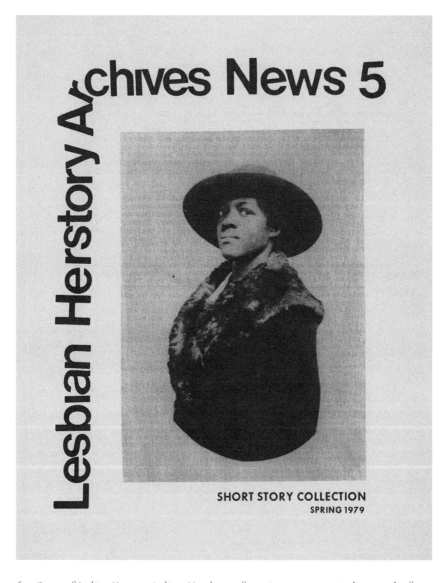

6.1 Cover of *Lesbian Herstory Archives Newsletter* 5 featuring 1919 portrait photograph of Mabel Hampton, 1979.

Young Negro. Locke's follow-up, "The Negro: 'New' or Newer," also reproduces a sketch of an older Gullah Geechee woman from Florence Crannell Means's South Carolina–based young adult novel *Shuttered Windows* (1938). Activists at the LHA similarly mobilized visual cultures across lifespans with projects such as a National Lesbian Photograph Drive "to end the legacy of lost faces."[46]

Calling in 1980 for "a slide and tape presentation of Lesbian images pre 1970," Nestle told *Lesbian Herstory Archives Newsletter* readers that "the purpose of the presentation is to portray the complexity, courage, strength, oppression and sensuality of pre-Stonewall Lesbian life. The Archives is dedicated to encouraging generational understanding and respect."[47] Hampton bridged both projects, countering double jeopardy with curated portraits of herself as an elder who exemplified queer Black modernity for generations to come. In less than a half-decade after these images began to circulate, she would become an icon in the U.S. LGBTQ community.

Three images featured in her "Surviving and More" interview contributed to this elevated status. Framed above the article's title, the first is a black-and-white full profile photograph of Hampton, accompanied by stacks of books and a few piles of papers, sitting at her desk in her Bronx apartment (figure 6.2). On the following page is a second picture of Hampton in sunglasses and a winter coat standing next to a friend on the city streets. The third photograph is a sitting portrait of Hampton again at her desk, smiling and holding up a copy of *Voices of New Women* (1973), a poetry collection from the University of Massachusetts-Amherst's Everywoman's Center featuring a drawing of a younger Black female on its front and back cover (figure 6.3). Each of these photographs was taken by thirty-four-year-old JEB on two assignments in November 1978. An original member of Washington, D.C.–based lesbian collective The Furies, JEB taught herself photography and was keenly invested in countering homophobia and ageism with her visuals: "One stereotype makes us afraid to identify as Lesbians because we don't want to be 'unnatural' and ugly. The other ultimately makes us feel inferior because we aren't (or do not forever remain) teen-aged, slim, blond, and blurry à la David Hamilton." Devoted to "enlarging our vision" via "new ways of looking that have not existed before," JEB also reprinted two photographs from her sessions with an older Hampton in her now-classic *Eye to Eye: Portraits of Lesbians* (1979), as contact sheets archived at the Sophia Smith Collection of Women's History at Smith College attest.[48]

Before I discuss how these images transmit a queer Black modernism, I acknowledge, too, that their everyday realism testifies to racial modernity in the diasporic longue durée.[49] *Eye to Eye* commits to racial diversity with photographs of Barbara Smith, her twin sister Beverly Smith, and Hampton. JEB elsewhere acknowledges that her subjects "may be affected by race, class, age, and regional or other differences."[50] While LHA supporter Judith Schwarz's foreword in *Eye to Eye* places JEB's documentarian images in genealogies of white lesbian

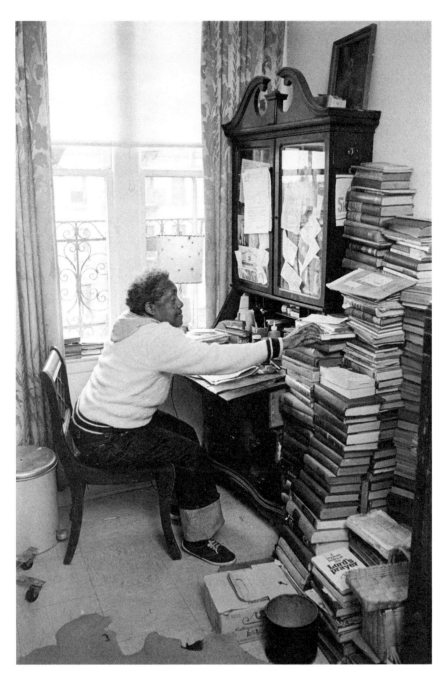

6.2 JEB (Joan E. Biren), photograph of Mabel Hampton featured in *Sinister Wisdom*, November 21, 1978. Reproduced by permission from the artist.

6.3 JEB (Joan E. Biren), photograph of Mabel Hampton featured in *Sinister Wisdom*, November 22, 1978. Reproduced by permission from the artist.

photography that included Berenice Abbott and Janet Flanner, we could just as easily place them in alternative traditions such as Dorothea Lange's Farm Security Administration photographs that included *Ex-Slave with Long Memory, Alabama* (1937) or James Van Der Zee's portraits of Harlem denizens.[51] Indeed, JEB's images of Hampton socializing outdoors or working at her desk document a life that had endured poverty in the U.S. South in the 1900s and years of labor leading up to her retirement from Jacobi Medical Center in 1972. When we remember *Double Jeopardy*'s declaration that "Negroes who reach of the age of 60 are the survivors," a flourishing Hampton illustrates that, as much as she survived her youth, making it to old age was also a modernist feat recorded by JEB's portraiture.[52] "She was not dead," her admirer Jewelle Gomez once affirmed. "She was still alive and curious and interested in everything."[53]

JEB's photographs record that Hampton continued to live out this life with flair. Like others featured in *Eye to Eye*—a cook from Washington, D.C., three back-to-the-landers in Willits, California, an electrician from Maryland—JEB's photographs of Hampton strive for an everyday verisimilitude negating sensationalist depictions of same-sex female desire as "sick, perverted vampires and

murderers."[54] Framed in ambient light and surrounded by mundane office supplies (a bottle of glue, a stapler), Hampton seems remarkably unremarkable in these *Sinister Wisdom* photographs. That in itself is innovative when we consider debility and Black aging. Yet these three photographs based in and around 639 East 169th Street, apartment 2C, also visualize what art historian Richard J. Powell deems a "nuanced sense of *sharpness*—a black American-informed artistic strategy of modern style" that testifies to Hampton's surviving and more in the twentieth-century United States.[55] As much as these images draw attention to her domestic environment, they pull the viewer toward blue jeans cuffed with surgical precision, ringed fingers, a V-neck sweater, and laced-up loafers. Self-stylizing with a "brimmed hat over brazen smile" in the late 1910s, Hampton appears dapper in her later butch modernity on a late fall day of November 21, 1978.

We know from LHA transcripts that she took great interest in how fashion enabled her modernist self-performances of female masculinity. Echoing Zora Neale Hurston's praise of "the will to adorn" in "Characteristics of Negro Expression," Hampton tells Nestle in one oral history that "my favorite outfit, when I was young, was a suit—and a shirt—a tie. That all. Nobody know what you was when you had a suit on and flat, low-heeled shoes."[56] In the same interview she recalls with delight that "I knew I was a woman. I dressed in a suit with low-heeled shoes—and, in those days, people—if they seen you too much with low-heeled shoes on, they think you were queer. . . . But that didn't stop me from wearin' 'em."[57] For Hampton, this sharp attire signaled aesthetic freedom within her social constraints and an indifference to sartorial policing: "I didn't care nothin' about bein' how I was dressin,' 'long as I was dressin' and I was dressin' good because I had three or four suits and shoes. I had Oxford shoes—."[58]

When Hampton recalls the gender nonconformity advertised by a suit and its accoutrements ("well, you had to be a stud, you know. And you'd wear a little tie or collar pin or something like that"), I hear echo of her close associations with butch icon Gladys Bentley.[59] By the time Hampton met Bentley, the latter was well-known for bawdy cabaret performances and her trademark white tuxedo and top hat as she drew spectators in the Life and adventure-seeking slummers alike from the tristate area. Hartman notes that "Mabel envied the freedom of her friends Jackie Mabley and Gladys Bentley, who lived as they wanted," and

may have seen Bentley as a fashion icon to mirror "who wore slacks and jackets when few dared to."[60] Relating her performances with Bentley at the Garden of Joy, Hampton tells Nestle that "we all was friendly together."[61] Such being the case, JEB's white lesbian-feminist portrait photography documents an alternative Black modernist genealogy of sharpness that connects Bentley to Hampton-in-the-1920s to Hampton-in-the-1970s. Literally and figuratively adding herself to *Voices of New Women* with her "Surviving and More" interview (the collection featured Erica Jong and a reprint of Nikki Giovanni's "Revolutionary Dreams"), Hampton in 1978 also presents us with a fashionable portrait of an older New Negro butch in the midst of second-wave and Third World feminisms. From suits and Oxford shoes to blue jeans and low-heeled loafers, she put a collar pin on her long lifespan.

As she continued to dress down ageism with sinister sartorial style, Hampton offered this self-image as an exemplar to a younger crowd—how to live right and look sharp as all get-out. Whether they attended the LHA or "An Afternoon with Mabel Hampton" sponsored by Lesbian Feminist Liberation at the Women's Liberation Center in the late 1970s and early 1980s, some sought out her visual modernism with their own genealogical impulses, or what Nestle referred to as "our creation and rediscovery of lesbian visual forms."[62] Commenting on Hampton in the documentary *Not Just Passing Through* (1994)—a cinematic project intent on fighting ageism in the LGBTQ community—Jewelle Gomez (then forty-six) found that Hampton acquired a modernist aura during this time:

> She was my past embodied, which enabled me to imagine myself in my eighties—as a lesbian and it was not going to be some tragic ending at forty from drink, you know, or a life lived out, you know, alone with my cats—a frustrating and lonely existence that was going to be in some Victorian novel. It was going to be a really full life, a potential for a really full life existed, and it really was embodied by Mabel Hampton.

With her implied reference to Miss Havisham in Charles Dickens's *Great Expectations*, Gomez sees Hampton's life narrative as anti-Victorian or, rephrased, modernist. Recalling Hampton five years after her death, she envisions her as an "embodied" elder-modern who wore her experimentalism on her literal sleeve. Importantly, as Gomez's "past embodied," Hampton is not an archaic figure but

also her future: seeing Hampton in her eighties, Gomez sees herself. Leading by example, Hampton's older image is Gomez's self-imagining, as if one modernist generation fashioned the next—precisely the art of "passing along" that Nestle identified as a core LHA objective and an interesting contrast to Charles Henri Ford's old-old white gay male loneliness. Commented Deborah Edel in the same documentary: "It was as if her life took on meaning, not just her present life. But she was getting recognition for having lived her life as she had lived it with a kind of respect I don't think that she expected. And she became this folk hero to people."

Gomez and Edel were not alone, for heroic pictures of a modernist Hampton quickly saturated the LGBTQ community by the 1980s. Examine the black-and-white photograph that captured exuberant LHA activists at a Pride march in New York City about a year after Hampton's *Sinister Wisdom* interview (figure 6.4). Redolent of Diana Davies's photographs of the inaugural Christopher Street Liberation Day Parade in 1970, the image prominently features Hampton holding the LHA banner as she walks at the front of the parade. She wears trousers, a beret, and a t-shirt from Lammas Women's Shop, located near Logan

6.4 Artist unknown, photograph of Gay and Lesbian Pride Parade in New York City, ca. 1980. Photo source: Arpadi/IMAGES/Getty Images.

Circle in Washington, D.C. Nestle and Edel walk two marchers to her right. Along with two smaller posters of Hampton's friend Mary Jane Taylor, other demonstrators hold up five portraits high above the crowd. A recap of this moment in a *Lesbian Herstory Archives Newsletter* noted that "for this year's Gay Pride March in New York, we made 30″ by 40″ blow ups of photographs of Radclyffe Hall, Bryher, Eleanor Roosevelt, Lorena Hickok [Roosevelt's companion], and Mabel Hampton, age 17. They rose eight feet into the air and were supported by a strong contingent of Archives friends."[63] Carried by an unidentified LHA affiliate, this enlarged portrait of Hampton was the same image Wainwright idealized in "On the Occasion of Her 78th Birthday—To Mabel Hampton."

Only a failure of imagination and the persistence of the color line would surprise us in finding Hampton and Hall rubbing shoulders as modernist foremothers in this parade. Hall's *The Well of Loneliness* was, of course, an ur-text for many lesbian, queer, and trans readers after its initial publication in England in 1928. In the documentary *Before Stonewall* (1984), Hampton tells the camera that "well, you know how it all started: *The Well of Loneliness*. From then on, anything that came past, I read it."[64] Hampton may refer to the original U.S. edition published by Pascal Covici and Donald Friede, but she possibly references the Permabooks paperback edition of 1951, an inexpensive reprint that Paula Rabinowitz terms a sapphic "secondhand modernism."[65] But in this photograph, on that summer afternoon, and on many more days to come, Hampton is not an eager reader of Hall. She is a peer. With a portrait of Hampton raised high in the sky by her fellow activists, she too is recognized as a modernist, one who would continue to set a stage for the remainder of the 1980s by publicly performing a sharp late life. There's no loneliness to be found in this street photograph, just the sparking of generations and generations gathered in age and action.

Thanks to JEB's imagery in *Sinister Wisdom* and *Eye to Eye*, LHA newsletters, documentaries such as *Before Stonewall*, and photographs such as the one just mentioned, Hampton's modernism became as exemplary as Hall's—"a lesbian celebrity and role model, unique for someone of her generation and social standing."[66] So many Jewelle Gomezes and Sonny Wainwrights came to be oldened by the one and only Mabel Hampton. She enabled a reach of queer and trans New Negro survival strategies that united her stylish self-performances in 1920s and 1930s Harlem with older performances at LHA with transatlantic lesbian modernism such as Hall's

with Afro-modernism such as Bentley's. Her long march in Oxford shoes, the next section details, kept going strong after all these early steps.

III

With these words and images, Hampton sparked a renaissance of the Renaissance, one that was as cross-gender, cross-racial, and cross-generational as that realized in the 1920s and 1930s. Aiding this revitalization was a white gay male amateur historian searching, like LHA members, for forgotten pieces of the U.S. LGBTQ past and finding it in her transcripts; queer Black women seeking pre-Stonewall survivors; and Hampton's own public appearances that continued throughout the 1980s, up to her death in 1989. Overlapping in unanticipated ways, these collective efforts further cemented her hallowed status as a Harlem Renaissance elder. To quote from a companion volume to the *Before Stonewall* documentary published after its release: "Mabel was part of another marginal community as well—the cultural resurgence of American Blacks known as the Harlem Renaissance."[67] Quickened in the 1920s, this resurgence would again occur six decades later, thanks, in no small part, to the tireless bonds Hampton continued to forge with those eager to share her fond memories of its height.

One fellow traveler who facilitated this strain of generational continuity was a scholar mentioned in this chapter's introduction, historian Eric Garber. A few years shy of his thirtieth birthday, Garber published a path-clearing essay, "Tain't Nobody's Business: Homosexuality in Harlem in the 1920s," in an *Advocate* issue in 1982 that relied to some extent on Hampton's LHA interviews (figure 6.5). Employed at the San Francisco Public Library, Garber was a founding member of what would become known as the GLBT Historical Society and a self-trained expert in early-twentieth-century U.S. lesbian and gay subcultures. Titled after a blues song once recorded by Bessie Smith and composed by Porter Grainger and Everett Robbins, his six-page article cited queer Harlem Renaissance affiliates—Bentley, Thurman, Nugent, Hughes, Locke, Cullen, Van Vechten—and quoted Hampton on queer of color parties while briefly rehearsing her biography. Housed at the Gay, Lesbian, Bisexual and Transgender (GLBT) Historical Society, the Eric Garber Papers document that his source materials specifically relied on Hampton's May 21, 1981, interview with Nestle as well as her "Coming Out Story" published in a *Lesbian Herstory Archives Newsletter* in 1981.[68]

Heritage

TAIN'T NOBODY'S BUSINESS

HOMOSEXUALITY IN HARLEM IN THE 1920s

(far left) Dancer Mabel Hampton at 17; *(left)* Novelist and playwright Wallace Thurman; *(above)* Heiress A'Lelia Walker Robinson.

BY ERIC GARBER

Flappers, raccoon coats, cars with running boards, pocket flasks, bathtub gin and jazz bands—all these images spring quickly to mind whenever the Roaring '20s are mentioned. But other images that were just as much a part of that time have slipped out of memory and out of the popular imagination. These are the images of Harlem in the '20s, when a renaissance of black culture made this poor and crowded neighborhood a vital, busy hub of creativity. Many of the key figures who made the renaissance possible were lesbians and gay men. Then, as now, sexual minorities played an important role in the formation of urban minority culture.

Harlem was largely the creation of the thousands of black Americans who migrated north after the turn of the century. They came in search of a better life and to escape the racist violence of the South. When the United States entered World War I, a freeze was put on all immigration, and hundreds of openings in northern factories were immediately available for blacks. Within two decades, large metropolitan communities of black Americans had sprung up. So significant was this shift of population that historians refer to it as the "Great Migra-

Eric Garber, a founding member of the San Francisco Lesbian and Gay History Project is the co-author (with Lyn Paleo) of Uranian Worlds: An Annotated Bibliography of Lesbian and Gay Images in Science Fiction and Fantasy, to be published later this year.

Eric Garber

tion." Black communities developed in Chicago, Detroit and San Francisco, but the largest and most spectacular was Harlem.

Harlem became the mecca for Afro-Americans all over the country. Nowhere else could you find so large an area, really a city within a city, populated entirely by blacks. The lure was particularly enticing to young, unmarried, transient blacks, and Harlem's streets became filled with energetic, often gifted, youth.

Following the war, the United States, yearning in vain for a return to simpler times, took a decided swing to the right. The most conspicuous manifestation of this conservative trend was the prohibition of alcohol, mandated by passage of the 18th Amendment. Hand in hand with this reactionary political climate was the frightening resurgence of white racism. In 1918 alone, 78 blacks were murdered by white lynch mobs.

The Afro-American community quickly countered with a self-conscious pride and militancy. Marcus Garvey, the charismatic West Indian orator, had thousands of followers in his black nationalistic "Back to Africa" movement. Black servicemen had been treated with a degree of respect and been given a taste of near equality while in Europe; their wartime experiences influenced their expectations when they returned home. Participation in the war effort had given the black community a sense of involvement in the American process, and there was a new feeling in the air that demanded participation in the mainstream of American life. W.E.B. Dubois and his National Association for the Advancement of Colored People (NAACP) usual-

ly appealed to a more educated crowd than Garvey's followers but were just as powerful and influential. Though different, both of these popular movements offered black pride and racial unity as a means to help their people, a new idea at the time.

This rise in black militancy coincided with a nationwide surge of white interest in aspects of Afro-American culture. Some whites, in reaction to the nation's new conservatism, had adopted a devil-may-care attitude, tweaking their noses at authority and devoting themselves to the discovery of new thrills. They began to listen to the jazz of Duke Ellington, Fletcher Henderson and Fats Waller. The Charleston and the Black Bottom, dances previously limited to the jazz halls, became national crazes. *Shuffle Along*, an all-black musical, was a smash success on Broadway and rocketed Florence Mills to stardom. White authors and playwrights began to use race and racial prejudice as serious subject matter.

In Harlem this vogue for the Negro manifested itself primarily in the huge influx of whites slumming in the district's nightclubs. The Cotton Club, Connie's Inn, Small's Paradise and Pod and Jerry's were packed nightly with whites drinking bootleg liquor and watching talented black entertainers.

It came as no surprise to most of Harlem that many of these fancy clubs were exclusively for whites. The majority of those slumming had little concern for social equality or justice. Americans had recently been exposed to popular versions of the shocking theories of Sigmund Freud. Spotting neuroses, latent

6.5 Photographs of Mabel Hampton, A'Lelia Walker, Wallace Thurman, and Eric Garber reproduced for Garber's article, "Tain't Nobody's Business: Homosexuality in Harlem in the 1920s," published in the *Advocate*, May 13, 1982, 39.

With its focus on "energetic, often gifted, youth," Garber's piece is equal parts social history, literary history, and truncated biography that situates Hampton within Harlem's "homosexual carrying on," Renaissance included.[69] At a pivotal moment when social historians such as David Levering Lewis revisited the movement with comprehensive works like *When Harlem Was in Vogue* (1981), Garber's piece highlighted the queerness that such retellings often muffled.[70] Visuals accompanying his article amplified this attention to sexual and gender nonconformity. The *Advocate* reprinted several original photographs of Garber's subjects, including one of his informant Richard Bruce Nugent and wife Grace Marr Nugent. To the lower left of a heading titled "Heritage" on the article's first page, we also find a trio of photographs: A'Lelia Walker, Thurman, and the portrait of Hampton made famous by LHA Pride marchers. Hampton's familiarity with Walker is well-documented, but her transcripts make no mention of Thurman. The *Advocate*'s interconnected images, however, visualize a tantalizing proximity. Thurman had parodied Walker as Amy Douglas in his satirical novel *Infants of the Spring* (1932), and I see no reason not to assume that he may have fictionalized Hampton as one of the many revelers at a rent party that this book describes. Hampton, remember, "maybe heard all the names," and her LHA transcripts recall her attendance at such social events.

Another visual displayed underneath these three keystones of queer Harlem testifies to the cross-generational desire buoying Garber's heritage project: a sitting photograph of the librarian holding a coffee mug. Garber's acknowledgments at his article's end inform readers that he sought out Hampton: "*I am particularly grateful for the conversation with Mabel Hampton recorded for me by Joan Nestle of the Lesbian Herstory Archives, and for my many hours of conversation with Richard Bruce Nugent*" (T 53). In our correspondence in 2020, Nestle wrote to me that "I don't remember doing a tape especially for him—but as Ms. Hampton spoke, I would have made a note to tell Eric about her experiences."[71] Fact-checking this encounter is, however, not my main point. I am more interested in Garber's potential desire for affinity with Hampton that her LHA remembrances allowed—a cross-identification between a young white gay male scholar and an older African American butch, however complicated this racialized transference. We do know for sure, Susan Stryker recalled in 1996, that "Eric was zealously committed to racial and ethnic diversity, and to overcoming racism within the queer community."[72] Hence when "Tain't Nobody's Business" mentions that "many white lesbians and gay men felt a kinship with Harlem's residents" in the

1920s, or that "white homosexuals found sanctuary and a sense of camaraderie uptown in Harlem," Garber may be describing himself and his psychic attachments to a living member of the Renaissance as much as those slumming it back in the day (T 40).

Guided by antiracism, oral history and, perhaps, generational longing, Garber reprinted a slightly revised version of "Tain't Nobody's Business" as the lead essay in Michael J. Smith's *Black Men/White Men: A Gay Anthology* (1983), an edited collection that also reproduced Nugent's "Smoke, Lilies and Jade" from *Fire!!* and Hughes's "Café: 3 a.m." from *Montage of a Dream Deferred* (1951). Six years later, he published another revised, greatly expanded, and retitled version as "A Spectacle in Color: The Lesbian and Gay Subculture of Jazz Age Harlem" in the watershed collection *Hidden from History: Reclaiming the Gay and Lesbian Past* (1989), edited by historians Martin Duberman, Martha Vicinus, and George Chauncey. Garnishing hundreds of scholarly citations, this latter piece has proven lasting historical scholarship.[73] Canvassing "the so-called Harlem Renaissance period, roughly 1920–1935," "A Spectacle in Color" reprints verbatim lines from Garber's original *Advocate* article.[74] Others he rewrites while he again cites Hampton on parties and attributes that source to her May 21, 1981, interview with Nestle in an endnote. Continuing to shape "a full generational discussion" three decades into the twenty-first century, Garber's retelling of Hampton's early life widely circulates.[75] As it does so, we should remember that both her younger and older selves were a portal for Garber—and, by extension, many scholar-activists working today—whose carrying on assisted subsequent generations of new LGBTQ Afromodernist scholarship.

At the same time, Hampton-via-Garber also incited a Renaissance reimagining for older generations of nonacademic LGBTQ individuals equally interested in Jazz Age goings-on that had "slipped out of memory" (T 39). While this chapter has emphasized Hampton's engagements with younger queers, I asterisk that her life narrative featured in "Tain't Nobody's Business" inspired admirers from within her own chronological cohort. Garber facilitated at least one event anchored in this intragenerational intimacy. In the buildup to the publication of "Tain't Nobody's Business" and "A Spectacle in Color," he toured a slide show of his project at various locales: Hunter College in 1982, Valencia Rose Restaurant and Cabaret in 1983, the Walt Whitman Bookshop and the LHA in 1984, DePaul University in 1988, and elsewhere. He also presented at SAGE (Senior Action in a Gay Environment, now Services and Advocacy for GLBT Elders) in New York

City, a community center mentioned in chapter 5. Such gathering spaces for older urban populations had begun in 1943, with the William Hodson Center in the Bronx often identified as the first of its kind.[76] Many found financial support with aid provided by the Older Americans Act of 1965 and its subsequent reauthorizations. A queer offshoot of this modern phenomenon, SAGE opened its doors in 1978 at the Church of St. Luke in the Fields and then moved to what is now the Center (Lesbian, Gay, Bisexual, & Transgender Community Center) in the West Village in 1981. An East Coast counterpart to San Francisco's GLOE (Gay and Lesbian Outreach to Elders), the nonprofit organization was socially oriented with field trips to Walt Whitman's birthplace in Huntington Station, New York; activist-minded with participation in Pride marches; attentive to financial and emotional age matters such as widowhood and retirement income; and invested in preserving past communities, much like the LHA. The community organization also worked closely with Nestle to collate oral histories of older lesbians and gays living in New York City in order "to share their memories with future generations."[77] Nestle, in fact, compiled an extensive list of "Suggested Questions for Doing Gay Oral History Tapes" with SAGE members in February 1983.[78]

Garber's slide show was a perfect fit for this inquisitive bunch. A promotional flyer for his April 21, 1984, SAGE-sponsored presentation was subtitled "Gay Men and Women of the Harlem Renaissance" (figure 6.6). Archived in the LHA's Mabel Hampton Special Collection, one journalist's chronicle of this midafternoon event, "A Tour of Gay Harlem by Night," recounted that "Eric Garber treated an audience of over 100 to his 90-minute slide show and commentary— T'Aint Nobody's Business—on this fascinating, colorful period in our history." The article went on to quote Hampton as "one of the founding mothers of the Lesbian Herstory Archives—now in her 80s and still going strong.... 'We used to go to parties every other night,' she told Garber." It concluded by rejecting Hampton as a vestige of a past era and firmly situated her in the present day: "Survivors like Hampton and artist Bruce Nugent, still painting in Hoboken, are happily still with us."[79]

I must wonder if Hampton was in the audience listening to Garber read from her transcripts while he contended that "a New Negro was emerging" back in the 1920s.[80] As much as she affiliated with the LHA, Hampton was also quite well-known for her commitments to SAGE. Nestle tells us that "in the 1970s, Ms. Hampton discovers senior citizen centers and 'has a ball,' as she liked to say, on their subsidized trips to Atlantic City," and one feature of Hampton's late-life

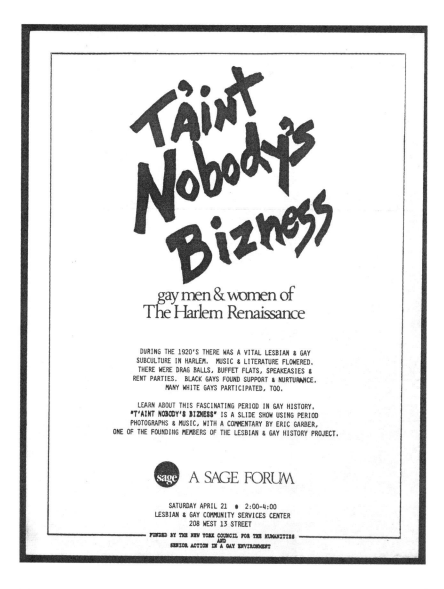

6.6 Promotional flyer for Eric Garber's "T'Aint Nobody's Bizness" presentation sponsored by SAGE, April 21, 1984. Photo source: Archives of Sexuality and Gender.

sartorial performances was a "bright red T-shirt proclaiming her membership in SAGE."[81] In summer 1984 Hampton gave a brief speech at a Pride rally praising the organization and LHA in the same breath: "I, Mabel Hampton, have been a Lesbian all my life, for 82 years.... Places like the Lesbian Herstory Archives and SAGE help gay people know that they are full citizens of this city and the

world."[82] A Spring 1983 SAGE newsletter likewise featured a picture of Hampton at one of their many socials, and the "Coming Out Story" included in the Eric Garber Papers was recorded at a Pride-related event in 1981 also featuring SAGE members who recollected their own lives. While no public video recordings have yet been found of her participation at SAGE, it's clear that her contemporary words about her past life in Harlem extended the Renaissance into this senior center and perhaps connected its members to a forgotten past. SAGE volunteers often offered its homebound members "phone reassurance" as a form of outreach. Hampton's transcriptions did something similar with modern U.S. LGBT/queer history.

While I can only wish that she and Garber met in person at this SAGE function, I can say with confidence that Hampton performed her own version of queer Harlem Renaissance studies with encouragement from younger Black lesbian activists while he toured. On February 22, 1987, she participated in the "More Than You Can Count" series hosted by Douglass Residential College and the Bisexual, Lesbian, and Gay Alliance at Rutgers University-New Brunswick with an event titled "From the Harlem Renaissance Thru Stonewall and Beyond—Experiences of Black Lesbians." Alongside Hampton, whom one promotional flyer identified as "an activist born at the turn of the century," were Jewelle Gomez and Cheryl Clarke.[83] A close friend of Garber's who memorialized him as "a feminist man" after his death in 1995 from AIDS-related causes, Gomez herself was Hampton's intimate acquaintance at the LHA and venerated her with a poem "(Untitled) No Immediate Survivors" in 1990.[84] Clarke, too, would signal affection for Hampton's "years of ancient pride" with "An Epitaph," a poem published in *Experimental Love* (1993).[85]

Speaking to a room with a seating capacity of 150 about her life narrative, Hampton herself reprises two roles at this forum in Art History Hall 200: her vanguard life as a youth and her vanguard later life as a legendary raconteur. Both inform her experimental age activism that again links up to a queer intergenerationalism undercutting Old Negro depictions of racist senescence. In front of what one hopes was a full house, she shared vibrant tales full of ever more sinister wisdom. In my mind I imagine that this event must have felt like Henry Louis Gates Jr.'s description of filmmaker Isaac Julien's *Looking for Langston* (1989) in an essay he also titled "Looking for Modernism": "a transtemporal dialogue on the nature of identity and desire and history."[86] Hampton, after all, had been doing "Ain't Nobody's Bizness"—"But I'm going

to do just as I want to, anyway, / And don't care if they all despise me"—for her entire life.[87]

That Hampton enabled Renaissance gathering after Renaissance gathering alongside Gomez, Clarke, Garber, and countless other keepers of her memories needs acknowledgment. We know that rent parties, salons, cabarets, and buffet flats sponsored her modernism, but so too did the LHA, post-Stonewall Pride marches, SAGE, and a university lecture series. Each a part of her butch herstory, these spaces together functioned as an intergenerational workshop for queer New Negro imaginings. Hampton stood as a trailblazing "spectacle in color" at these respective venues, and they are as integral to preserving Afro-modernisms as the Beinecke's James Weldon Johnson Memorial Collection or the Schomburg Center for Research in Black Culture. Scholars today rightly note that the "queer Harlem Renaissance is as much a contemporary formation as a historical one—an unending creative process that exceeds the 1920s and 1930s."[88] The contemporaneity of that living history was made possible, in part, due to Hampton's creative aging and that of her many survivors, including future queer and trans scholars. When we do what we do, we are all doing some version of the Harlem Renaissance as told by "lesbian elder" Mabel Hampton.

IV

"During the height of the New Negro era," writes Langston Hughes in his memoir *The Big Sea* (1940), we find forgotten older queer and trans color performers. Describing participants at the Hamilton Lodge Ball in a section titled "Spectacles in Color," Hughes imagines a scene of decrepitude:

> The pathetic touch about the show is given by the presence there of many former "queens" of the ball, prize winners of years gone by, for this dance has been going on a long time. . . . These former queens of the ball, some of them aged men, still wearing the costumes that won for them a fleeting fame in years gone by, stand on the sidelines now in their same old clothes—wide picture hats with plumes, and out-of-style dresses with sweeping velvet trains. And nobody pays them any mind—for the spotlights are focused on the stage, where today's younger competitors, in their smart creations, bid for applause.[89]

To some, Hughes remarks, these sharp performers at 280 West 155th Street seem antiquated, dismissed, frozen in time. But they could not be newer if they tried. Each was part of an intensifying queer and trans New York subculture that Hampton joined. Each was also a spectacular contribution to the New Negro Renaissance. As Hughes recounts his youthful self participating in this milieu, *The Big Sea* helpfully documents this scene for future readers, and he introduces two historical points. First, and perhaps anachronistically, generation after generation of deviant New Negroes had been gathering *en force* for years.[90] Second, nothing is more modern—more ultramodern—than an aging Black queen in the prime of their life.

Hampton might have come to know a thing or two from their avant-garde. After Nestle asks about "those drag balls" in one LHA oral history, Hampton tells her that "everybody went to those. The women wore pants and the men wore dresses."[91] Mindful of her fondness for sharp suits and slacks, was Hampton's attendance at these drag balls one of her earliest modernist performances, complementing those at the Garden of Joy or 80 Edgecombe Avenue? Maybe she never took to the stage at these events, but perhaps she was part of the festivities. Perhaps, too, these Harlem balls were part of what Hartman calls her "sensual education."[92] If so, the tutorial stayed with her for decades. Such was the sinister wisdom of these New Negroes matching any produced by Locke, Hughes, or other queer members of the Renaissance. Along with what she absorbed from carrying on with Bentley and other performers, Hampton transmitted these teachings to LGBTQ audiences in the 1970s and 1980s as living historiography and modernist work of art.

Hers was, in the end, anything but a small fame. In 1985 she received the Lifetime Achievement Award from the National Coalition of Black Lesbians and Gays, with this ceremony detailed in the journal *Black/Out*, edited by Joseph Beam. The National Museum of African American History and Culture has archived a slide of the event "honoring the commitment, energy, example, and life of our eldest family member" that features Barbara Smith handing Hampton a bouquet of yellow roses as the latter holds a golden plaque.[93] Even when frailty made public appearances onerous after the LHA became her permanent home, she stole the spotlight with her disability justice. "When she could no longer walk the whole way [at Pride marches]," Nestle remembers, "Ms. Hampton would be the center of a mob of younger lesbian women all fighting for the right to push her wheelchair down the avenue."[94]

We too aid her in that parade when we teach Garber's essay in our classrooms, or listen to Hampton on the LHA's digitized audiotapes with our AirPods, or read a paperback version of Hartman's reimagining of her youth. Her renaissance keeps growing, and her performances in later life continue to advocate for an "emancipatory gerontology."[95] In recordings, newsletters, unpublished poems, portrait photographs, public lectures, and scholarly articles, she embodies a radical relation between her younger and older selves as well as between younger and older generations within and across the color line. In so doing, she temporally expands the idea of a modernist New Negro cohort by building a temple for tomorrow with stones from her yesterday. "That's all I lived for," she professed a year before she died, "to see that something comes to generations that I had been longing to see."[96] Perhaps she learned that fullness from watching aging queens watch New Negro youth speak and slay. If the toughest competition on the grand stage of her life—like theirs—was depleting imagery of the Old Negro, then she snatched the trophy.

Coda

After Jacob Lawrence at Iona Senior Services

Emboldened by the new, older adults still make their modernism. Starting in 2011, Iona Senior Services began a program that hosted outings for its participants at the Phillips Collection in Washington, D.C., one of the premier museums in the United States dedicated to modernist art. Over more than a decade now, individuals with "memory loss, Parkinson's disease, the lingering effects of stroke and other chronic conditions" have traveled to the Phillips to view and chat about its priceless works.[1] After "mindful looking and inquiry" at this museum, they would then craft their own art at Iona's Wellness and Arts Center as supernal replies.[2] According to the program's extensive publicity, some of this art has referenced Rockwell Kent's *Azopardo River* (1922), Vincent van Gogh's *The Road Menders* (1889), Beverly Buchanan's *Two Chairs* (2009), Pablo Picasso's *The Blue Room* (1901), and an odd-numbered panel from Jacob Lawrence's *Migration Series* (1940–1941). Several of these pieces have been featured at the Phillips under the rubric of *Creative Aging*. Documented on social media platforms, receptions have toasted these impressive feats with ample wine and hunks of good cheese.

The most recent *Creative Aging* exhibition ran from October 12, 2019, to February 9, 2020—weeks before the Phillips and Iona had to temporarily shutter their respective doors due to the pandemic sparked by SARS-CoV-2. Thankfully, the exhibition had gone online. Uploaded to the Phillips's website are fifty eye-popping visuals that intimately dialogue with panel 25 of Lawrence's *Migration Series* (among other pieces), which depicts the interior of a deserted dwelling that once sheltered African Americans from the U.S. South. Artwork produced by these individuals shows a range of responses to what a panel 26 caption refers to as "this great movement" of internal migration to the northern and midwestern

United States, which "people all over the South began to discuss."[3] In one digitally archived piece, a circular tuft of baby blue felt riffs on the song "Blue Moon" (1934)—someone's own Blue Period, perhaps filled with happier days. Others featured abstractions in a watercolor rainbow; self-portraits drawn with dignity in reds, yellows, and blues; frottage in seaweed green; copper paper layered with slivers of gold and leafmeal. Some of these impressive feats were also pasted as one: "In the Iona studio, the artists collected and arranged an assortment of materials, *synthesizing* to construct an 'art house' with room for all, which they decided to call *A Magic Place*."[4]

The museum's collector, curator, and one-time resident Duncan Phillips would have loved this joint production. So, too, his partner and collaborator, Marjorie Acker Phillips, whose *New York Times* obituary after her death at age ninety on June 19, 1985, states that "Mrs. Phillips continued to paint until three years ago."[5] A year or so before his own passing in 1966, contemporary endeavors at the Phillips had weighed on her husband's mind. "It has always been the policy of The Collection to stress the continuities of art," he wrote. "This Collection which my wife and I have made together, respects all these varieties and welcomes new directions."[6] Over the ensuing decades, his closer-to-dying wish came true. Following other renovations, 2006 saw the mansion-museum add five floors of the Sant Building, which displayed *Creative Aging* on lower level 2. "New directions" included not only more square footage for Mark Rothko, but also accessible venues that spotlighted older artists with disabilities working in the vein of an Afro-modernist masterpiece.

Jacob Lawrence would have loved this art as well. From the beginning of his career in Harlem to works undertaken during his later life in Seattle, he excelled at aging compositions. Take *Library* (1937), his homage to a studious Arthur A. Schomburg. Or an unnamed isolate playing a game of solitaire in *The Dilemma of an Aging Population* (1950), reprinted in *Fortune* magazine. Or his portraits of a white-haired Harriet Tubman, such as *A Plan to Escape*, *The North Star*, *Fugitives*, and *An Underground Railroad* for his children's book *Harriet and the Promised Land* (1967), undertaken with Robert Kraus. Or a painting from his twelve-part *Supermarket* series (1994) completed at age seventy-seven, such as *Supermarket—Periodicals*, a work that depicts a bald older male utilizing a grocery shopping cart as a mobility aid along with a walking cane (figure C.1). Commenting on this modernism, art historian Lowery Stokes Sims remarks that "Jacob Lawrence has expressed his disinclination to experiment with new styles or new

204 Coda

C.1 Jacob Lawrence, *Supermarket—Periodicals*, 1994. Gouache and pencil on paper, 19¾ x 25½ in. (50.2 x 64.8 cm). Private collection. © 2021 The Jacob and Gwendolyn Knight Lawrence Foundation, Seattle/Artists Rights Society (ARS), New York.

materials once he had found his stride early in his career."[7] Via this lifelong aesthetic, these elderscapes track Afro-Latino genealogy and archiving (Schomburg), freedom and rebellion (Tubman), and the everyday doings of a later life. They testify to Lawrence's own creative aging over almost six decades, which, in turn, enabled that of Iona seniors at the Phillips.

To my mind, works included in *Creative Aging* fall into at least two overlapping genres. The first, obviously, is *life enrichment*, or social activities that supplement—enhance—the days and months of any older individual.[8] Partially supported by local and federal agencies and sponsored by legislation such as the Older Americans Act of 1965 (again reauthorized by the Supporting Older Americans Act of 2020), Iona specializes in such undertakings for the Washington, D.C., area. Offering "adult day health services," its staff members "provide stimulating activities, socialization, a nutritious and well-balanced lunch, and nursing supervision for older adults with Alzheimer's, Parkinson's, intellectual

disabilities, and other challenges."[9] A trip to the Phillips and a return trip to Iona to make magic with paintbrushes and one another neatly fits this self-description.

The second genre is the aesthetic-temporal category of *after*, whereby artists accurately or inaccurately replicate an original work. In another digitally archived piece shown at the Phillips in November 2012 and promoted by *Smithsonian* magazine, for instance, one painter repeats Van Gogh's Saint-Rémy-based *The Road Menders*, with a few differences. The brushstrokes are similar, and the number of trees adds up to four, but the scene is more depopulated and less detailed. Still, it is immediately recognizable as a piece of postimpressionism more than a century after that movement's historical height. The unnamed piece could be titled *After Van Gogh* as much as a Van Gogh piece could be titled *Flowering Plum Orchard (after Hiroshige)* (1887). Following the Phillips's "Your #Panel61" initiative, which asks visitors to contribute to the sixty *Migration Series* panels that it shares with the Museum of Modern Art, we could also title some of these *Creative Aging* compositions *After Jacob Lawrence*. The art may not be exact in terms of its formal qualities, but its making rehearses themes of novelty, self-worth, generational legacy, security, and fortitude that infuse his panels.

My main point: as much as the Phillips Collection periodically functions as an adult day health services center, so, too, do these creatively aging participants periodically function as modernists. These descriptors are not precious. For Iona participants' artwork to be shown in same museum as Lawrence's panels is a radical aesthetic and social act. Together Iona and the Phillips—let's call this magic place the Iona—realize a remark that Alain Locke made about Lawrence and the experimental tradition in an article for *United Asia: International Magazine of Asian Affairs* in 1953: "From 1925 on there has been a brilliant succession of such artists, who, although interested in racial types and situations, were also modernists."[10] *Succession* is the word I wish to emphasize. Not in terms of its synonym *replacement*, exactly, but in line with its more philologically antiquated definition of "the course, lapse, or process *of time*."[11] In not-so-swift succession, twenty-first-century Iona innovators are aging moderns after Lawrence, Van Gogh, myriad other works that *Creative Aging* captured on lower level 2, and the artists featured throughout this book.

What predisposes us to pass over a Tenleytown senior center in the third decade of the twenty-first century as a sustained scene of experimental aging? Why have we not recognized Iona Senior Services as one of our newest modernist

institutions, given ample attention paid to the Phillips's above-ground collections? I like to think that this museum holds more than a frozen field. Jeremy Braddock writes of Duncan Phillips's compeers at MoMA that the latter "canonized modernism primarily as both *field* and *period*, not as an ever-renewing and evolving set of aesthetic and cultural practices."[12] This freezing allows for its thaw, and Iona's vanguard late-onset disability cultures—Latinx, Black, Asian and Asian American, white; working-class, middle-class, mixed-class; alone, in pairs, as a collective—should be added to our timelines (figure C.2). They are the next wave.

As such, Barnes, Steward, Albright, Olsen, Ford, Tamang, and Hampton would have appreciated these newcomers. Their older-newer modernisms, after all, were made near-bedside in Barnes's Patchin Place studio in 1982, in Steward's overstuffed Berkeley cottage in 1989, in Olsen's in-law suite, in Ford and Tamang's Dakota pad up to 2001, and at Hampton's apartment in the Bronx in 1978. The lessons from these exceptional case studies are worth repeating for those of us lucky enough to blow out our candles once a year. To recap:

1. American modernists have not ceased experimenting with growing older.
2. A focus on aging widens our appreciation of chronologically peripheral artists.
3. While frustrating and socially wearying, aging hums with potential.
4. You will find spaces for older persons to age with modernism all over the place.
5. In conjunction with other interdisciplines, the vocabulary of critical age studies facilitates #1 through #4.

Gerontophobia, oldest-old, fragilization, vulnerability, creative aging, decline ideology, life review, cross-generational intimacies, age consciousness, double jeopardy, assisted modernist living: may this list of analytics keep growing. These keywords and phrases give new meaning to a grocery store list and self-revision (chapter 1); a miniature book and detective fiction (chapter 2); magic realism and skin creams (chapter 3); a poetic fragment praising a nonreproductive female body (chapter 4); a birthday card, gay male collage, daily planners, and in-home care work (chapter 5); and lesbian-feminist photographs of a butch Afro-modernist (chapter 6).

C.2 Sharon O'Connor, *Participants creating collaborative artwork in the Iona/Phillips Creative Aging partnership*, 2019. Courtesy of Donna Jonte on behalf of Art & Wellness and Family Programs at The Phillips Collection, Washington, D.C.

My focus on varieties of geromodernism in the later twentieth- and early twenty-first-century United States likewise leads me to a corollary for scholars in American studies attuned to aesthetics: we can better attend to old age imaginaries within aging populations as they traverse later-life microhabitats. Detailing but six elderscapes, I spent most of my energies on the particulars of

their late modern lives. The world of aging is, however, large and small. There are other rooms, other voices, other senescent heterogeneities. American modernism will remain what Janet Lyon calls "a house of many mansions"—a definition that complements the Iona's "'art house' with room for all."[13]

Our job is to furnish this dwelling with grab bars and couch canes, security poles and lever extenders for those who need them. Take up the rugs. Remove any tripping hazard. Fill its drawers with zipper pulls and shoehorns, pens and ink and lighted magnifiers. Rearrange rooms to allow those who enter the world of frailty their audacious capacities. While they do so, sit with them and their works in progress. Over the thousands of days that I undertook this project, I began to think of myself as both a researcher and a scholarly service to older artists. Requesting boxes from the Lesbian Herstory Archives or reels from the University of Maryland Libraries, I concluded that my dedicated hours spent with their special collections should double as intellectual long-term care. Yes, this book made a few claims for a few fields. But I do hope against hope that it prevents the fall of several creative late lives into greater obscurity. My decade-long shift ends if *Aging Moderns* proves itself nothing more, or less, than a handrail for them to hold on to.

For Christine Oblitas, in gratitude

Notes

INTRODUCTION

1. Margaret Morganroth Gullette, *Aged by Culture* (Chicago: University of Chicago Press, 2004), 184. On the concept of elderscapes, see Stephen Katz, *Cultural Aging: Life Course, Lifestyle, and Senior Worlds* (Peterborough, Can.: Broadview, 2005), 202–31.
2. Langston Hughes, "Old Age," *Border* 1, no. 1 (1965): n.p.
3. Kathleen Woodward, *At Last, the Real Distinguished Thing: The Late Poems of Eliot, Pound, Stevens, and Williams* (Columbus: Ohio State University Press, 1980), 13.
4. Djuna Barnes, marginalia, ca. February 11–12, 1979, series 3, box 10, folder 12, DBP.
5. Robert Reid-Pharr, "Queers Growing Old and Young," *Public Books*, March 12, 2018, www.publicbooks.org/queers-growing-old-and-young/. In agreement with Reid-Pharr, see Anne Basting, "How We Underestimate the Arts in Long-Term Care," *Caring for the Ages* 19, no. 7 (2018): 10–11; and Basting, *Creative Care: A Revolutionary Approach to Dementia and Elder Care* (New York: HarperOne, 2020).
6. See Susan Sontag, "The Double Standard of Aging," *Saturday Review*, September 23, 1972, 29–38.
7. Scott Heller, "New Life for Modernism," *Chronicle of Higher Education*, November 5, 1999, A21. For a digitally archived conference program, see "The Inaugural Conference of the Modernist Studies Association, 7–10 October 1999, The Nittany Lion Inn, Pennsylvania State University," Modernist Studies Association, https://msa.press.jhu.edu/archive/msa1/program.htm. For an overview of this conference, see Mark Wollaeger, "Scholarship's Turn: Origins and Effects of the New Modernist Studies," in *The New Modernist Studies*, ed. Douglas Mao (Cambridge: Cambridge University Press, 2021), 41–63.
8. Douglas Mao and Rebecca L. Walkowitz, "The New Modernist Studies," *PMLA* 123, no. 3 (2008): 738. For further elaborations, see Sean Latham and Gayle Rogers, *Modernism: Evolution of an Idea* (London: Bloomsbury Academic, 2015), who write that modernism "serves simply as a kind of shorthand to mark almost any cultural or aesthetic work that appeared between roughly 1890 and 1970 (even though these dates are elastic)" (151); Vincent Sherry, "Introduction: A History of Modernism," in *The Cambridge History of Modernism*, ed. Vincent Sherry (Cambridge: Cambridge University Press, 2017), 1–25; and Douglas Mao, introduction to *The New Modernist Studies*, 1–21.

9. Amy Hungerford, "On the Period Formerly Known as Contemporary," *American Literary History* 20, no. 1–2 (2008): 418. Earlier iterations of this idea can be found in an essay in 1985 by Marc Chénetier, who found it in a 1980 essay by André Bleikasten, who wrote "that many self-designated postmodern creations betray Romantic tenets and that Modernism lives on" (664). Chénetier, "Charting Contemporary American Fiction: A View from Abroad," *New Literary History* 16, no. 3 (1985): 653–69.

10. Harry Levin, "What Was Modernism?," *Massachusetts Review* 1, no. 4 (1960): 618, 620. For ruminations on Levin's thesis, see Latham and Rogers, *Modernism*, who confirm that "the death of the movement's primary figures meant that modernism had become a historically limited era with a demarcated aesthetic canon" (69); and Robert Genter, *Late Modernism: Art, Culture, and Politics in Cold War America* (Philadelphia: University of Pennsylvania Press, 2010), who finds "many eulogies written in the 1960s about the supposed end of modernism" (5).

11. Levin, "What Was Modernism?," 613, 618.

12. William Carlos Williams, *The Autobiography of William Carlos Williams* (1951; New York: New Directions, 1967), 318.

13. Malcolm Cowley, *The View from 80* (New York: Viking, 1980), 27.

14. Denise Levertov, "September 1961," in *Poems: 1960–1967* (New York: New Directions, 1983), 81.

15. Hugh Kenner, *The Pound Era* (Berkeley: University of California Press, 1971), 551, 541.

16. Shari Benstock, *Women of the Left Bank: Paris, 1900–1940* (Austin: University of Texas Press, 1986), 5, 4.

17. Delia Konzett, "The Belated Tradition of Asian-American Modernism," in *A Companion to the Modern American Novel, 1900–1950*, ed. John T. Matthews (Oxford: Wiley-Blackwell, 2009), 499; Aarthi Vadde, *Chimeras of Form: Modernist Internationalism Beyond Europe, 1914–2016* (New York: Columbia University Press, 2017), 21; Mark Goble, "Forever Modernism," *Novel* 52, no. 3 (2019): 484–88; Morag Shiach, "Periodizing Modernism," in *The Oxford Handbook of Modernisms*, ed. Peter Brooker, Andrzej Gąsiorek, Deborah Longworth, and Andrew Thacker (New York: Oxford University Press, 2010), 30. See also Svetlana Boym, *The Future of Nostalgia* (New York: Basic Books, 2001); Christopher Nealon, "The Matter of Literacy, or Poetry Without Modernity," *J19* 1, no. 1 (2013): 206–13, who calls for "a literary history that would be better told outside the influential language of 'modernity' that insists on imagining a sharp break between the Victorians and the moderns, and between the moderns and the postmoderns" (210); Susan Stanford Friedman, "Alternatives to Periodization: Literary History, Modernism, and the 'New' Temporalities," *Modern Language Quarterly* 80, no. 4 (2019): 379–402; David James, ed., *The Legacies of Modernism: Historicising Postwar and Contemporary Fiction* (New York: Cambridge University Press, 2012); and Madelyn Detloff, *The Persistence of Modernism: Loss and Mourning in the Twentieth Century* (New York: Cambridge University Press, 2009).

18. For more on modernist afterlives, see Sara Blair, *How the Other Half Looks: The Lower East Side and the Afterlives of Images* (Princeton, N.J.: Princeton University Press, 2018); Michael D'Arcy and Mathias Nilges, eds., *The Contemporaneity of Modernism: Literature, Media, Culture* (New York: Routledge, 2016); and David James, *Modernist Futures:*

Introduction 211

Innovation and Inheritance in the Contemporary Novel (New York: Cambridge University Press, 2012).

19. Mao and Walkowitz, "The New Modernist Studies," 738.
20. Mark McGurl, *The Program Era: Postwar Fiction and the Rise of Creative Writing* (Cambridge, Mass.: Harvard University Press, 2009), 42. In no particular order, a roll call would announce the following: George Hutchinson, *Facing the Abyss: American Literature and Culture in the 1940s* (New York: Columbia University Press, 2018); Greg Barnhisel, *Cold War Modernists: Art, Literature, and American Cultural Diplomacy* (New York: Columbia University Press, 2015); Will Norman, *Transatlantic Aliens: Modernism, Exile, and Culture in Midcentury America* (Baltimore: Johns Hopkins University Press, 2016); Claire Seiler, *Midcentury Suspension: Literature and Feeling in the Wake of World War II* (New York: Columbia University Press, 2020); Shane Vogel, *Stolen Time: Black Fad Performance and the Calypso Craze* (Chicago: University of Chicago Press, 2018); William J. Maxwell, *F.B. Eyes: How J. Edgar Hoover's Ghostreaders Framed African American Literature* (Princeton, N.J.: Princeton University Press, 2015); Richard Meyer, *What Was Contemporary Art?* (Cambridge, Mass.: MIT Press, 2013); Heidi Kim, *Invisible Subjects: Asian America in Postwar Literature* (New York: Oxford University Press, 2016); Darlene Clark Hine and John McCluskey Jr., eds., *The Black Chicago Renaissance* (Urbana: University of Illinois Press, 2012); Mary Helen Washington, *The Other Blacklist: The African American Literary and Cultural Left of the 1950s* (New York: Columbia University Press, 2015); Paula Rabinowitz, *American Pulp: How Paperbacks Brought Modernism to Main Street* (Princeton, N.J.: Princeton University Press, 2014); and Pamela M. Lee, *Think Tank Aesthetics: Midcentury Modernism, the Cold War, and the Neoliberal Present* (Cambridge, Mass.: MIT Press, 2020).
21. McGurl, *The Program Era*, 223, 222.
22. Woodward, *At Last*, x, 5.
23. See Zhaoming Qian, *East-West Exchange and Late Modernism: Williams, Moore, Pound* (Charlottesville: University of Virginia Press, 2017); Peter Brooker, "Afterword: 'Newness' in Modernisms, Early and Late," in Brooker et al., *Oxford Handbook of Modernisms*, 1012–36; Michaela Bronstein, *Out of Context: The Uses of Modernist Fiction* (New York: Oxford University Press, 2018), who writes that "we have theories of 'late modernism' for mid-century works" (25); Tyrus Miller, *Late Modernism: Politics, Fiction, and the Arts Between the World Wars* (Berkeley: University of California Press, 1999), who dates late modernism as post-1925 while granting "the problem of defining its chronological boundaries" (21); and Anthony Mellors, *Late Modernist Poetics: From Pound to Prynne* (Manchester, UK: Manchester University Press, 2005), who announces from the outset "what I call 'late modernism' (schematically, occupying the period 1945–1975)" (2).
24. Fredric Jameson, "Gherman's Anti-Aesthetic," *New Left Review* 97 (2016): 96, 97.
25. Walt Whitman, "A Backward Glance O'er Travel'd Roads," in *November Boughs* (Philadelphia: David McKay, 1888), 5.
26. Walt Whitman, "Old Age's Lambent Peaks," *Century Illustrated Monthly Magazine* 38 (1888): 735. See also Sari Edelstein, "'Now I Chant Old Age': Whitman's Geriatric Vistas," *Commonplace: The Journal of Early American Life* 19, no. 1 (2019), http://commonplace.online/article/now-chant-old-age/, and its reading of Whitman "as a theorist of the aging body."

27. Walt Whitman, "Year of Meteors (1859-60)," in *Leaves of Grass* (Philadelphia: David McKay, 1891-1892), 191.
28. Walt Whitman, "Preface Note to Second Annex," in *Leaves of Grass*, 407, 408.
29. Whitman, "Preface Note," 408; Langston Hughes, "Old Walt," *Beloit Poetry Journal* 5, no. 1 (1954): 10.
30. Quoted in Horace Traubel, *With Walt Whitman in Camden (March 28–July 14, 1888)* (London: Gay and Bird, 1906), 11.
31. Margaret Morganroth Gullette, *Agewise: Fighting the New Ageism in America* (Chicago: University of Chicago Press, 2011), 16. See Devoney Looser, "Age and Aging Studies, from Cradle to Grave," *Age, Culture, Humanities* 1 (2014): 25-29; Leni Marshall, *Age Becomes Us: Bodies and Gender in Time* (Albany, N.Y.: SUNY Press, 2015); Sari Edelstein, *Adulthood and Other Fictions: American Literature and the Unmaking of Age* (New York: Oxford University Press, 2019); Habiba Ibrahim, *Black Age: Oceanic Lifespans and the Time of Black Life* (New York: New York University Press, 2021); and Amelia DeFalco, *Uncanny Subjects: Aging in Contemporary Narrative* (Columbus: Ohio State University Press, 2007).
32. Bernice L. Neugarten, Joan W. Moore, and John C. Lowe, "Age Norms, Age Constraints, and Adult Socialization," in *The Meanings of Age: Selected Papers of Bernice L. Neugarten*, ed. Dail A. Neugarten (Chicago: University of Chicago Press, 1996), 31; Jacquelyne Johnson Jackson, "The Blacklands of Gerontology," *Aging and Human Development* 2, no. 3 (1971): 156-71.
33. Gullette, *Aged by Culture*, 18, 38; Kathleen Woodward, *Aging and Its Discontents: Freud and Other Fictions* (Bloomington: Indiana University Press, 1991), 19.
34. Robert N. Butler, "Age-ism: Another Form of Bigotry," *Gerontologist* 9, no. 4 (1969): 243.
35. See Margaret Morganroth Gullette, "Creativity, Aging, Gender: A Study of Their Intersections, 1910-1935," in *Aging and Gender in Literature: Studies in Creativity*, ed. Anne M. Wyatt-Brown and Janice Rossen (Charlottesville: University Press of Virginia, 1993), 19-48.
36. Woodward, *At Last*, xii.
37. Heather Love, *Feeling Backward: Loss and the Politics of Queer History* (Cambridge, Mass.: Harvard University Press, 2007), 6.
38. Michael North, "The Afterlife of Modernism," *New Literary History* 50, no. 1 (2019): 94, 106-7. For an adjacent reading, see Sarah Ehlers, "Making It Old: The Victorian/Modern Divide in Twentieth-Century American Poetry," *Modern Language Quarterly* 73, no. 1 (2012): 37-67. Attending to "the anxious space between the Victorian and the modern" in writings by Harriet Monroe and Selma Walden, Ehlers finds that such modernists "strategically incorporated the old into the new" (38, 43).
39. North, "Afterlife," 106.
40. Sam See, *Queer Natures, Queer Mythologies*, ed. Christopher Looby and Michael North (New York: Fordham University Press, 2020), 198.
41. See Elizabeth Gregory, "'Still Leafing': Celebrity, Confession, Marianne Moore's 'The Camperdown Elm' and the Scandal of Age," *Journal of Modern Literature* 35, no. 3 (2012): 51-76; Elizabeth Gregory, "Marianne Moore's 'Blue Bug': A Dialogic Ode on Celebrity, Race, Gender, and Age," *Modernism/modernity* 22, no. 4 (2015): 759-86; Benjamin Kahan, *Celibacies: American Modernism and Sexual Life* (Durham, N.C.: Duke University Press, 2013);

and Melanie V. Dawson, *Edith Wharton and the Modern Privileges of Age* (Gainesville: University Press of Florida, 2020).

42. Wanda M. Corn, *Georgia O'Keeffe: Living Modern* (Brooklyn, N.Y.: Brooklyn Museum, and Munich: DelMonico Books/Prestel, 2017), 263, 283. See also Woodward, *At Last*, who describes Pound's *Cantos* as "an unfolding of his life" (72); and Melanie Micir, *The Passion Projects: Modernist Women, Intimate Archives, Unfinished Lives* (Princeton, N.J.: Princeton University Press, 2019), who suggests that the "late activities" of modernist authors "should be read as modes of life writing" (36).

43. Christine Stansell, *American Moderns: Bohemian New York and the Creation of a New Century* (New York: Metropolitan Books, 2000), 2. In tandem with Stansell, we also find Paul Rosenfeld, *Port of New York: Essays on Fourteen American Moderns* (New York: Harcourt, Brace, 1924); and ShiPu Wang, *The Other American Moderns: Matsura, Ishigaki, Noda, Hayakawa* (University Park: Penn State University Press, 2017).

44. Donald Hall, "A House Without a Door," in *Essays After Eighty* (Boston: Houghton Mifflin Harcourt, 2014), 120.

45. Gullette, *Aged by Culture*, 157.

46. Samuel Steward to Jeannie Barney, January 5, 1990, box 5, SSP.

47. Michael Williams, "Remembering Sam," in *Samuel Steward and the Pursuit of the Erotic: Sexuality, Literature, Archives*, ed. Debra A. Moddelmog and Martin Joseph Ponce (Columbus: Ohio State University Press, 2017), 212.

48. Gullette, "Creativity, Aging, Gender," 20.

49. Paul K. Saint-Amour, "Weak Theory, Weak Modernism," *Modernism/modernity* 25, no. 3 (2018): 455, 456. A sampling of works in modern/ist disability studies includes Wai Chee Dimock, *Weak Planet: Literature and Assisted Survival* (Chicago: University of Chicago Press, 2020); Michael Davidson, *Invalid Modernism: Disability and the Missing Body of the Aesthetic* (New York: Oxford University Press, 2019); Rebecca Sanchez, *Deafening Modernism: Embodied Language and Visual Poetics in American Literature* (New York: New York University Press, 2015); David Serlin, "Disabling the *Flâneur*," *Journal of Visual Culture* 5, no. 2 (2006): 193-208; Joseph Valente, "The Accidental Autist: Neurosensory Disorder in *The Secret Agent*," *Journal of Modern Literature* 38, no. 1 (2014): 20-37; Maren Tova Linett, *Bodies of Modernism: Physical Disability in Transatlantic Modernist Literature* (Ann Arbor: University of Michigan Press, 2017); Janet Lyon, "On the Asylum Road with Woolf and Mew," *Modernism/modernity* 18, no. 3 (2011): 551-74; Douglas C. Baynton, *Defectives in the Land: Disability and Immigration in the Age of Eugenics* (Chicago: University of Chicago Press, 2016); Jess Waggoner, "'The Seriously Injured of Our Civic Life': Imagining Disabled Collectivity in Depression-Era Crip Modernisms," *Modern Fiction Studies* 65, no. 1 (2019): 89-110; Susan M. Schweik, *The Ugly Laws: Disability in Public* (New York: New York University Press, 2009); Ryan Lee Cartwright, *Peculiar Places: A Queer Crip History of White Rural Nonconformity* (Chicago: University of Chicago Press, 2021); and Stephen Knadler, *Vitality Politics: Health, Debility, and the Limits of Black Emancipation* (Ann Arbor: University of Michigan Press, 2019). Age studies as it further overlaps with disability studies can be found in Leni Marshall, "Ageility Studies: The Interplay of Critical Approaches in Age Studies and Disability Studies," in *Alive and Kicking at All Ages: Cultural Constructions of Health and Life Course Identity*, ed. Ulla Kriebernegg, Roberta Maierhofer, and Barbara Ratzenböck (Bielefeld, Ger.:

Transcript, 2014), 21–39; Katie Aubrecht, Christine Kelly, and Carla Rice, eds., *The Aging-Disability Nexus* (Vancouver: University of British Columbia Press, 2020); Chris Gilleard and Paul Higgs, *Ageing, Corporeality and Embodiment* (London: Anthem, 2013), 69–85; Jane Gallop, *Sexuality, Disability, and Aging: Queer Temporalities of the Phallus* (Durham, N.C.: Duke University Press, 2019); Aimi Hamraie, "Inclusive Design: Cultivating Accountability Toward the Intersections of Race, Aging, and Disability," *Age, Culture, Humanities* 2 (2015): 337–46; and Margaret Morganroth Gullette, *Declining to Decline: Cultural Combat and the Politics of the Midlife* (Charlottesville: University Press of Virginia, 1997), 53–55. I note, finally, that Gallop, *Sexuality*, retheorizes late-onset disability in relation to queer studies following the many decades that age-minded critics have worked with this concept.

50. See Scott Herring, "Weak, Frail Modernism," *Modernism/modernity* Print Plus 3, cycle 4 (2019), https://modernismmodernity.org/forums/posts/responses-special-issue-weak-theory-part-i.

51. Woodward, *Aging and Its Discontents*, 188. This reference also includes her thoughts on psychoanalytically informed fragilization.

52. Tillie Olsen, draft fragment, n.d., series 14, box 20, folder 18, TOP.

53. Kathleen Woodward, "Aging," in *Keywords for Disability Studies*, ed. Rachel Adams, Benjamin Reiss, and David Serlin (New York: New York University Press, 2015), 34.

54. Susan Stanford Friedman, *Planetary Modernisms: Provocations on Modernity Across Time* (New York: Columbia University Press, 2015), 218, 217. For engagements with Friedman, see David James and Urmila Seshagiri, "Metamodernism: Narratives of Continuity and Revolution," *PMLA* 129, no. 1 (2014): 87–100, especially their claim that modernism appears "as both a moment and a movement" (93); and Edwige Tamalet Talbayev, "Berber Poetry and the Issue of Derivation: Alternate Symbolist Trajectories," in *The Oxford Handbook of Global Modernisms*, ed. Mark Wollaeger with Matt Eatough (New York: Oxford University Press, 2012), 81–108.

55. Michel Foucault, *"Society Must Be Defended": Lectures at the Collège de France, 1975–76*, ed. Mauro Bertani and Alessandro Fontana, trans. David Macey (New York: Picador, 2003), 244.

56. Gordon McMullan, "The 'Strangeness' of George Oppen: Criticism, Modernity, and the Conditions of Late Style," in *Late Style and Its Discontents: Essays in Art, Literature, and Music*, ed. Gordon McMullan and Sam Siles (Oxford: Oxford University Press, 2016), 47. For considerations of this topic within age studies, see Stephen Katz, ed., *Ageing in Everyday Life: Materialities and Embodiments* (Bristol, UK: Policy Press, 2019); and Amanda Grenier et al., "Meanings and Feelings of (Im)mobility in Later Life: Case Study Insights from a 'New Mobilities' Perspective," *Journal of Aging Studies* 51 (2019), doi.org/10.1016/j.jaging.2019.100819.

57. Linda Hutcheon and Michael Hutcheon, "Historicizing Late Style as a Discourse of Reception," in McMullan and Siles, *Late Style*, 68. See also Linda Hutcheon and Michael Hutcheon, *Four Last Songs: Aging and Creativity in Verdi, Strauss, Messiaen, and Britten* (Chicago: University of Chicago Press, 2015); Linda Hutcheon and Michael Hutcheon, "Late Style(s): The Ageism of the Singular," *Occasion: Interdisciplinary Studies in the Humanities* 4 (2012), https://arcade.stanford.edu/occasion/late-styles-ageism-singular;

and Ben Hutchinson, afterword to McMullan and Siles, *Late Style*, 235–40. Each complicates theorizations featured in Edward W. Said, *On Late Style: Music and Literature Against the Grain* (New York: Pantheon, 2006); and Theodor W. Adorno, "Late Style in Beethoven," in *Essays on Music*, selected by Richard Leppert, trans. Susan H. Gillespie (Berkeley: University of California Press, 2002), 564–68.

58. Samuel M. Steward, *Chapters from an Autobiography* (San Francisco: Grey Fox Press, 1981), 140.

59. Beinecke Staff, Guide to the Charles Henri Ford Papers, Archives at Yale, accessed October 8, 2020, https://ead-pdfs.library.yale.edu/1519.pdf.

60. Empire Medicare Services notice, October 11, 2000, series 7, box 23, folder 5, CHFP. For a history of Social Security that overlaps with Ford's papers, see Carole Haber and Brian Gratton, *Old Age and the Search for Security: An American Social History* (Bloomington: Indiana University Press, 1994).

61. See Howard P. Chudacoff, *How Old Are You? Age Consciousness in American Culture* (Princeton, N.J.: Princeton University Press, 1989); Jill Lepore, *The Mansion of Happiness: A History of Life and Death* (New York: Knopf, 2012), 137–51; Carole Haber, *Beyond Sixty-Five: The Dilemma of Old Age in America's Past* (Cambridge: Cambridge University Press, 1983); W. Andrew Achenbaum, *Old Age in the New Land: The American Experience Since 1790* (Baltimore: Johns Hopkins University Press, 1978); Thomas R. Cole, *The Journey of Life: A Cultural History of Aging in America* (Cambridge: Cambridge University Press, 1992); Steven Mintz, *The Prime of Life: A History of Modern Adulthood* (Cambridge, Mass.: Belknap Press of Harvard University Press, 2015); Corinne T. Field, *The Struggle for Equal Adulthood: Gender, Race, Age, and the Fight for Citizenship in Antebellum America* (Chapel Hill: University of North Carolina Press, 2014); and Corinne T. Field and Nicholas L. Syrett, eds., *Age in America: The Colonial Era to the Present* (New York: New York University Press, 2015).

62. On U.S. geriatrics and gerontology, see W. Andrew Achenbaum, *Crossing Frontiers: Gerontology Emerges as a Science* (Cambridge: Cambridge University Press, 1995); Stephen Katz, *Disciplining Old Age: The Formation of Gerontological Knowledge* (Charlottesville: University Press of Virginia, 1996); and Hyung Wook Park, *Old Age, New Science: Gerontologists and Their Biosocial Visions, 1900–1960* (Pittsburgh: University of Pittsburgh Press, 2016).

63. Chudacoff, *How Old Are You?*, 115.

64. Older Americans Act of 1965, H.R. 3708, 89th Cong. (1965).

65. Robert N. Butler, *The Longevity Revolution: The Benefits and Challenges of Living a Long Life* (New York: PublicAffairs, 2008). See also David W. Plath, *Long Engagements: Maturity in Modern Japan* (Stanford, Calif.: Stanford University Press, 1980); and Laura L. Carstensen, *A Long Bright Future: Happiness, Health, and Financial Security in an Age of Increased Longevity* (New York: PublicAffairs, 2009), 10.

66. W. Andrew Achenbaum, "Delineating Old Age: From Functional Status to Bureaucratic Criteria," in Field and Syrett, *Age in America*, 302. This number differs from nineteenth-century means, but I do not presume that period to be absent dynamic age norms that spilled over into the twentieth century. See Edelstein, *Adulthood and Other Fictions*; and Nathaniel Windon, "Superannuated: Old Age on the Antebellum

Plantation," *American Quarterly* 71, no. 3 (2019): 767–87. For more on U.S. life expectancy declines, see Anne Case and Angus Deaton, *Deaths of Despair and the Future of Capitalism* (Princeton, N.J.: Princeton University Press, 2020); and Elizabeth Arias, Betzaida Tejada-Vera, Farida Ahmad, and Kenneth D. Kochanek, "Provisional Life Expectancy Estimates for 2020," *Vital Statistics Rapid Release* 15 (2021), https://cdc.gov/nchs/data/vsrr/VSRR015-508.pdf.

67. Gullette, *Aged by Culture*, 179.
68. Zora Neale Hurston, *Their Eyes Were Watching God* (1937; New York: Harper Perennial Modern Classics, 2006), 2, 3.
69. Corinne T. Field and Nicholas L. Syrett, introduction to "Chronological Age: A Useful Category of Historical Analysis," *American Historical Review* 125, no. 2 (2020): 378.
70. Corinne T. Field and Nicholas L. Syrett, "Age and the Construction of Gendered and Raced Citizenship in the United States," *American Historical Review* 125, no. 2 (2020): 445.
71. The petition can be found in Mabel Hampton to County Clerk Hall of Records, n.d., box 2, folder 7, MHSC; affidavit of Mabel Hampton, May 26, 1943, box 2, folder 7, MHSC. Further details are in Joan Nestle, "'I Lift My Eyes to the Hill': The Life of Mabel Hampton as Told by a White Woman," in *A Fragile Union: New and Selected Writings* (San Francisco: Cleis, 1998), 23–48; and Joan Nestle, "In Memory on October 26: 'I Lift My Eyes to the Hill': The Life of Mabel Hampton (1902–October 26, 1989) Part 1," *Don't Stop Talking 2* (blog), October 27, 2011, https://joannestle2.blogspot.com/2011/10/in-memory-on-october-26-i-lift-my-eyes.html.
72. "Positive Aging," *Prime of Life* 22, no. 8 (1987): 1.
73. Jean-Christophe Cloutier, *Shadow Archives: The Lifecycles of African American Literature* (New York: Columbia University Press, 2019), 20. See also Latham and Rogers, *Modernism*, 71–72; and Matthew Feldman, Anna Svendsen, and Erik Tonning, eds., *Historicizing Modernists: Approaches to 'Archivalism'* (London: Bloomsbury Academic, 2021).
74. Tillie Olsen, "Radcliffe Forum: 'Comprehensions,'" March 13, 1979, series 6, box 42, folder 20, TOP.
75. Woodward, *At Last*, ix.
76. W. H. Auden, "Doggerel by a Senior Citizen," in *W. H. Auden: Collected Poems*, ed. Edward Mendelson (1969; London: Faber and Faber, 1976), 638.
77. Toni Morrison, "The Foreigner's Home," in *The Source of Self-Regard: Selected Essays, Speeches, and Meditations* (New York: Knopf, 2019), 62. See also Virginia Lynn Moylan, *Zora Neale Hurston's Final Decade* (Gainesville: University Press of Florida, 2011).
78. Jennifer Wicke, "Appreciation, Depreciation: Modernism's Speculative Bubble," *Modernism/modernity* 8, no. 3 (2001): 398, 401–2.
79. For more on this topic, see Kathleen Woodward, "Age-Work in American Culture," *American Literary History* 6, no. 4 (1994): 779–91.
80. Peggy Phelan, "Modernism and Morality," *Women's Review of Books* 4, no. 6 (1987): 10.
81. For contextualization of this art in relation to Ringgold's *French Collection* series (1990–97), see Moira Roth, "Of Cotton and Sunflower Fields: The Makings of *The French* and *The American Collection*," in *Dancing at the Louvre: Faith Ringgold's French Collection and Other Story Quilts*, Dan Cameron et al. (New York: New Museum of Contemporary Art, and Berkeley: University of California Press, 1998), 49–63.

82. Maryjane Fahey, "Faith Ringgold: Artist, Author ... Game Inventor?," Disrupt Aging, January 23, 2017, https://aarp.org/disrupt-aging/video-disrupt-aging/info-2017/faith-ringgold-quiltuduko-video.html.

1. DJUNA BARNES AND THE GERIATRIC AVANT-GARDE

1. Suzanne Daley, "Djuna Barnes Dies; Poet and Novelist," *New York Times*, June 20, 1982, 32.
2. Andrew Field, *Djuna: The Life and Times of Djuna Barnes* (New York: Putnam, 1983), 21, 22.
3. Hank O'Neal, *"Life Is Painful, Nasty, and Short . . . In My Case It Has Only Been Painful and Nasty": Djuna Barnes, 1978–1981: An Informal Memoir* (New York: Paragon, 1990), xvi, 10. Hereafter cited parenthetically in the chapter with an abbreviated *L*.
4. Richard Suzman and Matilda White Riley, "Introducing the 'Oldest Old,'" *Milbank Memorial Fund Quarterly. Health and Society* 63, no. 2 (1985): 177.
5. James B. Scott, "Reminiscences," in *Silence and Power: A Reevaluation of Djuna Barnes*, ed. Mary Lynn Broe (Carbondale: Southern Illinois University Press, 1991), 344.
6. The Wingchair Critic, "The Night Is a Hunter," review of *Nightwood*, by Djuna Barnes, Amazon, March 24, 2003.
7. An important exception to this characterization is Cathryn Setz, "'Trees of Heaven': Djuna Barnes's Late Metaphysical Verse," in *Shattered Objects: Djuna Barnes's Modernism*, ed. Elizabeth Pender and Cathryn Setz (University Park: Penn State University Press, 2019), 130–46.
8. For commentary on Barnes's post-1940 published poetry, see Louis F. Kannenstine, *The Art of Djuna Barnes: Duality and Damnation* (New York: New York University Press, 1977), 161–69; Walter Kalaidjian, *The Edge of Modernism: American Poetry and the Traumatic Past* (Baltimore: Johns Hopkins University Press, 2006); and Deborah Tyler-Bennett, "'Thick Within Our Hair': Djuna Barnes's Gothic Lovers," in *Gothic Modernisms*, ed. Andrew Smith and Jeff Wallace (New York: Palgrave, 2001), 95–110.
9. Phillip Herring and Osías Stutman, ed., *Collected Poems, with Notes Toward the Memoirs*, by Djuna Barnes (Madison: University of Wisconsin Press, 2005), 147.
10. Eve Kosofsky Sedgwick, *Touching Feeling: Affect, Pedagogy, Performativity* (Durham, N.C.: Duke University Press, 2003), 24.
11. *Oxford English Dictionary*, s.v. "geriatric," accessed August 18, 2021, oed.com.
12. Herring and Stutman, introduction to *Collected Poems*, 9. Herring, e.g., draws on O'Neal's memoir in *Djuna: The Life and Work of Djuna Barnes* (New York: Penguin, 1996).
13. Daniela Caselli, *Improper Modernism: Djuna Barnes's Bewildering Corpus* (Surrey, UK: Ashgate, 2009), 84.
14. Margaret Morganroth Gullette, *Aged by Culture* (Chicago: University of Chicago Press, 2004), 13, details the decline narrative; Margaret Morganroth Gullette, "Creativity, Aging, Gender: A Study of Their Intersections, 1910–1935," in *Aging and Gender in Literature: Studies in Creativity*, ed. Anne M. Wyatt-Brown and Janice Rossen (Charlottesville: University Press of Virginia, 1993), 20.
15. Howard P. Chudacoff, *How Old Are You? Age Consciousness in American Culture* (Princeton, N.J.: Princeton University Press, 1989), 58.

16. Gullette, *Aged by Culture*, 39, 154, 125.
17. To this body of work I add Max Saunders, *Self Impression: Life-Writing, Autobiografiction, and the Forms of Modern Literature* (Oxford: Oxford University Press, 2010), on "the ways in which modern authors have engaged with forms of life-writing—biography, autobiography, memoir, diary, [and] journal" (14); Maria DiBattista, "The Real Hem," in *Modernism and Autobiography*, ed. Maria DiBattista and Emily O. Wittman (New York: Cambridge University Press, 2014), 170–84: and Melanie Micir, *The Passion Projects: Modernist Women, Intimate Archives, Unfinished Lives* (Princeton, N.J.: Princeton University Press, 2019).
18. Personal Narratives Group, "Origins," in *Interpreting Women's Lives: Feminist Theory and Personal Narratives*, ed. Joy Webster Barbre et al. (Bloomington: Indiana University Press, 1989), 6.
19. Melissa Jane Hardie, "'That Man in My Mouth': Editing, Masculinity and Modernism," in *Modernism and Masculinity*, ed. Natalya Lusty and Julian Murphet (New York: Cambridge University Press, 2014), 39.
20. Cheryl J. Plumb, introduction to *Nightwood: The Original Version and Related Drafts*, by Djuna Barnes, ed. Cheryl J. Plumb (Normal, Ill.: Dalkey Archive, 1995), xxiii. For complementary accounts of their interactions, see Donna Gerstenberger, "The Radical Narrative of Djuna Barnes's *Nightwood*," in *Breaking the Sequence: Women's Experimental Fiction*, ed. Ellen G. Friedman and Miriam Fuchs (Princeton, N.J.: Princeton University Press, 1989), 129–39; and Cheryl J. Plumb, "Revising *Nightwood*: 'A Kind of Glee of Despair,'" *Review of Contemporary Fiction* 13, no. 3 (1993): 149–59.
21. Miriam Fuchs, "Djuna Barnes and T. S. Eliot: Authority, Resistance, and Acquiescence," *Tulsa Studies in Women's Literature* 12, no. 2 (1993): 289, 304. Further assessments of this relationship include Monika Faltejskova, *Djuna Barnes, T. S. Eliot, and the Gender Dynamics of Modernism: Tracing* Nightwood (New York: Putnam, 1983); Catherine Hollis, "No Marriage in Heaven: Editorial Resurrection in Djuna Barnes's *Nightwood*," *Text* 13 (2000): 233–49; and Lynda Curry, "'Tom, Take Mercy': Djuna Barnes' Drafts of *The Antiphon*," in Broe, *Silence and Power*, 286–98.
22. Chester Page, *Memoirs of a Charmed Life in New York* (New York: iUniverse, 2007), 112, 138.
23. Herring, *Djuna*, 311.
24. Herring and Stutman, introduction to *Collected Poems*, 16
25. Quoted in Plumb, introduction to *Nightwood*, viii.
26. Sidonie Smith and Julia Watson, ed., *Reading Autobiography: A Guide for Interpreting Life Narratives*, 2nd ed. (Minneapolis: University of Minnesota Press, 2010), 151. See also Miriam Fuchs, *The Text Is Myself: Women's Life Writing and Catastrophe* (Madison: University of Wisconsin Press, 2004); Leigh Gilmore, *Autobiographics: A Feminist Theory of Women's Self-Representation* (Ithaca, N.Y.: Cornell University Press, 1994); Nancy K. Miller, *Getting Personal: Feminist Occasions and Other Autobiographical Acts* (New York: Routledge, 1991); and Sidonie Smith, "Performativity, Autobiographical Practice, Resistance," *a/b: Auto/Biography Studies* 10, no. 1 (1995): 17–33.
27. A helpful critique of aging "angry women" is in Kathleen Woodward, *Statistical Panic: Cultural Politics and Poetics of the Emotions* (Durham, N.C.: Duke University Press, 2009), 75. Gender, modern literature, and aging discourses are also addressed in Audrey

Borenstein, *Chimes of Change and Hours: Views of Older Women in Twentieth-Century America* (Cranbury, N.J.: Fairleigh Dickinson University Press, 1983); and Kathleen Woodward, *Figuring Age: Women, Bodies, Generations* (Bloomington: Indiana University Press, 1999).

28. Broe, introduction to *Silence and Power*, 5.
29. Frances McCullough, "On Meeting Miss Barnes," in *A Festschrift for Djuna Barnes on Her 80th Birthday*, ed. Alex Gildzen (Kent, Ohio: Kent State University Libraries, 1972), n.p.
30. Nancy J. Levine, "Works in Progress: The Uncollected Poetry of Barnes's Patchin Place Period," *Review of Contemporary Fiction* 13, no. 3 (1993): 187. Another notable exception is Carolyne Burke, "'Accidental Aloofness': Barnes, Loy, and Modernism," in Broe, *Silence and Power*, 67–79, who describes late-life Barnes "engaged in private spiritual quests that few could understand" (67).
31. Catharine Stimpson, afterword to Broe, *Silence and Power*, 373.
32. Robert L. Beare to Djuna Barnes, November 13, 1972, series 2, box 16, folder 2, DBP.
33. Mary Boccaccio to Djuna Barnes, May 23, 1977, series 2, box 16, folder 2, DBP.
34. Will of Djuna Barnes, May 20, 1980, series 1, box 4, folder 11, DBP.
35. While most of these writings as well as Barnes's library were delivered to Maryland, O'Neal also took possession of several documents, as Barnes noted to herself in handwritten jottings a little more than a year before her death. See Barnes, miscellaneous note, June 15, 1981, series 3, box 8, folder 3, DBP.
36. "Djuna Barnes papers," Special Collections and University Archives (website), University of Maryland Libraries, accessed July 28, 2020, https://hdl.handle.net/1903.1/1512.
37. See Rachel Blau DuPlessis, *Blue Studios: Poetry and Its Cultural Work* (Tuscaloosa: University of Alabama Press, 2006), for a useful discussion of the modern long poem.
38. Djuna Barnes, "Dereliction. Pro Vita Sua of (Parasites,Parthengenesis,and Spectre Spring.)," June 1, 1970, series 3, box 8, folder 20, DBP.
39. Caselli, *Improper Modernism*, 83.
40. Nor is this to forget, as suggested earlier, the existence of an "Approved Poems" folder in the collections, which Levine, "Works in Progress," tells us was "apparently assembled with Hank O'Neal's help in 1979" (193).
41. Djuna Barnes, "Rite of Spring.," May 25, 1980, series 3, box 10, folder 9, DBP.
42. Djuna Barnes, "Work in progress: Rite of Spring," n.d., series 3, box 10, folder 9, DBP.
43. Gullette, *Aged by Culture*, 194.
44. Barnes, "Work in progress."
45. Levine's comprehensive discussion of Barnes's poetry before its categorization at the university addresses links between Barnes's later poetry and Joyce. She writes—and I concur—that "the title ['Work in Progress'] suggests a rhetorical marriage between Ingmar Bergman and James Joyce, sections of whose *Finnegans Wake* were called 'Work in Progress' when they first appeared in *transition*" ("Works in Progress," 194). In a not unrelated vein, O'Neal also links this project to Joyce's revisions of *Ulysses* (*L* 86). Predecessors who revised their literature over a lifetime, such as Walt Whitman, were, of course, possible models, and potential creative parallels exist between Barnes and her contemporaries in the 1970s and 1980s. Her most immediate influence appears to be later Joyce, so I approach her works in progress within this aesthetic parameter even as I gesture to apposite projects.

1. Djuna Barnes and the Geriatric Avant-Garde

46. Ezra Pound, *Ta Hio: The Great Learning* (Seattle: University of Washington Book Store, 1928), 12. See Michael North, *Novelty: A History of the New* (Chicago: University of Chicago Press, 2013), 162–71, which alerted me to this quotation's existence, for a literary history of the phrase *make it new*.
47. Hannah Sullivan, *The Work of Revision* (Cambridge, Mass.: Harvard University Press, 2013), 2.
48. Sullivan, 266. Melissa Jane Hardie, "Repulsive Modernism: Djuna Barnes' *The Book of Repulsive Women*," *Journal of Modern Literature* 29, no. 1 (2005): 118–32, supports Sullivan's claims in a close reading of Barnes's "labor of revision" (119).
49. Caselli, *Improper Modernism*, 84.
50. Edward W. Said, *On Late Style: Music and Literature Against the Grain* (New York: Pantheon, 2006), 7, 13. For an interpretation of late (British) modernism that incorporates Said's findings, see Melanie Micir, "'Living in Two Tenses': The Intimate Archives of Sylvia Townsend Warner," *Journal of Modern Literature* 36, no. 1 (2012): 119–31.
51. See Tyrus Miller, *Late Modernism: Politics, Fiction, and the Arts Between the World Wars* (Berkeley: University of California Press, 1999).
52. Barnes, "Work in progress."
53. Djuna Barnes, note on *Nightwood*, n.d., series 3, box 11, folder 6, DBP.
54. Djuna Barnes, "The Hummingbird," n.d., series 3, box 9, folder 8, DBP.
55. Djuna Barnes, prescription routine and C. O. Bigelow pharmacy request, 1981, series 3, box 9, folder 8, DBP.
56. Barnes, prescription routine and C. O. Bigelow pharmacy request.
57. Djuna Barnes, grocery list, February 5, 1979, series 3, box 10, folder 12, DBP.
58. Djuna Barnes, "C.O.Bigelow.," December 10, 1980, private collection of Hank O'Neal.
59. Djuna Barnes, "Jefferson Market,Barnes.," n.d., private collection of Hank O'Neal.
60. Herring and Stutman, "Guide to the Poems and Texts," in *Collected Poems*, xvi.
61. Kathleen Woodward, *At Last, the Real Distinguished Thing: The Late Poems of Eliot, Pound, Stevens, and Williams* (Columbus: Ohio State University Press, 1980), 163.
62. William Carlos Williams, *The Autobiography of William Carlos Williams* (1951; New York: New Directions, 1967), 171, 319, 171.
63. William Carlos Williams, *Paterson* (New York: New Directions, 1992), 221, 222.
64. I thank Brian Brennan for bringing this associative link to my attention.
65. For more on this matter, see Brian Glavey, *The Wallflower Avant-Garde: Modernism, Sexuality, and Queer Ekphrasis* (New York: Oxford University Press, 2015).
66. Jennifer A. González, "Autotopographies," in *Prosthetic Territories: Politics and Hypertechnologies*, ed. Gabriel Brahm Jr. and Mark Driscoll (Boulder, Colo.: Westview, 1995), 134.
67. Levine, "Works in Progress," 197.
68. Aaron Yale Heisler, "Literary Memory and the Moment of Modern Music," *Modernism/modernity* 19, no. 4 (2012): 709, 701.
69. Quoted in Caselli, *Improper Modernism*, 83.
70. Smith and Watson, *Reading Autobiography*, 4.
71. Djuna Barnes, "Pavan," n.d., series 3, box 11, folder 3, DBP.
72. Herring and Stutman, introduction to *Collected Poems*, 12.
73. *Oxford English Dictionary*, s.v. "puffball," accessed July 25, 2014, oed.com.

74. Djuna Barnes, "The Hem of Manhattan," *New York Morning Telegraph Sunday Magazine*, July 29, 1917, 2.
75. *Oxford English Dictionary*, s.v. "spaddle," accessed October 16, 2013, oed.com.
76. *Oxford English Dictionary*, s.v. "whipless," accessed July 26, 2014, oed.com.
77. Page, *Memoirs*, 110.
78. Levine, "Works in Progress," 188, 194, 199.
79. Djuna Barnes, "Virgin Spring," n.d., series 3, box 11, folder 11, DBP.
80. T. S. Eliot, "Gerontion," in *Collected Poems, 1909–1962* (1920; New York: Harcourt, Brace, 1970), 29.
81. Eliot, 31.
82. T. S. Eliot, "Little Gidding," *Four Quartets*, in *Collected Poems, 1909–1962*, 204.
83. For discussions of Eliot's late poetics, see Jack Halberstam, *Wild Things: The Disorder of Desire* (Durham, N.C.: Duke University Press, 2020); Jed Esty, *A Shrinking Island: Modernism and National Culture in England* (Princeton, N.J.: Princeton University Press, 2004); Andrew Goldstone, *Fictions of Autonomy: Modernism from Wilde to de Man* (New York: Oxford University Press, 2003), 80–109; and Genevieve Abravanel, *Americanizing Britain: The Rise of Modernism in the Age of the Entertainment Empire* (New York: Oxford University Press, 2012), especially the claim that "the mature Eliot was committed in much of his poetry to making it old" (132).
84. Woodward, *At Last*, 56.
85. Eliot, "Little Gidding," 207.
86. Caselli, *Improper Modernism*, 25.
87. Djuna Barnes, "(Item vrom Poems in Passing.): Phantom Spring," n.d., series 3, box 9, folder 13, DBP.
88. Djuna Barnes, "The Marian Year," n.d., series 3, box 8, folder 9, DBP.
89. Djuna Barnes, "VIATICUM.," n.d., series 3, box 11, folder 8, DBP.
90. Djuna Barnes, "Black-John. As Cried By.," October 4, 1967, series 3, box 8, folder 12, DBP.
91. Colleen Lamos, *Deviant Modernism: Sexual and Textual Errancy in T. S. Eliot, James Joyce, and Marcel Proust* (Cambridge: Cambridge University Press, 1999), 229.
92. Caselli, *Improper Modernism*, 118.
93. *Oxford English Dictionary*, s.v. "perfect" and "imperfect," accessed September 8, 2020, oed.com.
94. Djuna Barnes, note, series 3, box 12, folder 3, DBP.
95. Kannenstine, *Art of Djuna Barnes*, 168.
96. Shari Benstock, *Women of the Left Bank: Paris, 1900–1940* (Austin: University of Texas Press, 1986), 266-67.
97. Christopher Sawyer-Lauçanno, *E. E. Cummings: A Biography* (London: Methuen, 2005), 512.
98. Djuna Barnes to Rudolph "Silas" Glossop, May 23, 1973, series 2, box 8, folder 3, DBP.
99. Quoted in Henry Raymont, "From the Avant-Garde of the Thirties, Djuna Barnes," *New York Times*, May 24, 1971, 24.
100. Djuna Barnes to Rudolph "Silas" Glossop, November 9, 1967, series 2, box 8, folder 2, DBP.

222 1. Djuna Barnes and the Geriatric Avant-Garde

101. Michel Foucault, *The Use of Pleasure*, trans. Robert Hurley (New York: Vintage, 1990), 9.
102. Robert N. Butler, *Why Survive? Being Old in America* (New York: Harper and Row, 1975; repr., Baltimore: Johns Hopkins University Press, 2002), 422.
103. Following material culture studies scholar Daniel Miller, Lynne Segal also links the possessions of personal goods to the cultivation of late life in *Out of Time: The Pleasures and the Perils of Ageing* (London: Verso, 2013), 234.
104. Sedgwick, *Touching Feeling*, 24.
105. Barnes to Glossop, November 9, 1967.
106. Raymont, "From the Avant-Garde," 24.

2. THE SPECIAL COLLECTIONS OF SAMUEL STEWARD

1. Samuel M. Steward, *Chapters from an Autobiography* (San Francisco: Grey Fox Press, 1981), 58. Hereafter parenthetically cited in this chapter with an abbreviated C.
2. Philip Sparrow, "On Gertrude Stein," *Illinois Dental Journal* 16 (1947): 64.
3. Justin Spring, *Secret Historian: The Life and Times of Samuel Steward, Professor, Tattoo Artist, and Sexual Renegade* (New York: Farrar, Straus and Giroux, 2010), 329. Unless otherwise noted, further references are cited in the text by page number.
4. Spring outlines some of these various acquisitions in *Secret Historian*, 407–14.
5. Owen Keehnen, review of *Secret Historian*, by Justin Spring, *Windy City Times*, September 29, 2010.
6. Andrew Holleran, "Portrait of a Taboo Artist," *Washington Post*, December 5, 2010, B7.
7. Marvin R. Hiemstra, "A Long and Happy Afterword," in *A Pair of Roses*, by Samuel M. Steward (San Francisco: Juniper von Phitzer, 1993), 57, 56.
8. Quoted in Spring, *Secret Historian*, 400.
9. Michael Williams, interview by author, August 18, 2011. All subsequent interview quotations are marked parenthetically in this chapter with an abbreviated W.
10. With this description I have in mind what psychoanalytic theorist Christopher Bollas refers to as an "evocative object world" in *The Evocative Object World* (New York: Routledge, 2008). I note also that Michael Williams confirms this earlier interview in "Remembering Sam," in *Samuel Steward and the Pursuit of the Erotic: Sexuality, Literature, Archives*, ed. Debra A. Moddelmog and Martin Joseph Ponce (Columbus: Ohio State University Press, 2017), 201–13.
11. Spring also discusses these clocks in *Secret Historian*, 344.
12. Justin Spring, *An Obscene Diary: The Visual World of Sam Steward* (New York: Antinous and Elysium, 2010), n.p.
13. See Nayan Shah, *Contagious Divides: Epidemics and Race in San Francisco's Chinatown* (Berkeley: University of California Press, 2001), 13. For more on this concept, see also Sara Blair, "Home Truths: Gertrude Stein, 27 Rue de Fleurus, and the Place of the Avant-Garde," *American Literary History* 21, no. 3 (2000): 417–37; Stephen Vider, *The Queerness of Home: Gender, Sexuality, and the Politics of Domesticity After World War II* (Chicago: University of Chicago Press, 2021); and Magdalena J. Zaborowska, *Me and My House: James Baldwin's Last Decade in France* (Durham, N.C.: Duke University Press, 2018).
14. Philip Sparrow, "On Keepsakes, Gew-Gaws, and Baubles," *Illinois Dental Journal* 17 (1948): 392, 393.

15. Sparrow, 393.
16. Philip Sparrow, "On Gertrude Stein," *Illinois Dental Journal* 16 (1947): 65.
17. Samuel M. Steward, *Murder Is Murder Is Murder: A Gertrude Stein–Alice B. Toklas Mystery* (Boston: Alyson, 1985), 59. Unless otherwise noted, hereafter parenthetically cited in this chapter with an abbreviated *M*.
18. Jeremey Braddock, *Collecting as Modernist Practice* (Baltimore: Johns Hopkins University Press, 2012), 80. See also Melanie Micir, *The Passion Projects: Modernist Women, Intimate Archives, Unfinished Lives* (Princeton, N.J.: Princeton University Press, 2019), 88–94.
19. Braddock, *Collecting*, 6. See also Marika Cifor, "Stains and Remains: Liveliness, Materiality, and the Archival Lives of Queer Bodies," in *Archives and New Modes of Feminist Research*, ed. Maryanne Dever (New York: Routledge, 2019), 5–21; and Tim Dean, "Sam Steward's Pornography: Archive, Index, Trace," in Moddelmog and Ponce, *Samuel Steward*, 25–43.
20. See Sari Edelstein, *Adulthood and Other Fictions: American Literature and the Unmaking of Age* (New York: Oxford University Press, 2019); Cynthia Port, "No Future? Aging, Temporality, History, and Reverse Chronologies," *Occasion: Interdisciplinary Studies in the Humanities* 4 (2012), https://arcade.stanford.edu/occasion/no-future-aging-temporality-history-and-reverse-chronologies; José Esteban Muñoz, "Cruising *The Toilet*: LeRoi Jones/Amiri Baraka, Radical Black Traditions, and Queer Futurity," *GLQ: A Journal of Lesbian and Gay Studies* 13, no. 2–3 (2007): 353–67; and Kathryn Bond Stockton, *The Queer Child, or, Growing Sideways in the Twentieth Century* (Durham, N.C.: Duke University Press, 2009).
21. Samuel M. Steward, "Detachment: A Way of Life," *Der Kreis* (August 1958): 35. Hereafter parenthetically cited in this chapter with an abbreviated D.
22. Philip Sparrow, "On Getting to Be Forty," *Illinois Dental Journal* 18 (1949): 182. For more on Steward's essays in this journal, see Jeremy Mulderig, "'Foibles and Fripperies, Reminiscences and Tributes': Reading Samuel Steward's Lost Chicago Essays," in Moddelmog and Ponce, *Samuel Steward*, 122–39.
23. Margaret Morganroth Gullette, *Declining to Decline: Cultural Combat and the Politics of the Midlife* (Charlottesville: University Press of Virginia, 1997), 161. Gullette further discusses this genre in *Aged by Culture* (Chicago: University of Chicago Press, 2004); *Safe at Last in the Middle Years: The Invention of the Midlife Progress Novel* (Berkeley: University of California Press, 1988), which states from its outset that "the midlife image has primarily taken for granted a despicable or pitiable persona or an ironizing plot of decline" (xviii); and "Midlife Discourses in the Twentieth-Century United States: An Essay on the Sexuality, Ideology, and Politics of 'Middle-Ageism,'" in *Welcome to Middle Age! (And Other Cultural Fictions)*, ed. Richard A. Shweder (Chicago: University of Chicago Press, 1998), 3–44, on the "ideology of midlife decline, which I call *middle-ageism*" (4).
24. Sparrow, "On Getting to Be Forty," 182. For accounts of the midlife and the midlife crisis that Steward mirrors, see *Middle Age and Aging: A Reader in Social Psychology*, ed. Bernice L. Neugarten (Chicago: University of Chicago Press, 1968); Bernice L. Neugarten and Dail A. Neugarten, "Age in the Aging Society," *Daedalus* 115, no. 1 (1986): 31–49; Margaret Morganroth Gullette, "Male Midlife Sexuality in a Gerontocratic Economy: The Privileged Stage of the Long Midlife in Nineteenth-Century Age-Ideology," *Journal of the History of Sexuality* 5, no. 1 (1994): 58–89; Stanley Brandes, *Forty: The Age and the*

Symbol (Knoxville: University of Tennessee Press, 1985), on "increasing age grading in the United States in the post–World War II era" (102); Steven Mintz, *The Prime of Life: A History of Modern Adulthood* (Cambridge, Mass.: Belknap Press of Harvard University Press, 2015); and Dale M. Bauer, *Sex Expression and American Women Writers, 1860–1940* (Chapel Hill: University of North Carolina Press, 2009). For a consideration of feminism and the midlife that I wish Steward had lived to read, see Susanne Schmidt, *Midlife Crisis: The Feminist Origins of a Chauvinist Cliché* (Chicago: University of Chicago Press, 2020).

25. Sparrow, "On Getting to Be Forty," 183.
26. Margaret Morganroth Gullette, "The Other End of the Fashion Cycle: Practicing Loss, Learning Decline," in *Figuring Age: Women, Bodies, Generations*, ed. Kathleen Woodward (Bloomington: Indiana University Press, 1999), 49.
27. Gertrude Stein, *A Long Gay Book*, in *A Stein Reader*, ed. Ulla E. Dydo (1933; Evanston, Ill.: Northwestern University Press, 1993), 164.
28. Bruce Rodgers, *Gay Talk: A (Sometimes Outrageous) Dictionary of Gay Slang* (1972; New York: Paragon, 1979), 25.
29. See, for example, Anthony Slide, *Gay and Lesbian Characters and Themes in Mystery Novels: A Critical Guide to Over 500 Works in English* (Jefferson, N.C.: McFarland, 1993), 160-61; and Judith A. Markowitz, *The Gay Detective Novel: Lesbian and Gay Main Characters and Themes in Mystery Fiction* (Jefferson, N.C.: McFarland, 2004), 227-28.
30. Sequelguerrier, review of *Murder Is Murder Is Murder*, by Samuel Steward, Goodreads, November 19, 2011, goodreads.com/review/show/237247188.
31. Matthew Levay, "Remaining a Mystery: Gertrude Stein, Crime Fiction, and Popular Modernism," *Journal of Modern Literature* 36, no. 4 (2013): 18, 8, 18. For a reading of this novel in relation to Steward, see Karen Leick, "The Mysteries of Samuel Steward and Gertrude Stein, Private Eyes," in Moddelmog and Ponce, *Samuel Steward*, 105-21.
32. See Steven Watson, introduction to *The Young and Evil*, by Charles Henri Ford and Parker Tyler (1933; New York: Masquerade Books, 1996), for more on Stein and her "protégé business" (n.p.).
33. See Gertrude Stein, "Lifting Belly," in *Bee Time Vine and Other Pieces (1913–1927)* (New Haven, Conn.: Yale University Press, 1953), 96.
34. Gertrude Stein, "Sacred Emily," in *Geography and Plays* (1913; Boston: Four Seas, 1922), 187.
35. Fredric Jameson, *The Cultural Turn: Selected Writings on the Postmodern, 1983–1998* (London: Verso, 1998), 1. See also Spring, *Secret Historian*, which identifies a "Stein-like pastiche" in Steward's initial correspondence with her (33).
36. *Oxford English Dictionary*, s.v. "pastiche," accessed July 16, 2015, oed.com.
37. Samuel Steward to Gertrude Stein and Alice B. Toklas, September 10, 1937, box 2, folder 19, Samuel M. Steward Collection, Howard Gotlieb Archival Research Center, Boston University.
38. Michael North, *Novelty: A History of the New* (Chicago: University of Chicago Press, 2013), 205.
39. Samuel Steward to Jeannie Barney, January 5, 1990, box 5, SSP.
40. Samuel M. Steward, *The Caravaggio Shawl* (Boston: Alyson, 1989), 62. Hereafter cited parenthetically in this chapter with an abbreviated *S*.

41. Samuel Steward, lecture notes for The Modern Novel, 1955, box 5, SSP.
42. Samuel Steward to Jeannie Barney, January 5, 1990, box 5, SSP.
43. Gullette, *Declining to Decline*, 200.
44. John Preston, introduction to *$tud*, by Phil Andros (1966; Boston: Perineum, 1982), 13.
45. Gene McNamara, "Meet Your Professor," *DePaulia*, November 30, 1951, 4.
46. Jack Fritscher, *Gay San Francisco: Eyewitness* Drummer: *A Memoir of the Sex, Art, Salon, Pop Culture War, and Gay History of* Drummer *Magazine: The Titanic 1970s to 1990s: Volume 1*, ed. Mark Hemry (San Francisco: Palm Drive, 2008), 448.
47. Quoted in memorial service notice, n.d., box 3, Jim Kane Papers, Leather Archives and Museum, Chicago.
48. Preston, introduction to *$tud*, 14.
49. Rodgers, *Gay Talk*, 25.
50. Samuel Steward, interview by Len Evans, July 2, 1983, transcript, Voices of the Oral History Project, GLBT Historical Society, San Francisco.
51. A postcard from Andersen to Steward in May 28, 1981, states: "Went to both houses, and cemetery. Put flowers on after a 20 minute search for stone" (box 3, SSP).
52. Preston, introduction to *$tud*, 12.
53. Samuel Steward to Marge Krogsrud, May 31, 1991, box 5, SSP.
54. Gertrude Stein, "To Sammy on His Birthday," 1939, quoted in Samuel M. Steward, ed., *Dear Sammy: Letters from Gertrude Stein and Alice B. Toklas* (Boston: Houghton Mifflin, 1977), 68.

3. IVAN ALBRIGHT'S ANTI-ANTIAGING TREATMENTS

1. John Murphy, "Fleshing Out Ivan Albright," Art Institute of Chicago (website), May 11, 2018, https://artic.edu/articles/687/fleshing-out-ivan-albright.
2. Steve Johnson, "Ivan Albright and the Shock of the 'Flesh' at the Art Institute," *Chicago Tribune*, May 18, 2018, https://chicagotribune.com/entertainment/museums/ct-ent-ivan-albright-art-institute-0520-story.html.
3. Roberta Smith, "Comfortable Old Friends," *New York Times*, August 23, 2013, 21.
4. David M. Lubin, *Grand Illusions: American Art and the First World War* (New York: Oxford University Press, 2016), 224.
5. Susan S. Weininger, "Fantasy in Chicago Painting: 'Real "Crazy," Real Personal, and Real Real,'" in *Chicago Modern, 1893–1945: Pursuit of the New*, ed. Elizabeth Kennedy (Chicago: University of Chicago Press, 2004), 67.
6. Susan S. Weininger, "Ivan Albright in Context," in *Ivan Albright*, by Courtney Graham Donnell, Susan S. Weininger, and Robert Cozzolino, ed. Susan F. Rossen (Chicago: Art Institute of Chicago, 1997), 67.
7. Teresa A. Carbone, "Body Language: Liberation and Restraint in Twenties Figuration," in *Youth and Beauty: Art of the American Twenties*, ed. Teresa A. Carbone (New York: Skira Rizzoli, 2011), 90.
8. Carbone, 92.
9. Weininger, "Fantasy in Chicago Painting," 75.
10. Margaret Morganroth Gullette, *Aged by Culture* (Chicago: University of Chicago Press, 2004), 33, 28, 163. See also Kathleen Woodward, *Aging and Its Discontents: Freud and Other*

Fictions (Bloomington: Indiana University Press, 1991), on "the body as a *specular* body" (169).

11. Robert Cozzolino, plate 6 commentary and plate 9 commentary, in Rossen, *Ivan Albright*, n.p.
12. Robert Cozzolino, "Every Picture Should Be a Prayer: The Art of Ivan Albright," (Ph.D. diss., University of Wisconsin-Madison, 2006), 10–11, 14.
13. Margaret Morganroth Gullette, *Agewise: Fighting the New Ageism in America* (Chicago: University of Chicago Press, 2011), 98.
14. For sharp criticisms of "a generalizing concept of late style," see Linda Hutcheon and Michael Hutcheon, "Late Style(s): The Ageism of the Singular," *Occasion: Interdisciplinary Studies in the Humanities* 4 (May 2012): 11; and Gordon McMullan and Sam Siles, eds., *Late Style and Its Discontents: Essays in Art, Literature, and Music* (New York: Oxford University Press, 2016).
15. Anne Anlin Cheng, *Second Skin: Josephine Baker and the Modern Surface* (New York: Oxford University Press, 2011), 14.
16. See Maud Ellmann, "Skinscapes in 'Lotus-Eaters,'" in *Ulysses—En-Gendered Perspectives: Eighteen New Essays on the Episodes*, ed. Kimberly J. Devlin and Marilyn Reizbaum (Columbia: University of South Carolina Press, 1999), 51–66. See also Ellmann, "More Kicks Than Pricks: Modernist Body-Parts," in *A Handbook of Modernism Studies*, ed. Jean-Michel Rabaté (Sussex, UK: Wiley-Blackwell, 2013), 255–80; and Emily Braun, "Skinning the Paint," in *Paint Made Flesh*, ed. Mark W. Scala (Nashville, Tenn.: Vanderbilt University Press, 2009), 27–41. On skin studies, see Michelle Ann Stephens, *Skin Acts: Race, Psychoanalysis, and the Black Male Performer* (Durham, N.C.: Duke University Press, 2014); Steven Connor, *The Book of Skin* (Ithaca, N.Y.: Cornell University Press, 2004); Sara Ahmed and Jackie Stacey, eds., *Thinking Through the Skin* (London: Routledge, 2001); and Nina G. Jablonski, *Skin: A Natural History* (Berkeley: University of California Press, 2006).
17. Jay Pridmore, "The Albright Tradition," *Chicago Tribune*, May 12, 1988, 9, names the model by first and last name. Robert Cozzolino, plate 12 commentary, in Rossen, *Ivan Albright*, n.p., identifies her as "Mrs. Arthur Stanford."
18. One source in *Oxford English Dictionary* on *flapper* chronologically dates this personage "aged twenty-one to thirty," while the *OED* itself defines her as "a girl in her late teens" (s.v. "flapper," accessed May 20, 2020, oed.com); Louis W. Banner, *In Full Flower: Aging Women, Power, and Sexuality* (New York: Knopf, 1992), 289. For a brief discussion of the term *flapperdame* as it emerged in the 1920s, see Adie Nelson and Barrie W. Robinson, *Gigolos and Madames Bountiful: Illusions of Gender, Power, and Intimacy* (Toronto: University of Toronto Press, 1994), 54.
19. Howard P. Chudacoff, *How Old Are You? Age Consciousness in American Culture* (Princeton, N.J.: Princeton University Press, 1989), 5.
20. Elizabeth Lee notes that he "embraced a version of the body in which lived experience is mapped across every inch of flesh," in "Ivan Albright's Ida and the 'Object Congealed around a Soul,'" *American Art* 29, no. 3 (2015): 113. For a more detailed discussion of this claim, see Cozzolino, "Every Picture," on "the excessive corporeality of his bodies" (52).
21. Gullette, *Agewise*, 98.

22. Chris Gilleard and Paul Higgs, *Ageing, Corporeality, and Embodiment* (London: Anthem, 2013), 147, 148, 150. See also Gilleard and Higgs, *Cultures of Ageing: Self, Citizen, and the Body* (Essex: Pearson Education Limited, 2000), 131-34; and Paul Higgs and Ian Rees Jones, *Medical Sociology and Old Age: Towards a Sociology of Health in Later Life* (New York: Routledge, 2009), 87-90.
23. Lubin, *Grand Illusions*, 229.
24. T. J. Jackson Lears, *Fables of Abundance: A Cultural History of Advertising in America* (New York: Basic Books, 1994), 169.
25. Sander L. Gilman, *Making the Body Beautiful: A Cultural History of Aesthetic Surgery* (Princeton, N.J.: Princeton University Press, 1999), 295.
26. Susan Squier, "Incubabies and Rejuvenates: The Traffic Between Technologies of Reproduction and Age-Extension," in *Figuring Age: Women, Bodies, Generations*, ed. Kathleen Woodward (Bloomington: Indiana University Press, 1999), 89, 93. See also Sadie Wearing, "Subjects of Rejuvenation: Aging in Postfeminist Culture," in *Interrogating Postfeminism: Gender and the Politics of Popular Culture*, ed. Yvonne Tasker and Diane Negra (Durham, N.C.: Duke University Press, 2007), 277-310.
27. Gilman, *Making the Body Beautiful*, 296.
28. George F. Corners, *Rejuvenation: How Steinach Makes People Young* (New York: Thomas Seltzer, 1923), 89, 94. See also Tim Armstrong, *Modernism, Technology, and the Body* (Cambridge: Cambridge University Press, 1998), 143-55; Dirk Schultheiss et al., "Rejuvenation in the Early 20th Century," *Andrologia* 29, no. 6 (1997): 351-55; Squier, "Incubabies and Rejuvenates," 89; Carole Haber, "Life Extension and History: The Continual Search for the Fountain of Youth," *Journal of Gerontology: Biological Sciences* 59A, no. 6 (2004): 515-22; Carole Haber, "Anti-Aging: Why Now? A Historical Framework for Understanding the Contemporary Enthusiasm," *Generations* 25, no. 4 (2001-2002): 9-14; and Gullette, *Agewise*, 97-100.
29. Corners, *Rejuvenation*, 42.
30. Corners, 80.
31. Gilleard and Higgs, *Ageing, Corporeality, and Embodiment*, 147.
32. Kathy Peiss, *Hope in a Jar: The Making of America's Beauty Culture* (New York: Metropolitan Books, 1998), 73. See also Sally Pointer, *The Artifice of Beauty: A History and Practical Guide to Perfumes and Cosmetics* (Phoenix Mill, UK: Sutton, 2005), 155-66; and Frida Kerner Furman, *Facing the Mirror: Older Women and Beauty Shop Culture* (New York: Routledge, 1997).
33. Kathy Peiss, "On Beauty . . . and the History of Business," in *Beauty and Business: Commerce, Gender, and Culture in Modern America*, ed. Philip Scranton (New York: Routledge, 2001), 12.
34. "The Big Business of Cosmetics Moves Forward on a New Basis," *New York Times*, July 14, 1940. Elaborations of this cosmetics culture include Eric J. Trimmer, *Rejuvenation: The History of an Idea* (Cranbury, N.J.: Barnes, 1970); John Emsley, *Vanity, Vitality, and Virility: The Science Behind the Products You Love to Buy* (New York: Oxford University Press, 2004), 7-15; and Arlene Weintraub, *Selling the Fountain of Youth: How the Anti-Aging Industry Made a Disease Out of Getting Old—and Made Billions* (New York: Basic Books, 2010).

35. "Ganesh Strapping Muscle Treatments," *Town and Country*, August 20, 1919, 9; "A Biological Remedy for Skin Rejuvenation," *American Medicine* 33, no. 7 (1927): 398; Ralph G. Harry, *Modern Cosmeticology: The Principles and Practice of Modern Cosmetics* (Brooklyn: Chemical Publishing, 1940), 67; "New and Startling Beauty to the Skin Thru Radium!," *Motion Picture Magazine*, January 1923, 117.

36. John P. Murphy, "Flesh: Ivan Albright and the Aesthetics of Ugliness," in *Ivan Albright Paintings at the Art Institute of Chicago*, ed. Sarah Kelly Oehler (Chicago: Art Institute of Chicago, 2019), para. 11, https://publications.artic.edu/albright/reader/paintings/section/85.

37. Gertrude Atherton, quoted in "Noted Germans To Be Compelled to Rejuvenate," *Brooklyn Daily Eagle*, March 19, 1924, 2. See Julie Prebel, "Engineering Womanhood: The Politics of Rejuvenation in Gertrude Atherton's *Black Oxen*," *American Literature* 76, no. 2 (2004): 307-37; and Melanie V. Dawson, *Edith Wharton and the Modern Privileges of Age* (Gainesville: University Press of Florida, 2020), 240-78, for more on Atherton's investment in Steinachian procedures.

38. Lee, "Ivan Albright's *Ida*," 111, 114.

39. Gullette, *Agewise*, 34.

40. Weininger, "Ivan Albright in Context," 61.

41. Cozzolino, plate 12 commentary, in Rossen, *Ivan Albright*, n.p.

42. See Barbara Macdonald with Cynthia Rich, *Look Me in the Eye: Old Women, Aging, and Ageism* (1983; Denver: Spinsters Ink Books, 2001).

43. J. Z. Jacobson, introduction to *Art of Today, Chicago 1933*, ed. J. Z. Jacobson (Chicago: Stein, 1932), xxv.

44. Robert Cozzolino, "Chicago's Modernism," in *Art in Chicago: Resisting Regionalism, Transforming Modernism* (Philadelphia: Pennsylvania Academy of the Fine Arts, 2007), 12. See also Weininger, "Fantasy in Chicago Painting," which likewise finds that Albright's art "becomes less anomalous and more clearly rooted in the fantastic when seen in the context of the work of other Chicagoans" (74).

45. Cozzolino, "Chicago's Modernism," 11, 13. See also Sue Ann Price, ed., *The Old Guard and the Avant-Garde: Modernism in Chicago, 1910–1940* (Chicago: University of Chicago Press, 1990); and Robert Storr, *Modern Art Despite Modernism* (New York: Museum of Modern Art, 2000).

46. Weininger, "Fantasy in Chicago Painting," 67.

47. Ivan Albright, Untitled "(35 Vl 79)," series 2, box 1, folder 2, IAC.

48. Harold Heydon, "Medical Drawings by Ivan Lorraine Albright," in *An Exhibition of Medical Drawings by Ivan Lorraine Albright* (Chicago: Renaissance Society at the University of Chicago, 1972), n.p. See also Pearl James, *The New Death: American Modernism and World War I* (Charlottesville: University of Virginia Press, 2013).

49. Ivan Albright, Untitled "(35 Vl 40)," series 2, box 1, folder 2, IAC.

50. Gullette, *Aged by Culture*, 19.

51. Permanent collection label, *Into the World There Came a Soul Called Ida*, American Art, Gallery 262, Art Institute of Chicago.

52. Ivan Le Lorraine Albright, interview by Paul Cummings, February 5, 1972, transcript, Archives of American Art, Smithsonian Institution, Washington, D.C.

53. Robert Cozzolino, *With Friends: Six Magic Realists, 1940–1965* (Madison: Elvehjem Museum of Art and University of Wisconsin Press, 2005), 13.
54. Alfred H. Barr Jr., "Magic Realism," in *Painting and Sculpture in the Museum of Modern Art*, ed. Alfred H. Barr Jr. (New York: Museum of Modern Art, 1942), 16. The phrase was then quoted by Dorothy C. Miller, "Foreword and Acknowledgement," in *American Realists and Magic Realists*, ed. Dorothy C. Miller and Alfred H. Barr Jr. (New York: Museum of Modern Art, 1943), 5. See also Michael Croydon, *Ivan Albright* (New York: Abbeville, 1978), who contends that "Magical Realism appears to come closer to accommodating his vision and this style did become a force in American painting in the late twenties at the same time that Albright began to exhibit seriously" (274). For a detailed analysis of the 1943 exhibition, see Sandra Zalman, *Consuming Surrealism in American Culture: Dissident Modernism* (Farnham, Surrey, UK: Ashgate, 2015), 54-60.
55. Miller, "Foreword and Acknowledgement," 5.
56. Sarah Newmeyer, press release for *Americans 1943: Realists and Magic Realists*, February 2, 1943, Museum of Modern Art (website).
57. Lincoln Kirstein, introduction to *American Realists and Magic Realists*, 7, 8.
58. Weininger, "Fantasy in Chicago Painting," 67. See also Jeffrey Wechsler, "Magic Realism: Defining the Indefinite," *Art Journal* 45, no. 4 (1985): 293-98.
59. Courtney Graham Donnell, "A Painter Am I: Ivan Albright," in Rossen, *Ivan Albright*, 25.
60. *Cassell's Dictionary of Slang*, "face stretcher," comp. by Jonathon Green, 2nd ed. (London: Weidenfeld and Nicolson, 2005), 483.
61. Gullette, *Aged by Culture*, 33.
62. Michael Brenson, "Ivan Albright, 86, Dies; 'Magic Realist' Painter," *New York Times*, November 19, 1983, 31.
63. Barbara Rose, *American Painting: The 20th Century* (Lausanne: Skira, 1969), 44.
64. Albright, interview by Cummings.
65. Robert Cozzolino, plate 59 commentary, in Rossen, *Ivan Albright*, n.p.
66. Ivan Albright, "Notes on Vermonter," January 28, 1968, series 1, IAC.
67. Menton, *Magic Realism Rediscovered, 1918–1981*, 20.
68. Bernice L. Neugarten, "Age Groups in American Society and the Rise of the Young-Old," *Annals of the American Academy of Political and Social Science* 415, no. 1 (1974): 191.
69. Ivan Albright, notebook entry, August 12, 1980, series 1, IAC.
70. Maria Farland, "Modernist Versions of Pastoral: Poetic Inspiration, Scientific Expertise, and the 'Degenerate' Farmer," *American Literary History* 19, no. 4 (2007): 915.
71. Dona Brown, *Inventing New England: Regional Tourism in the Nineteenth Century* (Washington, D.C.: Smithsonian Institution Press, 1995), 215, 137.
72. Amanda C. Burdan, "Off the Beaten Path: Aspects of Rural Modernism," in *Rural Modern: American Art Beyond the City*, ed. Amanda C. Burdan (New York: Skira Rizzoli, 2016), 28. See also Debra Bricker Balken, *After Many Springs: Regionalism, Modernism, and the Midwest* (Des Moines, Iowa: Des Moines Art Center, and New Haven, Conn.: Yale University Press, 2009).
73. Burdan, "Off the Beaten Path."
74. Cozzolino, plate 59 commentary, in Rossen, *Ivan Albright*, n.p. See also Phylis Floyd, "Ivan Albright: *The Vermonter (If Life Were Life There Would Be No Death)*," in *Ivan Albright:*

The Late Self-Portraits (Hanover, N.H.: Hood Museum of Art at Dartmouth College, 1986), 17–27, who finds that "Albright chose Atwood as a subject for this portrait because he perceived in him parallels with himself" (18).

75. John Davies Stamm, "The Shadows of Ivan Albright," *Yankee* (October 1971): 104.
76. Stamm, 132.
77. See Bruce Robertson, "Yankee Modernism," in *Picturing Old New England: Image and Memory*, ed. William H. Truettner and Roger B. Stein (New Haven, Conn.: Yale University Press, 1999), 171–98; and Julia B. Rosenbaum, *Visions of Belonging: New England Art and the Making of American Identity* (Ithaca, N.Y.: Cornell University Press, 2006).
78. Ivan Albright, notebook entry, n.d., series 1, IAC.
79. Richard R. Brettell, "Ivan Albright: The Self-Portraits," in *Ivan Albright: The Late Self-Portraits*, 15.
80. Christopher Lyon, "'Synthetic Realism': Albright, Golub, Paschke," *Art Journal* 45, no. 4 (1985): 331.
81. Brettell, "Ivan Albright," 14.
82. Lubin, *Grand Illusions*, 224.
83. Robert Cozzolino, "Homecomings, Hauntings, Returns," in *World War I and American Art*, ed. Robert Cozzolino, Anne Classen Knutson, and David M. Lubin (Princeton, N.J.: Princeton University Press, and Philadelphia: Pennsylvania Academy of the Fine Arts, 2016), 121. See also Weininger, "Ivan Albright in Context," who claims that "Albright's firsthand involvement with the physical and emotional traumas of war helped shape a world view" (67).
84. Frederick A. Sweet, "A Tradition of Fine Craftsmanship," in *Ivan Albright: A Retrospective Exhibition Organized by The Art Institute of Chicago in Collaboration with The Whitney Museum of American Art*, catalogue by Sweet (Chicago: Art Institute of Chicago, 1964, and New York: Whitney Museum of American Art, 1965), 14.
85. Ivan Albright, Untitled "(36 VI 87)," series 6, box 6, folder 6, IAC.
86. Ulrike Blume-Peytavi et al., "Age-Associated Skin Conditions and Diseases: Current Perspectives and Future Options," *Gerontologist* 56, no. S2 (2016): S233.
87. Gullette, *Aged by Culture*, 178.

4. TILLIE OLSEN AND THE OLD-OLD LEFT

1. For histories and assessments of this movement, see Roger Sanjek, *Gray Panthers* (Philadelphia: University of Pennsylvania Press, 2009); and Henry J. Pratt, *The Gray Lobby* (Chicago: University of Chicago Press, 1976).
2. "Tillie Olsen: Hail and Farewell," *SF Gray Panthers Newsletter*, February 2007, https://graypantherssf.igc.org/07-02-newsletter/07-02-NL-tillie_olsen.htm.
3. "Calendar of Events: July August 2001," *SF Gray Panthers Newsletter*, https://graypantherssf.igc.org/archive/julaug2001.html. My thanks to Steve Zeltzer of the LaborFest Organizing Committee for confirming Olsen's participation at this event.
4. "About LaborFest," LaborFest (website), accessed October 6, 2017, http://laborfest.net/aboutLF.htm (now defunct).
5. "Tillie Olsen: Hail and Farewell."
6. Tillie Olsen, "Tell Me a Riddle," in *Tell Me a Riddle* (Philadelphia: Lippincott, 1961), 103.

7. Julie Bosman, "Tillie Olsen, Feminist Writer, Dies at 94," *New York Times*, January 3, 2007.
8. Panthea Reid, *Tillie Olsen: One Woman, Many Riddles* (New Brunswick, N.J.: Rutgers University Press, 2010), 45, 47. See also Reid's contention that "Tillie used what she had learned at Central High School about Virginia Woolf's stream of consciousness to delve into six-year-old Mazie's mind" (80). For a complementary account of this modernist self-training, see Maggie Doherty, "What Kind of Worker Is a Writer?," *New Yorker*, September 1, 2014, which finds that "though she devoted herself to politics, she also had literary ambitions (at sixteen, she placed a photo of Virginia Woolf on her desk and practiced writing like Woolf and Gertrude Stein)."
9. Seth Moglen, *Mourning Modernity: Literary Modernism and the Injuries of American Capitalism* (Stanford, Calif.: Stanford University Press, 2007), sees "a tragic appropriateness to the truncated state of *Yonnondio*" and reads the novel alongside John Dos Passos, Langston Hughes, and other modernists (60). Joseph Entin, *Sensational Modernism: Experimental Fiction and Photography in Thirties America* (Chapel Hill: University of North Carolina Press, 2007), likewise places the book next to James Agee and William Faulkner to theorize that *Yonnondio* "mourns not only the cultural invisibility of working-class people like the Holbrooks, neglected by the grand narratives of historical record and the dominant canons of literature, but also the very possibility of its own textual completion" (157). See also Jessica Berman, *Modernist Commitments: Ethics, Politics, and Transnational Modernism* (New York: Columbia University Press, 2012), 237–80; and Alan M. Wald, *Exiles from a Future Time: The Forging of the Mid-Twentieth-Century Literary Left* (Chapel Hill: University of North Carolina Press, 2002).
10. See Paula Rabinowitz, *Labor and Desire: Women's Revolutionary Fiction in Depression America* (Chapel Hill: University of North Carolina Press, 1991); Deborah Rosenfelt, "From the Thirties: Tillie Olsen and the Radical Tradition," *Feminist Studies* 7, no. 3 (1981): 371–406; and Constance Coiner, *Better Red: The Writing and Resistance of Tillie Olsen and Meridel Le Sueur* (New York: Oxford University Press, 1995).
11. Susan Edmunds, *Grotesque Relations: Modernist Domestic Fiction and the U.S. Welfare State* (New York: Oxford University Press, 2008), 124.
12. Michael Denning, *The Cultural Front: The Laboring of American Culture in the Twentieth Century* (London: Verso: 1997), 26.
13. Tillie Olsen, untitled fragment, n.d., series 14, box 21, folder 18, TOP; Tillie Olsen, untitled fragment, ca. 1973, series 1, box 4, folder 4, TOP.
14. Tillie Olsen, "A Response," *Frontiers: A Journal of Women's Studies* 18, no. 3 (1997): 160.
15. James D. Schmidt, "'Rendered More Useful': Child Labor and Age Consciousness," in *Age in America: The Colonial Era to the Present*, ed. Corinne T. Field and Nicholas L. Syrett (New York: New York University Press, 2015), 159. For earlier elaborations of this concept, see Abraham Holtzman, "Analysis of Old Age Politics in the United States," *Journal of Gerontology* 9, no. 1 (1954): 56–66; Irving Rosow, *Socialization to Old Age* (Berkeley: University of California Press, 1974); Bernice L. Neugarten and Dail A. Neugarten, "Age in the Aging Society," *Daedalus* 115, no. 1 (1986): 31–49; and Howard P. Chudacoff, *How Old Are You? Age Consciousness in American Culture* (Princeton, N.J.: Princeton University Press, 1989), on how "the AARP, NRTA, National Council of Senior Citizens, Gray Panthers, and other so-called senior organizations have exploited consciousness

of, and sympathy toward, old age to lobby with varying degrees of militancy for rights" (179).
16. Olsen, "A Response," 159–60.
17. Reid, *Tillie Olsen*, 335.
18. See Jesse Olsen Bay, "Makings," Jesse Olsen Bay: Sound Maker (website), accessed September 5, 2020, http://jesseolsenbay.com/makings; and Sandy Boucher, "Friendship and Change with Tillie Olsen," *Persimmon Tree*, Spring 2007, http://persimmontree.org/spring-2007/friendship-and-change-with-tillie-olsen/.
19. See Rachel Adams, "Slow Emergency: Life Writing, Dementia, Gender, and Care," in *Gender in American Literature and Culture*, ed. Jean M. Lutes and Jennifer Travis (Cambridge: Cambridge University Press, 2021), 110–24; Marlene Goldman, *Forgotten: Narratives of Age-Related Dementia and Alzheimer's Disease in Canada* (Montreal: McGill-Queen's University Press, 2017); Anne Davis Basting, "Dementia and the Performance of Self," in *Bodies in Commotion: Disability and Performance*, ed. Carrie Sandahl and Philip Auslander (Ann Arbor: University of Michigan Press, 2005), 202–13; Amelia DeFalco, *Uncanny Subjects: Aging in Contemporary Narrative* (Columbus: Ohio State University Press, 2007), 53–94; and Amanda Grenier, Liz Lloyd, and Chris Phillipson, "Precarity in Late Life: Rethinking Dementia as a 'Frailed' Old Age," in *Ageing, Dementia, and the Social Mind*, ed. Paul Higgs and Chris Gilleard (Hoboken, N.J.: Wiley-Blackwell, 2017), 142–54.
20. Adams, "Slow Emergency," 111.
21. Leni Marshall, "Ageility Studies: The Interplay of Critical Approaches in Age Studies and Disability Studies," in *Alive and Kicking at All Ages: Cultural Constructions of Health and Life Course Identity*, ed. Ulla Kriebernegg, Roberta Maierhofer, and Barbara Ratzenböck (Bielefeld, Ger.: Transcript, 2014), 33.
22. Bell Gale Chevigny, review of *Yonnondio: From the Thirties*, by Tillie Olsen, *Village Voice*, May 23, 1974; William Hogan, "Tillie Olsen's Late, Late Novel," *San Francisco Chronicle*, March 8, 1974.
23. Susan Stanford Friedman, *Planetary Modernisms: Provocations on Modernity Across Time* (New York: Columbia University Press, 2015), 4.
24. Hogan, "Tillie Olsen's Late, Late Novel."
25. Walt Whitman, "Yonnondio," *Critic* 11 (1887): 267; Moglen, *Mourning Modernity*, 60.
26. Elizabeth Jameson, "Written, They Reappear: Rereading *Yonnondio*," *Frontiers* 18, no. 3 (1997): 141.
27. Tillie Olsen, "A Note About This Book," *Yonnondio: From the Thirties* (New York: Delacorte/Seymour Lawrence, 1974), 196.
28. Christopher P. Wilson, "'Unlimn'd They Disappear': Recollecting *Yonnondio: From the Thirties*," in *The Power of Culture: Critical Essays in American History*, ed. Richard Wrightman Fox and T. J. Jackson Lears (Chicago: University of Chicago Press, 1993), 46, 47, 48, 60.
29. Tillie Olsen, "A Note About This Book" draft, n.d., series 1, box 4, folder 4, TOP; Olsen, fragment, n.d., series 1, box 4, folder 8, TOP.
30. Tillie Olsen, *Yonnondio* corrections, n.d., series 1, box 4, folder 8, TOP; Olsen, draft fragment, n.d., series 1, box 4, folder 4, TOP.
31. Tillie Olsen, draft fragment, n.d., series 1, box 4, folder 4, TOP.
32. Wilson, "'Unlimn'd They Disappear,'" 54.

33. Tillie Olsen, *Yonnondio: From the Thirties* (1974; New York: Dell, 1989), 48. Unless otherwise noted, hereafter references to this primary text can be found in this reissue.
34. Peter A. Harkness, introduction to *Inflation and Unemployment* (Washington, D.C.: Congressional Quarterly, 1975), 2. I take historical guidance from Meg Jacobs, "The Conservative Struggle and the Energy Crisis," in *Rightward Bound: Making America Conservative in the 1970s*, ed. Bruce J. Schulman and Julian E. Zelizer (Cambridge, Mass.: Harvard University Press, 2008), 193–209.
35. Harry Magdoff and Paul M. Sweezy, *The End of Prosperity: The American Economy in the 1970s* (New York: Monthly Review Press, 1977), 59.
36. Catharine R. Stimpson, "Three Women Work It Out," *Nation*, November 30, 1974, 565.
37. Fredric Jameson, "*History and Class Consciousness* as an 'Unfinished Project,'" *Rethinking Marxism* 1, no. 1 (1988): 70.
38. Jameson, 70–71.
39. Jameson, 72. For a parallel consideration of modernist U.S. working-class literatures, see Walter Kalaidjian, "Left Poetry," in *A Companion to Modernist Poetry*, ed. David E. Chinitz and Gail McDonald (Malden, Mass.: Wiley-Blackwell, 2014), 267–80.
40. Tillie Olsen, "Reflections," March 21, 1974, series 6, box 42, folder 19, TOP.
41. Reid, *Tillie Olsen*, 333.
42. Tillie Olsen, *Silences* (New York: Delacorte, 1978), n.p.
43. Enda Duffy, *The Speed Handbook: Velocity, Pleasure, Modernism* (Durham, N.C.: Duke University Press, 2009), 11, 7, 49, 10–11.
44. Tillie Olsen, statement of plans, 1970, series 1, folder 1.1, TOCP. For complementary readings of slowness in modernisms, see Lutz Koepnick, *On Slowness: Toward an Aesthetic of the Contemporary* (New York: Columbia University Press, 2014). For the value of slowness within critical age studies, see Amelia DeFalco, "In Praise of Idleness: Aging and Morality of Inactivity," *Cultural Critique* 92 (2016): 84–113.
45. Tillie Olsen, draft, n.d., series 1, box 4, folder 4, TOP.
46. "Editor's Note," in *Yonnondio*, by Tillie Olsen (1974; New York: Dell, 1994), 135.
47. Tillie Olsen to Trish Todd, n.d., series 14, box 18, folder 8, TOP; Tillie Olsen, note to Trish Todd, n.d., series 14, box 18, folder 8, TOP.
48. Olsen to Todd.
49. Tillie Olsen, "Till the Day.... An Afterlook—In More Ways Than One," n.d., series 14, box 18, folder 8, TOP.
50. Tillie Olsen, drafts and draft fragments, n.d., series 1, box 4, folder 4, TOP.
51. See also Peter C. Coleman, "Reminiscence: Developmental, Social and Clinical Perspectives," in *The Cambridge Handbook of Age and Ageing*, ed. Malcolm L. Johnson (Cambridge: Cambridge University Press, 2005), 301–9.
52. Robert N. Butler, "The Life Review: An Interpretation of Reminiscence in the Aged," *Psychiatry* 26, no. 1 (1963): 65.
53. Kathleen Woodward, "Reminiscence and the Life Review: Prospects and Retrospects," in *What Does It Mean to Grow Old? Reflections from the Humanities*, ed. Thomas R. Cole and Sally A. Gadow (Durham, N.C.: Duke University Press, 1986), 143. See also DeFalco, *Uncanny Subjects*, 21–52.
54. Harry R. Moody, "Twenty-Five Years of the Life Review: Where Did We Come From? Where Are We Going?," *Journal of Gerontological Social Work* 12, no. 3–4 (1988): 9.

55. Walter Benjamin, "On Some Motifs in Baudelaire," *Illuminations*, trans. Harry Zohn (New York: Schocken, 1968), 343.
56. Olsen, "Tell Me a Riddle," 148.
57. Kathleen Woodward, *Aging and Its Discontents: Freud and Other Fictions* (Bloomington: Indiana University Press, 1991), 169. See also Margaret Morganroth Gullette, *Aged by Culture* (Chicago: University of Chicago Press, 2004), on "the body-mind" of older adults (106).
58. Tillie Olsen, draft fragments, ca. 1970s, series 1, box 4, folder 7, TOP.
59. Linda Hutcheon and Michael Hutcheon, "Historicizing Late Style as a Discourse of Reception," in *Late Style and Its Discontents: Essays in Art, Literature, and Music*, ed. Gordon McMullan and Sam Siles (New York: Oxford University Press, 2016), 61.
60. Olsen, *Silences*, 27.
61. Tillie Olsen, "Responding to the Nuclear Threat," March 16, 1982, series 6, box 42, folder 1, TOP.
62. Tillie Olsen, "Radcliffe Forum: 'Comprehensions,'" March 13, 1979, series 6, box 42, folder 20, TOP.
63. Olsen, "Radcliffe Forum."
64. Olsen, "Radcliffe Forum."
65. In so doing, her public lectures on life as an older member of the working-classes parallel accounts in David P. Shuldiner, *Aging Political Activists: Personal Narratives from the Old Left* (Westport, Conn.: Praeger, 1995). These narratives also mirror feminist self-recordings in Barbara Macdonald with Cynthia Rich, *Look Me in the Eye: Old Women, Aging, and Ageism* (1983; Denver: Spinsters Ink Books, 2001).
66. Woodward, *Aging*, 188. For like-minded thought on this concept, see Stephen Katz, "Hold On! Falling, Embodiment, and the Materiality of Old Age," *Corpus: An Interdisciplinary Reader on Bodies and Knowledge*, ed. Monica J. Casper and Paisley Currah (New York: Palgrave Macmillan, 2011), 187–205.
67. Tillie Olsen, draft, 1968, series 14, box 21, folder 1, TOP; Doherty, "What Kind of Worker Is a Writer?"
68. Randall Jarrell, "The End of the Line," *Nation*, February 21, 1942, 224.
69. Tillie Olsen, draft, ca. 1993, series 14, box 20, folder 18, TOP.
70. Tillie Olsen, draft, n.d., series 14, box 21, folder 13, TOP.
71. Kathleen Woodward, *At Last, the Real Distinguished Thing: The Late Poems of Eliot, Pound, Stevens, and Williams* (Columbus: Ohio State University Press, 1980), xi.
72. Tillie Olsen, draft, n.d., series 14, box 21, folder 18, TOP.
73. Tillie Olsen, draft fragment, n.d., series 14, box 20, folder 18, TOP.
74. Charles Baudelaire, "Mists and Rains," trans. Edna St. Vincent Millay, in *Flowers of Evil*, trans. George Dillon and Millay (New York: Harper and Brothers, 1936), 195.
75. Edna St. Vincent Millay, preface to *Flowers of Evil*, xxxiii.
76. Rosenfelt, "From the Thirties," 378.
77. Tillie Olsen, draft, ca. 1997–98, series 14, box 21, folder 12, TOP.
78. Elizabeth Gregory, "Marianne Moore's 'Blue Bug': A Dialogic Ode on Celebrity, Race, Gender, and Age," *Modernism/modernity* 22, no. 4 (2015): 783.
79. Tillie Olsen, draft, n.d., series 14, box 20, folder 3, TOP.

80. For a broad overview of U.S. retirement policies and practices, see William Graebner, "Age and Retirement: Major Issues in the American Experience," in Field and Syrett, *Age in America*, 187-208. For recent sociological accounts of retirement, see Caitrin Lynch, *Retirement on the Line: Age, Work, and Value in an American Factory* (Ithaca, N.Y.: Cornell University Press, 2012); and Mary Gatta, *Waiting on Retirement: Aging and Economic Insecurity in Low-Wage Work* (Stanford, Calif.: Stanford University Press, 2019).
81. Tillie Olsen, draft, ca. 1984, series 14, box 18, folder 12, TOP. Phrased as such, this is not to presume that these two categories were mutually exclusive. According to Alan Wald, "worker-writer" was "a classification of the time for which considerable proletarian job experience was a requirement." Wald, "American Poetry and the Popular Front," in *The Cambridge Companion to Modern American Poetry*, ed. Walter Kalaidjian (New York: Cambridge University Press, 2015), 105.
82. Tillie Olsen, draft, ca. 1997-98, series 14, box 21, folder 12, TOP.
83. Tillie Olsen, draft, May 1987, series 14, box 18, folder 7, TOP.
84. See Tillie Olsen (website), accessed September 5, 2020, http://tillieolsen.net/.
85. Tillie Olsen, draft, n.d., series 14, box 21, folder 14, TOP.
86. Tillie Olsen, draft, ca. 1984, series 14, box 18, folder 12, TOP.
87. See Olsen Bay, "Makings."
88. Tillie Olsen, draft, n.d., series 14, box 21, folder 1, TOP.
89. Tillie Olsen, draft, n.d., series 14, box 21, folder 1, TOP. My thanks to Sam Tett as well as other members of a 2017 graduate seminar at Indiana University for translating this handwriting.
90. Tillie Olsen, draft, 1990, series 14, box 21, folder 1, TOP; Tillie Olsen, draft, 1968, series 14, box 21, folder 1, TOP.
91. Tillie Olsen, draft, 2003, series 14, box 21, folder 1, TOP.
92. Reid, *Tillie Olsen*, 333, 334.
93. Walt Whitman, "Thanks in Old Age," in *November Boughs* (Philadelphia: David McKay, 1888), 32.

5. QUEER SENIOR LIVING

1. Josh Barbanel, "The Butler Did It—at the Dakota," *Wall Street Journal*, May 11, 2010. There is a follow-up chapter that remains to be written on Tamang and Ruth Ford. For more on her career, see Elspeth H. Brown, *Work! A Queer History of Modeling* (Durham, N.C.: Duke University Press, 2019).
2. Josh Barbanel, "Butler Did It: Sells Dakota Co-op," *Wall Street Journal*, February 2, 2011. Tamang's later interviews likewise confirm these facts.
3. "Silver Flower Coo by Charles Henri Ford" promotional notice, n.d., box 32, CHFP; Steven Watson, introduction to *The Young and Evil*, by Charles Henri Ford and Parker Tyler (1933; New York: Masquerade Books, 1996), n.p.
4. See George Chauncey, *Gay New York: Gender, Urban Culture, and the Making of the Gay Male World, 1890–1940* (New York: Basic Books, 1994), 370–71.
5. Dennis Harvey, review of *Sleep in a Nest of Flames*, directed by James Dowell and John Kolomvakis, *Variety*, August 10, 2001, quoted in Myrna Oliver, "Charles H. Ford, 94;

Poet Founded 2 Influential Literary Magazines," *Los Angeles Times*, October 4, 2002, B15.

6. Louise Glück, "Visitors from Abroad," *Faithful and Virtuous Night* (New York: Farrar, Straus and Giroux, 2014), 22.

7. Keren Brown Wilson, "Historical Evolution of Assisted Living in the United States, 1979 to the Present," *Gerontologist* 47, no. S.1 (2007): 15. See also Judith Ann Trolander, *From Sun Cities to the Villages: A History of Active Adult, Age-Restricted Communities* (Gainesville: University Press of Florida, 2011); Carole Haber and Brian Gratton, *Old Age and the Search for Security: An American Social History* (Bloomington: Indiana University Press, 1994), 123-41; W. Andrew Achenbaum and L. Christian Carr, "A Brief History of Aging Services in the United States," *Generations* 38, no. 2 (2014): 9-13; Timothy Diamond, *Making Gray Gold: Narratives of Nursing Home Care* (Chicago: University of Chicago Press, 1995); Benyamin Schawrz and Ruth Brent, eds., *Aging, Autonomy, and Architecture: Advances in Assisted Living* (Baltimore: Johns Hopkins University Press, 1999); Iris Carlton-LaNey, "Old Folks' Homes for Blacks During the Progressive Era," *Journal of Sociology and Social Welfare* 16, no. 3 (1989): 43-60; and primary documents such as W. E. B. Du Bois, ed., *Efforts for Social Betterment Among Negro Americans* (Atlanta: Atlanta University Press, 1909), 65-77.

8. Considerations of aging in place can be found in Stephen M. Golant, *A Place to Grow Old: The Meaning of Environment in Old Age* (New York: Columbia University Press, 1984); and Shulamit L. Bernard, Sheryl Zimmerman, and J. Kevin Eckert, "Aging in Place," in *Assisted Living: Needs, Practices, and Policies in Residential Care for the Elderly*, ed. Sheryl Zimmerman, Philip D. Sloane, and J. Kevin Eckert (Baltimore: Johns Hopkins University Press, 2001), 224-41. J. Kevin Eckert et al., *Inside Assisted Living: The Search for Home* (Baltimore: Johns Hopkins University Press, 2009), 167-94, also offers a helpful reminder that this idea can encompass multiple built environments via "aging in places."

9. Paul Mariani, *William Carlos Williams: A New World Naked* (New York: McGraw-Hill, 1981), 766.

10. Kathleen Woodward, "A Public Secret: Assisted Living, Caregivers, Globalization," *International Journal of Ageing and Later Life* 7, no. 2 (2012): 45. See also Kathleen Woodward, "Assisted Living: Aging, Old Age, Memory, Aesthetics," *Occasion: Interdisciplinary Studies in the Humanities* 4 (2012), https://arcade.stanford.edu/occasion_issue/volume-4; Kathleen M. Woodward, "Frailty and the Meanings of Literature," in *Vitalizing Long-Term Care: The Teaching Nursing Home and Other Perspectives*, ed. Stuart F. Spicker and Stanley R. Ingman (New York: Springer, 1984), 128-37; Anne Basting, "How We Underestimate the Arts in Long-Term Care," *Caring for the Ages* 19, no. 7 (2018): 10-11; and Suzanne Gordon, Patricia Benner, and Nel Noddings, eds., *Caregiving: Readings in Knowledge, Practice, Ethics, and Politics* (Philadelphia: University of Pennsylvania Press, 1996).

11. Charles Henri Ford, "I feel like I'm on," ca. 1993-94, series 2, box 12, CHFP. See also Victor Koshkin-Youritzin, "Introduction: Charles Henri Ford's Career," in *Photographs by Charles Henri Ford* (Norman: Fred Jones Jr. Museum of Art at University of Oklahoma, 2006), 1-50, for his extended biography, and his confirmation that "by the early

1990s, Ford ceased traveling, choosing to remain either in New York at the Dakota, or, during the summers, at Montauk, Long Island" (11).
12. Charles Henri Ford, "Haiku and cutouts," 1994, series 2, box 12, CHFP.
13. Charles Henri Ford, "First Young and Evil," May 17, 1993, series 2, box 13, CHFP.
14. Charles Henri Ford, "I'm sitting here like," ca. 1998-99, series 2, box 12, CHFP.
15. In a letter dated April 5, 1942, André Masson provides an origin story for the magazine's title and writes that "Bataille and I, who were then concerned with most mysterious Greek and Iranian mythologies, proposed *Minotaure*. This was accepted" ("Re 'Minotaure,'" *View* 2 [1942] n.p.). For more on modernism's use of Minotaur mythology, see Jean Starobinski, "Day Side and Night Side," trans. A. St. J. Shawcross, in *Focus on Minotaure: The Animal-Headed Review* (Geneva: Musée d'Art et d'Histoire, 1987), 31–41; Theodore Ziolkowski, *Minos and the Moderns: Cretan Myth in Twentieth-Century Literature and Art* (Oxford: Oxford University Press, 2008), 71–73; and Dickran Tashjian, *A Boatload of Madmen: Surrealism and the American Avant-Garde, 1920–1950* (New York: Thames and Hudson, 1995).
16. Catrina Neiman, "Introduction: *View* Magazine: Transatlantic Pact," in *View: Parade of the Avant-Garde: An Anthology of View Magazine (1940–1947)*, ed. Charles Henri Ford, comp. Catrina Neiman and Paul Nathan (New York: Thunder's Mouth, 1991), xii. For more on *View*, see Ann Reynolds, "No Strangers," in *The Young and Evil: Queer Modernism in New York, 1930–1955*, ed. Jarrett Earnest (New York: David Zwirner Books, 2019), 25-35; and Joanna Pawlik, *Remade in America: Surrealist Art, Activism, and Politics, 1940–1978* (Oakland: University of California Press, 2021), 21–63. For more on Ford and surrealism, see Martica Sawin, *Surrealism in Exile and the Beginning of the New York School* (Cambridge, Mass.: MIT Press, 1997); Alexander Howard, *Charles Henri Ford: Between Modernism and Postmodernism* (London: Bloomsbury, 2017), on the artist's "transformative reworking of what he believed to be a conceptually stunted Surrealism" (115); Howard, "Keep on Waking: Charles Henri Ford, Camp, and Surrealism," *Miranda* 17 (2017): n.p., on Ford's "attempted modification of Surrealism"; and Stamatina Dimakopoulou, "From a 'Garden of Disorder' to a 'Nest of Flames': Charles Henri Ford's Surrealist Inflections," *Miranda* 14 (2017): n.p.
17. Charles Henri Ford, "The Minotaur left," ca. 1993-94, series 2, box 12, CHFP.
18. Ira Cohen, "Ira Cohen: The Great Rice Paper Adventure, Kathmandu, 1972-1977," *New Observations* 106 (1995): 8. I thank Indra B. Tamang for pointing me to this influence.
19. Charles Henri Ford and Indra B. Tamang, "Charles Henri Ford BIBLIOGRAPHY," ca. 1981?, series 6C, box 53, folder 5, CHFP RLSC.
20. Cohen, "Great Rice Paper Adventure," 8.
21. When once asked, "How did you pick up the haiku form as an expression?," Ford responded: "Basho and Issu. I'm magnetized by haiku to this day." I believe Ford refers to Matsuo Bashō and Kobayashi Issa. "Charles Henri Ford: Catalyst Among Poets," interview by Asako Kitaori, *Rain Taxi Review of Books*, 2000, https://www.raintaxi.com/charles-henri-ford/.
22. Charles Henri Ford, interview by Bruce Wolmer, *BOMB* 18 (1987): 56.
23. Jeffrey Johnson, *Haiku Poetics in Twentieth-Century Avant-Garde Poetry* (Plymouth, UK: Lexington Books, 2011), 15. Further readings of haiku's prominence in modernism

include Hoyt Long and Richard Jean So, "Literary Pattern Recognition: Modernism Between Close Reading and Machine Learning," *Critical Inquiry* 42, no. 2 (2016): 235-67; Yoshinobu Hakutani, *Haiku and Modernist Poetics* (New York: Palgrave Macmillan, 2009), 69-88; Robert Kern, *Orientalism, Modernism, and the American Poem* (New York: Cambridge University Press, 1996) on Pound's "haiku-like" poetics (155); Jahan Ramazani, *A Transnational Poetics* (Chicago: University of Chicago Press, 2009); Audrey Wu Clark, *The Asian American Avant-Garde: Universalist Aspirations in Modernist Literature and Art* (Philadelphia: Temple University Press, 2015), 60-97; Josephine Nock-Hee Park, *Apparitions of Asia: Modernist Form and Asian American Poetics* (New York: Oxford University Press, 2008), 23-56; Lawrence Buell, "Worldings of American Literature off the Cultural Radar," in *American Literature as World Literature*, ed. Jeffrey R. Di Leo (New York: Bloomsbury Academic, 2018), 49-63; and Grace Lavery, *Quaint, Exquisite: Victorian Aesthetics and the Idea of Japan* (Princeton, N.J.: Princeton University Press, 2019).

24. "Domestic space," Howard confirms, "comes to dominate in Ford's late modernist haiku." *Charles Henri Ford*, 205.
25. Ford, interview by Wolmer, 54.
26. "Ira Cohen Interviews Charles Henri Ford," in *Gay Sunshine Interviews*, vol. 1, ed. Winston Leyland (San Francisco: Gay Sunshine, 1978), 62. See also Charles Henri Ford, "Street Diary: A Walk through Athens and the Islands," 1961, series 4, box 21, folder 2, Charles Henri Ford Papers, Harry Ransom Center, University of Texas at Austin.
27. Charles Henri Ford, "I sometimes feel like," November 10, 1993, series 2, box 13, CHFP. There is also a connection here between Ford-as-machine and the surrealist artist-as-machine. For more on the latter, see Hal Foster, *Compulsive Beauty* (Cambridge, Mass.: MIT Press, 1995), 125-53.
28. Rhonda Roland Shearer and Thomas Girst, "From *Blues* to Haikus: An Interview with Charles Henri Ford," *Tout-Fait: The Marcel Duchamp Studies Online Journal* 1, no. 2 (2000): n.p.
29. Charles Henri Ford, "I had a T-shirt," April 19, 1993, series 2, box 13, CHFP. For more on this technique, see Tashjian's interview with Ford, quoted in *A Boatload of Madmen*: "He later said he did not engage in an 'official' sort of automatism, though he claimed that his writing was automatic because he never knew what was coming next" (160).
30. Ford, interview by Wolmer, 54.
31. Charles Henri Ford, "Thought collages means," n.d., series 2, box 12, CHFP.
32. Charles Henri Ford, "From A Record of Myself," 1950, box 5, folder 3, Charles Henri Ford Papers, Harry Ransom Center, University of Texas at Austin, quoted in Howard, *Charles Henri Ford*, 128.
33. Kitaori, "Ford: Catalyst Among Poets," n.p. Howard, *Charles Henri Ford*, also reads this interview "as the point of continuity that Ford moves to establish between the haiku and the sort of chance aesthetic encounter that has traditionally been associated with Surrealism," yet he argues that these poetics "read as more Poundian than Surrealist" (205). I wish to preserve the connection to surrealism that Ford's poetic theories reaffirm.
34. Charles Henri Ford, "All writing is sur-," ca. 1993-1994, series 2, box 12, CHFP; Charles Henri Ford, "When you reach my age," n.d., series 2, box 12, CHFP.

35. Charles Henri Ford, "An experiment of," 1976, series 2, box 13, CHFP; Glen MacLeod, "Charles Henri Ford: Responses to a Questionnaire," *William Carlos Williams Review* 22, no. 1 (1996): 100. For more on Ford's everyday poetics, see Jim Kacian, "An Overview of Haiku in English," *Haiku in English: The First Hundred Years*, ed. Jim Kacian, Philip Rowland, and Allan Burns (New York: Norton, 2013), who describes "veteran surrealist Charles Henri Ford" as "said to have written a poem a day during the last several years of his life, and thus an advocate of the 'haiku as life' school of thought" (349). See also Siobhan Phillips, *The Poetics of the Everyday: Creative Repetition in Modern American Verse* (New York: Columbia University Press, 2010), on "everyday modernism" (17); Liesl Olson, *Modernism and the Ordinary* (New York: Oxford University Press, 2009); and Andrew Epstein, *Attention Equals Life: The Pursuit of the Everyday in Contemporary Poetry and Culture* (New York: Oxford University Press, 2016).
36. Susan Rosenbaum, "Exquisite Corpse: Surrealist Influence on the American Poetry Scene, 1920-1960," in *The Oxford Handbook of Modern and Contemporary American Poetry*, ed. Cary Nelson (New York: Oxford University Press, 2012), 283. See also Sandra Zalman, *Consuming Surrealism in American Culture: Dissident Modernism* (Farnham, Surrey, UK: Ashgate, 2015); Jeffrey Wechsler, *Surrealism and American Art: 1931–1947* (New Brunswick, N.J.: Rutgers University Art Gallery, 1976); Isabelle Dervaux, *Surrealism USA* (Ostfildern-Ruit, Ger.: Hatje Cantz, 2004); and Ilene Susan Fort, "American Social Surrealism," *Archives of American Art Journal* 22, no. 3 (1982): 8–20.
37. *Oxford English Dictionary*, s.v. "oldie," accessed January 23, 2020, oed.com.
38. Charles Henri Ford, "You'll be more famous," ca. 1993-1994, series 2, box 12, CHFP.
39. See Joseph Allen Boone, *Libidinal Currents: Sexuality and the Shaping of Modernism* (Chicago: University of Chicago Press, 1998); Brent Hayes Edwards, "The Taste of the Archive," *Callaloo* 35, no. 4 (2012): 944-72; Tirza True Latimer, *Eccentric Modernisms: Making Differences in the History of American Art* (Oakland: University of California Press, 2017), 78–110; and Juan A. Suárez, *Pop Modernism: Noise and the Reinvention of the Everyday* (Urbana: University of Illinois Press, 2007), 179-207.
40. Patti Smith, *Just Kids* (New York: HarperCollins, 2010), 150.
41. Joanna Pawlik, "Re-Membering Surrealism in Charles Henri Ford's *Poem Posters* (1964-65)," *Art History* 41, no. 1 (2017): 188.
42. Charles Henri Ford, "Older than I am," n.d., series 2, box 12, CHFP.
43. Charles Henri Ford, "The day he hit ninety," n.d., series 2, box 12, CHFP; Charles Henri Ford, "Here are evoked the," 1994, series 2, box 12, CHFP.
44. Robert N. Butler, "The Life Review: An Interpretation of Reminiscence in the Aged," *Psychiatry* 26, no. 1 (1963): 69.
45. Charles Henri Ford, "Life used to be just," 1994, series 2, box 12, CHFP.
46. Michael Kimmelman, "Art in Review; Charles Henri Ford," *New York Times*, January 24, 2003.
47. Howard, *Charles Henri Ford*, 194.
48. Charles Henri Ford, "Djuna loved laughing," ca. 1993-94, series 2, box 12, CHFP.
49. Charles Henri Ford, "Who was it went to," 1994, series 2, box 12, CHFP. See Chad Bennett, *Word of Mouth: Gossip and American Poetry* (Baltimore: Johns Hopkins University Press, 2018), 164, for more on this phrase.
50. Charles Henri Ford, "Ezra Pound Gertrude," June 2, 1993, series 2, box 13, CHFP.

51. James Dowell, "Charles Henri Ford Was There," *Gay and Lesbian Review* 8, no. 6 (2001): 34.
52. Steve Dalachinsky, "For Charles-Henri Ford—Another I Did Not Know," *Brooklyn Rail*, April 1, 2003, http://brooklynrail.org/2003/04/art/for-charles-henri-ford-another-i-did-not-know.
53. Charles Henri Ford, "It read Dirty Old," series 2, box 12, ca. 1993-94, CHFP.
54. To begin this thesis, start with Allan McLane Hamilton, *A Manual of Medical Jurisprudence* (New York: Bermingham, 1883); then move to Carole Haber, *Beyond Sixty-Five: The Dilemma of Old Age in America's Past* (Cambridge: Cambridge University Press, 1983); then to Edward J. Stieglitz, ed., *Geriatric Medicine: Medical Care of Later Maturity* (Philadelphia: Lippincott, 1954), which Carole Haber quotes in "Sexuality," in *Keywords in Sociocultural Gerontology*, ed. W. Andrew Achenbaum, Steven Weiland, and Carole Haber (New York: Springer, 1996), 157-62; and conclude with Laud Humphreys, *Out of the Closets: The Sociology of Homosexual Liberation* (Englewood Cliffs, N.J.: Prentice-Hall, 1972), 116.
55. Ralph S. Schaffer, "Will You Still Need Me When I'm 64?," in *Out of the Closets: Voices of Gay Liberation*, ed. Karla Jay and Allen Young (New York: Douglas, 1972), 278.
56. Charles Henri Ford, "The two best known kinds," 1994, series 2, box 12, CHFP.
57. Charles Henri Ford, "This ninety-year-old," ca. 1998, series 2, box 12, CHFP.
58. Charles Henri Ford, "Tolerating a," 1994, series 2, box 12, CHFP.
59. Charles Henri Ford, "Days no longer trip," ca. 1993-94, series 2, box 12, CHFP.
60. Charles Henri Ford, "Where is the mirror?," ca. 1998-99, series 2, box 12, CHFP.
61. Mary Ann Caws, *The Surrealist Look: An Erotics of Encounter* (Cambridge, Mass.: MIT Press, 1997), 228; Lars Tornstam, *Gerotranscendence: A Developmental Theory of Positive Aging* (New York: Springer, 2005).
62. Charles Henri Ford, "sweet and sour," n.d., series 2, box 12, CHFP.
63. Charles Henri Ford, "There's no where to go," n.d., series 2, box 12, CHFP.
64. Charles Henri Ford, "Keep your pencils," 1994, series 2, box 12, CHFP.
65. Charles Henri Ford, "Out out out out out," n.d, series 2, box 12, CHFP.
66. Charles Henri Ford, "His life span was for," ca. 1993-94, series 2, box 12, CHFP.
67. Charles Henri Ford, "Two decades of," n.d., series 2, box 12, CHFP.
68. Charles Henri Ford, "Someone To Watch Over," ca. 1993-94, series 2, box 12, CHFP.
69. Charles Henri Ford, "Indra Bahadur," n.d., series 2, box 12, CHFP.
70. Charles Henri Ford, *Om Krishna I: Special Effects* (Rhinebeck, N.Y.: Open Studio Print Shop, 1979), n.p.
71. Charles Henri Ford, "Poet in Kathmandu: An Oriental Idyll," n.d., series 3, box 14, folder 2, CHFP.
72. "Ira Cohen Interviews Charles Henri Ford," 63.
73. Paulita Sedgewick, "The Silver Dracula: Charles Henri Ford: An Interview in Two Acts," *Cream City Review* 9, no. 1-2 (1984): 143.
74. Eng-Beng Lim, *Brown Boys and Rice Queens: Spellbinding Performance in the Asias* (New York: New York University Press, 2014), 17; Joseph Allen Boone, *The Homoerotics of Orientalism* (New York: Columbia University Press, 2015), 372.
75. See also Robert Aldrich, *The Seduction of the Mediterranean: Writing, Art and Homosexual Fantasy* (London: Routledge, 1993); and Amy Sueyoshi, *Queer Compulsions: Race, Nation, and Sexuality in the Affairs of Yone Noguchi* (Honolulu: University of Hawai'i Press, 2012).

76. Mark Liechty, *Far Out: Countercultural Seekers and the Tourist Encounter in Nepal* (Chicago: University of Chicago Press, 2017), 228. For histories of Nepal, see Nancy E. Levine, "Caste, State, and Ethnic Boundaries in Nepal," *Journal of Asian Studies* 46, no. 1 (1987): 71-88; David H. Holmberg, *Order in Paradox: Myth, Ritual, and Exchange Among Nepal's Tamang* (Ithaca, N.Y.: Cornell University Press, 1989); Stacy Leigh Pigg, "Inventing Social Categories Through Place: Social Representations and Development in Nepal," *Comparative Studies in Society and History* 34, no. 3 (1992): 491-513; Ben Campbell, "The Heavy Loads of Tamang Identity," in *Nationalism and Ethnicity in a Hindu Kingdom: The Politics of Culture in Contemporary Nepal*, ed. David N. Gellner, Joanna Pfaff-Czarnecka, and John Whelpton (Amsterdam: Harwood Academic, 1997), 205-35; Susan I. Hangen, *The Rise of Ethnic Politics in Nepal: Democracy in the Margins* (New York: Routledge, 2010); and Tanka B. Subba and A. C. Sinha, eds., *Nepali Diaspora in a Globalised Era* (New York: Routledge, 2016).

77. See Mukta S. Tamang, "Tamang Activism, History, and Territorial Consciousness," in *Ethnic Activism and Civil Society in South Asia*, ed. David N. Gellner (Thousand Oaks, Calif.: SAGE, 2009), 283; Susan Hangen, "Global Gurungs: Ethnic Organizing Abroad," in *Facing Globalization in the Himalayas: Belonging and the Politics of the Self*, ed. Gérard Toffin and Joanna Pfaff-Czarnecka (New Delhi: SAGE India, 2014), 264-85; Pratikshya Bohra-Mishra, "Nepalese Migrants in the United States of America: Perspectives on Their Exodus, Assimilation Pattern and Commitment to Nepal," *Journal of Ethnic and Migration Studies* 37, no. 9 (2011): 1527-37; and James Clifford, "Varieties of Indigenous Experience: Diasporas, Homelands, Sovereignties," in *Indigenous Experience Today*, ed. Marisol de la Cadena and Orin Starn (New York: Berg, 2007), 197-223. For more on Asian and Asian American migrations in the later twentieth century, see Lisa Lowe, "Epistemological Shifts: National Ontology and the New Asian Immigrant," in *Orientations: Mapping Studies in the Asian Diaspora*, ed. Kandice Chuh and Karen Shimakawa (Durham, N.C.: Duke University Press, 2001), 267-76.

78. "Ira Cohen Interviews Charles Henri Ford," 43. Compare Ford's quote to a piece, "Damphu Saanjh, 2010," which Tamang posted on his *Hermitage* blog on June 19, 2012, that details the intricacies of Tamang cultural collectivity in relation to immigrant life in the United States. Or his accounts of his young life as a Tamang in Indra Tamang, "Indra from Nepal," interview by Romy Ashby, *Goodie* 23 (2004): 3-21.

79. Author bio for Charles Henri Ford, in *Operation Minotaur: Haikus and Collages by Charles Henri Ford and Photographs by Indra Tamang* (Kathmandu: Mandala Graphics, 2006), n.p.

80. Tamang, "Indra from Nepal," 19.

81. Charles Henri Ford, note to self, August 2, 1993, series 2, box 13, CHFP.

82. See Evelyn Nakano Glenn, *Forced to Care: Coercion and Caregiving in America* (Cambridge, Mass.: Harvard University Press, 2010); Linta Varghese, "Looking Home: Gender, Work, and the Domestic in Theorizations of the South Asian Diaspora," in *The Sun Never Sets: South Asian Migrants in an Age of U.S. Power*, ed. Vivek Bald, Miabi Chatterji, Sujani Reddy, and Manu Vimalassery (New York: New York University Press, 2013), 156-75; Martin F. Manalansan IV, "Queer Intersections: Sexuality and Gender in Migration Studies," *International Migration Review* 40, no. 1 (2006): 224-49; Cati Coe, *The New American Servitude: Political Belonging Among African Immigrant Home Care Workers* (New York: New York University Press, 2019); Eileen Boris and Rhacel

Salazar Parreñas, eds., *Intimate Labors: Cultures, Technologies, and the Politics of Care* (Stanford, Calif.: Stanford University Press, 2010); Rhacel Salazar Parreñas, *Servants of Globalization: Women, Migration, and Domestic Work* (Stanford, Calif.: Stanford University Press, 2001); Laura Katz Olson, *The Not-So-Golden Years: Caregiving, the Frail Elderly, and the Long-Term Care Establishment* (Lanham, Md.: Rowman and Littlefield, 2003); Rüdiger Kunow, "Another Kind of Intimacy: Care as Transnational and Transcultural Relationship," *Age, Culture, Humanities* 2 (2015): 329–35; Christiane Brosius and Roberta Mandoki, eds., *Caring for Old Age: Perspectives from South Asia* (Heidelberg, Ger.: Heidelberg University Publishing, 2020); and Woodward, "A Public Secret."

83. Glenn, *Forced to Care*, 175. When I asked Tamang, "How were you remunerated or paid for your labor?," he replied that his was a "complex situation—I didn't have actually a weekly or monthly salary or anything like that" (Indra B. Tamang, interview by author, May 8, 2018). Woodward, "A Public Secret," historicizes this response: "In the United States, as a result of federal legislation and regulations dating from the 1930s and the 1970s, there is no requirement at the national level that home care workers be paid either minimum wage or overtime" (28).

84. Tamang, "Indra from Nepal," 19.

85. Indra B. Tamang, interview by author, June 10, 2019.

86. Martin F. Manalansan IV, "Servicing the World: Flexible Filipinos and the Unsecured Life," in *Political Emotions*, ed. Janet Staiger, Ann Cvetkovich, and Ann Reynolds (New York: Routledge, 2010), 226.

87. Julien Levy, *Surrealism* (New York: Black Sun, 1936), 15. See also Louise Tythacott's claim in *Surrealism and the Exotic* (New York: Routledge, 2003) that "the Surrealists exploited to the full the disjunctive and disorientating potentiality of collage" (30); and Caws, *Surrealist Look*, 298.

88. Ford, interview by Wolmer, 57.

89. Indra Tamang, "Thinking of Charles Henri Ford on the 15th Anniversary of His Departure," *Hermitage* (blog), September 27, 2017, https://thundernip.blogspot.com/2017/09/thinking-of-charles-henri-ford-on.html.

90. Philip Sherwell reported that "he wants to pay off the mortgage on his Queens house, visit Nepal for the first time in more than a decade, help relatives there, [and] save for his 10-year-old daughter Zina's college fees." "Nepali Butler Inherits a Manhattan Fortune," *Sydney Morning Herald*, May 17, 2010.

91. Laura Doyle and Laura Winkiel, "Introduction: The Global Horizons of Modernism," in *Geomodernisms: Race, Modernism, Modernity*, ed. Doyle and Winkiel (Bloomington: Indiana University Press, 2005), 4; Jessica Berman, "Neither Mirror nor Mimic: Transnational Reading and Indian Narratives in English," in *The Oxford Handbook of Global Modernisms*, ed. Mark Wollaeger with Matt Eatough (New York: Oxford University Press, 2012), 207. It is also no stretch to imagine this piece as an instance of what Ramazani, *A Transnational Poetics*, terms "translocal cosmopolitanisms" (17).

92. Jahan Ramazani, "Modernist Bricolage, Postcolonial Hybridity," *Modernism/modernity* 13, no. 3 (2006): 460. For more on Shah and modernist Nepali art in general, see Sangeeta Thapa, "Transitions in Nepali Contemporary Art," in *Nepal Art Now*, ed. Swosti Rajbhandari Kayastha and Christian Schicklgruber (Bielefeld, Ger.: Kerber, 2019),

5. Queer Senior Living 243

59-73; and Sangeeta Thapa, *Retrospective: Celebrating 40 Years of Creativity: Shashi Shah 2007* (Kathmandu: Siddhartha Art Gallery, 2007). For more on indigenous global modernisms, see Elizabeth Harney and Ruth B. Phillips, eds., *Mapping Modernisms: Art, Indigeneity, Colonialism* (Durham, N.C.: Duke University Press, 2019).

93. Charles Henri Ford, "From Gautier to," ca. 1993-1994, series 2, box 12, CHFP.
94. Susan Stanford Friedman, *Planetary Modernisms: Provocations on Modernity Across Time* (New York: Columbia University Press, 2015), 218.
95. Empire Medicare Services to The Estate of Charles Henri Ford, March 15, 2003, series 7, box 23, folder 7, CHFP.
96. Charles Henri Ford, comments to Indra B. Tamang, 1997-99, series 7, box 23, folders 1, 3, 4, and 7, CHFP. For a sociohistorical account of Ford's bewilderment, see Muriel R. Gillick, *Old and Sick in America: The Journey Through the Health Care System* (Chapel Hill: University of North Carolina Press, 2017); and Karen Buhler-Wilkerson, *No Place Like Home: A History of Nursing and Home Care in the United States* (Baltimore: Johns Hopkins University Press, 2001), on "the maze of entitlements, functional eligibility requirements, and continuous shifts in reimbursement sources" (202).
97. Alfred H. Barr Jr., "Fantastic Architecture," in *Fantastic Art, Dada, Surrealism*, ed. Alfred H. Barr Jr. (New York: Museum of Modern Art, 1936), 239.
98. Rosenbaum, "Exquisite Corpse," 284.
99. Indra B. Tamang, interview by author, May 8, 2018.
100. Charles Henri Ford, "Second childhood's here," ca. 1993-94, series 2, box 12, CHFP.
101. Charles Henri Ford, interview by Allen Frame, *Journal of Contemporary Art*, accessed September 8, 2020, http://jca-online.com/ford.html.
102. Pawlik, *Remade in America*, 58.
103. Maggie Kuhn (with Christina Long and Laura Quinn), *No Stone Unturned: The Life and Times of Maggie Kuhn* (New York: Ballantine, 1991), 186. Kuhn explicitly alludes to a quote in Robert N. Butler and Myrna I. Lewis, *Sex After Sixty: A Guide for Men and Women for Their Later Years* (Boston: Hall, 1976): "perhaps only in the later years can life with its various possibilities have the chance to shape itself into something approximating a human work of art" (248).
104. Bess Williamson, *Accessible America: A History of Disability and Design* (New York: New York University Press, 2019), 178. Williamson provides a comprehensive history of OXO Good Grips products that were first aimed at individuals with age-related disabilities.
105. Tamang, interview by author, July 10, 2018.
106. Theodorus M. Tumelaire to Indra B. Tamang, December 16, 1976, series 7, box 54, folder 3, CHFP RLSC.
107. Howard P. Chudacoff, *How Old Are You? Age Consciousness in American Culture* (Princeton, N.J.: Princeton University Press, 1989), 133, 134, 136.
108. Ministry of Industry and Commerce, *Visitor's Guide to Nepal* (Kathmandu: Department of Tourism, 1973), n.p.
109. For more on surrealism's fascination with statues, see Elza Adamowicz, *Surrealist Collage in Text and Image: Dissecting the Exquisite Corpse* (Cambridge: Cambridge University Press, 1998), 159-84.
110. Rosenbaum, "Exquisite Corpse," 279.

111. Indra Tamang, "On Leaving the Dakota," *Hermitage* (blog), posted November 13, 2019, https://thundernip.blogspot.com/2019/11/on-leaving-dakota-view-from-dakota-room.html; Charles I. Glicksberg, "The Poetry of Surrealism," *Prairie Schooner* 23, no. 3 (1949): 308.
112. Tamang, "On Leaving."
113. Tamang, "Thinking of Charles Henri Ford."
114. Gerard Malanga, "Malanga's Life of Ford," *Café Review* 7 (1996): 16.
115. Gertrude Stein, *Everybody's Autobiography* (1937; New York: Vintage, 1973), 167.
116. Anne Basting, *Creative Care: A Revolutionary Approach to Dementia and Elder Care* (New York: HarperOne, 2020).
117. Carolyn Burke, "Getting Spliced: Modernism and Sexual Difference," *American Quarterly* 39, no. 1 (1987): 103.

6. THE HARLEM RENAISSANCE

1. Alain Locke, "Negro Youth Speaks," in *The New Negro: Voices of the Harlem Renaissance*, ed. Alain Locke (1925; New York: Atheneum, 1992), 47, 48, 49. Hereafter parenthetically cited in this chapter with an abbreviated Y.
2. Henry Louis Gates Jr., *Stony the Road: Reconstruction, White Supremacy, and the Rise of Jim Crow* (New York: Penguin, 2019), 91; Lydia Ferguson, "Pro-Slavery Appropriations and Inadvertent Agencies: The Elder(ly) 'Uncle' in Plantation Fiction," *American Studies* 58, no. 1 (2019): 63.
3. Gates, *Stony the Road*, 231.
4. Adena Spingarn, "Writing the Old Negro in a New Century: James Weldon Johnson and the Uses of *Uncle Tom's Cabin*," *American Literature* 89, no. 1 (2017): 47.
5. Langston Hughes, "The Negro Speaks of Rivers," *New Negro*, 141. See also "Being Old" (1927) in *The Collected Works of Langston Hughes, Volume 1: The Poems: 1921–1940*, by Langston Hughes, ed. Arnold Rampersad (Columbia: University of Missouri Press, 2001), 190.
6. Langston Hughes, "The Negro Artist and the Racial Mountain," *Nation*, June 23, 1926, 694.
7. Claude McKay, *A Long Way from Home*, ed. Gene Andrew Jarrett (1937; New Brunswick, N.J.: Rutgers University Press, 2007), 245.
8. Jeffrey C. Stewart, *The New Negro: The Life of Alain Locke* (New York: Oxford University Press, 2018), 436.
9. Alain Locke, "The Negro: 'New' or Newer: A Retrospective Review of the Literature of the Negro for 1938," *Opportunity* 17 (1939), 4-5.
10. Stewart, *New Negro*, 441.
11. Jonathan Ned Katz, "Sassy and Strong: Lesbian Elder Mabel Hampton: A Heroine of Black History," *Advocate*, February 27, 1990, 46. See also "Mabel Hampton: A Lesbian Elder, a Life of Passion and Inspiration," *Sappho's Isle* 2, no. 12 (1989): 1.
12. For mentions of Hampton in these referenced scholars, see Lillian Faderman, *Odd Girls and Twilight Lovers: A History of Lesbian Life in Twentieth-Century America* (New York: Columbia University Press, 1991), 76; Eric Garber, "A Spectacle in Color: The Lesbian and Gay Subculture of Jazz Age Harlem," in *Hidden from History: Reclaiming the Gay and*

Lesbian Past, ed. Martin Duberman, Martha Vicinus, and George Chauncey Jr. (New York: Meridian, 1989), 320, 321, 325; and Barbara Smith, "African American Lesbian and Gay History: An Exploration," in *The Truth That Never Hurts: Writings on Race, Gender, and Freedom* (New Brunswick, N.J.: Rutgers University Press, 2000), 91.

13. Saidiya Hartman, *Wayward Lives, Beautiful Experiments: Intimate Histories of Social Upheaval* (New York: Norton, 2019), xv, 61.
14. In identifying Hampton as such, I follow Jack Halberstam, *Female Masculinity* (Durham, N.C.: Duke University Press, 1998). I also acknowledge Hartman's biographical fabulation that presents Hampton as "a gender-fluid and nonbinary black person" while finding that "it didn't matter what other people called her, whether they called her a stud or a butch" (*Wayward Lives*, 412, 338). Over the course of her later-life narratives, Hampton self-identified with variations on "bulldykers and ladylovers, stud and butch," as she states in Joan Nestle, "Excerpts from the Oral History of Mabel Hampton," *Signs* 18, no. 4 (1993): 934. Taking guidance from Halberstam and Hartman, I hope to avoid any foreclosures of Hampton's erotic subjectivity and lived sense of gender in this chapter's reliance on various primary and secondary sources.
15. Hartman, *Wayward Lives*, 313, 323, 228.
16. In so doing I join other scholarly projects focused on the later lives of modern African American performers as well as critical age studies of U.S. performance. For the former, see Matthew Pratt Guterl, *Josephine Baker and the Rainbow Tribe* (Cambridge, Mass.: Harvard University Press, 2014). For the latter, see Anne Davis Basting, *The Stages of Age: Performing Age in Contemporary American Culture* (Ann Arbor: University of Michigan Press, 1998), on a request "to read aging and old age as performative acts, both on- and offstage" (9); Kathleen Woodward, "Performing Age, Performing Gender," *NWSA Journal* 18, no. 1 (2006): 162–89; and Sally Chivers et al., "'There's a Reason We're Here': Performative Autobiographics and Age Identity in Performer-Created Intergenerational Theatre," in *Alive and Kicking at All Ages: Cultural Constructions of Health and Life Course Identity*, ed. Ulla Kriebernegg, Roberta Maierhofer, and Barbara Ratzenbock (Bielefeld, Ger.: Transcript, 2014), 153–68.
17. For more on this line of thinking, see Michael Soto, *The Modernist Nation: Generation, Renaissance, and Twentieth-Century American Literature* (Tuscaloosa: University of Alabama Press, 2004).
18. Howard P. Chudacoff, *How Old Are You? Age Consciousness in American Culture* (Princeton, N.J.: Princeton University Press, 1989), 181.
19. Maggie Kuhn (with Christina Long and Laura Quinn), *No Stone Unturned: The Life and Times of Maggie Kuhn* (New York: Ballantine, 1991), 209. See also Carroll B. Estes with Nicholas B. DiCarlo, "Intergenerational Intersubjectivity," in *Aging A–Z: Concepts Toward Emancipatory Gerontology* (New York: Routledge, 2019), 187; and Robert M. Venderbeck and Nancy Worth, eds., *Intergenerational Space* (New York: Routledge, 2015).
20. Locke, "The Negro," 6.
21. Hartman, *Wayward Lives*, 228.
22. Joan Nestle, "'I Lift My Eyes to the Hill': The Life of Mabel Hampton as Told by a White Woman," in *A Fragile Union: New and Selected Writings* (San Francisco: Cleis, 1998), 24.
23. Joan Nestle, "The Mabel Hampton Tapes," February 25, 1999, box 1, MHSC. Other than those already mentioned, complementary biographies of Hampton by Nestle include

"Mabel Hampton," in *Lesbian Histories and Cultures: An Encyclopedia*, ed. Bonnie Zimmerman (New York: Garland, 2000), 351–52; "Mabel Hampton (1902–1989)," in *The Persistent Desire: A Femme-Butch Reader*, ed. Nestle (Boston: Alyson, 1992), 43–44; and *Don't Stop Talking 2* (blog), October 27–29, 2011, http://joannestle2.blogspot.com/2011/10/in-memory-on-october-26-i-lift-my-eyes.html. See also Hugh Ryan, *When Brooklyn Was Queer* (New York: St. Martin's, 2019).

24. Joan Nestle, "Radical Archiving: A Lesbian Feminist Perspective," *Gay Insurgent: A Gay Left Journal* 4–5 (1979): 11. See also Polly J. Thistlethwaite, "Building 'A Home of Our Own': The Construction of the Lesbian Herstory Archives," in *Daring to Find Our Names: The Search for Lesbigay Library History*, ed. James V. Carmichael Jr. (Westport, Conn.: Greenwood, 1998), 153–74; Ann Cvetkovich, *An Archive of Feelings: Trauma, Sexuality, and Lesbian Public Cultures* (Durham, N.C.: Duke University Press, 2003), 251–53; and Joan Nestle, "Who Were We to Do Such a Thing? Grassroots Necessities, Grassroots Dreaming: The LHA in Its Early Years," *Radical History Review* 122 (2015): 233–42.

25. Sahli Cavallaro et al., "Statement of Purpose," *Lesbian Herstory Archives Newsletter* 1 (1975): 2. For an extended overview of this newsletter, see Cait McKinney, *Information Activism: A Queer History of Lesbian Media Technologies* (Durham, N.C.: Duke University Press, 2020).

26. Joan Nestle et al., note, *Lesbian Herstory Archives Newsletter* 3 (1976): 1.

27. Nestle, "Radical Archiving," 11.

28. Sahli Cavallaro et al., "Research Projects," *Lesbian Herstory Archives Newsletter* 1 (1975): 7.

29. Joan Nestle, "About the Archives: One Woman's View," *Lesbian Herstory Archives Newsletter* 5 (1979): n.p.; Thistlethwaite, "Building 'A Home of Our Own,'" 161.

30. Mabel Hampton, interview by Joan Nestle, May 21, 1981, transcript, box 7, MHSC.

31. Bruce Rodgers, *Gay Talk: A (Sometimes Outrageous) Dictionary of Gay Slang* (1972; New York: Paragon, 1979), 42. See also John Howard, introduction to *Carryin' On in the Lesbian and Gay South*, ed. John Howard (New York: New York University Press, 1997), 1–14.

32. Joan Nestle, "Surviving and More: An Interview with Mabel Hampton," *Sinister Wisdom* 10 (1979): 22. Hereafter cited parenthetically in this chapter with an abbreviated S.

33. Joan Nestle, "'I Lift My Eyes to the Hill,'" 23.

34. For the original draft, see Mabel Hampton, interview by Joan Nestle and Deborah Edel, n.d., transcript, box 7, MHSC.

35. Susan Leigh Star, "Introduction: Notes for a Magazine," *Sinister Wisdom* 10 (1979): 7. Hereafter cited parenthetically in this chapter with an abbreviated I.

36. Joanna Russ, *The Female Man* (New York: Bantam, 1975), 70.

37. Kathleen Woodward, *Statistical Panic: Cultural Politics and Poetics of the Emotions* (Durham, N.C.: Duke University Press, 2009), 75. See also Margaret Morganroth Gullette, "Wisdom and/or Dementia: Is This the Choice American Society Is Mired In?," *Interpretation* 68, no. 4 (2014): 122–35.

38. SAGE Speakers Bureau promotional flyer, n.d., Archives of Sexuality and Gender (website), accessed March 28, 2020.

39. Sari Edelstein, *Adulthood and Other Fictions: American Literature and the Unmaking of Age* (New York: Oxford University Press, 2019), 66. See also Habiba Ibrahim, *Black Age: Oceanic Lifespans and the Time of Black Life* (New York: New York University Press, 2021).

40. For more on the history of Black gerontology in the United States, see Leslie J. Pollard, *Complaint to the Lord: Historical Perspectives on the African American Elderly* (Selinsgrove, Pa.: Susquehanna University Press, 1996); Jacquelyne Johnson Jackson, "Negro Aged: Toward Needed Research in Social Gerontology," *Gerontologist* 11, no. 1 (1971): 52–57; and James S. Jackson, Linda M. Chatters, and Robert Joseph Taylor, eds., *Aging in Black America* (Newbury Park, Calif.: SAGE, 1993). Subsequent iterations of apposite thinking within these critical Black aging studies can be found in Katherine S. Newman, *A Different Shade of Gray: Midlife and Beyond in the Inner City* (New York: Free Press, 2003); Corey M. Abramson, *The End Game: How Inequality Shapes Our Final Years* (Cambridge, Mass.: Harvard University Press, 2015); Margaret Morganroth Gullette, *Agewise: Fighting the New Ageism in America* (Chicago: University of Chicago Press, 2011), 74–75; and Mary Poole, *The Segregated Origins of Social Security: African Americans and the Welfare State* (Chapel Hill: University of North Carolina Press, 2006).
41. National Urban League, *Double Jeopardy: The Older Negro in America Today* (New York: National Urban League, 1964), 1.
42. Edelstein, *Adulthood and Other Fictions*, 62.
43. Sonny Wainwright, "On the Occasion of Her 78th Birthday—To Mabel Hampton," box 1, folder 28, MHSC.
44. Joan Nestle, "The Bodies I Have Lived With: Keynote for 18th Lesbian Lives Conference, Brighton, England, 2011," *Journal of Lesbian Studies* 17, no. 3–4 (2013): 218.
45. See Anne Elizabeth Carroll, *Word, Image, and the New Negro* (Bloomington: Indiana University Press, 2005); Cherene Sherrard-Johnson, *Portraits of the New Negro Woman: Visual and Literary Culture in the Harlem Renaissance* (New Brunswick, N.J.: Rutgers University Press, 2007); Martha Jane Nadell, *Enter the New Negroes: Images of Race in American Culture* (Cambridge, Mass.: Harvard University Press, 2004); Phoebe Wolfskill, *Archibald Motley Jr. and Racial Reinvention: The Old Negro in New Negro Art* (Urbana: University of Illinois Press, 2017); *Rhapsodies in Black: Art of the Harlem Renaissance*, ed. Joanna Skipwith (Berkeley: University of California Press, 1997); and Emilie Boone, "Reproducing the New Negro: James Van Der Zee's Photographic Vision in Newsprint," *American Art* 34, no. 2 (2020): 4–25. For more on modern African American visuality in general, see Sara Blair, *Harlem Crossroads: Black Writers and the Photograph in the Twentieth Century* (Princeton, N.J.: Princeton University Press, 2007).
46. Deborah Edel, Valerie Itnyre, and Joan Nestle, "Announcing the Start of Our National Lesbian Photography Drive," *Lesbian Herstory Archives Newsletter* 5 (1979): 4.
47. Joan Nestle, "Lesbian Images Pre 1970," *Lesbian Herstory Archives Newsletter* 6 (1980): 4.
48. JEB (Joan E. Biren), "Lesbian Photography—Seeing Through Our Own Eyes," *Studies in Visual Communication* 9, no. 2 (1983): 81. See box 52, binder 3, sheets 2118 and 2119, Joan E. Biren Papers, Sophia Smith Collection of Women's History, Smith College, Northampton, Mass.
49. For more, see Nestle, "'I Lift My Eyes to the Hill,'" who situates Hampton in "the time of generational loss" and finds that her "deepest history lies in the middle passage of the Triangular Slave Trade" (29).
50. JEB, "Lesbian Photography," 81.
51. See Judith Schwarz, "Lesbian Photography," in Joan E. Biren (JEB), *Eye to Eye: Portraits of Lesbians* (Washington, D.C.: Glad Hag Books, 1979), 7–11.

52. *Double Jeopardy*, 14.
53. *Not Just Passing Through*, directed by Jean Carlomusto, Dolores Pérez, Catherine Saalfield, and Polly Thistlethwaite (New York: Not Just Passing Through Productions, 1994).
54. JEB, "Lesbian Photography," 81.
55. Richard J. Powell, *Cutting a Figure: Fashioning Black Portraiture* (Chicago: University of Chicago Press, 2008), 7.
56. Zora Neale Hurston, "Characteristics of Negro Expression," in *Negro: An Anthology*, ed. Nancy Cunard (London: Wishart, 1934), 39; Mabel Hampton, interview by Joan Nestle, n.d., transcript, box 1, MHSC. For more on Hurston and African American self-performance, see Daphne A. Brooks, *Liner Notes for the Revolution: The Intellectual Life of Black Feminist Sound* (Cambridge, Mass.: Belknap Press of Harvard University Press, 2021), 125–60.
57. Mabel Hampton, interview by Joan Nestle, n.d., transcript, box 1, MHSC.
58. Mabel Hampton, interview by Joan Nestle and Deborah Edel, July 1986, transcript, box 1, MHSC.
59. Hampton, interview by Nestle and Edel, July 1986.
60. Hartman, *Wayward Lives*, 337.
61. Hampton, interview by Nestle and Edel, July 1986. In this same interview Hampton recalls, "So, then, The Garden of Joy—she appeared there. I appeared there with her."
62. Nestle, "Radical Archiving," 10.
63. Deborah Edel, Joan Nestle, et al., "About Our Cover," *Lesbian Herstory Archives Newsletter* 6 (1980): 26.
64. *Before Stonewall*, directed by Greta Schiller and Robert Rosenberg (New York: First Run Features, 1984).
65. Paula Rabinowitz, *American Pulp: How Paperbacks Brought Modernism to Main Street* (Princeton, N.J.: Princeton University Press, 2014), 25.
66. Thistlethwaite, "Building 'A Home of Our Own,'" 161.
67. Andrea Weiss and Greta Schiller, *Before Stonewall: The Making of a Gay and Lesbian Community* (Tallahassee, Fla.: Naiad, 1988), 26.
68. See Garber's files on Mabel Hampton in series 2, carton 1, folder 11 and series 2, carton 2, folder 3, Eric Garber Papers, GLBT Historical Society, San Francisco.
69. Eric Garber, "Tain't Nobody's Business: Homosexuality in Harlem in the 1920s," *Advocate*, May 13, 1982, 39, 42. Hereafter parenthetically cited in this chapter with an abbreviated T.
70. In his preface to a later edition of *When Harlem Was in Vogue* (New York: Penguin, 1997), xxii, Levering Lewis notes "the limitations of my rather too implicit discussion of gay and lesbian affections."
71. Joan Nestle, personal email to author, June 16, 2020. Deborah Edel likewise recalled that "Joan was going to do an interview with Mabel and share that information with Eric. It is not inaccurate or a distortion for him to say that" (personal email to author, June 17, 2020). Garber himself also informed one New York-based interviewer that "I sort of wanted to come out here and see . . . what connections I could make with women and men who had been in gay Harlem during the '20s." Charles Michael Smith,

6. The Harlem Renaissance 249

"Recalling the Renaissance: Eric Garber and the History of Harlem," *New York Native*, August 29–September 11, 1983, 35.

72. Susan Stryker, "From the Editor," *Our Stories: The Newsletter of the Gay and Lesbian Historical Society of Northern California* 11, no. 1 (1996): 3.

73. See Eric Garber, "T'Ain't Nobody's Bizness (Homosexuality in 1920's Harlem)," in *Black Men/White Men: Afro-American Gay Life and Culture*, ed. Michael J. Smith (San Francisco: Gay Sunshine, 1983), 7–16; and Garber, "Spectacle in Color."

74. Garber, "Spectacle in Color," 318.

75. Nestle, "Radical Archiving," 11.

76. See "Bronx Center for Aged Marks 40 Years," *New York Times*, October 14, 1984, 58; and Debra Shollenberger, ed., *Senior Centers in America: A Blueprint for the Future* (Washington, D.C.: National Council on the Aging and National Eldercare Institute on Multipurpose Senior Centers and Community Focal Points, 1995). For a brief history of SAGE, see Lauren Jae Gutterman, "'Caring for Our Own': The Founding of Senior Action in a Gay Environment, 1977–1985," *Radical History Review* 139 (2021): 178–99.

77. SAGE Oral History Project Statement of Purpose, n.d., Archives of Sexuality and Gender (website), accessed June 9, 2020.

78. "Suggested Questions for Doing Gay Oral History Tapes," comp. Joan Nestle, New York Oral History Project, and SAGE Oral History Project, February 1983, Archives of Sexuality and Gender (website).

79. Elizabeth Ferris, "A Tour of Gay Harlem by Night: T'Aint Nobody's Business," *Connection*, May 9–30, 1984, 22.

80. Ferris, 22.

81. Nestle, "'I Lift My Eyes to the Hill,'" 46–47, 23.

82. Mabel Hampton, "Gay Pride Speech," June 1984, box 2, folder 12, MHSC.

83. My thanks to Cheryl Clarke for confirming this event and for filling out its details in an email exchange on July 26, 2021.

84. Jewelle Gomez, "Embracing the Dark," *Our Stories: The Newsletter of the Gay and Lesbian Historical Society of Northern California* 11, no. 1 (1996): 4.

85. Cheryl Clarke, "An Epitaph," *Experimental Love* (Ithaca, N.Y.: Cleis, 1993), 54.

86. Henry Louis Gates Jr., "The Black Man's Burden," in *Fear of a Queer Planet: Queer Politics and Social Theory*, ed. Michael Warner (Minneapolis: University of Minnesota Press, 1993), 233. Gates also published a version of this essay that same year entitled "Looking for Modernism," in *Black American Cinema*, ed. Manthia Diawara (New York: Routledge, 1993), 200–207.

87. Porter Grainger and Everett Robbins, "'Tain't Nobody's Business If I Do," in *From My People: 400 Years of African American Folklore*, ed. Daryl Cumber Dance (1922; New York: Norton, 2002), 123–24.

88. Shane Vogel, "The Sensuous Harlem Renaissance: Sexuality and Queer Culture," in *A Companion to the Harlem Renaissance*, ed. Cherene Sherrard-Johnson (West Sussex, UK: Wiley-Blackwell, 2015), 280. See also Henry Louis Gates Jr., "Harlem on Our Minds," in Skipwith, *Rhapsodies in Black*, 160–67; and Kara Keeling, *Queer Times, Black Futures* (New York: New York University Press, 2019).

89. Langston Hughes, *The Big Sea* (1940; New York: Hill and Wang, 1993), 273–74.

250 6. The Harlem Renaissance

90. George Chauncey finds that "the gay element became prominent only in the 1920s, perhaps after a new group of organizers within the lodge took charge of the ball in 1923." Chauncey, *Gay New York: Gender, Urban Culture, and the Making of the Gay Male World, 1890–1940* (New York: Basic Books, 1994), 257.
91. Hampton, interview by Nestle, n.d., transcript, box 1, MHSC.
92. Hartman, *Wayward Lives*, 323.
93. Craig G. Harris, "The NCBLG Family Gathers," *Black/Out* 1, no. 1 (1986): 11. For more on this magazine, see Darius Bost, *Evidence of Being: The Black Gay Cultural Renaissance and the Politics of Violence* (Chicago: University of Chicago Press, 2019), 54-55.
94. Nestle, "Excerpts," 926.
95. Estes with DiCarlo, *Aging A–Z*.
96. Kate Rushin, "Mabel Hampton: 'Cracking Open the Door,'" *Sojourner* 13, no. 12 (1988): 21.

CODA

1. Megan Gambino, "Art as Therapy: How to Age Creatively," *Smithsonian*, November 7, 2012, https://smithsonianmag.com/science-nature/art-as-therapy-how-to-age-creatively-112109631/. See also Brooke Rosenblatt, "Museum Education and Art Therapy: Promoting Wellness in Older Adults," *Journal of Museum Education* 39, no. 3 (2014): 293-301.
2. "Creative Aging," Phillips Collection (website), https://phillipscollection.org/event/2019-10-12-creative-aging.
3. Jacob Lawrence, panel 26 caption of *The Migration Series*, 1941, Museum of Modern Art, New York.
4. "Creative Aging"; their emphasis.
5. Glenn Fowler, "Marjorie Acker Phillips Dies; Co-Founder of Art Collection," *New York Times*, June 21, 1985.
6. Duncan Phillips, "A Statement of My Wish for the Future of The Phillips Collection," quoted in *Duncan Phillips and His Collection*, by Marjorie Phillips (Boston: Atlantic Monthly Press, 1970), 305.
7. Lowery Stokes Sims, "The Structure of Narrative: Form and Content in Jacob Lawrence's Builders Paintings, 1946-1998," in *Over the Line: The Art and Life of Jacob Lawrence*, ed. Peter T. Nesbett and Michelle DuBois (Seattle: University of Washington Press, 2000), 214.
8. See Gay Powell Hanna, Linda S. Noelker, and Beth Bienvenu, "The Arts, Health, and Aging in America: 2005-2015," *Gerontologist* 55, no. 2 (2015): 271-77.
9. "Adult Day Health Services," Iona Senior Services (website), accessed September 5, 2020, iona.org/services/adult-day-health-services/.
10. Alain Locke, "The Negro in the Arts," in *The Critical Temper of Alain Locke: A Selection of His Essays on Art and Culture*, ed. Jeffrey C. Stewart (1953; New York: Garland, 1983), 474.
11. *Oxford English Dictionary*, s.v. "succession," accessed July 23, 2021, oed.com.
12. Jeremy Braddock, *Collecting as Modernist Practice* (Baltimore: Johns Hopkins University Press, 2012), 213.
13. Janet Lyon, "Gender and Sexuality," in *The Cambridge Companion to American Modernism*, ed. Walter Kalaidjian (New York: Cambridge University Press, 2005), 239.

Index

Abbott, Berenice, 187
Activities of daily living (ADLs), 162
Adams, Rachel, 111
ADLs. *See* Activities of daily living
Adorno, Theodor W., 35
Advocate (publication), 68, 192, *193*, 194-95
African Americans, 176, 181, 188, 202-3, 245n16; age norms for, 14-15, 173-74
Afro-modernism, 2, 19-20, 177, 191-92, 195, 199
Age consciousness, 163-64, 189, 206; of T. Olsen, 110-11, 119, 121-24, 129, 131, 133
Age ideology, 8, 12, 43, 60, 105-6. *See also* Decline ideology
Ageism, 2, 5, 8, 72, 109, 185; gay men and, 61, 150-51; Gray Panthers fighting against, 8, 14, 107-8, 136, 160-61, 177, 231n15; Gullette on, 9, 82, 105; misogynist, 3, 95; *Not Just Passing Through* on, 189-90; race and, 173-74, 176, 181-82. *See also* Gerontophobia
Age norms, 8, 12, 13, 89, 101-2, 215n66; African Americans and, 14-15, 173-74
Age segregation, 177
Age studies, critical, 7-8, 26, 70-71, 82, 206
Age theories, 8-10, 57, 59, 62-63, 68, 70
Aging, 72-73, 163-64, 180; Albright on, 81-83, 92-93, 98, 100-2, 104; Barnes on, 48; Black, 8, 181-82, 188; conscious, 27-28, 43, 110; creative, 1-5, 10-11, 123, 125, 139, 199, 202-7; C. Ford on, 147-51;

frailty and, 11, 125, 138, 140, 200, 208; gender and, 3, 46, 83, 95; Hampton on, 180-82; T. Olsen on, 110-11, 123-26, 129 30; Steward on, 58, 68-69. *See also* Experimental aging
Aging and Its Discontents (Woodward), 8
Aging in place, 1, 139, 154, 236n8
Albright, Ivan, 12, 17-18, 79, *103*; on aging, 81-83, 92-93, 98, 100-2, 104; Chicago modernism of, 80-81, 89, 94; decline narratives and, 81, 89, 91, 97, 101; in exhibitions, 78, 80; health of, 10, 104; magic realism, 1-2, 80-81, 89, 94-97, 100, 102, 125, 229n54; poetry by, 81, 90-93, 95, 105; rural modernism of, 97, 101-2; skinscapes by, 78, 80, 83, 85, 92-97, 100; watercolors by, 78, 91, 104, 105. *See* Portrait paintings by Albright
Alice B. Toklas Cook Book, The (Toklas), 56, 66
Alzheimer's disease, 1, 111
American Medicine (journal), 87
American modernism, 1-2, 80, 207; built environment and, 139; new modernist studies of, 3, 9, 11, 18, 94, 175; of T. Olsen, 109, 140; queer, 5, 50, 75, 139-40, 156, 162, 168; timeline of, 5-9, 211n23
American Moderns (Stansell), 9
American People Series #20: Die, 19
American Quarterly (journal), 151
Americans 1943 (exhibition), 94, *95*, 105
Ancients and the Postmoderns, The (Jameson), 6

Andersen, Scott, 73-75, 225n51
Antiaging culture/industry, 2-3, 85-89, 94-95
Anti-antiaging, 95-97, 104
Antiphon, The (Barnes), 23, 27, 45
Appreciation, 18-19
Archives, 2, 15, 17, 109, 110-13; categorization of, 29, 219n45; compensation for work in, 28-29; of geromodernity, 13-18; modernism and, 16-18; of I. Tamang, 168, 170, 172. *See also specific archives*
Armstrong, Louis, 156
Art Institute of Chicago, 78, 82, 92, 104-5
Art of Today, Chicago, 1933 (Jacobson), 89, 92
Assisted living, 124, 138, 140, 159, 168
Atherton, Gertrude, 88
At Last, the Real Distinguished Thing (Woodward), 8
Atwood, Kenneth Harper, 97, 98-99, 100-2, 230n74
"Auntie" (slang), 61-62, 70-71, 73-74
Autobiography of Alice B. Toklas, The (Stein), 56, 71
Autobiography of William Carlos Williams, The, 4, 39
Automatic writing, 146-47, 155-56, 238n29
Autotopography, 40
Avant-gardism, 51, 54, 56, 59-60, 63-64, 73; of Barnes, 22, 24, 26-27, 34, 40-41, 43, 45; of C. Ford, influenced by, 146; T. Olsen, influenced by, 119

Barnes, Djuna, 147-48, 149; avant-gardism of, 22, 24, 26-27, 34, 40-41, 43, 45; correspondences by, 27-28, 39, 47; debilities experienced by, 2, 10, 47, 49; on editors/editorial control, 24, 26-27, 34-35, 45; grocery lists by, 9, 25, 36, 38, 39-41, 43; handwritten documents by, 29, 30, 31, 36, 38; high modernism of, 2, 22, 24, 34-35, 67, 139; hoarding by, 25, 28; marginalia by, 24, 30, 31, 38, 40; pharmacy orders by, 25, 36, 37, 40-41, p2; published works by, 23, 26-28, 40, 47; reclusive characterizations of, 22-23, 49; revised works by, 24, 29, 30, 31, 32-33, 34-36, 37-38, 46, 219n45; unfinished works by, 29, 34, 41, 45, 47; unpublished works by, 23-25, 28-29, 34-35, 40-41, 44. *See also* Djuna Barnes Papers, University of Maryland Libraries; Draft works by Barnes; Poetry by Barnes; Typescripts by Barnes; *specific works*
Barnes Foundation, 57
Barney, Natalie, 22, 149
Barr, Alfred H., Jr., 94, 139-40
Barracoon (Hurston), 174
Basting, Anne, 172
"Bathtub Haiku" (C. Ford), 141
Baudelaire, Charles, 121, 126-27, 159
Bay, Jesse Olsen, 111, 232n18
Beam, Joseph, 200
Beare, Robert L., 28
Beckett, Samuel, 8
Bee Time Vine and Other Pieces (Stein), 71
Before Stonewall (documentary), 191
Beinecke Rare Book and Manuscript Library, Yale University, 2, 28-29, 75; Charles Henri Ford Papers at, 13, 139, 141-43, 153, 159, 162; James Weldon Johnson Memorial Collection, 199; Samuel Steward Papers at, 50, 56, 75
Beloit Poetry Journal, 7
Benjamin, Walter, 120
Bennett, Gwendolyn, 173
Benstock, Shari, 4, 7, 47
Bentley, Gladys, 175, 188-89, 200
Berman, Jessica, 158
Big Sea, The (Hughes), 199-200
Bilignin, France, 50, 67, 72
Birthdates/birth documents, 15, 16, 17
Birthday cards, 162-64, *164*, 206
Bisexual, Lesbian, and Gay Alliance, Rutgers University-New Brunswick, 198
Black aging, 8, 181-82, 188
Black Men/White Men (Smith), 195
Black modernism, queer, 185, 189
Black/Out (journal), 200
Black Oxen (Atherton), 88
Blood on the Dining-Room Floor (Stein), 63-64

Blue Room, The, 202
Blues (magazine), 13, 138, 151, 156, *157*, 158
Bollas, Christopher, 222n10
Book of Repulsive Women, The (Barnes), 40, 47, 220n48
Boone, Joseph Allen, 148, 153
Bourgeois, Louise, 81
Boyle, Kay, 5, 18-19
Braddock, Jeremy, 57, 206
Breton, André, 55, 138, 142-43, 146, 148, 149, 166
Broe, Mary Lynn, 23
Bronstein, Michaela, 6
Bronx, New York, 2, 49, 177-78, 185, 196, 206
Brooklyn Museum, 9
"Brumes et pluies" (Baudelaire), 127
Buchanan, Beverly, 202
Butler, Robert N., 8, 14, 48-49, 119-21, 149

Cadmus, Paul, 81, 148-49
California: Berkeley, 2, 9, 55-57, 206; San Francisco, 51, 72-73, 107-8, 136
Cane (Toomer), 179
Capitalism, 115, 130
Caravaggio Shawl, The (Steward), 5, 50, 63, 68-69, 70-72, 73, 77
Caregiving by I. Tamang, 1, 11, 14, 140-42, 154-55, 159-60, 162; of archives, 168, 170, 172
Caregiving/caregivers, 14, 140, 178
Carson, Johnny, 8
Cartier-Bresson, Henri, 168
Caselli, Daniela, 25, 46, 47
Cather, Willa, 8, 90
Caws, Mary Ann, 151
Center for Independence of the Disabled, New York (CIDNY), 14
Chapters from an Autobiography (Steward), 59-60, 62, 73-74
"Charles Henri Ford Experience, The," 142, 147-48, 172
Charles Henri Ford Papers: Beinecke Rare Book and Manuscript Library, 13, 139, 141-43, 153, 159, 162; Getty Research Institute, 2, 139, 143, 153, 162-65

"Charles Henri Ford Was There" (Dowell), 150, 170
Charmed Circle (Mellow), 70
Chauncey, George, 138, 140, 250n90
Chénetier, Marc, 219n9
Cheng, Anne Anlin, 82-83
Chicago, Illinois, 50-51, 55, 89
Chicago modernism, 2, 89, 103, 228n14; of Albright, 80-81, 89, 94
Chicago Tribune (newspaper), 78
Chronicle of Higher Education (newspaper), 3
Chudacoff, Howard P., 13, 163, 177
CIDNY. *See* Center for Independence of the Disabled, New York
Citations. *See* References
Clarke, Cheryl, 198-99
Cloutier, Jean-Christophe, 16-17
C. O. Bigelow Chemists, 25, 36, *37*, *p2*
Cohen, Ira, 143
Coiner, Constance, 109
Coleman, Emily, 27
Collaboration between C. Ford and I. Tamang, 19, 137, 139-40, 143, 152, 154-55, 168; collages as, 17, 142, 156, *157*, 158-60, *161*, 162, 172. *See also* Caregiving by I. Tamang
Collages, 155, *163-67*, *164-66*, 168, *171*; C. Ford and I. Tamang collaborating on, 17, 142, 156, *157*, 158-60, *161*, 162, 172
Collected Poems (Barnes), 24, 28, 40
Collected Poems, 1909-1935 (Eliot), 46
Collecting as Modernist Practice (Braddock), 57
"Coming Out Story" (Hampton), 192, 198
Coming to That (Tanning), 148
Conscious aging, 27-28, 43, 110
Corn, Wanda M., 9
Cornell, Joseph, 148
Corners, George F. (penname), 86
Correspondences, 1, 13; by Barnes, 27-28, 39, 47; by Hampton, 177; by T. Olsen, 118, 124-25, 131; by Steward, 10, 50, 57, 66-67
Cosmeticology, 86-88
COVID-19 pandemic, 6, 14, 202
Cowley, Malcolm, 4
Cozzolino, Robert, 81-82, 89-90, 102

Creative aging, 1–5, 10–11, 123, 125, 139, 199, 202–7
Creative Aging (exhibition), 202–5
Creatures in an Alphabet (Barnes), 23, 36
Critical age studies, 7–8, 26, 70–71, 82, 206
"Crones" (slang), 69–70
Cross-generational relationships, 53, 73, 114, 152, 155, 160, 176–79, 192
Cullen, Countée, 173
Cummings, E. E., 22, 48, 149
Curry, John Steuart, 101

Dakota, the (apartment), 1, 137–42, 147, 152, 156, 158, 162, 168, *171*
Daughter of Earth (Smedley), 122
Davis, Rebecca Harding, 128
Dawson, Melanie, 9
Day planners by C. Ford, 2, 141, *141*, 155, 206
Dear Sammy (Steward), 50, 53, 66–67, 71, 74
Deaths, 4, 105, 108, 126–27, 148–49, 170; of Albright, 96, 104; of Barnes, 22, 25; of C. Ford, 150, 155, 159; of Hampton, 175, 189–90; of T. Olsen, 107; of Stein, 50; of Steward, 53, 75; of Toklas, 68
Debilities, 8, 11, 73, 188; experienced by Albright, 10, 104; experienced by Barnes, 2, 10, 40–41, 47, 49; experienced by C. Ford, 140–41, 147, 152, 159; experienced by Hampton, 178, 188; experienced by T. Olsen, 111, 124–25, 128–30, 133; experienced by Steward, 72, 77. *See also* Disability/disabilities
Decline ideology, 8–9, 62, 82, 91, 206
Decline narratives, 102; Albright experimenting with, 81, 89, 91, 97, 101; Barnes and, 26–28, 46, 49; T. Olsen, countering, 108, 125; about Steward, 53–54, 60, 62
DeFalco, Amelia, 120
Denning, Michael, 110, 112
DePaul University, 65–66, 71, 195
"Dereliction" (Barnes, typescript), 29, *30*, *31*, *33*, 40, 46
Der Kreis / Le Cercle / The Circle (magazine), 58, 59

"Detachment" (Steward), 58–62, 64, 68, 150
"Detective Story, A" (Steward), 67–68, 69
Dickens, Charles, 189
Dickinson, Emily, 124
Dilemma of an Aging Population, The, 203
Dillon, George, 127
Disability/disabilities, 7, 10, 204–5; late-onset, 11–12, 104, 125, 129, 206, 213n49. *See also* Debilities
Disability studies, modernist, 11, 213n49
Djuna (A. Field), 22
Djuna Barnes Papers, University of Maryland Libraries, 2, 24, 28–29, 31, 41, 207, 219n40
Doctorow, E. L., 110
Domesticity, queer, 55, 57, 138
Doolittle, Hilda, 4
Double jeopardy, 8, 181–82, 185, 206
Double standard of aging, 3
Douglas, Aaron, 183
Douglas, Alfred, 51, 74–75
Doyle, Laura, 158
Draft works by Barnes, 1, 25–28, *32–33*, *34–35*, *37–38*, 41; "Dereliction" as, 29, *30*, *31*, *34*, 40, 46; "Pavan" as, *42*, *43–45*
Draft works by Olsen, 108–9, 111, 113, 130–31, *132*
Du Bois, W. E. B., 14, 173, 174
Duchamp, Marcel, 165–66
Duffy, Enda, 116

Edel, Deborah, 190
Edelstein, Sari, 7, 57, 181–82
Editors/editorial control, 117–18, 139–40, 174–75; Barnes and, 24, 26–27, 34–35, 45
"Editor's Note" (*Yonnondio*, 1994 edition), 117–18
Edmunds, Susan, 109
Edwards, Julie Olsen, 117
Efforts for Social Betterment Among Negro Americans (Du Bois), 14
Elderscapes, modernist, 1, 43, 77, 139, 204, 207–8
Eliot, T. S., 6, 7, 27, 45–46, 109

Ellison, Ralph, 16
Ellmann, Maud, 83
Emerson, Ralph Waldo, 124
Emerson College, 115-17
Enfant Terrible at 80 (documentary), 81
Entry-into-decline narratives, 60, 77, 223n23
"Epitaph, An" (Clarke), 198
Everybody's Autobiography (Stein), 66-67, 170
Experimental aging, 2, 6, 9-10, 12, 19; of Albright, 102, 104; of Barnes, 24, 35, 49; of C. Ford, 139-40, 154; of Hampton, 198-99; at Iona Senior Services, 205; of T. Olsen, 110-11, 123; of Steward, 61, 68, 75, 77; of I. Tamang, 164-66, 168
Experimental Love (Clarke), 198
Ex-Slave with Long Memory, Alabama, 187
Eye to Eye (JEB), 185, 187-88, 191

"Face stretchers" (slang), 95
"Fall-out over Heaven" (Barnes), 23
Fauset, Arthur Huff, 174
Female Man, The (Russ), 181
Feminism/feminists, 4, 16-17, 18, 26, 48, 89, 181; class consciousness, 110, 133; of proletarian modernism, 2, 108-9; second-wave, 114-15, 189
Feminist Press, The, 122
Festschrift for Djuna Barnes on Her 80th Birthday, A (Gildzen), 28
Field, Andrew, 22, 27
Field, Corinne T., 15
Finnegans Wake (Joyce), 34
Fire!! (magazine), 174, 195
Fitzgerald, F. Scott, 14
Flanner, Janet, 187
Flapperdames, 83, 85, 226n18
Flesh, 80, 82-83, 91, 96-97, 100, 104, 226n20. See also Skin
Flesh, 83, 84, 85, 87, 88-89, p2
Flesh (exhibition), 78, 105
Flowers of Evil / Les Fleurs du mal (Baudelaire), 127
Food and Drug Administration, U.S., 88
Ford, Charles Henri, 40, *154*, 163, 190, 206; on aging, 147-51; automatic writing by, 146-47, 155-56, 238n29; *Blues* (magazine) edited by, 13, 138, 151, 156, *157*, 158; debilities experienced by, 140-41, 147, 152, 159; experimental aging of, 139-40, 154; Medicare documents of, 13-14; Orientalizing by, 18, 139, 152-54; queer modernism of, 5, 139-40, 156, 162, 168; references used by, 142-44, 146, 148-50, 160; unpublished works by, 141-43, 152-53; U.S. surrealism of, 1, 10, 142, 146-48, 155-56, 159-60, 238n33; *View* (magazine) edited by, 5, 13, 138, 142, 150. See also Charles Henri Ford Papers; Collaboration between C. Ford and I. Tamang; Haikus by C. Ford; Operation Minotaur (OM); specific works
Ford, Ruth, 137, 143, 168, 170
Fortune (magazine), 203
Foster, Lillian B., 15, 177-78
Foucault, Michel, 11-12, 48-49
Fountain, The (O'Neill), 88
Four Quartets (Eliot), 6, 45-46
Fragilization, 140-41, 148, 206; Woodward definition of, 11, 124
Fragments, writing, 31, 32; by T. Olsen, 109, 113, 117, 120-23, 126-31, *132*, p4. See also Draft works
Freud, Sigmund, 88
Friedman, Susan Stanford, 11-12, 112
Fuchs, Miriam, 27
Furies, The (collective), 185

"Galerie Religieuse" (Barnes), 23
Gallup, Donald, 28-29, 65
Garber, Eric, 192, *193*, 194-96, *197*, 199, 200-1, 248n71
Gates, Henry Louis, Jr., 173-74, 198
Gay and Lesbian Review, 150, 170
Gay Insurgent (journal), 178
Gay Liberation movement, 62, 150
Gay men, 53, 73, 160, 175, 190, 192, 194-95, 248n71; ageism and, 61, 150-51; subcultures, 58-59, 61-62, 139-40, 149-50
Gay New York (Chauncey), 138
Gay Sunshine (publication), 153

Gender, 1, 9, 16, 89, 188–89, 245n14; aging and, 3, 46, 83, 95; power dynamics and, 26–27
Georgia O'Keeffe: Living Modern (exhibit), 9, 39
Geromodernism, 5, 13, 61, 120–21, 156, 158–59, 207; of C. Ford, 140; queer, 12, 15
Geromodernity, U.S., 13–18; Albright and, 89, 96; LHA and, 15; Stein and, 61
"Gerontion" (Eliot), 45
Gerontology, 109, 119–20, 181, 201
Gerontophobia, 7, 12, 23, 45–46, 48, 85, 206; Albright responding to, 81–82, 101–2; C. Ford, confronting, 150–51; gay male, 57–58, 62; Hampton refuting, 180; T. Olsen, countering, 128; San Francisco, 72–73. *See also* Ageism
Getty Research Institute, Charles Henri Ford Papers in, 2, 139, 143, 153, 162–65
Giard, Robert, 51–52
Gilleard, Chris, 85, 86–87
Gilman, Sander L., 85–86
Gilmore, Ruth Wilson, 181
GLBT Historical Society, 74–75, 192
Glossop, Rudolph "Silas," 48
Glück, Louise, 138
Gnamat Design Studio, 143, *145*, 148
Gomez, Jewelle, 187, 189–90, *191*, 198–99
González, Jennifer A., 40
Grainger, Porter, 192
Grand Street (magazine), 23, 31
Gray Panthers, 7–8, 14, 107–8, 136, 160, 162, 177, 231n15
Great Depression, U.S., 108, 111–12, 114, 123, 176
Great Expectations (Dickens), 189
Great Recession (2007–2009), 6, 134
Great War. *See* World War I
Greenwich Village, 2, 22, 25, 27, 40, 44, 138
Gregory, Elizabeth, 9, 128
Grocery lists by Barnes, 9, 25, 36, *38*, 39–41, 43. *See also* pharmacy orders
Guggenheim, Peggy, 139–40
Gullette, Margaret Morganroth, 1, 7–8, 72–73, 88; on ageism, 9, 82, 105; on decline narratives, 26, 60; on modernism, 14; on old age imaginaries, 1; on rejuvenation, 85; on visual cultures, 81

"Haiku Autobiography" (C. Ford), 141–42, 147
Haikus by C. Ford, 2, 12, 139, 141, 143–44, 237n21; as surrealist, 146–51, 238n33
Hall, G. Stanley, 13, 16
Hall, Radclyffe, 191–92
Hamilton, Juan, 81
Hamilton Lodge Ball, 199–200
Hampton, Mabel, 2, 9, 14, 49, *184*, *186*, *187*, *190*, *193*; birthday uncertain for, 15, *16*; correspondences by, 177; debilities experienced by, 178, 188; intergenerationalism of, 175–77, 179–83, 198–99; as "lesbian elder," 175–77, 185, 189, 199; performances by, 1, 175–76, 189; SAGE and, 196–98; self-performances of, 175–76, 181, 182, 188, 191–92. *See also* Harlem Renaissance; Mabel Hampton Special Collection, LHA
Handwritten documents, 69; by Barnes, 29, *30*, 31, 36, *38*; by C. Ford, *141*, 141–42; by T. Olsen, 131, *132*, 134, *135*, 136
Hanna Holborn Gray Special Collections, University of Chicago, 104–5
Hardie, Melissa Jane, 26
Harlem, New York, 175, 179, 187, 191, 194–95, 199–200, 203
Harlem drag balls, 199–200
Harlem Renaissance, 2, 10, 156, 173–74, 195; queer, 174–76, 192, 194, 198–99
Harriet and the Promised Land (Lawrence, Kraus), 203
Hartman, Saidiya, 175–77, 188–89, 200
Health, 10, 11, 20–21, 72, 77, 104; antiaging and, 85–87; of C. Ford, 140–41, 147, 152, 159. *See also* Debilities
Heller, Scott, 3
Hells Angels Motorcycle Club, 51
Hemingway, Ernest, 71
"Hem of Manhattan, The" (Barnes), 42–43

Henry W. and Albert A. Berg Collection of English and American Literature, NYPL, 109
Hepburn, Katharine, 72
Hermitage (blog), 156, 168, 170, 241n78;
Herring, Phillip, 24, 31, 39
Hiemstra, Marvin R., 53
Higgs, Paul, 85, 86-87
High modernism, 2, 22, 24, 34-35, 67, 138, 139
History and Class Consciousness (Lukács), 115
"*History and Class Consciousness* as an 'Unfinished Project'" (Jameson), 114-15
HIV/AIDS crisis, 57-58, 77
Hoarders, The (Herring), 13
Hoelberg, Miranda, 134, 136
Holleran, Andrew, 53
Homophobia, 178, 181, 185
Hood Museum of Art, 97
Howard, Alexander, 148, 149
Hudson, Rock, 51
Hughes, Langston, 2, 5, 7, 173-74, 179, 199-200
Humphreys, Laud, 150
Hungerford, Amy, 3
Hurston, Zora Neale, 8, 15, 18, 88, 173-74, 188
Hutcheon, Linda, 12, 123
Hutcheon, Michael, 12, 123
Huxley, Aldous, 116

"If We Must Die" (McKay), 90
Illinois Dental Journal, 55-56, 60, 70
Immigration, 11, 17, 143, 153, 158, 166, 168, 241n78
Immigration and Nationality Act of 1965, U.S., 153
Indra's Cover for Blues 10, 156, 157, 158
Inequalities, 14, 26
Infants of the Spring (Thurman), 194
"In Flanders Fields" (McCrae), 90
Intergenerationalism, 2-3, 7-8, 75, 136, 163, 195; of Hampton, 175-77, 179-83, 198-99; of LHA mission, 178-79; of New Negro movement, 174-76; queer, 176-78, 180, 182-84, 198-99
International Male (magazine), 160
Interracial relationships, 174, 175-76, 178
Interwar modernism, 5, 80
Into the World There Came a Soul Called Ida, 82, 89, 92, 93, 94-95, p3
Iona Senior Services, 202-8, 207
"Iron Throat, The" (Olsen), 113, 123
"I Stand Here Ironing" (Olsen), 126

Jackson, Hobart C., 8, 181
Jackson, Jacquelyne Johnson, 8, 181
Jacobson, J. Z., 89
James, Henry, 124
Jameson, Fredric, 6, 67, 114-15, 136
James Weldon Johnson Memorial Collection, Beinecke Library, 199
Jarrell, Randall, 125
Jazz Age, 80, 83, 195
JEB (Joan E. Biren), 180, 185, 187-88, 189, 191
Jefferson Market, grocery lists for, 36, 38, 39-40
Joans, Ted, 158
Johnson, James Weldon, 173
Johnson, Philip, 148-49
Joyce, James, 22, 34, 39, 219n45
Julien, Isaac, 198
Just Kids (Smith, P.), 148

Kahan, Benjamin, 9
Kathmandu, Nepal, 12, 137, 143, 153
Katz, Stephen, 1
Kenner, Hugh, 4, 7
Kinsey, Alfred C., 51
Kirstein, Lincoln, 105
Kossola, Oluale (Cudjo Kazoola Lewis), 174
Kraus, Robert, 203
Kreymborg, Alfred, 139-40
Kuhn, Maggie, 7-8, 160, 162, 243n103

LaborFest (festival), 107-8
Ladies Almanack (Barnes), 26, 40, 47
Lamos, Colleen, 47

Lange, Dorothea, 187
Late modernism, 6, 35, 211n23
Late-onset disability, 11–12, 104, 125, 129, 206, 213n49
Late style, 12
Lawrence, Jacob, 78, 81, 202–5, 204, p8
Lears, T. J. Jackson, 85
Leaves of Grass (Whitman), 6–7
Lee, Elizabeth, 88, 226n20
Lennon, John, 137
"Lesbian elder," Hampton as, 175–77, 185, 189, 199
Lesbian Herstory Archives (LHA), 4, 16–17, 179, 184–85, 190, 207; oral histories in, 175–80, 194, 196, 200. *See also* Mabel Hampton Special Collection
Lesbian Herstory Archives Newsletter, 184, 185, 191, 192
Lesbians, 49, 188–89, 194–95, 245n14, 248n71; feminist, 5, 12, 124, 179, 182, 189, 206
Les Demoiselles d'Avignon, 19
Levay, Matthew, 64
Levertov, Denise, 4
Levin, Harry, 3–4
Levine, Nancy J., 28, 34, 40–41, 219n45
Levy, Julien, 155
Lewis, David Levering, 194
LHA. *See* Lesbian Herstory Archives
Library, 203
Liechty, Mark, 153
Life (magazine), 97
Life expectancy, 14, 133–34, 215n66
"Life in the Iron Mills" (Davis), 128
"*Life Is Painful, Nasty, and Short . . . In My Case It Has Only Been Painful and Nasty*" (O'Neal), 22–23
Life reviews, 1, 149, 206; by T. Olsen, 5, 119–23, 127–28
Life storytelling, 26–27
Life writing, 59, 119, 213n42, 218n1; by Barnes, 26–27, 40–41; haikus as, 147, 155–56
"Lifting Belly" (Stein), 67, 71
Lim, Eng-Beng, 153
"Little Gidding" (Eliot), 46–47

Little Review, The, 47
Locke, Alain, 139–40, 173–75, 177, 184, 205
Long Gay Book, A (Stein), 60–61, 64, 75
Long modernism, 3, 4, 14, 19, 130, 210n9
Long Way from Home, A (McKay), 174
Looking for Langston (Julien), 198
"Looking for Modernism" (Gates), 198
Lorde, Audre, 180
Lost Generation, 14, 105
Love, Heather, 9
Lowell, Amy, 146
Lubin, David M., 80, 88
Lukács, Georg, 115
Lyon, Janet, 207

Mabel Hampton Special Collection, LHA, 2, 10, 15–17, 16; oral histories in, 175–80, 194, 196, 200
Macdonald, Barbara, 89
Magic Mountain, The (Mann), 59–60
Magic realism, of Albright, 1–2, 80–81, 89, 94–97, 100, 102, 125, 229n54
Male editors/publishers, 26–27, 34, 45
Manalansan, Martin F., IV, 155
Mann, Thomas, 59–60
Man Ray (artist), 40, 158
Mansfield, Katherine, 109
Mao, Douglas, 3
Mapplethorpe, Robert, 148
Marginalia, 24, 30, 31, 38, 40
Marshall, Leni, 111
Marxism, 114, 115
Mason, Charlotte Osgood, 139–40
Mass longevity, 130, 155; American modernism and, 1, 14
Material cultures, 40, 54, 222n10
Matisse, Henri, 160
McCrae, John, 90
McCullough, Frances, 28
McGurl, Mark, 5
McKay, Claude, 90, 173, 174
Means, Florence Crannell, 184
Medicaid, U.S., 13–14
Medicare, U.S., 13–14, 159–60, 172

Mellow, James R., 70
Memories, 23, 90-91, 120-21, 146, 179; of C. Ford, 148-49; of Steward, 9-10, 54-56, 59-60, 62, 72-73
Micir, Melanie, 16-17
Migration Series, The, 202-3, 205
Millay, Edna St. Vincent, 126-27
Minotaure (periodical), 142, 237n15
Misogyny, 3, 4, 28, 60, 95
Mobility: Ford and, 140-41; Hampton and, 200; modernism and, 11-12
Modern Cosmeticology (Chemical Publishing Company), 87
Modernism. *See specific modernisms; specific topics*
Modernist Studies Association, 3
Moore, Marianne, 9, 34
Morrison, George, 81
Morrison, Toni, 18
Moss, Howard, 34-35, 47
Motion Picture Magazine, 87
Moveable Feast, A (Hemingway), 71
Murder Is Murder Is Murder (Steward), 50, 60-61, 63-68, 71-72
Museum of Modern Art, 4, 19, 78, 80, 159-60, 206

Naked City (Weegee), 4
Nantes, France, 90-91, 104-5
Nation (magazine), 35-36
National Coalition of Black Lesbians and Gays, 200
National Endowment for the Arts, U.S., 23
National Museum of African American History and Culture, 200
National Urban League, 8, 181
"Negro Artist and the Racial Mountain, The" (Hughes), 174
Nepal, 11, 153, 165-66, 168
Nepali modernism, 2, 137, 156, 158, 170; of I. Tamang, 163-67, 164-66, 168, 171, p5-p7
Nestle, Joan, 175, 178-81, 189, 192, 194, 196-97, 200, 248n71
Neugarten, Bernice L., 8, 100
New Left, 124

New Left Review (journal), 6
"New Life for Modernism" (Heller), 3
New modernist studies, 3, 9, 11, 18, 94, 175
"New Modernist Studies, The" (Mao, Walkowitz), 3
New Negro (movement), 174-76, 183-84, 189, 196, 199-201
New Negro, The (Locke), 173-74, 175, 183-84
New York, 46-47, 49, 153, 168, 175; Bronx, 2, 49, 177-78, 185, 196, 206; the Dakota (apartment), 1, 137-42, 147, 152, 156, 158, 162; Greenwich Village, 2, 22, 25, 27, 40, 44, 138; Harlem, 175, 179, 187, 191, 194-95, 203; Patchin Place (apartment), 9, 22-24, 40-41, 48-49, 139, 149, 206; Pride marches in, 177, 190, 190-91, 196-200
New Yorker, 23, 34, 39, 45, 129
New York Morning Telegraph Sunday Magazine, 43-44
New York Public Library (NYPL), 109, 113
New York Times, 49, 87-88, 175; obituaries, 22, 96, 203
Nightwood (Barnes), 2, 23, 25, 26-27, 34-35, 41, 47
Noguchi, Yone, 146
North, Michael, 9, 67
No Stone Unturned (Kuhn), 160, 162
"Note About This Book, A" (*Yonnondio*), 112, 115
Not Just Passing Through (documentary), 189-90
Novels, 108, 138; by Steward, 1, 50-51, 63. *See also specific novels*
Nugent, Richard Bruce, 81, 173-74, 183, 194-95
Nursing homes, 10
NYPL. *See* New York Public Library

Obituaries, 203; for Albright, 96; for Barnes, 22; for C. Ford, 138; for Hampton, 175; for Stein, 50, 53, 56, 70
Obscene Diary, An (Spring, Steward), 55
October Gallery, 143
Ohio State University, 73, 75
O'Keeffe, Georgia, 9, 78, 81
"Old Age" (Hughes), 2

"Old Age's Lambent Peaks" (Whitman), 7
Older Americans Act of 1965, U.S., 1, 14, 19, 196, 204
Old Folks (Mother and Father), The, 101
Old Left, 110, 124, 136
"Old Walt" (Hughes), 7
Olsen, Jack, 108
Olsen, Tillie, 18, 160, 162, 206, 234*n*65, 235*n*81; age consciousness of, 110–11, 119, 121–24, 129, 131, 133; on aging, 110–11, 123–26, 129–30; archives of, 2, 17, 109, 110–13; class consciousness of, 110, 114–15, 123–24, 129, 133; correspondences by, 118, 124–25, 131; debilities experienced by, 111, 124–25, 128–30, 133; draft works by, 108–9, 111, 113, 130–31, *132*; fragments of writing by, 109, 113, 117, 120–23, 126–31, *132*, *p4*; handwritten documents by, 131, 134, *135*, 136; on labor, 1, 108–14, 121–23, 129–30; life reviews by, 5, 119–23, 127–28; poetry by, 125–27, 131, *132*, 133; productivities/production of, 107, 110; proletarian modernism of, 2, 108–14, 117, 121, 123–24; published works by, 109–10, 115–16; revised works by, 110–11, 134, 136; slow writing by, 11, 45, 111, 115–17, 126–27; stream-of-consciousness writing of, 113, 120, 123, 127–28, 231*n*8. *See also* Tillie Olsen Papers, Stanford University; *specific works*
Olson, Charles, 34
O'Neal, Hank, 22–23, 25–26, 36, 39, 40, 219*n*35, 219*n*40
O'Neill, Eugene, 88
One of Ours (Cather), 90
"On Gertrude Stein" (Steward), 56
"On Getting to Be Forty" (Steward), 60–61, 67
"On Keepsakes, Gew-Gaws, and Baubles" (Steward), 55–56
"On the Occasion of Her 78th Birthday—To Mabel Hampton" (Wainwright), 182–83
"On Writing Slowly" (Olsen), 115–17
Operation Minotaur (C. Ford and I. Tamang), 154–55

Operation Minotaur (OM), 142–44, *144*, *145*, 146–48, 152, 154–55, 159–60, *161*, 164–65, *171*
Oral histories, 5, 74–75; of Hampton, 175–80, 194, 196, 200
Orientalism, 18, 139, 152–54
Osteoarthritis, 10, 49, 70
Others (magazine), 39
Our Thang (Joans), 158
Our Town (Wilder), 61
Out of the Closets (Humphreys), 150
Out of the Labyrinth (C. Ford), 143
Output. *See* Productivities/production, modernist
Oxford English Dictionary, 24, 44, 47, 83, 148, 226*n*18

Page, Chester, 49
Painting and Sculpture in the Museum of Modern Art (Barr), 94
Pair of Roses, A (Steward), 10, 53, 72
Paris, France, 50, 72; Left Bank of, 1, 4, 26
Partisan Review (journal), 108
Passion Projects, The (Micir), 16–17
Pastiche, modernist, 67–68, 72, 116
Patchin Place (apartment), 9, 22–24, 25, 40–41, 48–49, 139, 149, 206
Paterson V (Williams, W.), 6, 39
"Pavan" (Barnes), 42, *42*, 43–44, 47
Pawlik, Joanna, 148, 160
Performances, 107, 199–200, 245*n*16; by Hampton, 1, 175–76, 189
Periodization, 3, 6, 122–23, 151
Personæ (Pound), 144
Personal Narratives Group (feminist collective), 26
Pharmacy orders, 25, 36, *37*, 40–41, *p2*. *See also* Grocery lists
Phelan, Peggy, 18–19
Phil Andros (Steward pseudonym), 51
Philip Sparrow (Steward pseudonym), 55
Phillips, Duncan, 57, 203, 206
Phillips, Marjorie Acker, 203
Phillips Collection, 57, 202, 205, 207
Picasso, Pablo, 19, 142–43, 202

Picture of Dorian Gray, 97
Picture of Dorian Gray, The (Wilde), 74
Poetry, 2, 45-46, 173-74, 182-83, 198; by Albright, 81, 90-93, 95, 105; by T. Olsen, 125-27, 131, *132*, 133; W. Williams on, 39-40. *See also* Haikus by C. Ford; *specific poems*
Poetry by Barnes, 1, 23-25, 29, 30, 31, *32-33*, 34, *p2*; grocery lists/pharmacy orders and, 36, *37-38*, 39-41; "Pavan" as, 41, *42*, 43-45
Popular Front, 110, 112, 122, 133-34
Portrait of Mary Block, 97
Portrait paintings by Albright, 80, 82-83; *Flesh* as, 88-89, *p2*; *Self-Portrait* as, 95-96; *The Vermonter* as, 97, *98*, 100-102; *Woman* as, 78, *79*, 83, 96, *p2*; *Into the World There Came a Soul Called Ida*, 92-95, *93*, *p3*
Post-Stonewall era, 18, 61-62, 138, 199
Postwar American fiction, 5
Pound, Ezra, 4, 34-35, 39, 64, 144, 146; C. Ford on, 148-49
Pound Era, The (Kenner), 4, 11
Poverty, 39, 172, 187
Powell, Richard J., 188
Power/power dynamics, 81, 115; in editing, 26-27
Pride marches, 177, *190*, 190-91, 194, 196-200
Prime of Life (magazine), 15, 17, 177
Productivities/production, modernist, 12; of Barnes, 23-27, 34-35; of C. Ford, 141-42; of T. Olsen, 107, 110; of Steward, 9-10, 53
Progressive (magazine), 107, 108
Proletarian Literature in the United States (anthology), 108, 113
Proletarian modernism of Olsen, 2, 108-14, 117, 121, 123-24
Proust, Marcel, 8, 59, 120
Psychiatry (journal), 119, 120
Publishing/published works, 5; by Barnes, 23, 26-28, 40, 47; by C. Ford, 143, 147-48; by T. Olsen, 109-10, 115-16. *See also specific published works*

"Quarry" (Barnes), 23
Queer, 15-18, 152-54, 194-95; accumulation/collecting, 25, 28, 54, 222n103; Black modernism, 185, 189; domesticity, 55, 57, 138; geromodernism, 12, 15; Harlem Renaissance, 174-76, 192, 198-99; intergenerationalism, 176-78, 180, 182-84, 198-99; modernism, 5, 50, 75, 139-40, 156-57, 158, 162, 168; senior living, 138-39, 168; surrealism, 2, 163
Quiltuduko (smartphone app), 19-20

Rabinowitz, Paula, 109, 191
Race, 14, 82-83, 187, 189; ageism and, 173-74, 176, 181-82
Racialized debilities, 8
Racism, 181, 194-95, 198
"Radical Archiving" (Nestle), 178
Ragtime (Doctorow), 110
Reeve, Josephine Medill Patterson, 97
References: Steward use of, 56, 60-61, 63-68, 71; used by C. Ford, 142-44, *145*, 146, 148-50, 160; used by T. Olsen, 112, 119, 121
Reid, Panthea, 111
Reid-Pharr, Robert, 2
Rejuvenation (Viereck), 86
Rejuvenation industry, 2-3, 82, 85-89, 92, 95, 104
Remembrance of Things Past (Proust), 120
Reminiscences, 23, 120-21
Retirement, 8, 14, 129, 138, 187, 196, 235n80
Revisions/revised works, 62, 153, 195; by Barnes, 24, 29, 30, 31, *32-33*, 34-36, *37-38*, 46, 219n45; by T. Olsen, 110-11, 134, 136
Rich, Adrienne, 124, 180
Rich, Cynthia, 89
Rimbaud, Arthur, 146, 158
Ringgold, Faith, 19-20, *20*, *p1*
Road Menders, The, 202, 205
Robbins, Everett, 192
Rodgers, Bruce, 61-62
Rogers, Ida, 92-95, *93*, 102
Rose, Barbara, 96
Rosenfelt, Deborah, 109
Rural modernism, 2, 97, 101-2
Russ, Joanna, 181
Rutgers University–New Brunswick, 198

"Sacred Emily" (Stein), 67
SAGE. *See* Services and Advocacy for GLBT Elders
Said, Edward, 35
Saint-Amour, Paul K., 11
Sawyer-Lauçanno, Christopher, 48
Schomburg, Arthur A., 203
Schomburg Center for Research in Black Culture, 199
Schwarz, Judith, 185
Season in Hell, A (Rimbaud), 146
Second-wave feminism, 114–15, 189
Secret Historian (Spring), 50–51, 62, 72
Sedgwick, Eve Kosofsky, 24
See, Sam, 9
Self-Portrait, 82, 89, 95–96, 102, 104
Senescence, 13, 43, 86, 96, 126, 198. *See also* Aging
Senile sublime, 70, 74, 111; of Barnes, 24, 26, 47, 49
Senior Action in a Gay Environment. *See* Services and Advocacy for GLBT Elders
Senior living, 2–3, 9, 12, 138–39, 168
"September 1961" (Levertov), 4
Services and Advocacy for GLBT Elders (SAGE), 138, 195–99
7 Poems (Ford, C.), 142, *143*
Sexism, 8
Sexton, Anne, 124
Sexuality, 47–48, 51, 175–76, 183
Sexual modernism, 9, 57–58, 62, 75, 175
SF Gray Panthers Newsletter, 107, 136
Shah, Shashi, 158
Shuttered Windows (Means), 184
Silence and Power (Broe), 23
Silences (Olsen), 116, 121, 123
Sims, Lowery Stokes, 203–4
Sinister Wisdom (journal), 179–82, 186–187, 188, 190, 191
Sketchbooks, 97, 99, 104–5, 142
SKIB (artist collective), 158
Skin, 82–83, 86–87
Skinscapes in Albright paintings, 78, 80, 83, 85, 92–97, 100
Slavery, U.S., 14–15, 174

Sleep in a Nest of Flames (C. Ford), 147
Smedley, Agnes, 122
Smith, Barbara Herrnstein, 24, 200
Smith, Bessie, 192
Smith, Michael J., 195
Smith, Patti, 148
Smithsonian (magazine), 205
"Smoke, Lilies and Jade" (Nugent), 174
Social Security Act of 1935, U.S., 13
Social Security Explained (motion picture), 16
"Song of Nature" (Emerson), 124
Sontag, Susan, 3
"Spectacle in Color, A" (Garber), 195
Spring, Justin, 50–55, 57–58, 68, 73–74
Squier, Susan, 85–86
Stamm, John Davies, 102
Stanford, Arline, 83, 87, 88–89
Stanford University, Tillie Olsen Papers in, 2, 109, 110, 113, 118, 121–22, 124–25, 130–31
Stansell, Christine, 9
Star, Susan Leigh, 179–80
Stein, Gertrude, 8, 59–61, 63–64, 66–67, 75, 77; C. Ford and, 138, 149–50, 170; friendship with Steward of, 50, 56; Mellow on, 70–71; T. Olsen influenced by, 109
Steinach, Eugen, 86
Stereotypes/stereotyping, 70, 93–94, 185, 218n27; about Barnes, 26–28; about Steward, 52–53. *See also specific stereotypes*
Steward, Samuel, 12, 52, 76, 139; on aging, 58, 68–69; correspondences by, 10, 50, 57, 66–67; debilities experienced by, 72, 77; decline narratives and, 53–54, 60, 62; hoarding by, 51–52, 54–58; memories of, 9–10, 54–56, 59–60, 62, 72–73; miniature book by, 10, 53, 72, 206; personal collections of, 53–59, 73–74; pseudonyms used by, 51, 55, 65; references used by, 56, 60–61, 63–68, 71. *See also specific works*
Stewart, Jeffrey C., 174
Stieglitz, Alfred, 4, 7, 78
Stream-of-consciousness writing, 71, 97–98, 109, 147, 174; by T. Olsen, 113, 120, 123, 127–28, 231n8

Stryker, Susan, 194
Study for "The Vermonter," 97, 99
Stutman, Osías, 24, 31, 39
Subcultures, 36, 49, 69-70, 72, 179, 181, 199-200; gay male, 58-59, 61-62, 139-40, 149-50
Sullivan, Hannah, 35
Sunflower Quilting Bee at Arles, The, 19-20, *20, p1*
Supermarket (painting series), 81, 203-4
Supermarket—Periodicals, 203-4, *204, p8*
Surrealism (exhibition), 155
Surrealism, U.S., 80, 151; of C. Ford, 1, 10, 142, 146-48, 155-56, 159-60, 238n33
Survey Graphic (publication), 173, 183-84
"Surviving and More" (Nestle and Hampton), 179-82, 185, *186-90*
Syrett, Nicholas L., 15

"Tain't Nobody's Business" (Garber), 192, *193,* 194-96, *197*
Tales of the Jazz Age (Fitzgerald), 14
Tamang, Indra Bahadur, 137, *153,* 163-67, 169, 206, 242n83; collaboration with C. Ford, 19, 137, 139-40, 143, 152, 154-56, 168, 172; C. Ford orientalizing, 152-54, 172; *Hermitage* (blog) by, 156, 168, 170, 241n78; Nepali modernism of, *163-67, 164-66,* 168, *p5-p7;* Tamang diaspora and, 153, 168. See also Caregiving by I. Tamang; Operation Minotaur (OM)
Tamang, Mukta S., 153
Tanning, Dorothea, 148
Taylor, Mary Jane, 191
Tchelitchew, Pavel, 138, 155, 156, 158
Tell Me a Riddle (Olsen), 108, 116
"Tell Me a Riddle" (Olsen), 108, 109, 121
Temporal expansion of modernism, 3, 5, 6
Their Eyes Were Watching God (Hurston), 8, 15, 88
Thurman, Wallace, 174, *193,* 194
Tillie Olsen Papers, Stanford University, 2, 110, 113, 118, 121-22, 124-25, 130-31
Titles, 101, 192; Barnes workshopping, 29, 31, 41, *42;* by C. Ford, 147-48, 160; by T. Olsen, 112-13; references in Steward, 50, 61, 67
Toklas, Alice B., 64-66, 70-71; friendship with Steward, 1, 50, 56-57
Tolstoy, Leo, 119
Tooker, George, 81
Toomer, Jean, 173, 179
Tornstam, Lars, 151
Tourism/tourist documents of C. Ford, 143, 153, 157, 158
Transgenerationalism, 2-3, 180
Truth, Sojourner, 19
Tubman, Harriet, 203
Two Chairs, 202
"Two Pendants: for the Ears" (Williams), 39-40
Tyler, Parker, 9, 138
Typescripts, *145;* of Hampton oral histories, 177, 179-80; T. Olsen, 109, 111, 118-19, 127-28, 131, *132, p4*
Typescripts by Barnes, 10, 22, 36, *37-38,* 39, *p2;* of "Dereliction," 29, *30,* 31, 40, 46-47; of "Pavan," 41, *42, 43,* 47

Ulysses (Joyce), 71-72, 77, 83, 219n45
"Undones unfinisheds," by T. Olsen, 110, 126, 128-29, 134, 136
Unfinished works: by Barnes, 29, 34, 41, 45, 47; by T. Olsen, 109-12, 114-17, 126, 128-31, 134, 136. See also Unpublished works
United Asia (publication), 205
United States (U.S.), 23, 56, 60, 166, 168, 202; Food and Drug Administration, 88; geromodernism in, 13, 17-18; Great Depression, 108, 111-12, 114, 123, 176; Immigration and Nationality Act of 1965, 153; Medicare, 13-14, 159-60, 172; Older Americans Act of 1965, 1, 14, 19, 196, 204; slavery in, 14-15, 174; Social Security Act of 1935, 13
Unmuzzled OX (magazine), 156
Unpublished works: by Barnes, 23-25, 28-29, 34-35, 40-41, 44; by C. Ford, 141-43, 152-53; by Olsen, 113, 118
Upper East Side Rehabilitation and Nursing Center, 160

Valentino, Rudolph, 51
"Valet, The" (Barnes), 47
Van Der Zee, James, 187
Van Doren, Mark, 35-36
van Gogh, Vincent, 19, 124, 202, 205
Van Vechten, Carl, 16, 156, 158, 168, 174, 192
Vermont, 2, 80-81, 97, 100-1
Vermonter, The, 82, 97, 98, 100-2
Victorian era, 189, 210n17, 212n38
Viereck, George Sylvester, 86
View (magazine), 5, 13, 138, 142, 150
View from 80, The (Cowley), 4
"Virgin Spring" (Barnes), 45, 47
Visual cultures, 13, 81-82, 85, 96, 185
Vogue (magazine), 83, 85
Voices of New Women (Everywoman's Center), 185, 189

Wainwright, Sonny, 182-83, 191
Walker, A'Lelia, 175, *193*, 194
Walker, Alice, 18
Walker, Madam C. J., 19
"Walking-Mort, The" (Barnes), 23
Walkowitz, Rebecca L., 3
Wall Street Journal, 137
Ward, 81
Wars, 3-4, 5, 90-91, 104-5, 230n83. *See also* specific wars
Washington Post, 53
Waste Land, The (Eliot), 90, 109
Watercolors by Albright, 78, 91, 104, 105
Waters, Ethel, 175
Weak modernism, 11
Weary Blues, The (Hughes), 174
Weegee (photographer), 4, 7
Weininger, Susan S., 80, 82, 88, 228n14
Well of Loneliness, The (Hall, R.), 191
Wharton, Edith, 9
When Harlem Was in Vogue (Lewis), 194
Whiteness, 8, 194-95
Whitman, Walt, 6-7, 112, 196, 219n45
"Why I Like Detective Stories" (Stein), 64
Why Survive? Being Old in America (Butler), 48

Wicke, Jennifer, 18
Wilde, Oscar, 59, 60, 74-75
Wilder, Thornton, 51, 59-60, 61
Will and testament documents, 29, 177
Williams, Michael, 50, 54, 75
Williams, William Carlos, 4, 39-40, 149-50
Wilson, Christopher P., 113
Windy City Times (newspaper), 52-53
Winkiel, Laura, 158
Winston-Salem, North Carolina, 15
Woman, 78, 79, 83, 96, 104, *p2*
Women, 51, 86-89; in Albright paintings, 78, 79, 84, 93-96; Black, 175, 180-82, 192; labor of, 1, 108-10; white, 78, 83, 178, 185, 187
Women of the Left Bank (Benstock), 4
Women's Review of Books (journal), 19
Women's Studies Newsletter, 128
Woodward, Kathleen, 2, 6, 7-8, 17, 46, 121, 218n27; on caregivers, 140; on feminism, 181; on fragilization, 11, 124; on life reviews, 120
Woolf, Virginia, 8, 109, 231n8
"Work-in-Progress: Rite of Spring" (Barnes), 23, 31, *32-33*, 34-35, 48, 219n45
Works in progress, by Barnes, 36, 39-41, 219n45
World War I, 4, 78, 85, 90, 105
World War II, 5, 17, 49, 96, 142

Yankee (magazine), 102
Yeats, W. B., 88
Yonnondio (Olsen), 2, 108-9, 116-17, 120-21, 128, 231n9; 1994 edition, 117-18, 134, *135*, 136; 1974 edition, 112-13
Young and Evil, The (Ford, Tyler), 9, 138, *139*, 148, 151
Young Cherry Trees Secured Against Hares (Breton), 166
Youth-centric culture, 12, 61-62, 87-88, 93-95, 101-2
Youthism, 150

Zukofsky, Louis, 34